JUNG E. HA-BROOKSHIRE, Ph.D.
UNIVERSITY OF MISSOURI

Global Sourcing in the Textile and Apparel Industry

PEARSON

Boston Columbus Indianapolis New York San Francisco Upper Saddle River
Amsterdam Cape Town Dubai London Madrid Milan Munich Paris Montreal Toronto
Delhi Mexico City Sao Paulo Sydney Hong Kong Seoul Singapore Taipei Tokyo

Editorial Director: Vernon Anthony
Acquisitions Editor: Lindsey Gill
Editorial Assistant: Nancy Kesterson
Director of Marketing: David Gesell
Senior Marketing Coordinator: Alicia Wozniak
Program Manager: Laura J. Weaver
Project Manager: Janet Portisch
Procurement Specialist: Deidra Skahill
Manager, Rights and Permissions: Mike Lackey
Art Director: Jayne Conte
Cover Designer: Karen Salzbach
Cover Image: Fotolia
Media Director: Leslie Brado
Lead Media Project Manager: April Cleland
Full-Service Project Management: Thistle Hill Publishing Services
Composition: Cenveo® Publisher Services
Cover Printer: Lehigh-Phoenix Color/Hagerstown
Text Printer: Courier/Kendallville
Text Font: 9/15 Helvetica Neue

Credits and acknowledgments for materials borrowed from other sources and reproduced, with permission, in this textbook appear on the appropriate page within the text. Unless otherwise stated, all artwork has been provided by the author.

Many of the designations by manufacturers and seller to distinguish their products are claimed as trademarks. Where those designations appear in this book, and the publisher was aware of a trademark claim, the designations have been printed in initial caps or all caps.

Library of Congress Cataloging-in-Publication Data

Ha-Brookshire, Jung.
 Global sourcing in the textile and apparel industry/Jung E. Ha-Brookshire,
University of Missouri.
 pages cm
 Includes bibliographical references and index.
 ISBN-13: 978-0-13-297462-2 (pbk.)
 ISBN-10: 0-13-297462-2 (pbk.)
1. Textile industry. 2. Clothing trade. 3. Business logistics. 4. Imports.
5. Globalization. I. Title.
 HD9850.5.H3 2015
 677.0068'7—dc23
 2013043928

V011

10 9 8 7 6 5 4 3 2 1

ISBN 10: 0-13-297462-2
ISBN 13: 978-0-13-297462-2

brief contents

contents

7 Global Sourcing Step 3: Micro-Level Analysis for Supplier Selection | 117

8 Global Sourcing Step 4: Purchase Order and Methods of Payment | 135

9 Global Sourcing Step 5: Preproduction, Production, and Quality Assurance | 155

10 Global Sourcing Step 6: Logistics and Importing Processes | 185

11 Global Sourcing Step 7: Sourcing Performance Evaluation | 211

12 Current and Future Global Sourcing | 223

preface

U.S. textile and apparel businesses have engaged in global sourcing for more than six decades. I have been fortunate to be involved in global sourcing both directly and indirectly. I was born and raised in Daegu, South Korea. During my early childhood in the 1970s, the town of Daegu experienced rapid growth through its thriving textile mills and apparel manufacturing plants. DuPont, a U.S. textile manufacturing company, set up one of the largest textile and apparel manufacturing plants in my town. It was the first company where one of my aunts was able to get her very first job. Back then, women were less likely to have education or a career in my country. The fact that she woke up every morning, wore a uniform, went to work, and studied at DuPont's after-work school programs was so novel that the whole town was concerned about my brave aunt's future. She was too modern! I loved watching her going to work and school, and every year on Children's Day, May 5 (to most of us Korean children this national holiday celebrating children was more exciting than Christmas), she took me to the DuPont campus where I saw green grass for the first time. I thought DuPont was the best thing ever to happen to us and our town.

Since then I have wanted to be involved in global sourcing. At that time I had no concept of global sourcing. However, I knew what I wanted to do when I grew up. I wanted to travel all over the world, establish a factory (or find one), then throw annual Children's Day parties in lots of different countries. Twenty years later, after earning a bachelor's degree in clothing and textiles from Seoul National University, I flew to New York City looking for an opportunity to start accomplishing my childhood dream. Within a few months, I found my very first job as a production assistant at Popsicle Playwear, a division of Adjmi Apparel Group, on 33rd Street near Macy's. I was quickly promoted and became fully engaged in global sourcing. All of my company's product portfolios were sourced from foreign countries such as China, Taiwan, Hong Kong, Indonesia, Turkey, United Arab Emirates, Pakistan, and even South Korea. By 2000, my team was sourcing and importing over $100 million worth of goods from all over the world.

The success of my career at Adjmi Apparel Group helped me land a job at Richard Leeds International, Inc., whose specialty was sleepwear. From 2001 to 2004, I was responsible for Central American production, sourcing and importing up to $10 million at wholesale value. Sourcing from the Central American region had whole new sets of challenges and questions. I had to learn everything from the ground up by doing the job. While working at these jobs, I somehow managed to throw several birthday parties for factory workers, played with their children, and participated in their night school activities. Indeed, my childhood dream came true. People whom I worked with all over the world were extremely motivated, eager to learn and wanting to be an active part of the global economy.

Although my colleagues in these developing countries were eager to learn, at home in New York City I had become more and more frustrated with the lack of basic knowledge and skill sets from college graduates whom I interviewed for one of my staff positions. I found it extremely difficult to find college graduates with a decent level of understanding of international business, global trades, and global sourcing. Both then and today I question why college graduates do not have an adequate understanding of global sourcing when the majority of U.S. businesses are engaged in global sourcing. When I returned to academics, I found that there were no comprehensive, viable, up-to-date instructional materials available for global sourcing. Rather, global sourcing was deemed to be mysterious and too difficult to learn about in a classroom.

The ideas for this book were conceived in 2007, when I took an assistant professor position at the University of Missouri. I wanted to produce a textbook that had real-life implications while maintaining theoretical perspectives. I searched and gathered all the reference materials and information through personal contacts, library search, and literature from governments, laws, trades, and businesses. For the first class that I taught on global sourcing in 2008, I compiled all these materials into a reference book. Then I personalized the lectures with many of my business experiences so that students could better understand the concepts in the textile and apparel industry. My students loved the class. By 2009 my lectures were translated into PowerPoint slides and by 2010 they were audio-recorded. In 2011 and 2012 I began writing this textbook—the result of eight years of experience working in global sourcing and researching the subject, and six years of teaching experience related to global sourcing.

Throughout this book I have tried to cite sources as much as possible. However, some examples, such as the rubrics on financial sourcing performance in Chapter 11, stem from my experiences while working as a global sourcer. They worked for me and my team. The hypothetical company Amazing Jeans, used throughout this textbook, is very similar to the companies for which I worked. Many of the questions asked and issues dealt with in the learning activities at the end of each chapter relate to questions and issues that I encountered in my work. Some of the learning activities are actual activities I asked my staff members to complete to train them in the basic concepts of global sourcing.

Since this book is written from the U.S. sourcer's perspective and is somewhat biased toward U.S. businesses that target mass and midtier consumer segments, some might see this as negative. However, I believe this U.S. perspective could help many foreign suppliers better understand U.S. buyers and sourcers: By knowing the other, one could better prepare himself or herself. Similarly, by understanding mass and midtier business practices, students could apply these concepts to other consumer segment businesses. Therefore, this book will be useful for careers in many different industries. First and foremost, textile and apparel educators will find this book useful to help better prepare today's college students with clothing- and textile-related careers. Many of the terms and concepts will be extremely useful when they are trying to seek sourcing-related jobs. Students who seek jobs as product developers, designers, salespeople, and merchandisers in the United States will find this book beneficial because they will gain a more comprehensive view of the global textile and apparel industry through global sourcing. Students in other countries could also apply these concepts to better prepare their career either as sourcers or suppliers.

Throughout this process, I have received much help from many different people. I would like to thank staff members at Pearson for all the help they have provided me in completing this project, as well as the following reviewers: Elena Karpova, Iowa State University; Kathleen Colussy, The Art Institute; Leslie Simpson, Morgan State University; and Crystal Green, The Art Institute. I also would like to extend my gratitude to my advisor, Dr. Barbara Dyer, who was the first person to tell me that I, too, could write a textbook. I thank my graduate research assistants and my fellow colleagues at the University of Missouri for their extremely positive support and encouragement. Without all of their help and input, this book would not have been possible. Finally, I would like to express my deepest appreciation to my husband, Richard Brookshire, for his unselfish support throughout this process.

Jung E. Ha-Brookshire
University of Missouri

DOWNLOAD INSTRUCTOR RESOURCES FROM THE INSTRUCTOR RESOURCE CENTER

To access supplementary materials online, instructors need to request an instructor access code. Go to www.pearsonhighered.com/irc to register for an instructor access code. Within 48 hours of registering, you will received a confirming email including an instructor access code. Once you have received your code, locate your text in the online catalog and click on the 'Instructor Resources' button on the left side of the catalog product page. Select a supplement, and a login page will appear. Once you have logged in, you can access the instructor material for all Pearson textbooks. If you have any difficulties accessing the site or downloading a supplement, please contact Customer Service at http://247pearsoned.custhelp.com.

Jung E. Ha-Brookshire, Ph.D., is associate professor in the Department of Textile and Apparel Management at the University of Missouri (MU). Prior to her time at MU, she worked as a production assistant, production coordinator, production manager, and sourcing manager for Adjmi Apparel Group and Richard Leeds International, Inc., both located in New York City, from 1997 to 2004. During her time there she traveled extensively to various countries in Asia and Central America in textile and apparel product sourcing, product development, production coordination, and quality assurance capacity. At MU, Ha-Brookshire teaches global sourcing and the capstone for retail marketing and merchandising students. She also teaches global supply chain management and theory development and evaluation courses at the graduate level. She received several notable awards, including the 2011 Rising Star award by the International Textile and Apparel Association, the 2010 Excellence in Education award by the MU Division of Student Affairs, and the 2009 Professor of the Year award given by the MU Student Athlete group. Ha-Brookshire has completed numerous internal and external grants totaling over $350,000 since 2008. She has published over 25 manuscripts in peer review journals and presented her research more than 50 times at various international, national, and regional conferences or workshops, including giving a keynote speech in Egypt. She recently became a Made in USA working group member of the Outdoor Industry Association, following her appearance on an Internet news program, *HuffPost Live*, in 2013.

Global Sourcing in the Textile and Apparel Industry

INTRODUCTION TO GLOBAL SOURCING

LEARNING OBJECTIVES

The textile and apparel industry is one of the most globalized. Today's textile and apparel companies are doing business with companies from all over the world, and they are highly interdependent. This chapter discusses the historical background of global sourcing, provides a definition of global sourcing, states the goals of global sourcing, and describes the job responsibilities and requirements of sourcing personnel in today's marketplace. Upon completion of this chapter, students will be able to:

- Understand how global sourcing has developed from the historical perspective.
- Comprehend the role of global sourcing in the textile and apparel industry.
- Explain the pros and cons of global sourcing.
- Articulate differences among sourcing, outsourcing, global sourcing, and global supply chain management.
- Explain global sourcing within the global supply chain perspective.
- Understand the responsibilities of global sourcing for sustainable future.
- Describe the main goals of global sourcing.
- Understand what job responsibilities and requirements are for sourcing personnel.

1

(Opposite page) Source: Sylvie Bouchard/Shutterstock

FIGURE 1.1 *Prior to the Industrial Revolution, textiles were produced at home by manual labor.*
Source: © INTERFOTO/Alamy; © OSCAR/Fotolia

Global sourcing

Historical background

In today's society, when we need something to wear, we go to stores to purchase ready-made clothing. In many cases, retailers purchase clothing from other companies and make it available to consumers in their retail space. Although this seems to be a natural way to satisfy our clothing needs, this is one of the profound results of technological advance and the Industrial Revolution. Prior to the Industrial Revolution, up until the late eighteenth or early nineteenth century, women were in charge of spinning fiber, weaving fabrics, and sewing clothing at home for their families' needs (Wilson, 2002). Figure 1.1 shows traditional ways to spin yarns and weave fabrics manually. Advances in technology fueled the Industrial Revolution during the period between 1750 and 1850. The Industrial Revolution began in the United Kingdom and spread throughout western Europe, North America, and the rest of the world. Mechanism to spin cotton fibers was one of the earliest inventions contributing to the Revolution. Through these inventions and other technological advancements, factories started making yarn, fabrics, and clothing. Women no longer needed to make everything at home; rather, they could go to the market to purchase ready-made clothing and textiles (Wilson, 2002). Industrialization moved textile and apparel production from homes to factories, creating the textile and apparel industry.

As the textile and apparel industry developed, business clusters (geographic concentrations of interconnected businesses, suppliers, and associated institutions) were also created. Factories and businesses within each cluster were sharing and supplying raw materials, know-how, technology, and skills. Geographic concentration helped save transportation costs and delivery time. Until recently in the United States, North Carolina and Georgia comprised one of the main textile and apparel business clusters. These states were taking advantage of the abundant cotton fibers produced in their region.

Business clusters also helped companies become specialized. To be competitive, businesses concentrated on specialization to increase manufacturing efficiency and, ultimately, reduce unit costs. Thus, factories that specialized in sewing operations, fabric production, or yarn production were created within each business cluster. These factories were dependent on one another, as sewing plants needed fabric mills to produce fabrics at low cost, while fabric mills needed yarn mills for yarn production. Thus, buyer–supplier relationships were formed within the business cluster, and the buyer's sourcing of raw materials was typically limited to the firms within the cluster during the early industrial age.

As the industry developed and consumers' tastes changed, textile and apparel businesses needed new and special materials, knowledge, or skills that were not readily available within their own business clusters. These businesses then expanded their sourcing operations beyond their clusters, states, and even across national borders. For example, a sewing factory in North Carolina could now source wool fabrics from Australia or silk from Japan, as Australia is a leading wool producer and Japan is a leading silk producer. In this case, both Australia and Japan are the suppliers and a sewing factory in North Carolina is the buyer. On the other hand, a cotton fabric producer in Georgia could consider sourcing sewing operations from Mexico to produce low-cost cotton clothing. In this case, a Georgia-based cotton fabric producer is the buyer and a sewing factory in Mexico is the supplier of labor. This natural progression of industry development led to global sourcing.

As the history of the textile and apparel industry shows, sourcing is not a new phenomenon. In the early stages of the Industrial Revolution, women *sourced* yarns and fabrics so they could sew the garments at home for their families. Sourcing within the business cluster was natural because factories wanted to increase their production efficiency by concentrating on specialized operations. As communication and transportation technologies have advanced, and the movement of products, capital, and labor across the border has become easier, businesses have embarked on global sourcing to seek novel, high-quality, or low-cost products.

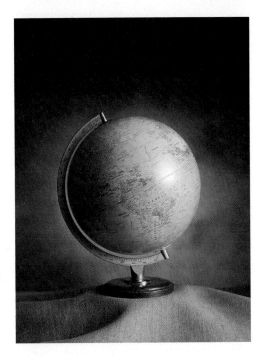

FIGURE 1.2 *Textile and apparel industries have made the world smaller than ever.*
Source: amebar/Fotolia

Current status of global sourcing

Today, global sourcing is common in many manufacturing sectors in the United States. For example, the mobile phone industry sources globally to keep up with growing demands (Stadtler & Kilger, 2008). The cosmetics and home appliance industries source globally to access emerging markets, gain high profit margins, and take advantage of the abundance of low-wage labor in developing countries (Stadtler & Kilger, 2008). The food and agriculture product industries also source globally to improve product availability (Laseter & Weiss, 2008).

Since World War II, textile and apparel businesses have been particularly motivated to save manufacturing costs to accommodate the increasing demand for low-cost clothing by newly emerged middle-class consumers. To save production labor costs, many businesses in high-wage economies (or developed countries) have moved their manufacturing facilities to or contracted manufacturing operations with businesses in low-wage economies (or developing countries) (Cook, 2007). This movement of manufacturing sites has led the textile and apparel industry to be one of the most globalized of all and the world has become ever smaller (see Figure 1.2).

Today, the United States is the single largest apparel-importing country in the world. According to *International Trade Statistics 2011* published by the World Trade Organization (WTO), the United States imported apparel worth US$82 billion in 2010, making up 22.3 percent of the world's apparel imports (World Trade Organization [WTO], 2012). In addition, recent research

suggests that over 90 percent of total apparel products available in the U.S. marketplace are, in fact, manufactured in and imported from other countries (Ha-Brookshire & Dyer, 2009). China, Vietnam, Indonesia, Bangladesh, and Mexico were the leading apparel exporters to the United States in 2010 (WTO, 2012). These statistics suggest that U.S. apparel companies are extensively sourcing their products from all over the world.

Pros and cons of global sourcing

Regardless of the various industry sectors, in general, global sourcing is known to have several benefits to businesses and economies. First, global sourcing helps businesses reduce material or operating costs, improve quality, increase product availability, and respond quickly to changing markets (Cho & Kang, 2001; Shelton & Wachter, 2005). In other words, global sourcing helps businesses gain access to a variety of products otherwise difficult to obtain. Second, global sourcing allows companies in developing countries to focus on labor-intensive manufacturing activities and exports, while companies in developed economies can concentrate on high-technology, capital-intensive, and global coordination activities (Dickerson, 1999; Shelton & Wachter, 2005). This concentration helps increase trade between developed and developing countries. Supporters for global sourcing emphasize that not only does it improve product quality, availability, cost, and responsiveness to the market, but it also helps developing countries grow their domestic economies and learn new technology and knowledge from developed countries.

Despite the benefits of global sourcing, significant downsides of global sourcing have been discussed as well. For example, some argue global sourcing leaves many factory workers unemployed and, thus, intensifies the gap between the rich and the poor within developed countries (Cho & Kang, 2001; Shelton & Wachter, 2005). On the other hand, global sourcing in developing countries could create issues related to unfair labor practices, child labor exploitation, or environmental degradation (Park & Stoel, 2005; Shelton & Wachter, 2005). Thus, opponents of global sourcing argue that businesses' considerations of global sourcing must include strategies to retrain factory workers in developed countries once factories are relocated to other countries, improve labor practices in developing countries, and monitor environmental protection practices in developing countries.

Definition of global sourcing

Sourcing, global sourcing, and outsourcing

Before we define global sourcing, we must clarify the concept of sourcing first. Although *sourcing* is a common term in today's marketplace, the definition of sourcing has not been well conceptualized. One of the early definitions, by Dickerson (1999, p. 253), states that sourcing is "the process of determining how and where manufactured goods or components will be procured (obtained)," and the terms *outsourcing* and *sourcing* are used interchangeably. Although this definition provided a general concept of the term *sourcing*, sourcing involves more than simple procurement determination.

Sourcing includes all aspects of a business's activities involved in acquiring parts or full products outside the organization. Some businesses acquire components to complete the final products. Others might acquire fully finished products for their business purposes, such as

wholesalers or retailers. Typically, decisions on sourcing are made based on the business's long-term goals rather than its short-term goals (Seshadri, 2005). In fact, whether a company will focus on sewing operations with fabrics sourced from other companies or countries is a big decision that any business must make using a long-term outlook. Thus, sourcing is different from "procurement," which typically refers to short-term purchasing contracts (Seshadri, 2005). Considering all of these aspects involved in sourcing, the term **sourcing** can be defined as *a set of business processes and activities by which businesses acquire and deliver components or fully finished products or services from outside the organization, with the objectives of finding, evaluating, and engaging suppliers of goods and services to achieve long-term competitive advantages*. Thus, sourcing is a business-to-business (B2B) activity, involving both the buyer and the supplier. When these buyers and suppliers are in different countries and require international trade, sourcing becomes global. Therefore, global sourcing is sourcing in the global marketplace.

Companies can source a variety of business processes including raw materials, labor, manufacturing equipment, technology, design skills, marketing know-how, business relationships, partially finished products, and fully finished products, domestically and globally. Thus, sourcing involves (a) analyzing the relationship between product, price, and volume; (b) understanding the market dynamics for products and the suppliers of products; (c) developing procurement strategies; and (d) establishing working relationships with suppliers (Hilstrom & Hilstrom, 2002).

More specifically, in the textile and apparel industry, sourcing involves making decisions regarding the amount of product needed, identifying production sites capable of producing goods for retail, negotiating prices and discounts, maintaining relationships with the manufacturers during the production process, scheduling deliveries, following up to ensure on-time delivery, and maintaining quality (Granger, 2007; Muhammad & Ha-Brookshire, 2011). In short, sourcing requires various business activities such as marketing, merchandising, purchasing, accounting, designing, product development, operation management, general management, and business strategy (Seshadri, 2005). Collaboration across the functions is key to global sourcing (see Figure 1.3). Global sourcing requires all of these business processes to be considered, planned, and practiced in the global marketplace. Typically, global sourcing is initiated by companies in developed economies seeking low-cost labor and high profits in the long term.

As seen in the definition of sourcing, the term *sourcing* itself does not bear any negative connotations. However, the term *outsourcing* has been used negatively along with certain phrases such as "domestic job loss" (Ha-Brookshire & Lu, 2010). In this light, the term *outsourcing* emphasizes the fact that jobs are shifted to *outside* the business cluster, state, or country. This term implies that workers inside the cluster, state, or country lose something that they had before. Thus, although both *outsourcing* and *sourcing* might not have fundamental differences in meaning, the term *outsourcing* often implies a negative impact of global sourcing on the domestic economy, while *sourcing* emphasizes only businesses' strategic practices. Thus, one might need to be cautious when using these terms.

Sourcing and supply chain

Supply chain and *supply chain management* are another set of terms we often face when it comes to sourcing. Although these terms might seem to overlap, there is a difference between them. Researchers explain a **supply chain** as a group of suppliers, suppliers' suppliers,

FIGURE 1.3 *Collaboration is the key to global sourcing.*
Source: © Monkey Business/Fotolia

buyers, and buyers of buyers of materials, information, and services providers, organized to supply raw materials, transform products, and satisfy the demand of ultimate consumers (Chen & Paulraj, 2004). In this light, a typical supply chain includes raw material suppliers, material-purchasing departments, production teams, logistics and distribution centers, technology developers, and even end consumers. All of these members within the supply chain are closely linked with one another to achieve the goal of meeting demand by supplying and transporting the goods or services required for such demand. Without transportation, raw materials will not be delivered to manufacturing facilities. Without raw materials, manufacturing sites will not be able to produce final products. Without information technology, it would be difficult for distribution to improve efficiency (see Figure 1.4). Similarly, consumers will not

FIGURE 1.4 *The supply chain includes even the exchange of information.*
Source: TebNad/Fotolia

be able to acquire the products and services that they want if there are no suppliers. All of these supply chain members are interdependent.

Managing such supply chain members and activities is called **supply chain management (SCM)**. John Mentzer is one of the leading SCM researchers in the United States, and he explains SCM as a business function that strategically and systematically coordinates the traditional business functions within a particular company as well as across businesses within the supply chain. Through the management of supply chain, not only firms' performance but also the supply chain as a whole would be able to improve long-term performance (Mentzer, 2004). He suggests the overall goal of SCM is to achieve customer satisfaction, value creation, increased profitability, and strong competitive advantages. To achieve this goal, Mentzer suggests SCM must be embedded into almost all aspects of traditional business functions such as marketing, sales, research and development, forecasting, production, purchasing, logistics, information systems, finance, and customer service. Through intercorporate and interfunctional coordination, successful SCM is achieved, and successful SCM is one of the most important business functions in today's global marketplace.

Menzter's approach to traditional business functions and the role of SCM in each of such functions is different and unique from the past perspective toward SCM. His perspective points out that traditional business functions must fall under the umbrella of the SCM framework, whereas previously it was thought SCM functions were executed to support traditional business functions. According to this perspective, SCM is a higher-level business function than traditional business functions, thus all of the traditional functions must feed information and services to SCM under the overarching SCM framework.

In this light, the Council of Supply Chain Management Professionals (2010) came up with a specific list of supply chain activities that may be found in today's business environment. According to them, SCM professionals:

- Coordinate and collaborate with channel members, such as suppliers, intermediaries, third-party service providers, and customers.
- Manage all logistics-related functions.
- Manage all manufacturing-related operations.
- Predict and satisfy supply and demand within and across companies.
- Connect major business functions and processes within and across companies into one, cohesive, and effective business system.
- Organize processes and activities with and across marketing, sales, product design, finance, information technology, and other core business functions.

Therefore, it can be said that global sourcing is one of the activities under the SCM framework. Global sourcing tends to concentrate on acquisition and delivery of components or fully finished products or services from outside the organization to the organization (see Figure 1.5), while supply chain management includes managing demand and supply, creating a big-picture business model, and interdepartmental coordination strategies within the company.

Global sourcing in the textile and apparel supply chain

With a clear understanding of global sourcing and supply chain, this section goes deep into global sourcing in the textile and apparel supply chain. As discussed previously, there are various

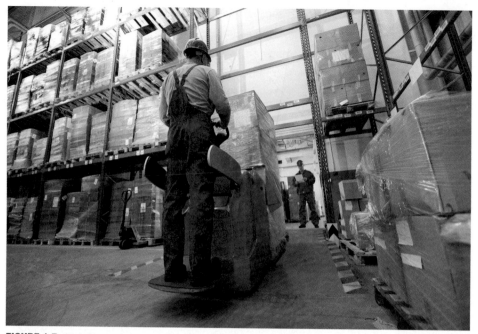

FIGURE 1.5 *Global sourcing concentrates on acquisition and delivery from outside the organization.*
Source: Marcin Balcerzak/Shutterstock

members in the global textile and apparel supply chain. Figure 1.6 illustrates interconnected relationships among various supply chain members in the global textile and apparel industry. More specifically, the ultimate suppliers in the upstream of the textile and apparel supply chain would be fiber producers, and the ultimate customers would be users of clothing and textiles.

To deliver the most desired and needed goods to ultimate users, various functions are necessary within the textile and apparel supply chain. By reviewing past history, one must forecast future needs and wants. Consumer research, including sociopsychological aspects of consumers, is extremely useful to carefully predict consumers' purchase, use, and disposal behavior. Design and product development functions are necessary to engineer the finished goods in the way humans need and want—both creatively and functionally. Global sourcing exists to implement design and product development strategies. Sourcing activities are involved in global supply chain management by identifying ideal places to manufacture finished goods, inspecting finished goods, and coordinating logistics. Merchandising helps the supply chain produce the optimal amount of goods in a timely manner so producers still gain profits while consumers find the needed and/or wanted products. Finally, retailing—such as brick-and-mortar retailing, electronic commerce (e-commerce), and mobile commerce (m-commerce)—is responsible for creating transactions among consumers and the entire global supply chain members.

These functions are managed through interfunctional coordination within an organization, as well as interorganizational coordination. These functions and coordination are managed through creative problem solving, leadership, and education. The dotted lines symbolize that these functions are highly interdependent. Vertical organizations may have all of these functions within the global supply chain. Others may focus on only one function, reflecting the fragmented nature of clothing and textile industries. It is not to say all clothing and textile products are produced through all of these functions. Yet, these are the core functions found within today's clothing and textile supply chain.

Figure 1.6 shows that all of these supply chain activities exist to satisfy humans' clothing needs and wants that are affected by political, economic, social, technological, and natural

FIGURE 1.6 Global supply chain management of textiles and apparel
Source: Ha-Brookshire and Hawley (2013)

environments. Successful global supply chain management in the textile and apparel industry would result in human satisfaction for clothing. Through these satisfaction processes, businesses would gain financial profits, humans would get satisfied by economic gains as bargain-hunting consumers, and employees working for textile and apparel businesses would get satisfied through financial gains that businesses may get from this process. These economic gains, however, must not ignore social and environmental consequences the global supply chain processes may cause. By responsibly meeting the current generation's needs and wants, humans also gain satisfaction for a better society and environment.

Overall, humans' needs and wants create demands for certain clothing and textile products (see Figure 1.7), and such demands motivate supply chain members to work together. The results of global supply chain management can be actual products, services, and/or information. Products refer to tangible clothing and textile products, while services refer to intangible aspects of products such as customer services, returns, repairs, or delivery. Information could be certain messages, including corporate social responsibility, brand image, or status symbol. Through these products, services, and information, humans achieve satisfaction or dissatisfaction related to clothing and textiles. The postconsumption experiences are then shared with society, influencing new demands and even new policies through feedback systems. People who are dissatisfied because of poor supply chain management may demand changes in policies or new policies. These policies then affect the way supply chain members function. All of these processes take place in the global environment. Therefore, the focus of the global supply chain management of textile and apparel is not to satisfy humans only in developed economies. It should also include humans in developing economies as producers as well as consumers. Through this global supply chain management of textile and apparel, global sourcing is one of the key business activities closely related to production.

FIGURE 1.7 *Individual human needs and wants drive the larger supply chain.*
Source: Ariwasabi/Fotolia

Goals of global sourcing and sustainability

Most people think companies source (or outsource) their products for cheap labor. Although low-cost labor helps reduce the cost of labor-intensive processes, it is not the only goal of global sourcing. As seen in Figure 1.6, through successful and responsible global sourcing, businesses gain financial benefits, consumers could afford to get a variety of products in high quality at affordable prices. Although these are important aspects of global sourcing, too much focus on business profits and people's overconsumption has been criticized by many leaders and thinkers. After long decades of growth, production, and expansion after World War II, people in developed economies started questioning the fast growth of the world population, which was expanding at an unprecedented rate, and the lack of resources available to meet future needs. To address these questions, on March 20, 1987, the Brundtland Commission of the United Nations (UN) published a document called *Report of the World Commission on Environment and Development: Our Common Future.* In this report, **sustainable development** is "the development that meets the needs of the present without compromising the ability of future generations to meet their own needs" (United Nations General Assembly, 1987). Following this definition, the UN report emphasized that sustainable development must consider the needs of the world's poor and the limited resources on Earth to meet their basic needs (such as food, clothing, shelter, and jobs).

In this light, the goals of successful and responsible global sourcing must include social and environmental dimensions, in addition to businesses' economic performance (Carter & Rogers, 2008). This is consistent with the UN's definition of sustainability in that organizations and businesses must consider and balance the **triple bottom lines**—economic, environmental, and social goals—simultaneously to meet present needs without compromising the needs of future generations. Thus, the goals of global sourcing must be at the intersection of environmental, social, and economic performance. Figure 1.8 illustrates the triple bottom lines of sustainable global sourcing.

This section discusses the main goals of global sourcing, an important part of global supply chain management, from the triple bottom line perspective. For businesses' economic gains, sourcing seeks to achieve (a) cost reduction, (b) productivity growth, (c) value acquisition, (d) quick response and flexible product supply, (e) supply assurance, (f) quality assurance, and (g) capacity management (Seshadri, 2005). Through global sourcing, consumers also achieve financial gains and clothing satisfaction. Finally, social and environmental dimensions are discussed as one of the important goals of global sourcing.

The goal of businesses' economic improvement

COST REDUCTION

By sourcing their components or finished goods globally, companies can reduce their costs significantly. One of the main sources of cost reduction comes from savings in labor costs (labor costs include salary and health/retirement benefits). By using low-cost labor, companies producing labor-intensive products can save a substantial amount of labor input cost (see Figure 1.9). Companies also can reduce costs by avoiding paying taxes or duties imposed by one country or another. By trading products between countries with free trade agreements, companies can pay lower or no duties, which otherwise could have added expense.

In addition, if required raw materials are produced only in a certain country—for example, Japan—companies might want to find manufacturing facilities in nearby countries with low-cost labor to coordinate raw materials and produce finished products more efficiently. This sourcing strategy can save overall production and transportation costs, rather than moving Japanese materials to another distant country, such as Turkey, to complete the finished products before they are shipped to the United States for final consumption.

Finally, companies can save costs by reducing or removing risks that might stem from late delivery, production defects, inaccurate demand forecasting, currency fluctuation, geopolitical conflicts, or even natural disasters. Global sourcing allows the sourcer to share such unforeseen risks with suppliers. Often, the sourcer provides financial or contractual incentives for the supplier to control risks that can be managed internally. However, there are many risks that cannot be managed by either the sourcer or the supplier. In many cases, both the sourcer and supplier work to manage the risks and share the burden.

PRODUCTIVITY GROWTH

Productivity growth is another goal of global sourcing. By sourcing components or finished products from other companies that specialize in certain products, the sourcer (or the buyer) is able to quickly acquire those specialized products. Particularly if the sourcer is not familiar with and does not have expertise in producing such products, global sourcing helps the sourcer focus on core competencies while sourcing special products from others, thus improving productivity.

VALUE ACQUISITION

Global sourcing also allows companies to gain new values that otherwise would not have been available to them. Often, companies acquire new, novel, one-of-a-kind products from other companies. They also acquire from other companies human resources, skills, knowledge, or know-how that they might deem critical to enhancing their competitive advantages. When companies suffer from poor reputation or publicity,

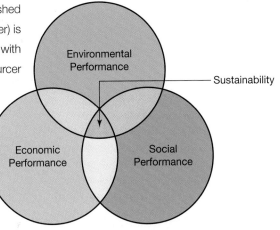

FIGURE 1.8 Triple bottom lines of sustainable global sourcing
Source: Carter and Rogers (2008)

FIGURE 1.9 *Cost reduction is one of the key goals of sourcers.*
Source: Narongsak/Shutterstock

they also can source social or environmental values by partnering or collaborating with other companies proven to have excellent reputations. In this light, the goal of global sourcing is to acquire effective values that are not available to the sourcer yet critical for its competitive advantages.

QUICK RESPONSE AND FLEXIBLE PRODUCT SUPPLY

As the consumers' demands and tastes quickly change in today's marketplace, most companies seek to offer the right products at the right time so they can maximize sales and profits. Global sourcing helps companies achieve quick responses to such market changes for reasons similar to global sourcing's positive effect on productivity growth. Global sourcing allows the sourcer to pay attention to and analyze market demands and identify new trends, while the supplier focuses on production. This division of business activities helps the sourcer achieve quick response as well as flexible product supply. The sourcer makes decisions regarding when to deliver what from whom as consumer demands change. Without global sourcing, it would be much more difficult to analyze a trend, come up with a product plan, manufacture the desired products, and deliver them before consumers changed their tastes. Thus, one of the key goals of sourcing managers is to have a wide network of suppliers of a variety of components and products that can satisfy market demands in a timely manner.

SUPPLY ASSURANCE

While quick response and flexible product supply might be important objectives to meet, this division of business activities also can hurt the sourcer without direct ownership of the components or finished goods. Sourcing contracts between the sourcer and the supplier help ensure delivery of future products. Yet, these contracts can often fail. For example, the supplier might not be able to make delivery due to the loss of finished goods as a result of a natural disaster. Or the supplier could fail to meet delivery because it does not have sufficient financial resources to hire the right amount of labor. The best to way for a business to ensure future product supply

is to own its own factories, rather than engage in global sourcing. Direct ownership of factories in a geographically close location might help supply assurance, but this also can create conflicts between rapid response and flexible product supply. Thus, global sourcing strategies must consider both flexibility as well as supply assurance to maximize business performance.

QUALITY ASSURANCE

Recently, quality assurance has become an important sourcing objective, even more so than cost reduction (Seshadri, 2005). Cheap price is no longer a key condition for the sourcer. Rather, reliability is often more important in satisfying consumers. If the supplier is reliable and produces high-quality products, the sourcer will spend less time dealing with the supplier's production problems, conducting inspections, and monitoring rework. The sourcer will also have less loss due to defects, late delivery, and incorrect processes. Thus, more often than not, sourcing managers seek suppliers with quality production and quality assurance certificates, rather than suppliers with cheap cost without assurance of quality products, putting cost and quality puzzles together in the most effective way (see Figure 1.10).

EFFICIENT CAPACITY MANAGEMENT

For any manager, dealing with highly fluctuating demand and supply is difficult. Having too much inventory at any given time can force companies to lower the retail price to promote quick and high-volume sales. Having insufficient inventory is also a problem for sourcing managers, as the lack of stock can result in the loss of potential sales. Similarly, having too many resources at a given time results in inefficient utilization of resources, while having shortages of resources can result in a shortage of product output. Thus, capacity management is another important objective of global sourcing. The objective of capacity management can be achieved by reducing the opportunity cost of capacity while keeping core competencies located internally.

Decisions on which components and resources should be sourced from outside and which business activities and processes will be kept within the company are critical for any sourcer. Sourcing managers constantly evaluate opportunity cost, the money or benefits lost when pursuing a particular course of action instead of a mutually exclusive alternative, and decide which

FIGURE 1.10 *Sourcers are responsible for putting together both cost and quality puzzles in the most effective way.*
Source: Palto/Shutterstock

sourcing options would maximize resource utilization and minimize the opportunity cost of resources (Seshadri, 2005). One important consideration when evaluating internal resource capacity and opportunity cost of capacity, however, is that it is unwise to source proprietary and strategic parts, knowledge, or skills that are fundamental for the sourcer's competitive advantages. Seshadri (2005, p. 57) stated that, "if a firm outsources difficult tasks and insources easier ones, it will lose its competitive advantage."

Because of the need for keeping core competencies within the company, sourcing managers will always have a set of internal suppliers as well as external suppliers. For example, if a company outsources manufacturing activities while insourcing design, a sourcing manager will need internal designers who will supply design plans as well as external suppliers who will be in charge of apparel manufacturing. Or, if a company has its own manufacturing facilities overseas (internal suppliers), it might need another manufacturing company's help to fulfill large orders before deadlines. In this case, the sourcing manager has internal and external apparel manufacturers. In both cases, the sourcing manager will have to work with both internal and external suppliers to maximize resource utilization and minimize opportunity cost.

The goal of social responsibility

In addition to goals of global sourcing that most businesses seek to achieve through their successful and responsible sourcing practices, consumers would be able to access a greater variety of high-quality and safe products at affordable prices, resulting in overall consumer satisfaction in their apparel consumption. Therefore, sourcing managers must consider consumer satisfaction in addition to businesses' goals when making critical decisions related to sourcing. For example, let's assume a sourcing manager is about to make a decision on the quality of colorants that will be used to dye main fabrics for infants. One choice is a pigment colorant that has a certain, yet tolerant level of lead. Another option that a sourcing manager has is completely lead-free. Yet, this lead-free option is 30 percent more expensive than the first option. Which decision should this sourcing manager make? If the manager makes his or her decision purely based on the business's economic performance, the manager would choose the first option. However, if the manager truly cares about consumers' safety and long-term satisfaction, the manager may choose the latter option even if it is 30 percent more expensive. That is, sourcers are also responsible for balancing cost and consumer safety concerns when selecting raw materials that may contain hazardous contents (see Figure 1.11).

Another social responsibility example of sourcing that managers may need to be concerned with is related to labor practices in developing countries. Today's sourcing managers cannot afford to be at the center of any type of scandals due to poor labor practices or irresponsible business practices in foreign countries. Even if a factory offers the lowest prices, most sourcing managers in today's marketplace understand that they cannot simply choose the cheapest option without checking the factory's fair labor practices.

These are not the only examples where the dimension of social improvement is important to achieve the goal of global sourcing. There are many other examples, such as the case where sourcing managers decide to produce goods from Haiti to provide economic and employment support to the Haitian communities devastated by the earthquake in 2010 that affected over 3 million people. If sourcing managers looked at only the economic bottom line, the decision to go to Haiti for sourcing would have been difficult to be made.

FIGURE 1.11 *Sourcers are also responsible for balancing cost and consumer safety concerns when selecting raw materials that may contain hazardous contents.*
Source: Don Farrall/Getty Images

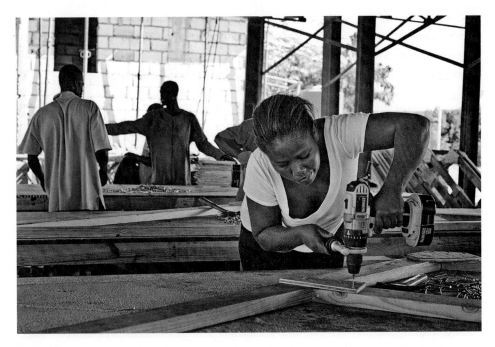

FIGURE 1.12 *This woman is working in a male-dominant work environment side by side with other males, providing equal power to these women.*
Source: © Bart Pro/Alamy

The goal of environmental responsibility

Similar to the goal of social responsibility, sourcing managers must also consider environmental impact of any type of business decisions they make. For example, factory A provides the lowest prices on fabrics, yet it does not have the proper system to clean and dispose of chemical dyes and finishing agents. On the other hand, factory B has slightly higher prices with full water treatment systems for chemical dyes and finishing chemical substances. When under the pressure of achieving a certain margin rate, sourcing managers may be tempted to select factory A for its low cost. However, if all sourcing managers choose factory A, these types of harmful business practices would continue and the natural environment would suffer across the world. Therefore, it is critical for sourcing managers to evaluate all of the three bottom lines of sustainable global sourcing—economic, social, and environmental—before making any critical decisions. Figure 1.12 shows a woman working in a male-dominant work environment side by side with other males, providing equal power to these women. After all, the goals of global sourcing are to improve businesses' economic performance, to advance social conditions in the world, and to protect the natural environments.

Job requirements and responsibilities for sourcing personnel in today's marketplace

To meet these goals, sourcing personnel in today's textile and apparel industry are engaged in many different business activities. They may operate under various job titles, yet they share core functional responsibilities and, therefore, require different characteristics and skills. An evaluation of job requirements and responsibilities through help-wanted advertisements is a good way to understand the role of global sourcing professions (see Figure 1.13). After reviewing over 71 "Job

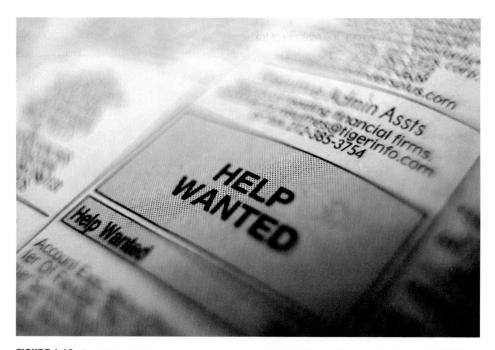

FIGURE 1.13 *Evaluation of job requirements and responsibilities through help-wanted advertisements is a good way to understand the role of global sourcing professions.*
Source: © 2120StockVS/Alamy

Wanted" advertisements from 2007 to 2008 from *Women's Wear Daily*, a leading news source for the businesses of women's apparel, accessories, fibers, and textiles in the United States, Muhammad and Ha-Brookshire (2011) reported that sourcing personnel were recruited with the following job titles:

- Fabric or trim sourcing manager, assistant, coordinator, or merchandiser.
- Sourcing specialist, coordinator, manager, or director.
- Production/sourcing or sourcing/production.
- Merchandise sourcing/creative designer.

These job titles suggest that sourcing personnel could be specialized in fabric or trim sourcing, and that sourcing is closely related to production, design, and merchandising. Dual job titles, such as sourcing/design and production/sourcing, also suggest sourcing is highly interconnected with other job functions within a firm.

Muhammad and Ha-Brookshire's (2011) study further explains that the main responsibilities and daily duties of sourcing personnel are vendor management, product development, production, and internal collaborations. First, with respect to vendor management, sourcing personnel's responsibility is to identify, negotiate with, and select the most appropriate vendors for any given sourcing assignment. Second, for product development, sourcing personnel "must understand the product development process" and actively acquire new materials for product developers. Third, sourcing personnel are also responsible for production, so they need to possess the ability to achieve specific cost, delivery, quality, and legal compliance objectives. Finally, sourcing personnel work side by side with various personnel within a firm including merchandisers, sales, operations, import logistics, design, and so on.

Therefore, organizational skills, multitasking skills, and communication skills are required for successful sourcing personnel (Muhammad & Ha-Brookshire, 2011). Particularly, communication skills with foreign businesses and vendors are critical. "On-the-job" experience, willingness to travel, existing connections and relationships with foreign factories and vendors, and

language skills are highly valued by employers seeking sourcing personnel (Muhammad & Ha-Brookshire, 2011). Given that the majority of textile and apparel products in today's retail markets are globally sourced, there are many employment opportunities in global sourcing. By understanding what the responsibilities are and what types of skill sets are required, they are better prepared for working in the industry.

summary

Sourcing is not new. Even when all manufacturing was done domestically, sourcing was a common business practice between companies. Some companies focused on apparel manufacturing while others produce textiles. Both textile producers and apparel manufacturers were interdependent. Thus, geographic concentrations of similar businesses, or business clusters, were created, and companies sourced raw materials, technology, skills, and know-how from one another. Global sourcing has become important as the economy has become globalized and technology has advanced (see Figure 1.14). Thanks to transportation and communication technologies, companies no longer need to source from other businesses that are geographically close to them. Companies are able to expand their sourcing destinations to anywhere in the world. Although global sourcing has allowed cost savings and transfer of knowledge from developed economies to developing economies, it also has resulted in manufacturing job losses in developed countries and unethical business practices in developing countries.

Global sourcing is one of the key business activities of global supply chain management. Global sourcing is defined as a set of business processes and activities by which businesses acquire and deliver components or fully finished products or services from outside the organization in the global marketplace, with the objectives of finding, evaluating, and engaging suppliers of goods and services to achieve long-term competitive advantages. Global supply chain management includes demand and supply forecasting, integrated business model development, and interdepartmental strategy development, in addition to global sourcing. Although the terms *outsourcing* and *global sourcing* are used interchangeably, there are

FIGURE 1.14 *Global sourcing has become important in a global economy.*
Source: Atiketta Sangasaeng/Shutterstock

subtle yet different nuances between the two. Thus, one must be cautious when using these terms.

The main objectives of global sourcing are to improve businesses' economic performance, to advance social conditions in the world, and to protect the natural environments. For businesses' economic performance, cost reduction, productivity growth, value acquisition, quick response and flexible product supply, supply assurance, and capacity management are some of the main goals of global sourcing. For social and environmental performance, sourcing managers must carefully evaluate potential consequences in society and the natural environment prior to making any significant sourcing decisions.

Finally, sourcing personnel are responsible for managing vendors, overseeing foreign production, and providing new product development ideas by working with multiple departments within the firm. Various skill sets such as communication, organization, and multitasking are desirable. Finally, hands-on experience and relationships with foreign factories and vendors are highly valued and, thus, sourcing personnel generally hold managerial positions.

key terms

Sourcing refers to a set of business processes and activities by which businesses acquire and deliver components or fully finished products or services from outside the organization, with the objectives of finding, evaluating, and engaging suppliers of goods and services to achieve long-term competitive advantages.

Supply chain refers to a network of materials, information, and services processing links with the characteristics of supply, transformation, and demand (Chen & Paulraj, 2004).

Supply chain management (SCM) is defined as the systemic, strategic coordination of the traditional business functions within a particular company and across businesses within the supply chain, for the purposes of improving the long-term performance of the individual companies and the supply chain as a whole (Menzter, 2004).

Sustainable development explains the development that meets the needs of the present without compromising the ability of future generations to meet their own needs (United Nations General Assembly, 1987).

Triple bottom lines of sustainability include economic, environmental, and social goals.

learning activities

1. What are the roles that the textile and apparel industry played for the Industrial Revolution?

2. How was global sourcing developed from domestic sourcing? What are the roles of global sourcing in today's textile and apparel industry?

3. What are some examples of news articles discussing the negative aspects of global sourcing?

4. What are some examples of news articles discussing the positive aspects of global sourcing?

5. Explain the relationship between global sourcing and global supply chain management.

6. What are some examples of apparel global sourcing activities that help improve social conditions in foreign countries?

7. What are some examples of apparel global sourcing activities that help improve environmental conditions in foreign countries?

8. Discuss the possibilities of how all businesses, consumers, society, and environments could benefit through successful and responsible global sourcing activities.

9. After researching various companies' global sourcing strategies, show examples of a company's global sourcing strategy seeking the following objectives:
 a. Cost reduction
 b. Productivity growth
 c. Value acquisition

 d. Flexible product supply
 e. Quality assurance
 f. Social improvement
 g. Environmental improvement

10. Look for job classifications available from various newspapers, trade papers, and magazines and find out:
 a. The type of companies that are looking for sourcing personnel
 b. The location of such companies
 c. Job descriptions
 d. Experience requirements

references

Carter, C., & Rogers, D. (2008). A framework of sustainable supply chain management: Moving toward new theory. *International Journal of Physical Distribution & Logistics Management, 38*, 360–387.

Chen, I. J., & Paulraj, A. (2004). Toward a theory of supply chain management: The constructs and measurements. *Journal of Operations Management, 22*, 119–150.

Cho, J., & Kang, J. (2001). Benefits and challenges of global sourcing: Perceptions of U.S. apparel retail firms. *International Marketing Review, 18*(5), 542–561.

Cook, T. (2007). *Global sourcing logistics: How to manage risk and gain competitive advantage in a worldwide marketplace.* New York, NY: American Management Association.

Council of Supply Chain Management Professionals. (2010, February). *Glossary of terms.* Retrieved August 14, 2011, from Resources & Research: http://cscmp.org/digital/glossary/glossary.asp

Dickerson, K. G. (1999). *Textiles and apparel in the global economy* (3rd ed.). Upper Saddle River, NJ: Prentice Hall.

Granger, M. (2007). *Fashion: The industry and its careers.* New York, NY: Fairchild.

Ha-Brookshire, J., & Dyer, B. (2009). The impact of capabilities and competitive advantages on import intermediary performance. *Journal of Global Marketing, 22*(1), 5–19.

Ha-Brookshire, J., & Hawley, J. (2013). Envisioning the clothing and textile discipline for the 21st century: Discussion on its scientific nature and domain. *Clothing and Textiles Research Journal, 31*(1), 17–31.

Ha-Brookshire, J., & Lu, S. (2010). Organizational identities and their economic performance: An analysis of U.S. textile and apparel firms. *Clothing and Textiles Research Journal, 28*(3), 174–188.

Hilstrom, K., & Hilstrom, L. (2002). *Encyclopedia of small business* (2nd ed., Vol. 2) (K. Hilstrom & L. Hilstrom, Eds.) Detroit, MI: Gale.

Laseter, T., & Weiss, E. (2008). Structural supply chain collaboration among grocery manufacturers. In C. Tang, C. Teo, & K. Wei (Eds.), *Supply chain analysis: A handbook of the interaction of information, system, and optimization* (pp. 29–44). New York, NY: Springer.

Mentzer, J. (2004). *Fundamentals of supply chain management.* Thousand Oaks, CA: Sage.

Muhammad, A., & Ha-Brookshire, J. (2011). Exploring job responsibilities and requirements of U.S. textile and apparel sourcing personnel. *Journal of Fashion Marketing and Management, 15*(1), 41–57.

Park, H., & Stoel, L. (2005). A model of socially responsible buying/sourcing decision-making processes. *International Journal of Retail & Distribution Management, 33*(4), 235–248.

Seshadri, S. (2005). *Sourcing strategy: Principles, policy, and designs.* New York, NY: Springer.

Shelton, R., & Wachter, K. (2005). Effects of global sourcing on textiles and apparel. *Journal of Fashion Marketing and Management, 9*(3), 318–329.

Stadtler, H., & Kilger, C. (2008). *Supply chain management and advanced planning: Concepts, models, software, and case studies* (4th ed.). Berlin: Springer.

United Nations General Assembly. (1987). *Report of the World Commission on environment and development: Our common future.* Transmitted to the General Assembly as an Annex to document A/42/427—Development and International Co-operation: Environment.

Wilson, L. (2002). Technology, dress, and social change. *Proceedings of the International Costume Conference* (pp. 3–9).

World Trade Organization. (2012). *Merchandise trade by product.* Retrieved from Statistics: International Trade Statistics 2011: http://www.wto.org/english/res_e/statis_e/its2011_e/its11_merch_trade_product_e.htm

THEORETICAL PERSPECTIVE OF GLOBAL SOURCING

LEARNING OBJECTIVES

Why do companies source their components or final products from other companies in foreign countries? Why wouldn't they just make everything on their own? These same questions have been raised by many people before us, and several theories have been suggested to answer them. This chapter discusses various theories and perspectives about international trade that could be useful in explaining global sourcing. Upon completion of this chapter, students will be able to:

- Understand why global sourcing takes place in the global marketplace.
- Comprehend the five international trade theories from the global sourcing perspective: the law of supply and demand, theories related to comparative advantage, Porter's competitive advantage of nations, fragmentation theory, and industry life cycle theory.
- Understand the five strategic sourcing theories, including resource-based view of the firm, resource dependence theory, strategic choice theory, sociocognitive theory, and critical theory.
- Articulate the relationship between each of these theories and global sourcing.

2

hy do companies source in the global marketplace? When answering this question, one must remember that the term *global sourcing* has two key components—*global* and *sourcing*. Therefore, to explain why global sourcing occurs, we must understand these two different phenomena. The aspect of "global" business can be explained by several theories proposed in the area of international trade. International trade theories attempt to explain and predict why international trades occur and why companies trade globally. The "sourcing" phenomenon can be explained by several theories in the areas of strategic management and the theory of the firm. These theories focus on what affects a firm's decision to make, buy, or ally with a supplier to acquire products or services from outside the organization.

International trade theories for global sourcing

The four key theories are discussed to explain international trade: (1) the law of supply and demand in international trade, (2) comparative advantage theory, (3) competitive advantage theory of nations, (4) fragmentation theory, and (5) industry life cycle theory.

Law of supply and demand

The **law of supply and demand** is not an actual law (see Figure 2.1). Rather, it is an economic theory that has been so well confirmed and corroborated by evidence that it is reasonable to believe that the relationship between supply and demand can be explained almost always in a certain way (Hunt, 2002). The law of supply and demand is described by the Marshallian supply–demand cross, showing that demand and supply interact to determine the equilibrium price and the quantity that will be traded in the market (Nicholson, 2005). Four basic laws of supply and demand are explained by the Marshallian cross:

1) If there is a high demand yet supply remains unchanged, the equilibrium price of the good and the quantity of the traded goods will increase.
2) If there is a low demand yet supply remains unchanged, the equilibrium price of the good and the quantity of the traded goods will decrease.
3) If there is a high supply yet demand remains unchanged, the equilibrium price of the good and the quantity of the traded goods will decrease.
4) If there is a low supply yet demand remains unchanged, the equilibrium price of the good and the quantity of the traded goods will increase.

This relationship of supply and demand is also applicable for international trade. Figure 2.2 illustrates the domestic demand and supply curves for a certain good—for example, a pair of jeans. When there is no international trade, the price of jeans in the domestic market should be set at P^* (or the equilibrium price) with the quantity of Q^* (or the equilibrium quantity). The equilibrium price and quantity are the results of interactions between domestic demanders and suppliers of jeans. This equilibrium would be disturbed if more goods entered into the domestic market through international trade.

In particular, if the price of jeans from other countries or in the world (P_w) is lower than the domestic price of P^*, international trade will cause prices to decrease to the level of P_w. Because of the drop in price, more consumers will want to buy jeans because they are more

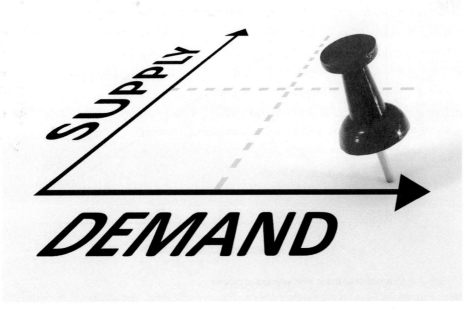

FIGURE 2.1 *The theory of supply and demand explains why international trade occurs.*
Source: Price less Photos/Fotolia

affordable, while fewer suppliers will want to produce jeans, as producing jeans is now less profitable. That is, the decrease in price from P^* to P_w would result in an increase in demand from Q^* to Q_1, and a decrease in supply from Q^* to Q_2. In Figure 2.2, the difference between Q_1 and Q_2 will be supplied through foreign jean producers, whereas domestic jean producers will produce jeans only up to Q_2. In other words, the domestic market will have jeans supplied by foreign producers at the world price, while domestic jean producers are discouraged to produce jeans at the world price.

The reduction of price, increase in domestic demand, and decrease in domestic supply of jeans through international trade also contributes to a total welfare increase in the domestic marketplace as the market equilibrium changes from E_0 before international trade to E_1 after international trade. The area $P^*E_0E_1P_w$ of Figure 2.2 illustrates the overall increase in consumer gain from low-priced jeans supplied by the world's producers. Consumers gain their welfare from reduction of domestic jean producers' welfare and from foreign suppliers at a low price. In Figure 2.2, domestic jean producers' welfare is represented by the area $P^*E_0 AP_w$, while the area E_0E_1A represents a welfare gain in the domestic marketplace through international trade.

From the perspective of the law of supply and demand, international trade (or global sourcing) helps give consumers access to products at the world price, which is usually lower than the domestic price due to intense competition in the world's marketplace, and results in an overall gain in welfare. However, the low-priced products from the world threaten domestic suppliers' ability to compete with these products, and many domestic suppliers who are not prepared for world competition will have to close their businesses or move on to different product items where they still have competitive advantages.

Consumer advocates or retailers are typically supportive of international trade, or global sourcing, due to consumer welfare gain, while domestic manufacturing sectors are often against it due to the loss of their welfare, including business closing and employment loss. Thus, many producers have actively engaged in various lobbying activities to influence the government to put up barriers to international trade, such as tariffs and quotas. *Tariffs* are taxes imposed on

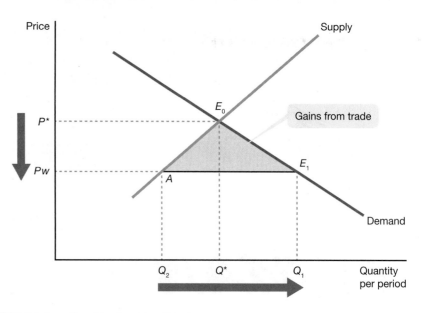

FIGURE 2.2 International trade and welfare increase

Note: *International trade will change the market equilibrium from E_0 to E_1. This shift results in the drop of price from P^* to Pw, the increase in domestic demand from Q^* to Q_1, and the decrease in domestic supply from Q^* to Q_2. The lower price from the world suppliers creates gain in total welfare represented by the triangular area of E0 E1A.*
Source: Adopted from Nicholson (2005)

imported goods, resulting in higher prices for consumers. *Quotas* refer to quantity limitations on imported goods to ensure there will not be too many imported goods in the marketplace, so domestic producers can still supply a sufficient quantity of the goods for the domestic demand. Both barriers essentially decrease consumer welfare while protecting domestic producers' welfare.

Comparative advantage theory

In 1817, David Ricardo introduced the notion of *comparative* (or relative) advantage to explain the nature of international trade (Ricardo, 1960). The **theory of comparative advantage** explains that international trade occurs when two countries can gain from trade due to their different *relative* costs for producing the same goods. That is, if country A is relatively more efficient in producing product X than is country B, and country B is relatively more efficient in producing product Y, then each country would focus on manufacturing X or Y and then trade them. By doing so, both countries will get net benefits or gains from trade (see Figure 2.3).

Tables 2.1 and 2.2 show specific examples of production and total output before and after international trade. As seen in Table 2.1, country A has absolute advantage over country B in making both products X and Y. That is, country A is more efficient in making products X and Y than is country B, requiring 10 hours and 15 hours of labor to produce 1 unit each of product X and Y, respectively. Thus, with 1,000 labor hours, country A would be able to produce 50 units of product X and 33.3 units of product B, totaling 83.3 units. Meanwhile, before trade, country B would be able to produce only 12.5 units of product X (it needs 40 hours to produce 1 unit of product X) and 25 units of product B (it requires 20 hours to produce 1 unit of product Y) totaling 37.5 units. Between the two countries, 62.5 units of product X and 58.3 units of product Y were produced with a total of 2,000 labor hours, totaling 120.8 units.

FIGURE 2.3 *Comparative advantage between countries can result in lower costs for basic materials, such as thread.*
Source: Levent Konuk/Shutterstock

Even if country A has absolute advantages over country B for both products X and Y, international trade provides gains for both countries by focusing on the products that require *relatively* less labor productivity. In this example, country A has 25 percent higher efficiency than country B for product Y, as it requires 15 hours of labor, compared with 20 hours, to produce 1 unit. Country A has an even higher, or 75 percent more, efficiency than country B for product X, as it requires only 10 hours, compared with 40 hours. Thus, as seen in Table 2.2, country A decides to focus on product X and put 70 percent of its labor toward producing product X and 30 percent of its labor to produce product Y, where country B allocates all its labor to product Y. This results in a total of 140 units produced by the two countries, 19.2 units higher than before trade. Overall, both countries produce more units after trade than before trade. Both countries gain net benefits of 70 units of each product, greater output than before trade.

In this light, international trade, or global sourcing, creates the international division of labor and specialization. In this example, country A would have more labor involved in product X and country B in product Y. Thus, the labor force is now divided between the two countries for two different products. By doing so, country A will be more specialized in product X and country B

TABLE 2.1

Production and total output before trade

Before Trade	Country A	Country B	Total Output
Product X	10 hours/unit × 50 units	40 hours/unit × 12.5 units	62.5 units/ 1,000 hours
Product Y	15 hours/unit × 33.3 units	20 hours/unit × 25 units	58.3 units/ 1,000 hours
Total Labor	83.3 units/ 1,000 hours	37.5 units/ 1,000 hours	120.8 units/ 2,000 hours

TABLE 2.2
Production and total output after trade

After Trade	Country A	Country B	Total Output
Product X	10 hours/unit × 70 units	0 units	70 units
Product Y	15 hours/unit × 20 units	20 hours/unit × 50 units	70 units
Total Labor	90 units/ 1,000 hours	50 units/ 1,000 hours	140 units/ 2,000 hours

in product Y. Therefore, international trade is beneficial for both exporting and importing countries, as it increases welfare in both countries.

Although the theory of comparative advantage illustrates the benefits of international trade, it also bears a few fundamental assumptions. First, the theory assumes that labor resources in the two countries are fully employed—that is, that there are no unemployed workers available in either of the two countries. Second, it assumes that both countries have the same and constant opportunity cost (the cost of any products that could have been produced if resources had been used in the best alternative way). That means that the cost or sacrifice of country A giving up part of product Y production for product X and that of country B giving up the entire product X production for product Y are the same or constant. Third, only two countries and two goods are used in the example to explain the theory, which is not realistic. Fourth, the theory assumes labor freely moves with little or no cost from producing product X to product Y domestically; however, labor cannot move freely internationally. Fifth, the theory does not consider transportation cost. And finally, the theory is based on the fundamental assumption of perfect competition. That is, the market conditions are such that no participants are large enough to have the market power to set the price of a product. In this market, all productive resources are efficiently allocated in an idealized free market. These assumptions do not necessarily invalidate the core principles of the theory of comparative advantage. However, they do limit the magnitude of the explanatory power of the theory.

Porter's competitive advantage of nations

While comparative advantage theories suggest regions or nations must focus on those industries in which they have an advantage relative to others, more recently, **competitive advantage** has been a focus in business and research. Michael Porter, a professor at Harvard Business School and a leading researcher in the area of industry competitiveness, has published many books and articles about why firms in certain countries succeed in certain industries or industry segments. In his book titled *The Competitive Advantage of Nations*, Porter (1990) argued that firms in a certain country must possess a competitive advantage over other firms in other countries to enjoy competitive success. Porter continued that such competitive advantage is typically developed through either lower costs or product differentiation: Lower costs are usually possible through efficiency in production, and product differentiation could command premium prices.

Thus, competitive advantage is *created* by firms within the nation, rather than simply inherited. That is, even without abundance of natural resources, some countries could be successful. Or, even with a great deal of inherited natural resources, some countries might not be successful if they fail to create competitive advantages. In addition, to sustain competitive advantages, firms must constantly innovate themselves to create a higher-level competitive advantage than they had in a previous period.

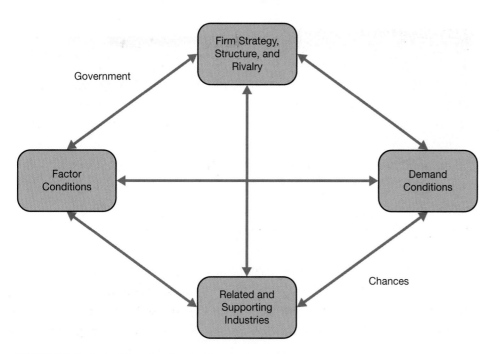

FIGURE 2.4 **Porter's determinants of national advantage**
Source: Porter (1990, p. 72).

To explain why a certain nation achieves success in international trade in a particular indus-
try, Porter (1990, p. 72) introduced four attributes of a nation that can shape domestic firms'
competitive advantages. He called these four attributes the *determinants of national advantage*
(see Figure 2.4). They are described as follows:

1. FACTOR CONDITIONS

All nations have factors of production. The term *factors of production* refers to inputs necessary to
compete in any industry such as labor, land, natural resources, capital, and infrastructure. Porter
argued it is important for a nation to inherit many factors or inputs that other countries do not have,
as these factors would provide *comparative* advantage. However, for a nation to have a *competitive*
advantage and sustain it in the long term, how these factors are efficiently and effectively deployed
and utilized is more important. For example, no matter how much labor a nation has, if there is no
infrastructure to efficiently and effectively utilize such labor, there will be no significant output, and
thus the nation will be less likely to be competitive. Likewise, even if a nation has a great amount of
water as a natural resource, if it does not have technology to convert such water into energy, the
country will be less likely to gain a competitive advantage in water energy over others.

2. DEMAND CONDITIONS

Porter explained that home demand conditions are another important factor for nations to gain
a competitive advantage. Demand conditions of the domestic (or home) marketplace influence
how domestic firms improve and innovate their products or services. In particular, Porter sug-
gested the three broad attributes of home demand conditions that are critical for a nation's
competitive advantage—(a) the nature of domestic buyer needs, (b) the size and pattern of
domestic demand growth, and (c) the mechanisms by which a nation's domestic demand is
converted to foreign markets.

First, a country gains a competitive advantage in industry or industry segments if the do-
mestic demand provides firms within the country with a clear or early understanding of what

FIGURE 2.5 *Large domestic market size incentivizes firms to make investments in large-scale infrastructure.*
Source: © jelwolf/Fotolia

future consumers will need and want. Often, the domestic demand pressures firms within the country to improve their products and services continuously or innovate quickly. This characteristic helps firms in a certain industry or industry segment gain competitive advantage over that industry or segment in other foreign countries without such domestic demand conditions.

Second, the size and pattern of domestic demand growth also help a nation's competitive advantage. Large domestic market size helps firms achieve economies of scales and learning, and thus it is more likely for firms to make investments in large-scale facilities, technology development, and productivity improvement (see Figure 2.5). This helps nations achieve and sustain a competitive advantage.

Third, the mechanisms by which a nation's domestic demand is converted into foreign markets and pushes a nation's products and services abroad also help a nation's competitive advantage. If a nation's products and services are satisfying not only domestic demand but also foreign demand, its industries are more likely to succeed in international trade. The latter two attributes are contingent on the first, and the quality of domestic demand is more important than its quantity for a nation's competitive advantage.

3. RELATED AND SUPPORTING INDUSTRIES

Industries or industry segments within a nation are more likely to be competitive if they have internally competitive supplier or related industries. Having a competitive domestic supplier industry is preferable to relying on foreign suppliers, even if they are well qualified. That is because well-established domestic supplier industries offer efficient, rapid, and early preferential access to high-quality yet low-cost inputs. Ongoing coordination between an industry and its domestic supplier industries also helps promote innovation and upgrading.

Similar to supporting industries, related industries can coordinate or share activities when sharing would help increase efficiency and effectiveness by sharing technology development, manufacturing, distribution, marketing, or services. For example, Japan has traditionally produced silk and silk fabrics, and the experience and the know-how from the silk industry helped develop

long-filament synthetic textile fibers, very much like silk. Therefore, it can be said that Japan's silk industry, as a related industry to the synthetic textile fiber industry, contributed to the success of the latter.

4. FIRM STRATEGY, STRUCTURE, AND RIVALRY

Industry or industry segments in a nation can gain a competitive advantage if there is "a good match" between the choices of how firms are created, organized, and managed and the sources of the competitive advantage within the industry. In other words, if the goals of firms, individuals (or employees), and a nation are all aligned, the industry in which these firms operate will be more likely to be competitive than that same industry in other nations without such a cohesive industry structure. Further, all parties' sustained commitment to the goals is critical for a nation's competitive advantage. For example, when newly industrializing countries started dominating the global textile and apparel industry, Italian family firms stayed committed to their traditional woolen fabric and apparel businesses, local communities, and the industry. By upgrading technology and innovating other production processes, the Italian textile and apparel industry still keeps a highly competitive position in the global industry. In addition, domestic rivalry creates pressure on firms to improve and innovate. This rivalry forces firms to lower costs, improve quality and service, and create new products and services. Eventually, domestic rivalry pressures firms to expand their sales to foreign countries in order to grow, affecting a nation's competitive advantage.

5. GOVERNMENT AND CHANCES

In addition to these four main attributes, Porter also argued that two additional factors might help shape a nation's competitive advantage: chance and government. Some examples of chance strongly influencing a nation's competitive advantage are pure inventions, major technological discontinuities, significant shifts in world financial markets, surges of world or regional demand, political changes, and wars. These shocks or major changes facilitate firms to be highly innovative and entrepreneurial to compensate for disruptions in the market.

Finally, the government also plays a significant role in a nation's competitive advantage (see Figure 2.6). Government can influence or be influenced by each of the four determinants either positively or negatively. For example, factory conditions could be affected by government subsidies, policies toward the capital market, or policies toward education. For instance, countries with free and public education might possess higher-quality labor than countries with no public education policies. Government could also affect demand conditions, as it could set local product standards or regulations, mandating buyer needs. For example, banning products from Cuba affects U.S. consumers' demand for Cuban products. Similarly, government policies and regulations affect the development of supporting and related industries, as well as firm strategy, structure, and rivalry. For instance, government's control over advertising media can affect domestic firms' strategies and rivalry. Government's ownership of transportation industries can affect the development of the logistics industry. Capital market regulation also can impact the efficiency of foreign capital transactions when industries compete in the global marketplace.

Overall, Porter suggested, nations are more likely to be competitive and succeed in industries or industry segments if national demand is most favorable. One determinant could help reinforce other determinants; advantage in one determinant can upgrade advantage in others. Therefore, Porter (1990) explained, once a nation's industry develops and sustains a certain competitive advantage, it creates a unique environment that is difficult for other foreign competitors to compete against or copy. This environment in return forces its competitive advantage even more strongly.

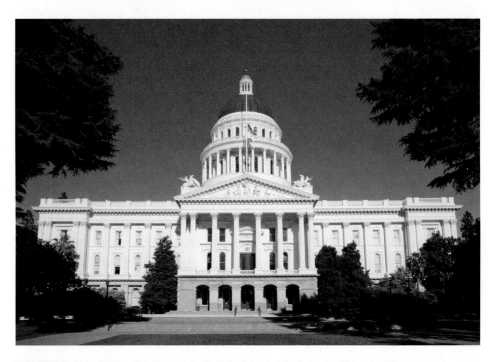

FIGURE 2.6 *Government also plays a significant role in a nation's competitive advantage.*
Source: Andy Z./Shutterstock

Fragmentation theory

While many trade theories focus on why countries trade the end products, the **theory of fragmentation** in international trade explains why countries trade parts and components (Arndt & Kierzkowski, 2001). In recent years, the proportion of trade in parts and components has increased tremendously. For example, automobile producers in the United States import tires from Korea, while apparel designed and developed by U.S. companies is manufactured in China with materials and components produced by several other countries. These trades in parts and components have been relatively overlooked by economists in the past (see Figure 2.7), and little has been discussed about why countries trade parts and components, not just end products.

A general framework for analyzing fragmentation was first introduced by Jones and Kierzkowski (1990) and further articulated by Arndt and Kierzkowski (2001). The core thesis of the fragmentation theory in international trade is that, due to advances in transportation and communication technologies, and reductions in trade and regulatory barriers, it has become easier for companies to divide production functions and share them with companies in foreign countries. Thus, companies' production systems become fragmented and dispersed into the global marketplace. Companies within the global production networks then trade parts and components with one another, creating a complex division of labor and specialization. In this light, fragmentation refers to separation of production processes by various producers of parts and components, both domestic and foreign. The fragmentation theory explains that physical proximity among production partners is no longer as important as it was before, and companies can have multiple production and trade partners across the borders.

Figure 2.8 illustrates how fragmentation of production systems can happen, and the role of the service link in fragmentation (Arndt & Kierzkowski, 2001). The first process explains a typical, traditional production process. That is, inputs, such as capital and labor, are organized and combined to produce final outputs. The production block in this model shows the production system in which inputs are organized and combined, and all production activities are performed, in one or close location.

FIGURE 2.7 *Trading of parts and components has been relatively overlooked by economists.*
Source: Jamie Marshall/Pearson Education

The second production process shows the previous production block divided into two production blocks, production blocks 1 and 2, suggesting a fragmented production system. In this case, inputs are transported into two separate production blocks and processed into the final products. The possible production processes that do not need to be performed together or in proximity could be separated into different locations at which specialized labor and technology exist. The third model of Figure 2.8 illustrates a more complex production process, involving multiple production blocks coordinated by multiple service links before final products are available in markets.

In both the second and third cases of production processes, one thing to note in fragmentation is that, because of the separation of production blocks, the role of service links becomes

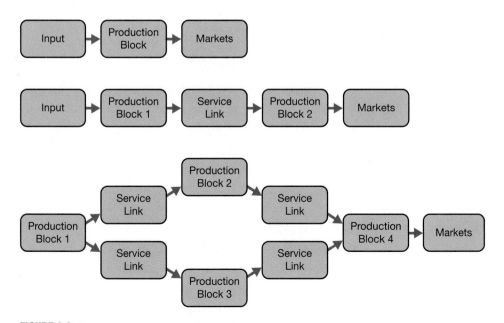

FIGURE 2.8 Fragmentation and service links
Source: Adapted from Arndt and Kierzkowski (2001, p. 3).

important to coordinate the entire production process (Arndt & Kierzkowski, 2001). A service link could include trasnportation, communication, quality control, compliance audits, and management coordination to ensure that the production blocks interact in the proper way. Efficiency and speed of service links are essential for fragmentation. Therefore, various pieces of software and technologies become important to facilitate efficient activities for service links.

Fragmentation used to occur within a nation. In today's global economy, along with world governments' liberalization of trades, companies seek production blocks from all over the world so that components are produced in the best possible location. Sometimes each production block is owned by a different company, while the entire production block system in multiple countries is owned by one company (Arndt & Kierzkowski, 2001). Thus, multinational corporations and direct investment become important in global fragmentation.

The U.S. textile and apparel manufacturing industry provides many examples of fragmented production processes. For example, before fragmentation, cotton fibers grown in the Mississippi Delta region in the United States used to get harvested, ginned, spun, and knitted by companies in the surrounding area before they were processed into cotton shirts. Most of these textile and apparel manufacturing activities were performed in southern states, such as North Carolina, Georgia, and South Carolina, where most producers wanted to complete all production activities in one area.

As technologies advanced and trade barriers were removed during the 1970s and 1980s, cotton shirt producers sought cheaper labor in other countries to complete apparel manufacturing processes while keeping yarn and textile processes at home. More recently, in the past two decades or so, a greater portion of cotton yarn and textile manufacturing processes has been divided and moved into developing countries, and most cotton apparel companies in the United States are involved in product development, design, branding, marketing, and so on. Activities offered by service links have also increased to help coordinate U.S. companies' fragmented prodution processes. This process left the United States specialized in value-added activities, while foreign countries concentrated on manufacturing activities. From this perspective, the theory of fragmentation truly explains why global sourcing occurs in today's global markeplace.

Industry life cycle theory

INDUSTRY LIFE CYCLE THEORY DEFINED

The **industry life cycle theory** suggests that, as most organisms do, an industry goes through certain stages throughout its life cycle. Industry life cycle theory stems from Vernon's (1966) product life cycle theory. As a product transitions from the growth phase to the mature phase in a country, domestic sales decrease or stagnate. Therefore, the company that owns the product may seek international sales, while seeking foreign manufacturing sites that could help reduce the cost of production. This concept led to the industry life cycle theory in the late 1970s (Abernathy & Utterback, 1978). The core concept of the theory is that when a new industry is born, the number of firms within the new industry grows, then declines sharply, and finally levels off (see Figure 2.9). As the number of firms changes throughout the industry life cycle, firms' output, prices, and market shares also increase and then fall, eventually leveling off (Klepper & Graddy, 1990).

More recently, Klepper (1997) distinguished and explained the three evolutionary stages for an industry. In the beginning stage, also called the embryonic stage, the market environment is quite uncertain, product design is primal, and products are produced using unspecialized

FIGURE 2.9 *In a newly developed industry, the number of firms grows rapidly before sharply declining and finally leveling off.*
Source: Lev Kropotov/Shutterstock

equipment. In this stage, total market volume is low. In the second stage, the growth stage, the rate of product innovation declines, and then remains stable. Products are manufactured with more specialized machinery, resulting in more refined products. In this stage, the output growth is higher, while the entry of new companies is slow. Thus, a shakeout of producers can occur. In stage three, the mature stage, innovations become more important, and other business functions, such as management and marketing, advance. The mature stage often comes with a mature market, which is characterized as slow output growth, declining new entry, and stabilizing market shares. During this stage (or even during the previous stage), the industry also seeks external markets for new sales. This process creates international trade. Figure 2.10 shows a graphical interpretation of industry life cycle.

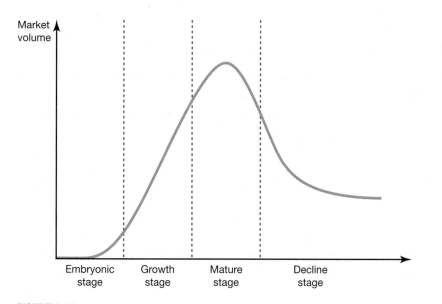

FIGURE 2.10 Industry life cycle theory
Source: Author's interpretation of Klepper (1997).

GLOBAL TEXTILE AND APPAREL INDUSTRY FROM THE INDUSTRY LIFE CYCLE PERSPECTIVE

The history of the global textile and apparel industry offers a relevant context to examine industry life cycles. Since the birth of the industry after the Industrial Revolution, it has grown and matured, and its core economic activities have shifted from developed countries to developing countries. For example, the United Kingdom and the United States were the main countries in which the industry was born and developed. Until the mid-twentieth century, these countries were known for textile and apparel manufacturing and dominated the global industry. Later, Asian newly industrialized countries, such as Korea, Hong Kong (then it was an independent country, although it is part of China today), and Taiwan, emerged as destinations for textile and apparel manufacturing thanks to the abundance of labor from after World War II into the mid-twentieth century. As labor costs rose in these countries, textile and apparel manufacturing activities shifted to developing countries in Southeast and southern Asia such as Sri Lanka, Bangladesh, and Thailand (Dicken, 2007; Jin, 2004).

Some researchers believe this is partly because the locus of comparative advantages has also changed from one country to another, depending on the level of a country's economic development (Kilduff & Chi, 2006). Countries in the early stages of economic development have comparative advantages in labor-intensive sectors, such as apparel assembly, and thus the apparel manufacturing sector can start and grow. Countries in the mature stages of economic development tend to have comparative advantages in capital-intensive sectors, such as synthetic fiber production, and thus fiber and textile production can prosper. When a country's economic development level is so high, it loses comparative advantages in fiber and textile production over other countries. Firms in countries such as the United States and the United Kingdom are now more focused on value-added business activities such as design, branding, and product development.

To describe these patterns of industry evolution, Toyne, Arpan, Barnett, Ricks, and Shimp (1984) identified six phases, from embryonic to significant decline, of the global textile and apparel industry. First, in the embryonic stage as seen in Figure 2.11, most of the products are

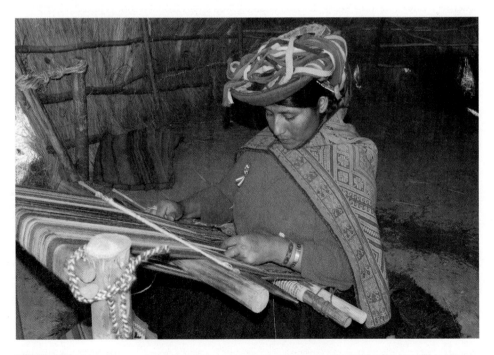

FIGURE 2.11 *A local Incan woman is weaving naturally dyed llama wool in Awana Kancha, Peru.*
Source: Linda Witwam © Dorling Kindersley

made out of simple fabrics and natural fibers. Most textile and apparel production is for domestic market needs. Second, in the early export of apparel stage, the labor cost is still low and manufacturing equipment is not advanced. Typically, products are made for the low-end market in developed countries. Third, in the more advanced production of fabric and apparel stage, domestic manufacturing of the textile sector improves greatly in volume and quality, resulting in an increase in textile export. Concurrently, once a sufficient amount of textile products are produced, apparel manufacturing is also expanded and upgraded. Further, technical equipment becomes more sophisticated, and typically more investment is made into the textile and apparel industry by both domestic and foreign investors.

Fourth, in the golden age stage, manufacturing technology becomes more advanced and the volume of textile and apparel output increases. Textile and apparel products are more diversified, and become a dominant force in the international market. Furthermore, textile and apparel firms in this stage can start investing overseas. Fifth, in the full maturity stage, although total output might increase, employment starts to drop as manufacturing technology advances. In this stage, manufacturing is more capital-intensive than labor-intensive. Finally, in the declining stage, the numbers of firms and workers decrease significantly, and the industry faces large trade deficits as there are more imports and exports.

Strategic sourcing theories

To explain sourcing as a strategic business function, the following five theories are reviewed: (1) resource-based view of the firm, (2) resource dependence theory, (3) strategic choice theory, (4) sociocognitive theory, and (5) critical theory.

Resource-based view of the firm

The **resource-based view of the firm (RBV)** proposes that a firm is a collection of productive resources (Barney, 1991). These resources must be valuable, rare, and costly to copy so competitors would not be able to easily acquire them. Therefore, in RBV, these unique resources are the key for the firm's competitive advantage and superior performance in the long run (Barney, 1991; Conner, 1991). In this light, a firm is said to have a competitive advantage when it is implementing a value-creating strategy not simultaneously being implemented by any current or potential competitors (Barney, 1991). Therefore, competitive advantages are composed of a firm's relative value that was produced by its resources and relative costs of resources used to produce such value (Hunt, 2002).

In RBV, firm resources refer to both tangible and intangible entities available to the firm. Physical buildings and plants would be examples of tangible resources, while knowledge and capabilities would be examples of intangible resources a firm may have (Day, 1994; Grant, 1996). Particularly, Day (1994) emphasized firm capabilities as a key resource for competitive advantage by making a specific distinction of capabilities from other asset-oriented resources. He defined firm capabilities as "complex bundles of skills and accumulated knowledge, exercised through origination processes" (p. 38). He argued that firm capabilities differ from firm assets in that capabilities cannot be easily tracked by a monetary value, while other tangible plant and equipment can. Firm capabilities are seen to be deeply embedded in the organizational routines and practices that cannot be easily traded or imitated, while other physical asset resources can. From this perspective, human capital and

FIGURE 2.12 *Firms also source capabilities and knowledge, particularly if they are unique, rare, and difficult to copy, such as R&D for dyes.*
Source: © Darren Baker/Fotolia

knowledge are one of the key components of firm capabilities and, in return, its competitive advantage (Grant, 1996).

From a sourcing perspective, RBV helps explain why firms source a variety of business processes discussed in Chapter 1. For example, manufacturing equipment, raw materials, and parts seem tangible resources for a firm to source. On the other hand, firms also source technology, design skills, marketing know-how, and/or business relationships that are closely related to firm capabilities and knowledge (see Figure 2.12). In other words, firms may engage in sourcing as a means of identifying, exploring, and transferring these key resources, particularly unique capabilities and knowledge (Shook, Adams, & Ketchen, 2009). Therefore, firms are seeking other organizations that may have unique resources that they may not have internally. Sometimes, firms may establish a short- or long-term sourcer–supplier relationship agreement with an outside organization. Other times, firms may choose to build a joint venture with an outside organization to create a new business entity by taking advantage of complementary capabilities and knowledge.

Resource dependence theory

Resource dependence theory maintains the perspective of RBV in that firms that lack critical resources will seek to establish relationships with others that possess such resources. On a slightly different note, however, resource dependence theory focuses on the dependency that this type of relationship may create between the sourcer and suppliers (Shook et al., 2009). Resource dependence theory argues that dependence on other firms' resources may not be helpful for a firm's competitive advantage and performance and, therefore, firms would make their sourcing decisions to minimize their dependence on other firms (Pfeffer & Slancik, 1978). Therefore, questions on (a) how important the resources in need are and (b) how easily firms could acquire such resources in the market are important factors for firms' sourcing decisions (Shook et al., 2009).

For example, firms would decide to *source* certain resources from outside organizations if they are not important for firms' competitive advantage and performance and could be performed by many suppliers (Shook et al., 2009). In this case, interdependence between the sourcer and supplier is not very important as the sourcer could easily find another supplier. If the resources are not critical but could be performed by only a few suppliers, firms many decide to source from outside organizations. However, resource dependency theory suggests that firms may want to do so in a way that both sourcers and suppliers are highly interdependent (Shook et al., 2009). That is because the sourcer would not want to jeopardize the relationship with the supplier because there are only few that could deliver such resources.

On the other hand, if the resources in need are critical for the firm and only a few suppliers could deliver them, then the firm would be more likely to decide to *make* or *buy* such resources to possess permanent ownership of resources (Shook et al., 2009). Both options—make or buy—would allow the firm to reduce dependence on the supplier and increase the control of those resources. Finally, if the resources in need are critical yet many suppliers could deliver them, the firm may want to form alliance or joint venture relationships with the suppliers (Shook et al., 2009). Alliance or joint venture relationships would be a less costly option than a making or buying option if the resources in need are difficult to obtain. However, alliance or joint venture relationships create more dependence of the firm on suppliers. Firms would have to know these different scenarios of sourcing options and make the best decisions for their competitive advantage and performance.

Strategic choice theory

Strategic choice theory suggests that top managers make their business decisions and choices to align their firms with the market environment (Child, 1972). Strategic choice theorists suggest that top managers typically face three types of organizational problems: (a) entrepreneurial problems, (b) engineering problems, and (c) administrative problems (Miles & Snow, 1978). The entrepreneurial problems are centered on how firms define their business scope in terms of specific goods or services and, therefore, identifying target markets and market segmentations are important business activities. The engineering problems are related to organizational systems to solve the entrepreneurial problems. That is, once specific goods and services are identified during the entrepreneurial problem-solving stage, top managers in the business of solving engineering problems are involved in creating and implementing organization-wide systems to deliver such products and services to target consumers. For example, sourcing strategies and supply chain matters would be typical engineering problems. Finally, top managers who solve the administrative problem seek to rationalize and stabilize organizational flows and activities performed during the entrepreneurial and engineering problem-solving stages. Human resource management, including hiring and training, would be a good example of administrative problems.

What is important in Miles and Snow's (1978) typology of business problems is the notion that different firms make different decisions to solve these problems in a different way, resulting in four different strategic types: (a) the defender, (b) the prospector, (c) the analyzer, and (d) the reactor. These strategic types have strong implications for sourcing as a strategic business activity. First, defenders focus on efficiently producing and distributing a certain set of goods and services in a quite predictable marketing environment (Miles & Snow, 1978). Therefore, a single core resource is the key to defend their businesses in the market. Therefore, defenders would not consider sourcing such key resources. For example, one of the key success factors of Walmart is its everyday low-price strategies through efficient supply chain mechanism. Therefore, as a defender in the market it is not advisable for Walmart to consider sourcing its logistics, distribution, and other supply chain processes.

Second, prospectors are easily found in fast-changing market environments and their goal is to adapt to changes in market situations (Miles & Snow, 1978). Therefore, they are consistently and constantly looking for new products or services and new gaps in the market. Long-term commitments to a single resource or a single supplier are not desirable and, thus, prospectors are deep into sourcing various resources to deliver different products or services. Fast-fashion brands or retailers, such as Forever 21, face constant changes in consumers' tastes and preferences. Thus, these companies constantly look for new suppliers who could deliver different technologies and products and it makes sense for them to source their products from various suppliers to quickly respond to market changes.

Third, analyzers show both defenders' and prospectors' aspects (Miles & Snow, 1978). That is, analyzers maintain a core base of both fundamental products and services while they seek new opportunities and markets (see Figure 2.13). In terms of sourcing, these firms take a dual approach. To produce core products in fairly predictable market environments, top managers may decide to make such products internally. For fast-changing fashion products, top managers may decide to source them from outside organizations. Many of today's retailers take this analyzer's approach. They would like to maintain a balanced mix between core products (usually under private brand names) and fashion products (usually under other designer brand names) to maximize performance and market responsiveness.

FIGURE 2.13 *Analyzers maintain both core fundamental products and services within themselves while they seek new opportunities.*
Source: Mike Flippo/Shutterstock

Finally, reactors typically react to market changes and other firms' behavior, therefore, they lack consistency among sourcing strategies, business structures, and market environments (Miles & Snow, 1978). That is, sourcing decisions are made haphazardly without evaluation or long-term prospects. They are less likely to be successful in the long run and maintain their business operations.

Sociocognitive theory

Sociocognitive theory suggests sourcing decisions are an act of sense-making and a reflection of organizational identity (Shook et al., 2009). According to this theory, firms with well-established structures and processes around sourcing strategies will more likely continue the same strategies. For example, if Levi's currently sources its zippers from certain zipper suppliers, it would be more likely to continue sourcing zippers in the future instead of making zippers internally. For similar reasons, organizational identity also plays an important role in sourcing decisions. If a firm has a strong sense of identity as an "American manufacturer," it will be more likely to decide to make products in the United States rather than source them from foreign countries.

Critical theory

Critical theory, in general, focuses on active improvements of society as a whole, rather than a simple understanding or explanation of a phenomenon (Frost, 1980). In this light, sourcing decisions are considered important channels to improve society, not firms (Shook et al., 2009). Therefore, critical theory suggests firms should make sourcing decisions to maximize social improvement, after comparing the benefits to society and short-term profitability (see Figure 2.14). Social improvement

FIGURE 2.14 *Santiago, Chile: Sourcing decisions can improve society, but sourcing itself can also be the problem.*
Source: Nataliya Hora/Fotolia

in critical theory includes equalities of gender, ethnicity, and race; emancipation of employees; alleviation of poverty in the world; and so on. TOMS shoes, founded by Blake Mycoskie in 2006, is one of the examples of businesses whose mission is "to create a better tomorrow by taking compassionate action today" (TOMS Shoes, 2011). TOMS promotes the One for One movement under which TOMS pledges to give a pair of new shoes to a child in need with every pair purchased. Although it is not certain where TOMS shoes are made internally or sourced from outside organizations, this type of strategic business decision can be explained by critical theory.

summary

There are many reasons why companies trade and source their products and components internationally. This chapter reviewed the four commonly discussed international trade theories: (1) law of supply and demand in international trade, (2) comparative advantage theory, (3) Porter's competitive advantage theory of nations, (4) fragmentation theory, and (5) industry life cycle theory. The chapter also discussed the five important theories explaining strategic sourcing: (1) resource-based view of the firm, (2) resource dependence theory, (3) strategic choice theory, (4) sociocognitive theory, and (5) critical theory.

First, the law of supply and demand suggests that international trade occurs if foreign suppliers can offer certain products at lower prices than domestic suppliers. Low cost would then increase consumers' well-being at the expense of the domestic suppliers' well-being. Industry protectionism and trade barriers often arise because of the loss of domestic suppliers' welfare. Second, the theory of comparative advantage explains that international trade occurs when two countries can gain from trade due to their different relative costs for producing the same goods. By focusing on activities that companies have advantages in, division of labor takes place between the trading countries and each country becomes specialized in certain activities, intensifying comparative advantage.

Third, Porter's competitive advantage of nations suggests that companies in different countries would be able to create different competitive advantages over those in other countries due to different factors. If a country has favorable factor conditions, demand conditions, related and supporting industries, industry structure, and healthy rivalry, companies in this country would be more likely to be competitive in the global marketplaces over countries without such attributes. Because of the differences in competitive advantage, companies trade and source products from companies in other countries that could produce products of higher quality at lower prices.

Fourth, fragmentation theory explains that production systems can be divided and spread around the world so companies can produce products at the best possible locations. Advances in communication and transportation as well as reductions in trade barriers made fragmented production systems possible. Finally, industry life cycle theory illustrates that industries go through distinctive stages of life, while core comparative advantages change along with the life cycle. In particular, at the mature or decline stage, companies are no longer competitive in the domestic market and, thus, seek international markets for new sales and sourcing, resulting in international trade.

From the strategic sourcing perspective, resource-based view of the firm explains that firms decide sourcing options to gain or maintain rare, unique, and costly to copy resources. Depending on the importance of the resources in need and the availability of such resources in the marketplace, resource dependence theory suggests that managers make sourcing decisions to minimize dependence on suppliers. Strategic choice theory suggests that firms make different sourcing decisions, depending on business problems that they would like to solve and strategic types that they like to implement to solve such problems. Sociocognitive theorists argue that sourcing decisions are sense-making activities as well as revelation of organizational identity. Finally, critical theory suggests that sourcing decisions are made to improve society as a whole. Therefore, the degree of social welfare improvement, including global poverty elimination, race equality, and working condition advancement, is important for sourcing decisions.

All of these theories are relevant to global sourcing in the textile and apparel industry. Not one theory explains all activities of global sourcing. However, these different perspectives of international theories collectively help us understand why we source globally in the textile and apparel industry.

key terms

Comparative advantage theory explains that international trades occur when each country in the world focuses on a particular economic activity that it has a relative advantage in compared to other countries. Outputs from the country will then be traded with those from other countries, creating international trades.

Competitive advantage theory explains that international trades take place because different countries have different demand conditions, factor conditions, firm and industry structure, and related supporting industries, and therefore have different strengths in producing different products and services. Outputs from countries will then be traded with those from other countries.

Critical theory explains that sourcing decisions are made to improve society in general, not just firms.

Fragmentation theory explains the production network systems that are divided and dispersed throughout the global marketplace, due to advances in technology and transportation.

Industry life cycle theory explains that an industry goes through certain stages throughout its life cycle, from embryonic to growth, mature, and decline stages.

Law of supply and demand explains how lower prices from goods imported from another country affect the degree of demands and suppliers in a domestic marketplace.

Resource-based view of the firm (RBV) explains that firms are engaged in sourcing to acquire unique and valuable tangible and intangible resources from outside organizations.

Resource dependence theory explains that certain decisions related to sourcing are made for firms to minimize their dependence on other firms.

Sociocognitive theory explains that sourcing decisions are an act of sense-making and a reflection of organizational identity.

Strategic choice theory suggests that firms conduct sourcing to align their firms with the market environment. Some firms are engaged in sourcing to defend their market shares within the market environment. Others source to adapt to changes in market situations quickly. There are also firms that source to analyze new market situations or to react to such new market situations.

learning activities

1. What is the law of supply and demand? How does the lower price from the world impact domestic supply and demand?

2. How do tariffs and quotas impact gains from trade, consumer welfare, and supplier welfare?

3. What are the differences between comparative advantage and competitive advantage?

4. Explain the examples of the comparative advantages that the following countries may have on textile and apparel products:
 a. Italy
 b. United States
 c. Germany
 d. Vietnam
 e. China
 f. Taiwan
 g. India

5. Describe some of Porter's four key attributes that the following countries may have to achieve and sustain for competitive advantage on textile and apparel products:
 a. Germany
 b. Vietnam
 c. China
 d. South Korea
 e. El Salvador
 f. France

6. Show examples of textile and apparel products produced from fragmented production systems. For example, find products that are sewn in one country yet the materials were produced in another country, and discuss why sourcing managers decided to assemble the finished goods in one country while getting materials from another country, creating a fragmented production system.

7. Show examples of companies that apply service links in a fragmented production system. Search news articles about a company called Li and Fung, and discuss the role that the company has historically provided to U.S. sourcers. Discuss the role of Li and Fung in terms of the role of service links.

8. Explain the evolutionary patterns of the textile and apparel industry for the following countries:
 a. United Kingdom
 b. United States
 c. Japan
 d. South Korea
 e. Mexico
 f. China
 g. Bangladesh
 h. Vietnam

9. Show examples of sourcing activities that can be explained by:
 a. The resource-based view of the firms
 b. Critical theory
 c. Resource dependence theory
 d. Sociocognitive theory
 e. Strategic choice theory

references

Abernathy, W., & Utterback, J. (1978). Patterns of innovation in technology. *Technology Review, 80*(7), 40–47.

Arndt, S., & Kierzkowski, H. (2001). *Fragmentation: New production patterns in the world economy.* New York, NY: Oxford University Press.

Barney, J. (1991). Firm resources and sustained competitive advantage. *Journal of Management, 17*, 99–120.

Child, J. (1972). Organizational structure, environment, and performance: The role of strategic choice. *Sociology, 6*, 1–22.

Conner, K. (1991). A historical comparison of resource-based theory and five schools of thought within industrial organization economics: Do we have a new theory of the firm? *Journal of Management, 17*, 121–154.

Day, G. S. (1994, October). The capabilities of market-driven organizations. *Journal of Marketing, 58*, 37–51.

Dicken, P. (2007). *Global shift: Mapping the changing contours of the world economy* (5th ed.). New York, NY: Guilford Press.

Frost, P. (1980). Toward a radical framework for practicing organization science. *Academy of Management Review, 5*(4), 501–507.

Grant, R. (1996). Toward a knowledge-based theory of the firm. *Strategic Management Journal, 17*, 109–122.

Hunt, S. (2002). *Foundations of marketing theory: Toward a general theory of marketing.* Armonk, NY: M. E. Sharpe.

Jin, B. (2004). Apparel industry in East Asian newly industrialized countries: Competitive advantage, challenge and implications. *Journal of Fashion Marketing and Management, 8*, 230–244.

Jones, R., & Kierzkowski, H. (1990). The role of services in production and international trade: A theoretical framework. In R. Jones & A. Krueger (Eds.), *The political economy of international trade.* Oxford, England: Blackwell.

Kilduff, P., & Chi, T. (2006). Longitudinal patterns of comparative advantage in the textile complex. Part 1: An aggregate perspective. *Journal of Fashion Marketing and Management, 10*, 134–149.

Klepper, S. (1997). Industry life cycles. *Industrial and Corporate Change, 6*, 145–181.

Klepper, S., & Graddy, E. (1990). The evolution of new industries and the determinants of market structure. *RAND Journal of Economics*, 27–44.

Miles, R., & Snow, C. (1978). *Organizational strategy, structure, and process.* New York, NY: McGraw-Hill.

Nicholson, W. (2005). *Microeconomic theory: Basic principles and extensions.* Mason, OH: South-Western, Thompson.

Pfeffer, J., & Slancik, G. (1978). *The external control of organizations.* New York, NY: Harper & Row.

Porter, M. (1990). *The competitive advantage of nations.* New York, NY: Free Press.

Ricardo, D. (1960). *Principles of political economy and taxation.* New York, NY: E. P. Dutton.

Shook, C., Adams, G., & Ketchen, J. D. (2009). Towards a "theoretical toolbox" for strategic sourcing. *Supply Chain Management: An International Journal, 14*(1), 3–10.

TOMS Shoes. (2011). *TOMS company overview*. Retrieved November 30, 2011, from http://www.toms.com/corporate-info

Toyne, B., Arpan, J., Barnett, A., Ricks, D., & Shimp, T. (1984). *The global textile industry.* London, England: Allen & Unwin.

Vernon, R. (1966). International investment and international trade in the product cycle. *Quarterly Journal of Economics, 80*(2), 190–207.

GLOBAL TRENDS, BUSINESS TYPES, AND GLOBAL SOURCING

LEARNING OBJECTIVES

Previous chapters discussed why global sourcing occurs. Various theories attempted to explain why today's businesses source their products or components globally. This chapter discusses the current trends in global sourcing and the types of businesses that are engaged in global sourcing. Different business types have different business objectives, and therefore take different approaches to global sourcing. Upon completion of this chapter, students will be able to:

- Articulate the current trends in global sourcing.
- Understand the textile complex and the softgoods industry.
- Comprehend the North American Industry Classification System and how to use this system to analyze business activities within the industry.
- Clarify the differences between the three core economic sectors of the textile and apparel industry—manufacturing, wholesale trade, and retail trade.
- Explain the impact of global sourcing on business activities of these core economic sectors.
- Describe the economic contributions that today's textile and apparel industry makes in developed and developing countries.

3

(Opposite page) *Source:* LuckyPhoto/Shutterstock

Global sourcing and the changed market environment

Global sourcing fundamentally changed the nature of the global textile and apparel industry. In 2012, the entire world exported over US$709 billion worth of textiles and apparel (World Trade Organization [WTO], 2013). *International Trade Statistics 2012,* the latest world trade data published by the World Trade Organization, shows that China was the leading country exporter of textiles in 2012, accounting for 33.4 percent of the world's textile exports, followed by India with 5.3 percent. Twenty-seven member countries of the European Union (EU-27) collectively took 24.3 percent of textile export shares in 2012. The United States, South Korea, Taiwan, and Turkey were other leading textile exporters, yet all of them had less than 5 percent of the market share, respectively. Figure 3.1 shows the leading textile exporters in 2012.

EU-27 was also the leading textile importer, as its textile import share was 24.5 percent in 2012. The United States was the leading country importer of textiles in 2012, accounting for 8.6 percent of the world's textile imports, followed by China with 6.6 percent. China, Vietnam, Japan, Turkey, Mexico, Bangladesh, and Indonesia were other leading textile importers. Figure 3.2 illustrates the leading textile importers in 2012.

On the other hand, China was the leading apparel-exporting country in 2012, supplying 37.8 percent of apparel demand in the world. EU-27 was the next largest apparel exporter, accounting for 25.8 percent of the world's apparel export share, followed by Bangladesh with 4.7 percent. Turkey, India, Vietnam, and Indonesia were also significant apparel exporters in 2012. Figure 3.3 shows the leading apparel-exporting countries.

EU-27 was also the leading apparel-importing economic entity, as all 27 member countries collectively imported apparel accounting for 38.5 percent of the world's apparel imports. As a single country, the United States was the leading apparel importer with an apparel import share of 19.9 percent, followed by Japan with 7.7 percent. Canada and the Russian Federation each had approximately 2 percent of the world's apparel import shares, and Switzerland, Australia,

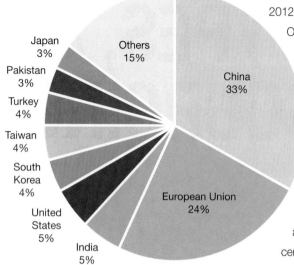

FIGURE 3.1 **Top 10 leading textile-exporting countries, 2012**
Source: Data from the World Trade Organization (2013).

FIGURE 3.2 **Top 10 leading textile-importing countries, 2012**
Source: Data from the World Trade Organization (2013).

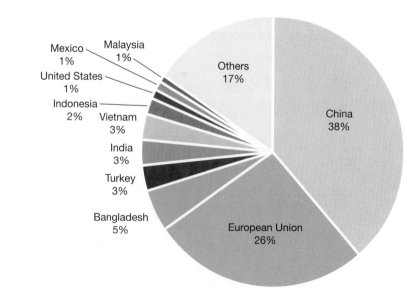

FIGURE 3.3 **Top 10 leading apparel-exporting countries, 2012**
Source: Data from World Trade Organization (2013).

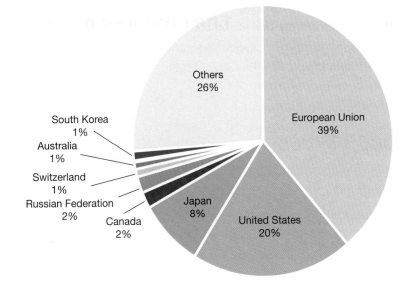

FIGURE 3.4 Top 10 leading apparel-importing countries, 2012
Source: Data from the World Trade Organization (2013).

and South Korea were other leading apparel importers in 2012. Figure 3.4 illustrates the leading apparel-importing countries in 2012.

These trade data clearly show that today the United States and Japan are the main sourcers of textile and apparel products, while China, Turkey, and India are the leading textile or apparel suppliers. The EU seems to both source and supply textile and apparel products. This is a very different picture of the world textile and apparel trade compared with the early 1960s, when global sourcing had just become popular. In 1963, the total value of world apparel exports was US$2.2 billion, of which 86 percent was generated by developed economies. By 2010, however, the value of world apparel exports had increased to US$314 billion, 51.3 percent of which were exported by just five leading exporters: China, Bangladesh, Turkey, India, and Vietnam (Ha-Brookshire & Dyer, 2008; WTO, 2011).

This shift in a country's importer–exporter status reflects the different business activities that textile and apparel companies perform. In the 1960s, when the United States was the leading exporter, most businesses in the U.S. apparel industry performed manufacturing and exporting. Today, the United States is the leading apparel importer, and therefore companies in the U.S. apparel industry are engaged in importing-related activities such as global sourcing. Ha-Brookshire and Dyer (2008) explained this industry transformation phenomenon by comparing the "old" and "new" market environments in the U.S. textile and apparel industry (see Figure 3.5). First, the old market environment is characterized by domestic manufacturing, relatively light

FIGURE 3.5 Transformation of the U.S. textile and apparel market environment
Source: Adopted from Ha-Brookshire and Dyer (2008).

competition, consolidated manufacturing processes, and weak consumer power relative to demand. After transformation, the new market environment is marked by global sourcing and manufacturing, intense competition, fragmented manufacturing processes, and fickle and strong consumer demand (Dyer & Ha-Brookshire, 2008).

Business types

While the industry transformed from being manufacturing- and export-oriented to being import-oriented, businesses within the industry changed their core activities as well. Thus, companies with new business activities have emerged within the industry. To understand what activities are new and how global sourcing affected types of business activities in today's marketplace, we must review the business activities that are core to the textile and apparel industry.

Textile complex versus softgoods industry

The traditional view of the textile and apparel industry focused on manufacturing activities within the industry. Therefore, fiber production, yarn and fabric production, and end-product production—such as apparel manufacturing—were considered the core business activities of the textile and apparel industry. In this light, Dickerson (1999) used the term *fiber-textile-apparel (FTA) complex* to describe the overall picture of the textile and apparel *manufacturing* industry. As manufacturing activities move from developed countries to developing countries, the FTA complex has been associated with phrases such as "dying industry," "plant closing," and "domestic job loss."

However, the relocation of manufacturing activities also created new business activities and job functions within developed countries to take advantage of the new market environment. Retailers are now directly involved in manufacturing through global sourcing. Manufacturers are now retailing their own products through online store formats. The textile and apparel industry in developed countries, such as the United States, no longer looks like it did decades ago, and a significant portion of its business activities are now different from in the past.

Some practitioners or researchers use a new term, *softgoods industry*, rather than *textile and apparel industry* to emphasize the changed nature of business activities. **Softgoods** refers to nondurable goods that are usually made with textiles (*Merriam-Webster,* 2011), and **textiles** refers to all of the products that the FTA complex produces—fibers, yarns, fabrics, apparel, and so on (Kadolph, 2011; see Figure 3.6). Therefore, the **softgoods chain** is "the total textile and apparel production–distribution chain," including "manufacturing products through retailing and other distribution phases associated with making products available to consumers" (Dickerson, 1999, pp. 286–287). Thus, the term *softgoods industry* provides an opportunity to include new business activities such as importing, exporting, and other distribution-related business practices. How to refer to today's textile and apparel industry depends on the user's precise meaning of these terms. However, what is important to know is that one must consider more than just manufacturing when analyzing the industry. The next section explains different sectors within the industry.

FIGURE 3.6 Textiles *refers to all the products that the FTA complex produces—from fibers to apparel.*
Source: © WoGi/Fotolia

North American Industry Classification System

In North America, the United States, Canada, and Mexico classify business activities following the **North American Industry Classification System (NAICS)**. Every five years, each country's census bureau conducts nationwide surveys to collect data on economic activities in every industry sector and business type. Since 1997, when NAICS was established, it has been used as the standard for federal statistical agencies in classifying business establishments for the purpose of collecting, analyzing, and publishing statistical data related to the nation's business economy (U.S. Census Bureau, 2011j).

NAICS uses a 2- to 6-digit hierarchical classification system (U.S. Census Bureau, 2011i). There are five levels of detail of business types. Each digit in the code is part of a series of progressively narrower categories, and more digits in the code signify greater classification detail. A complete and correct NAICS code must include six digits. Therefore, each business must be able to identify itself with a six-digit NAICS code. Each digit contains the following information:

- First two digits = the economic sector.
- Third digit = the subsector.
- Fourth digit = the industry group.
- Fifth digit = the NAICS industry.
- Sixth digit = the national industry.

The fifth digit is the level at which there is comparability in the code and definitions for most of the NAICS sectors across the three countries, and the sixth-digit level allows for each country to have country-specific details. Table 3.5 shows examples of six-digit codes and descriptions of businesses.

MAJOR ECONOMIC SUBSECTORS

There are 20 major economic sectors within NAICS (see Table 3.1). Thus, the first two digits explain the economic sector to which a business belongs. Most businesses in the textile and apparel industry belong to one of three economic sectors: manufacturing (31–33), wholesale trade (42), or retail trade (44–45).

NAICS codes 31, 32, and 33 describe **manufacturers** as businesses "engaged in the mechanical, physical, or chemical transformation of materials, substances, or components into new products. The assembling of component parts of manufactured products is considered manufacturing" (U.S. Census Bureau, 2011f).

Retailers belong to NAICS codes 44 and 45. They are "engaged in retailing merchandise, generally without transformation, and rendering services incidental to the sale of merchandise. The retailing process is the final step in the distribution of merchandise; retailers are, therefore, organized to sell merchandise in small quantities to the general public" (U.S. Census Bureau, 2011h).

Wholesalers, listed under NAICS code 42, are "engaged in wholesaling merchandise, generally without transformation, and rendering services incidental to the sale of merchandise. The wholesaling process is an intermediate step in the distribution of merchandise. Wholesalers are organized to sell or arrange the purchase or sale of (a) goods for resale [i.e., goods sold to other wholesalers or retailers], (b) capital or durable nonconsumer goods, and (c) raw and intermediate materials and supplies used in production" (U.S. Census Bureau, 2011g).

TABLE 3.1

NAICS economic sectors

Economic Sector	Description
11	Agriculture, Forestry, Fishing, and Hunting
21	Mining, Quarrying, and Oil and Gas Extraction
22	Utilities
23	Construction
31–33*	Manufacturing*
42*	Wholesale Trade*
44–45*	Retail Trade*
48–49	Transportation and Warehousing
51	Information
52	Finance and Insurance
53	Real Estate and Rental and Leasing
54	Professional, Scientific, and Technical Services
55	Management of Companies and Enterprises
56	Administrative and Support and Waste Management and Remediation Services
61	Educational Services
62	Health Care and Social Assistance
71	Arts, Entertainment, and Recreation
72	Accommodation and Food Services
81	Other Services (except Public Administration)
92	Public Administration

Note: The asterisk (*) indicates economic sectors mostly relevant to textile and apparel businesses.
Source: U.S. Census Bureau (2011a).

TABLE 3.2
NAICS definitions of manufacturer, retailer, and wholesaler

Business Type	Description
Manufacturer (NAICS 31–33)	"Engaged in the mechanical, physical, or chemical transformation of materials, substances, or components into new products. The assembling of component parts of manufactured products is considered manufacturing" (U.S. Census Bureau, 2011f).
Retailer (NAICS 44–45)	"Engaged in retailing merchandise, generally without transformation, and rendering services incidental to the sale of merchandise. The retailing process is the final step in the distribution of merchandise; retailers are, therefore, organized to sell merchandise in small quantities to the general public" (U.S. Census Bureau, 2011h).
Wholesaler (NAICS 42)	"Engaged in wholesaling merchandise, generally without transformation, and rendering services incidental to the sale of merchandise. The wholesaling process is an intermediate step in the distribution of merchandise. Wholesalers are organized to sell or arrange the purchase or sale of (a) goods for resale [i.e., goods sold to other wholesalers or retailers], (b) capital or durable nonconsumer goods, and (c) raw and intermediate materials and supplies used in production" (U.S. Census Bureau, 2011g).
Merchant wholesaler type	"Sell goods on their own account." Includes wholesale merchants, distributors, jobbers, drop shippers, import–export merchants, and manufacturers' sales offices and sales branches (U.S. Census Bureau, 2011g).
Business-to-business electronic market type	"Arrang(e) for the purchase or sale of goods owned by others or purchase goods, generally on a commission basis." Includes agents and brokers, commission merchants, import–export agents and brokers, auction companies, and manufacturers' representatives (U.S. Census Bureau, 2011g).

Source: Adopted from Ha-Brookshire and Dyer (2008).

More specifically, wholesalers are categorized into two types of operations: (a) merchant wholesalers and (b) business-to-business [B2B] electronic markets (U.S. Census Bureau, 2011g). Merchant wholesalers are wholesalers that take ownership of the goods and sell them on their own account. This business type includes wholesale merchants, distributors, jobbers, drop shippers, import–export merchants, and manufacturers' sales offices and sales branches. B2B electronic markets arrange the purchase or sale of goods owned by others or purchase goods, generally on a commission basis. B2B electronic market type wholesalers include agents and brokers, commission merchants, import–export agents and brokers, auction companies, and manufacturers' representatives (U.S. Census Bureau, 2011g). Table 3.2 defines manufacturers, retailers, and wholesalers as described by the U.S. Census Bureau.

TEXTILE AND APPAREL MANUFACTURING SUBSECTOR

Within the manufacturing economic sector, there are four specific subsectors that are directly relevant to businesses in the textile and apparel industry: (a) Textile Mills (313); (b) Textile Product Mills (314); (c) Apparel Manufacturing (315); and (d) Leather and Allied Product Manufacturing (316). Table 3.3 illustrates the four subsectors of the textile and apparel manufacturing industry.

Textile mills (NAICS 313) are businesses that "transform a basic fiber (natural or synthetic) into a product, such as yarn or fabric, that is further manufactured into usable items, such as apparel, sheets, towels, and textile bags for individual or industrial consumption" (U.S. Census Bureau, 2011b). Thus, any factories that produce fibers, yarns, and/or threads belong to this subsector.

TABLE 3.3

Relevant NAICS subsectors of textile and apparel manufacturing

Subsector	Description
313	Textile Mills
314	Textile Product Mills
315	Apparel Manufacturing
316	Leather and Allied Product Manufacturing

Textile product mills (NAICS 314) are businesses that "make textile products (except apparel). With a few exceptions, processes used in these industries are generally cut and sew (i.e., purchasing fabric and cutting and sewing to make nonapparel textile products, such as sheets and towels)" (U.S. Census Bureau, 2011c).

The apparel manufacturing sector (NAICS 315) consists of businesses "with two distinct manufacturing processes: (1) cut and sew (i.e., purchasing fabric and cutting and sewing to make a garment), and (2) the manufacture of garments in establishments that first knit fabric and then cut and sew the fabric into a garment" (U.S. Census Bureau, 2011d).

Finally, the leather and allied product manufacturing sector (NAICS 316) consists of businesses that "transform hides into leather by tanning or curing and fabricating the leather into products for final consumption. It also includes the manufacture of similar products from other materials, including products (except apparel) made from 'leather substitutes,' such as rubber, plastics, or textiles. Rubber footwear, textile luggage, and plastics purses or wallets are examples of 'leather substitute' products included in this group" (U.S. Census Bureau, 2011e).

TEXTILE AND APPAREL RETAIL SUBSECTOR

Textile and apparel products could be sold through many different channels, including brick-and-mortar stores, online, and in catalogs. Textile and apparel products are also sold through clothing stores, department stores, large grocery stores, furniture stores, and so on. Therefore, there are more classification options for textile and apparel retailers. These include NAICS codes 442 (Furniture and Home Furnishings Stores), 448 (Clothing and Clothing Accessories Stores), 452 (General Merchandise Stores), and 454 (Nonstore Retailers). Table 3.4 describes relevant NAICS codes and descriptions for businesses involved in textile and apparel product retailing.

TEXTILE AND APPAREL WHOLESALE TRADE SUBSECTOR

Although NAICS code 425 (Wholesale Electronic Markets and Agents and Brokers) can include textile and apparel wholesale businesses, NAICS code 4243 deals with most textile and apparel wholesaling activities. NAICS 4243 is titled "Apparel, Piece Goods, and Notions Merchant

TABLE 3.4

Relevant NAICS subsectors of textile and apparel retailers

Subsector	Description
442	Furniture and Home Furnishings Stores
448	Clothing and Clothing Accessories Stores
452	General Merchandise Stores
454	Nonstore Retailers

TABLE 3.5

Relevant NAICS textile and apparel wholesale trade

Subsector	Description
42	Wholesale Trade
424	Merchant Wholesalers, Nondurable Goods
4243	Apparel, Piece Goods, and Notions Merchant Wholesalers
42431	Piece Goods, Notions, and Other Dry Goods Merchant Wholesalers
424310	Piece Goods, Notions, and Other Dry Goods Merchant Wholesalers
42432	Men's and Boys' Clothing and Furnishings Merchant Wholesalers
424320	Men's and Boys' Clothing and Furnishings Merchant Wholesalers
42433	Women's, Children's, and Infants' Clothing and Accessories Merchant Wholesalers
424330	Women's, Children's, and Infants' Clothing and Accessories Merchant Wholesalers
42434	Footwear Merchant Wholesalers
424340	Footwear Merchant Wholesalers

Source: U.S. Census Bureau (2011g).

Wholesalers," and is one of the industry groups of NAIC's 424 sector (Merchant Wholesalers, Nondurable Goods) (U.S. Census Bureau, 2011g). In this definition, nondurable goods are items with a normal life expectancy of less than three years (U.S. Census Bureau, 2011g). Table 3.5 illustrates NAICS subsectors within the wholesale trade (42), including six-digit codes. As seen in this table, the six-digit code has the most details, while the two-digit code encompasses all the businesses with three-digit or more businesses.

Global sourcing by different business types

With a clear understanding of the different business types that exist in today's market environment, it is now possible to review how these different types of businesses conduct global sourcing.

MANUFACTURERS AND GLOBAL SOURCING

When most manufacturing was done domestically, sourcing was limited to within the borders, mostly through businesses located geographically nearby. However, as companies looked into low-cost labor in other countries, many of them simply closed their manufacturing operations or moved them to low-wage countries. In the United States, this trend started a few decades ago, and the United States is now importing over 95 percent of its textile and apparel products from foreign countries; an extremely limited amount of textile and apparel manufacturing activity remains within the country (Ha-Brookshire & Dyer, 2008). That is, textile and apparel manufacturers in the United States are now sourcing their components and products globally, either by owning manufacturing facilities in foreign countries or by partnering with foreign manufacturers.

RETAILERS AND GLOBAL SOURCING

In today's textile and apparel marketplace, retailers are ever more powerful than any other business types. Sociologist Gary Gereffi (1994) explained this type of industry as "buyer-driven" rather than

FIGURE 3.7 *In today's textile marketplace, retailers are more powerful than any other business type.*
Source: © Dinga/Fotolia

producer-driven (see Figure 3.7). In the buyer-driven marketplace, large retailers and brand-named merchandising companies take the pivotal role within the industry, and the core sources of profit are from design, values, services, and marketing (Gereffi, 1994). With negotiating strength on their side, retailers often engage in global sourcing by directly conducting business with foreign factories and suppliers. Sometimes, retailers also own factories in foreign countries. This means that today's retailers are getting more involved in manufacturing activities.

WHOLESALERS AND GLOBAL SOURCING

The role of wholesalers in global sourcing is much more complicated. According to NAICS, wholesalers are different from retailers, as they do not sell their products to end consumers. Wholesalers are also different from manufacturers in that they are not engaged in product transformation activities. Although identifying whether a business is engaged in direct retailing is easy, it has become more and more difficult to verify whether a business is a wholesaler or manufacturer in today's new market environment, as Ha-Brookshire and Dyer (2008) describe it in terms of the U.S. textile and apparel industry.

The confusion between manufacturers and wholesalers in today's marketplace comes from the term *product transformation.* Because of global sourcing, many of the traditional manufacturers are no longer engaged in manufacturing activities within the country. Therefore, these companies are not considered manufacturers according to NAICS. Instead, they are now performing design, product development, preproduction, marketing, branding, and global sourcing, all of which are fundamentally vital for product transformation. In addition, many of today's textile and apparel companies supply their products to retailers after branding, designing, and sourcing their own products. The goal of these companies is not to retail (i.e., selling products directly to end consumers), but to supply their products to retailers so retailers can then sell the products to consumers. In both cases, these companies are not transforming (or manufacturing)

products themselves, yet they do everything else. Are these companies then wholesalers who are at the forefront of global sourcing?

After surveying U.S. apparel businesses, Ha-Brookshire and Dyer (2009) found that over half of U.S. apparel wholesalers (as defined by NAICS) misclassify themselves as either "manufacturer" or "other" despite the fact that they do not own domestic manufacturing facilities. When only three business types—manufacturers, wholesalers, and retailers—were presented, some of these companies chose "other" rather than selecting "wholesaler" as their business type. Ha-Brookshire and Dyer (2008) extensively discussed these business identity issues and argued that the term *wholesaler* is not ideal for this type of business, which is performing new and different business activities in the new market environment. One reason for the need of a new term is the fact that the term *wholesaler* is generally associated with firms that simply buy and resell goods at a profit without transforming the products. Similarly, Scheffer and Duineveld (2004, p. 344) agreed that, "the term wholesaling underestimates the importance of design, branding, marketing and logistics."

IMPORT INTERMEDIARIES AND GLOBAL SOURCING

To help solve the problem of the current term *wholesaling*, Ha-Brookshire and Dyer (2008) introduced a new business classification term, **import intermediary**, and defined it as a domestic service firm that links domestic wholesalers or retailers with foreign distributors or manufacturers to facilitate import transactions in the global apparel supply chain. These import intermediary firms play a significant role in global sourcing (see Figure 3.8).

Import intermediaries include all textile and apparel service firms that have acted as intermediaries in the past, such as import wholesalers, import jobbers, import merchant wholesalers, import agents or brokers, import trading companies, and foreign manufacturers' sales offices or sales branches. Import intermediaries would also include new types of intermediary firms that have resulted from the changes in the textile and apparel industry.

FIGURE 3.8 *Import intermediary firms play a significant role in global sourcing.*
Source: © Faraways/Fotolia

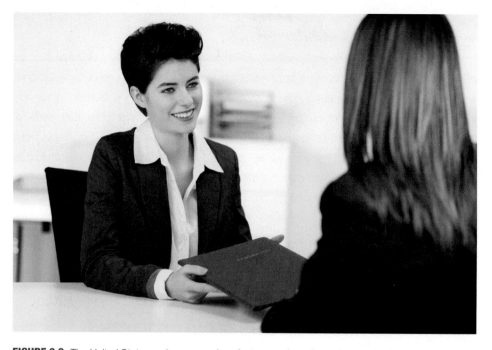

FIGURE 3.9 *The United States no longer employs factory workers; it requires professionals with global management skills.*
Source: © contrastwerkstatt/Fotolia

Some of the new intermediary firms in the textile and apparel industry have taken on preproduction functions traditionally performed by manufacturers, such as pattern making and grading, and the preparation of production order sheets and quality control plans, although these import intermediaries do not own or operate manufacturing facilities. Other new intermediary apparel firms provide services, such as design, product development, quality control, and logistics, for only certain parts of the supply chain. Regardless of the specific functions of the different types of import intermediary firms, one of the characteristics shared by all these firms is that their customers are other firms rather than consumers.

Whether the business classification must be changed to include intermediaries to replace the wholesale trade sector is a matter for government agencies to decide. What is important to know is that the nature of businesses in today's textile and apparel industry has been fundamentally changed, and we must look at the industry with different eyes. The textile and apparel industry in the United States no longer employs factory workers; instead, it hires brand managers, product developers, merchandisers, sourcing managers, global supply chain managers, marketers, and/or retail managers. There are a large number of small- and medium-sized businesses supplying globally sourced products for large domestic retailers or brand owners. These businesses require professionals with skills in such areas as multicultural negotiation, world politics and geography, and international communications, which were not necessary in the past (see Figure 3.9).

Despite these shifts in business activities, many people in the United States still believe sewing factories and textile plants represent the U.S. textile and apparel industry. To their eyes, it is obvious the industry has been declining and continues to decline, as the industry no longer produces any products within the country. However, society—including textile and apparel (or softgoods) professionals, educators, and the future workforce—must understand that the characteristics of the industry have changed, and we now have different job functions and employment opportunities, such as global sourcing, making different economic contributions to the nation's economy (see Figure 3.10).

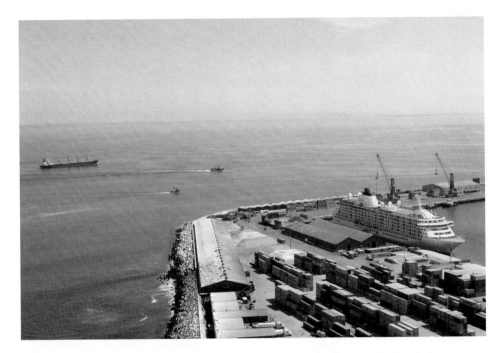

FIGURE 3.10 *The textile industry in developed countries still makes significant contributions to the economy.*
Source: © Demetrio Carrasco/Dorling Kindersley/Pearson Education

summary

The market environment in which textile and apparel businesses operate has fundamentally changed, and so the nature of business activities within the textile and apparel industry has changed. The industry's economic focus has shifted from being manufacturing- and export-oriented to being import-oriented. Naturally, global sourcing plays the core role in import-oriented business operations. A significant portion of businesses in the U.S. textile and apparel industry is now engaged in global sourcing.

Traditionally, businesses have been classified as belonging to one of the three main economic sectors—manufacturing, wholesale trade, or retail trade. With the transformation of the market environment, the distinction among the three business types has become blurred. Retailers now go directly to foreign factories to source their products. They often own factories in foreign countries, becoming manufacturers. Traditional manufacturers now relocate their plants overseas where labor wages are low, so they no longer are considered manufacturers. Wholesalers also have transformed into value-added service firms, connecting domestic retailers and foreign suppliers. These wholesalers are much more entrepreneurial, offering a variety of value-added activities such as marketing, product development, global sourcing, and logistics.

The profound impact of global sourcing on business activities in developed economies leads to identity crises among businesses that do not engage in domestic manufacturing, yet are involved in product transformation activities. *Import intermediary* is a newly proposed term to include new business types that have emerged in the new market environment. This term is designed to reflect the changed business responsibilities that today's companies take on and the new market environment. Through either the term *wholesaler* or *import intermediary*, we must understand that the textile and apparel industry in developed countries is still viable, critical, and flourishing, and is making significant economic contributions to the nation's economy by performing different business activities that did not exist in the past.

key terms

Import intermediaries are domestic service firms that link domestic wholesalers or retailers with foreign distributors or manufacturers to facilitate import transactions in the global apparel supply chain (Ha-Brookshire & Dyer, 2008).

Manufacturers are businesses "engaged in the mechanical, physical, or chemical transformation of materials, substances, or components into new products. The assembling of component parts of manufactured products is considered manufacturing" (U.S. Census Bureau, 2011d).

North American Industry Classification System (NAICS) is "the standard used by the Federal statistical agencies in classifying business establishments for the purpose of collection, analyzing, and publishing statistical data" related to the North American business economy (U.S. Census Bureau, 2011a).

Retailers are "engaged in retailing merchandise, generally without transformation, and rendering services incidental to the sale of merchandise. The retailing process is the final step in the distribution of merchandise; retailers are, therefore, organized to sell merchandise in small quantities to the general public" (U.S. Census Bureau, 2011h).

Softgoods refers to nondurable goods that are usually made with textiles such as fibers, yarns, fabrics, and apparel.

Softgoods chain refers to "the total textile and apparel production-distribution chain," including "manufacturing products through retailing and other distribution phases associated with making products available to consumers" (Dickerson, 1999, pp. 286–287).

Textiles refers to all of the products that the Fiber-Textile-Apparel complex produces, including fibers, yarns, fabrics, apparel, and other fiber-based products.

Wholesalers are "engaged in wholesaling merchandise, generally without transformation, and rendering services incidental to the sale of merchandise. The wholesaling process is an intermediate step in the distribution of merchandise. Wholesalers are organized to sell or arrange the purchase or sale of (a) goods for resale [i.e., goods sold to other wholesalers or retailers], (b) capital or durable nonconsumer goods, and (c) raw and intermediate materials and supplies used in production" (U.S. Census Bureau, 2011g).

learning activities

1. Ask 10 different people how they perceive the terms *fiber-textile-apparel complex, textile and apparel industry,* and *softgoods industry.* Ask what they think of these industries. Compare and contrast their responses. What did you find out?

2. Repeat question 1 using the terms *wholesalers, intermediaries,* and *importers.* Review the comments and discuss what you found out.

3. Review the North American Free Trade Agreement (NAFTA) at the Executive Office of the President website and the North American Industry Classification System (NAICS) at the U.S. Census Bureau website. Explain how NAFTA affected the creation of NAICS.

4. Review trade data of textile and apparel imports and exports in the world from the World Trade Organization's *Statistics: International Trade Statistics 2011* website. What do you conclude about the impact of the United States and China on the global textile and apparel industry?

5. Conduct primary and secondary research on what textile and apparel businesses do in New York, San Francisco, Atlanta, and Dallas (you may be able to talk to people who are working in these cities and ask what their companies do). Conclude whether they are manufacturers, wholesalers, or retailers, following the definition of each term.

6. Discuss how the approach to global sourcing would be different for these different types of businesses.

references

Dickerson, K. (1999). *Textiles and apparel in the global economy* (3rd ed.). Upper Saddle River, NJ: Prentice Hall.

Dyer, B., & Ha-Brookshire, J. (2008). Apparel import intermediaries' secrets to success: Redefining success in a hyper-dynamic environment. *Journal of Fashion Marketing and Management, 12*(1), 51–67.

Gereffi, G. (1994). *Commodity chains and global capitalism.* Westport, CT: Greenwood Press.

Ha-Brookshire, J., & Dyer, B. (2008). Apparel import intermediaries: The impact of a hyper-dynamic environment on U.S. apparel firms. *Clothing and Textiles Research Journal, 26*(1), 66–90.

Ha-Brookshire, J., & Dyer, B. (2009). Framing a descriptive profile of a transformed apparel industry: Apparel import intermediaries in the United States. *Journal of Fashion Marketing and Management, 13*(2), 161–178.

Kadolph, S. (2011). *Textiles* (11th ed.). Upper Saddle River, NJ: Prentice Hall.

Merriam-Webster. (2011). Soft goods. Retrieved October 10, 2011, from http://www.merriam-webster.com/dictionary/soft+goods?show=0&t=1318357614

Scheffer, M., & Duineveld, M. (2004). Final demise or regeneration?: The Dutch case. *Journal of Fashion Marketing and Management, 8*, 340–349.

U.S. Census Bureau. (2011a, February 28). *2007 NAICS.* Retrieved October 6, 2011, from North American Industry Classification System: http://www.census.gov/cgi-bin/sssd/naics/naicsrch?chart=2007

U.S. Census Bureau. (2011b, February 18). *2007 NAICS definition: 313 Textile Mills.* Retrieved October 6, 2011, from North American Industry Classification System: http://www.census.gov/cgi-bin/sssd/naics/naicsrch?code=313&search=2007%20NAICS%20Search

U.S. Census Bureau. (2011c, February 18). *2007 NAICS definition: 314 Textile Product Mills.* Retrieved October 6, 2011, from North American Industry Classification System: http://www.census.gov/cgi-bin/sssd/naics/naicsrch?code=314&search=2007%20NAICS%20Search

U.S. Census Bureau. (2011d, February 18). *2007 NAICS definition: 315 Apparel Manufacturing.* Retrieved October 6, 2011, from North American Industry Classification System: http://www.census.gov/cgi-bin/sssd/naics/naicsrch?code=315&search=2007%20NAICS%20Search

U.S. Census Bureau. (2011e, Feburary 18). *2007 NAICS definition: 316 Leather and Applied Product Manufacturing.* Retrieved October 6, 2011, from North American Industry Classification System: http://www.census.gov/cgi-bin/sssd/naics/naicsrch?code=316&search=2007%20NAICS%20Search

U.S. Census Bureau. (2011f, February 18). *2007 NAICS definition: Sector 31-33 Manufacturing.* Retrieved October 3, 2011, from North American Industry Classification System: http://www.census.gov/cgi-bin/sssd/naics/naicsrch?code=31&search=2007%20NAICS%20Search

U.S. Census Bureau. (2011g, February 18). *2007 NAICS definition: Sector 42 Wholesale Trade.* Retrieved October 3, 2011, from North American Industry Classification System: http://www.census.gov/cgi-bin/sssd/naics/naicsrch?code=42&search=2007%20NAICS%20Search

U.S. Census Bureau. (2011h, February 18). *2007 NAICS definition: Sector 44-45 Retail Trade.* Retrieved October 3, 2011, from North American Industry Classification: http://www.census.gov/cgi-bin/sssd/naics/naicsrch?code=44&search=2007%20NAICS%20Search

U.S. Census Bureau. (2011i, April 13). *Frequently asked questions.* Retrieved October 6, 2011, from North American Industry Classification System: http://www.census.gov/eos/www/naics/faqs/faqs.html

U.S. Census Bureau. (2011j, August 17). *Introduction.* Retrieved October 6, 2011, from North American Industry Classification System: http://www.census.gov/eos/www/naics

World Trade Organization. (2013). *International trade statistics 2013.* Retrieved November 22, 2013, from http://www.wto.org/english/res_e/statis_e/its2013_e/its13_merch_trade_product_e.htm

GLOBAL SOURCING OPTIONS

LEARNING OBJECTIVES

Previous chapters discussed how all business types—manufacturers, wholesalers, retailers, and intermediaries—are engaged in global sourcing. These businesses have different goals and, therefore, different reasons for global sourcing. So what criteria do businesses consider when choosing whether to make products or components of products themselves, or to source from other organizations? What are important aspects to consider? Once sourcing is decided, what are the sourcing options and what factors must these businesses consider when deciding on suppliers? This chapter discusses make-or-buy decision criteria, sourcing options, and evaluative factors when selecting suppliers. Upon completion of this chapter, students will be able to:

- Understand why a company decides to source products from outside organizations, instead of making products on its own.
- Comprehend the four major criteria for make-or-buy decisions.
- Describe various sourcing options, and articulate the advantages and disadvantages of different sourcing options—direct sourcing, CMT contracting, full-package sourcing, and joint venture sourcing.
- Understand the roles of cost, quality, lead time, compliance issues, and physical infrastructure that foreign suppliers can offer to businesses engaged in making decisions on sourcing options.

Make or Buy?

Chapter 1 explained global sourcing as a set of business processes and activities by which businesses acquire and deliver components or fully finished products or services from outside the organization. A decision on sourcing or global sourcing is directly related to a company's strategic decision on whether to "make or buy." *Make* in this context means that a company produces parts or products on its own. *Buy* refers to sourcing parts or products from other organizations. Many factors must be considered in such decisions, as the results of these decisions affect the company's long-term and short-term performance. Four key criteria are discussed in businesses' make-or-buy decisions: cost minimization, profit maximization, capabilities, and risk reduction criteria (Seshadri, 2005). All of these criteria could directly affect businesses' short-term economic goals. That is, if businesses consider all of these factors when choosing sourcing options, they may gain higher economic performance in a near term through low cost, high profit, unique capabilities, and fewer uncertainties. However, if businesses consider all of these criteria carefully, responsibly, and with a balanced approach, in the long term they may gain social and environmental goals, two of the triple bottom lines of sustainable global sourcing, through increased reputation and consumers' recognition for such balancing acts.

Cost minimization criterion

Although minimizing cost seems to be an obvious factor to consider when a company is deciding whether to make or buy its products or components, calculating the actual costs and assessing the net savings in costs are not easy. First, both production cost and service cost must be included to assess the overall cost of product or part acquisition (Seshadri, 2005). As fragmentation theory suggests, global sourcing involves multiple production blocks in multiple countries, and service links between these production blocks. **Production cost** includes the total cost of making or manufacturing products. **Service costs** refer to non-production-related expenses associated with transportation, legal counsel, travel, telecommunication, human resource management, accounting services, information technology, quality testing/inspection services, and many other needs (see Figure 4.1). Compared with the option of a business's making its own products that require few or no service links, the role of service links in a buying option is much more significant. Therefore, the cost of using such service links is higher in the buy option than the make option. If a company looks at the labor cost of manufacturing apparel products only, and makes a decision on the buy option without consideration of service costs, its decision might not yield overall savings in cost.

Second, both internal and external costs associated with product acquisition need to be considered (Seshadri, 2005). Let's assume there is a manufacturer whose core competency is to produce denim (fabrics) and jeans (apparel) — Amazing Jeans. To make jeans, Amazing Jeans needs zippers. Amazing Jeans has an option of investing capital to establish a zipper-manufacturing plant so it can make zippers on its own, but it also has an option of buying premade zippers from other companies. When considering these two options, Amazing Jeans would have to consider both internal cost (the cost of making zippers on its own) and external cost (the cost of purchasing zippers from others). Making zippers on its own might require significant internal costs, including "fixed costs," costs that do not vary depending on production or sales, such as rent, equipment, or interest expense. On the other hand, buying zippers from others

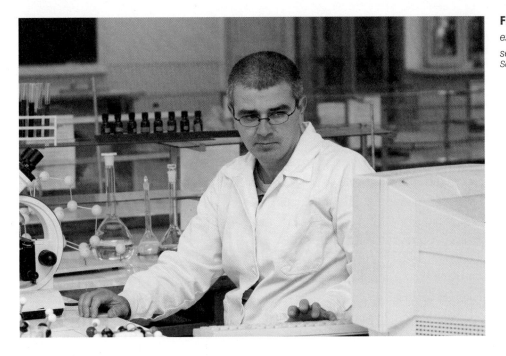

FIGURE 4.1 *Service costs refer to nonproduction expenses such as quality testing or inspection services.*
Source: Radu Razvan/Shutterstock.

might not require fixed costs; however, it would incur external costs to coordinate production and transport zippers to the desired location. Therefore, considerations of both production and service costs, as well as internal and external costs, are critical when a company makes a decision on whether to make or buy (see Figure 4.2).

Profit maximization criterion

When a company makes a decision on whether to make or buy, it must consider opportunity cost in addition to production and service costs. **Opportunity cost** is the value of something that must be given up to acquire or achieve something else. For example, the opportunity cost of going to

FIGURE 4.2 *Consideration of production or service and internal or external costs are critical even for Jeans' packaging, sizing labels, and folding costs.*
Source: Thanapat Chammaphruek/Shutterstock.

college is the money you would have earned if you had worked instead (Investopedia, 2011). Let's go back to Amazing Jeans, which needs zippers to complete jean manufacturing. If Amazing Jeans decided to make zippers on its own, the opportunity cost would be the extra cash flow that the company would have had by not investing such money to build a zipper-manufacturing plant. If Amazing Jeans decided to buy zippers from others, the opportunity cost would be the potential benefits gained from better control of quality and delivery, or even lower-cost zippers that Amazing Jeans would have had by manufacturing zippers on its own. In this light, production cost itself is not the sole source of the company's overall profits. The opportunity cost of choosing one option over another also impacts the company's overall profits. Therefore, when a company considers make-or-buy decisions, it must include opportunity cost to maximize profits.

Capabilities criterion

When a company makes a decision based on a belief that the most capable supplier or company must perform certain activities, it is said to take a capabilities criterion. The capabilities approach considers the fact that a significant amount of time and effort are necessary for any company to learn new knowledge or skills. Thus, by having the most capable unit or supplier perform certain activities that require knowledge or skills that others do not possess, the company can achieve high profit, efficiency, or productivity. In the example of Amazing Jeans, if it takes the capabilities approach to make a decision on make or buy, it should evaluate who is the most capable party to produce zippers. Amazing Jeans would raise questions such as, "Have we produced zippers before?", "How long will it take to learn making zippers?", and "What resources would it take to learn such knowledge?" The answers to these questions help sourcers address the make-or-buy decision: "Should we just purchase zippers from other companies whose core competency is in making zippers?" If Amazing Jeans makes a decision based on these questions and decides to buy zippers from outside the organization because it is not capable of making zippers on its own, then it is considered to be taking a capabilities approach.

Risk reduction criterion

Risk reduction criterion evaluates the degree of potential risk that a company might have in manufacturing components or products on its own (see Figure 4.3). Let's assume Amazing Jeans is now in need of special zippers containing no more than 600 parts per million (ppm) of lead to comply with new U.S. laws enforced by the Consumer Product Safety Improvement Act of 2009 (Consumer Product Safety Commission [CPSC], 2011). Prior to this act, a higher quantity of lead was allowed in the U.S. consumer market, and Amazing Jeans bought zippers from a company that supplies zippers without lead-testing results. With this new act, Amazing Jeans now has to find new zipper manufacturers that will guarantee the low lead content, even if their zippers might be expensive. That is because any company that violates this law will face significant monetary penalties as well as reputation degradation in the United States. In this case, one of the most important criteria Amazing Jeans must consider is risk avoidance or risk reduction, beyond cost or profit.

Businesses also face risks if they are not thoroughly prepared for or transparent with their business activities related to social and environmental responsibilities. For example, if a sourcer is unsure with foreign factories' fair labor practices and/or proper disposal of chemical residues after manufacturing, the sourcer may want to keep production in-house—that is, to *make* products on its own without sourcing. This decision would help increase the transparency of the sourcer's own business, and reduce potential scandals and/or negative publicity due to the suppliers' irresponsible business

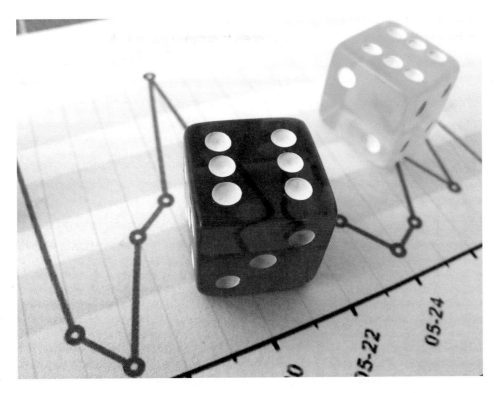

FIGURE 4.3 *Risk reduction criteria evaluate the risk of manufacturing on its own or sourcing.*
Source: gabuchia/Shutterstock.

practices. On the other hand, if a sourcer is unfamiliar with local labor laws and/or waste disposal regulations, the sourcer may want to *buy* products from foreign factories with proper capabilities and knowledge. This decision would help the sourcer avoid getting into unknown business territories in which the sourcer does not have expertise, and reduce risks of getting exposed to the public due to illegal labor and waste disposal practices. These types of decisions are very common, and companies constantly evaluate risks and rewards for their potential selection.

Sourcing options

While make-or-buy decisions are being made, sourcers also consider different sourcing options. The four major sourcing options are (a) direct sourcing, (b) CMT contracting, (c) full-package sourcing, and (d) joint venture sourcing. Each option has different advantages and disadvantages. Sourcers may choose different options for different sourcing projects.

Direct sourcing

Direct sourcing simply means doing it all yourself (American Apparel Manufacturers Association [AAMA], 1997). A company owns factories overseas, makes apparel with its own fabrics, and takes responsibility for all of its input and output. Let's say Amazing Jeans owns denim manufacturing plants in Mexico and jean manufacturing factories in El Salvador. Using zippers made in a zipper manufacturing plant in Guatemala owned by Amazing Jeans, the Salvadorian factory completes jean manufacturing before shipping to its distribution centers in the United States. This supply chain dynamic explains Amazing Jeans's direct sourcing of jeans.

There are a few advantages of direct sourcing. First, direct sourcing can reduce the overall cost of product acquisition in the long run because the sourcer owns all the facilities and plants.

Direct ownership requires less expense in employing key personnel and manufacturing products than does hiring experts or purchasing finished products from others. Thus, the sourcer could keep manufacturing profits.

Second, direct sourcing allows the sourcer to directly control production plans, delivery schedules, quality inspection, and other factory managerial issues such as labor practices and compliance. There are no other "clients" for factories to work for, therefore the factory managers must decide on production plans and quality control based on the sourcer's overall priorities. That is, the sourcer would have complete control over production schedules and quality assurance.

Third, direct sourcing helps the sourcer keep core competencies in manufacturing. Particularly if the sourcer has innovative production processes and these processes are the key to differentiate its products from those of competitors, direct sourcing is a better option to keep all knowledge and know-how within the company. To be competitive, any copyrighted materials, patented technology, and one-of-a-kind capabilities must remain within the company, and direct sourcing helps keep this objective.

As much as direct sourcing offers unique advantages, it also bears notable disadvantages. First, direct sourcing requires a great amount of fixed cost to build or purchase new factories in foreign countries (see Figure 4.4). Therefore, the sourcer would have less cash flow to operate its business. In addition to cash flow issues, working with experts who could help translate and research economic conditions, laws, and regulations in foreign countries is necessary prior to purchasing or building new plants. These learning activities bring additional cost for the sourcer.

Second, as easy as it is to control quality and/or production planning, because of this very fact, direct sourcing also carries risks in both quality and delivery for the sourcer if both fail. That is, when the product quality is poor and the delivery has not met the deadline, the sourcer is responsible for all of the consequences. The sourcer might have to remake products to the right quality or take discounts for the loss of potential sales due to late delivery. These are significant financial losses for the sourcer.

FIGURE 4.4 *Direct sourcing requires a greater amount of fixed costs to build or purchase new factories in foreign countries.*
Source: Bayram TUNC/Getty Images.

Third, owning factories and facilities overseas also limits the sourcer's ability to explore new techniques or technologies that other factories might possess. The trends in the textile and apparel industry change very fast, and retailers are constantly seeking new products that utilize new techniques and technologies. If the factories that the sourcer owns do not have such techniques and technologies, the sourcer has no choice but to purchase parts or products from outside organizations while its own factories lie idle. This could be a huge loss for the sourcer because of the lack of manufacturing activities from its own factories as well as the high cost of purchasing new products from other organizations.

Then who chooses an option of direct sourcing? Although it is not always true, there are a few cases in which direct sourcing is preferred. First, direct sourcing would be a good option for a large retailer selling basic products repeatedly. For example, a large discount retailer, such as Walmart, could consider purchasing apparel-manufacturing factories and fabric mills for basic shirts requiring few or no embellishments. The demand for such products is steady, without much fluctuation throughout the year. Therefore, this retailer knows how many such products to produce every year, over and over. This makes it easier for the retailer to predict future production, so owning factories overseas could be a viable option to produce these products consistently. Direct sourcing would provide low cost, as well as consistency in quality and delivery.

Direct sourcing could also be a good option for a company that owns unique manufacturing technologies or processes. For example, an entrepreneur business that makes custom hats using a patented, one-of-a-kind method might want to choose direct sourcing to keep trade secrets within the company. Although it might take a significant fixed cost in the beginning, direct sourcing would be a better option in the long run to protect the unique knowledge and technology.

CMT contracting

Cut Make Trim (CMT) contracts require other companies or factories to cut, sew, and finish trimming the sourcer's product (AAMA, 1997). Typically, in CMT contracts the sourcer provides his or her own design, fabrics, and other raw materials. The suppliers are solely responsible for cutting the fabrics, sewing and assembling products, and trimming, such as adding hang tags, sorting, and packing (see Figure 4.5). Many U.S. apparel companies prefer CMT contracts because they can control the type and quality of fabrics and raw materials, while the suppliers simply offer CMT operations that are labor-intensive. Because of the labor-intensive nature of the CMT processes, most CMT suppliers are located in developing countries in which an abundance of labor exists at low cost. The CMT contracting is a perfect example of the fragmentation theory of international trade, as apparel companies in developed economies concentrate on capital-intensive activities, such as design, fabric development, and material acquisitions, while countries in developing economies focus on labor-intensive activities, such as CMT.

There are a few key advantages of CMT contracts between the sourcer in developed economies and the supplier in developing economies. Compared to direct sourcing, CMT contracts do not require significant fixed cost from the sourcer—that is, the sourcer does not need to own factories in foreign countries. This is a significant benefit, as the sourcer could have access to apparel-manufacturing facilities in foreign countries with little or no investment cost, while retaining control over design and fabrics.

FIGURE 4.5 *CMT contracts require other companies or factories to cut, sew, and finish trimming the sourcer's product.*
Source: © Inmagine Asia/Corbis

Second, compared with direct sourcing, CMT contracts offer flexibility in product acquisition. CMT contracts are mostly made on a short-term basis, and once contracts are fulfilled, the sourcer can quickly move on to other factories and different countries that might have different skill sets and resources. The flexibility to work with a variety of suppliers is extremely important in today's marketplace because changes in demands occur very fast, and it is the sourcer's responsibility to find the right suppliers who can deliver the right products at the right time.

Third, CMT contracts are useful for suppliers in developing economies with limited experience and capital in apparel manufacturing. Compared with textile manufacturing, apparel manufacturing is labor-intensive and relatively easy to learn. History tells us that the apparel-manufacturing industry is one of the first industries to grow in a developing country where there is a sufficient workforce yet little sophisticated knowledge, few supporting industries, and little capital. These suppliers prefer taking on CMT contracts that do not demand large investments in textile manufacturing, fabric acquisition, or advanced design skills. For these suppliers in developing economies, CMT contracts can be learning opportunities to obtain advanced skills and knowledge from developed economies while the overall textile and apparel industry in their country advances through the path suggested by industry life cycle theory.

Despite these advantages, CMT contracts also have disadvantages for both sourcers and suppliers. First, unlike direct sourcing, once design and fabrics are delivered to the CMT supplier, the sourcer might lose some or all control over keeping design within the company as well as maintaining fabric inventory. Nondisclosure agreements or other types of confidentiality agreements are enforced between the sourcer and the supplier to discourage foreign suppliers from sharing confidential information with others. However, more often than not, intellectual property laws in developing countries are difficult to enforce, and it might not be easy for the sourcer to monitor and react to violations of such agreements.

Second, for similar reasons, in CMT contracts the sourcer might have less cooperative support from the suppliers than with direct sourcing. Changes in production schedules or last-minute adjustments of details are more difficult to make in factories with whom the sourcer has CMT contracts than in the factories that the sourcer owns. In addition, ensuring human and environmental compliance issues with CMT suppliers can be much more difficult than dealing with these issues in the sourcer's own factories. After all, the CMT suppliers are not part of the sourcer's organization, and they might have different goals and objectives that might not always be consistent with the sourcer's.

Third, as much as the flexibility of acquiring new styles and new products from different factories and different countries sounds appealing, changing factories and going to other countries comes with significant learning costs (see Figure 4.6). Each company has a different administrative structure and learning style. The difference in an individual company's learning curve is even greater when multiple countries are involved. Significant time and effort might be necessary to educate new suppliers so they can produce the right products for the sourcer. Time and effort are also necessary for the sourcer to find, understand, and establish business relations with new suppliers.

Finally, by CMT contracting, the sourcer does not get profits from apparel manufacturing. In addition, compared with direct sourcing, CMT contracts are more expensive, given the cost of CMT. However, this high cost of CMT and the lack of manufacturing profits are compensated for by the fact that CMT contracts require no investment cost in apparel-manufacturing plants in foreign countries.

FIGURE 4.6 *Changing factories and moving to other countries lead to significant learning costs.*
Source: SVLuma/Shutterstock.

Full-package sourcing

Full-package sourcing means that the sourcer buys the entire product from the suppliers, including design, fabrics, raw materials, sewing, and quality inspection (AAMA, 1997). Depending on specific terms, shipping and transportation could be included, as well as marketing, merchandising, and technology information services. Full-package service providers can be located domestically or internationally. Full-package suppliers are responsible for the entire sourcing process, from designing concepts to shipping documents.

One of the key advantages of full-package sourcing is the fact that the sourcer can focus on other core business activities other than sourcing. Let us assume that Amazing Jeans wants to expand its product line to t-shirts that could be coordinated with its jeans. However, Amazing Jeans has never been involved in the t-shirt business, and does not have expertise in t-shirt design, manufacturing, or importing. In this case, Amazing Jeans could consider full-package contracts with other companies specialized in t-shirts. This option provides an opportunity for Amazing Jeans to tap into new product markets (t-shirts) without learning or capital investment, while concentrating on its core competency—denim and jean manufacturing. For similar reasons, many retailers, whose main focus is on retail, make full-package contracts with sourcing companies who have specialties in design, foreign manufacturing, and global logistics.

When discussing direct sourcing, it was mentioned that direct sourcing would be a good option for a large retailer, such as Walmart, for basic products that have steady and predictable future demand. At the same time, Walmart could also consider full-package sourcing for products that have highly unpredictable demand due to fast-changing trends, or products requiring special knowledge and skills to produce, or products involving significant capital investment. Full-package suppliers exist to offer such products that retailers cannot execute, or do not want to get involved in. Full-package suppliers could be intermediaries, wholesalers, or manufacturers. Full-package suppliers conduct consumer research, acquire special knowledge and skills, and make capital investment so that retailers have to come to them to acquire particular products.

Examples of such products are those with unique selling points (USPs) that no other companies can offer, or with exclusive brand names that other companies are not allowed to produce.

The second advantage of full-package sourcing is that the sourcer needs little or no up-front investment. The sourcer will have to issue a purchase order and open a letter of credit to the full-package suppliers so the suppliers can acquire raw materials and pay for labor and transportation before they get paid by the sourcer upon shipping. A letter of credit acts as a kind of credit card issued by the sourcer to the supplier, and it will be further discussed in a later chapter in this book.

The third advantage of full-package sourcing is flexibility, as discussed in CMT contracts. However, the degree of the sourcer's flexibility in full-package contracts is much higher than that in CMT contracts. In CMT contracts, the sourcer at least owns the fabrics and design. The sourcer has already invested in designing and purchasing or manufacturing fabrics. Thus, the sourcer has to work within the existing designs and fabrics if it chooses new CMT contractors. However, in full-package sourcing, the sourcer made no long-term commitments to any designs or fabrics (see Figure 4.7). If desired, the sourcer could choose new contractors for different products, markets, and seasons at any time.

The disadvantages of full-package sourcing are less control and fewer profits. First, although full-package sourcing would be a great option for retailers that do not have expertise or special know-how, the lack of expertise also makes the sourcer rely heavily on the suppliers. Too much reliance on the suppliers can reduce the sourcer's bargaining power as it loses control over quality and delivery. In addition, because the supplier takes all the risks throughout the

FIGURE 4.7 *In full-package sourcing the sourcer makes no long-term commitments to any designs or fabrics. Source:* Andy Crawford © Dorling Kindersley.

FIGURE 4.8 *A joint venture is an agreement in which two or more individuals or companies agree to partner without legal incorporation.*
Source: © mangostock/Fotolia.

global sourcing process, the supplier's cost to the sourcer is higher than with any other sourcing options. Thus, full-package sourcing yields the least profits for the sourcer, despite the access to new products otherwise difficult to obtain.

Joint venture sourcing

A joint venture is a business agreement in which two or more individuals or companies agree to engage in a business enterprise for profit without actual partnership or incorporation (Hill & Hill, 2005). **Joint venture sourcing** refers to sourcing products from companies with which the sourcer has a business partnership agreement. Simply put, two or more companies establish a new business entity and share profits as well as loss (see Figure 4.8). Joint venture makes it possible for small businesses or companies that lack certain expertise to gain new business opportunities. Joint venture could be a viable option when direct sourcing is preferred, yet the ownership of foreign factories is not desired. In that case, the sourcer could establish a joint venture with foreign investors who might be interested in building and managing new apparel-manufacturing facilities in a foreign country.

Joint venture sourcing has the advantages of low investment cost and fast start-up. However, the biggest advantage of joint venture is the fact that the sourcer could have excellent access to foreign businesses and markets through the foreign partner's expertise without learning the foreign rules and regulations necessary to establish a new factory in a foreign country.

But joint venture sourcing does not bring the most profits to the sourcer. All the profits will be shared with the foreign partner. Also, the sourcer might not have full control of the business, as the foreign partner might have different goals and objectives. Thus, careful consideration is necessary when pursuing joint venture sourcing because it might require a great deal of compromise to satisfy the foreign partner's goals, while maintaining the sourcer's objectives as well.

Factors for evaluating sourcing options

Detailed information about advantages and disadvantages of each sourcing option is critical when determining particular sourcing options for specific sourcing objectives. The first section of this chapter discussed various criteria that must be considered when a company makes a make-or-buy decision. These criteria are useful when a company makes an overall decision on whether to do it on its own or buy products from outside its organization. This section focuses on specific factors that need to be incorporated into any decision regarding sourcing options for a particular sourcing objective. Let's say that the company has already decided to purchase, or source, products or components from outside the organization. The next step is to evaluate various factors before deciding on a particular supplier in a particular country for a particular sourcing program or order. At any given time, the sourcer might have several different products and programs to be sourced. Before issuing a sourcing contract with any suppliers, each program must be evaluated for different factors surrounding (a) overall cost, (b) quality, (c) lead time, (d) social and environmental compliance issues, (e) place, and (f) consistency. The goal of evaluating all of these factors is to meet the triple bottom lines of sustainable global souricng—achieving economic, social, and environmental goals. This chapter offers a brief overview of each factor, and more detailed and through discussion of each factor is available in Chapters 6 through 10.

Cost

Labor cost used to be the main factor in sourcing decisions. However, this is no longer true. Although it is important, labor cost is only one aspect for the sourcer to consider, as there are several other factors affecting the overall cost of acquiring certain products. For example, even if the labor cost in Central American countries is relatively higher than in other parts of the world, such as Bangladesh or Pakistan, countries in the Central American region remain viable sourcing destinations for a few key reasons. First, these countries have a free trade agreement with the United States (Central America Free Trade Agreement [CAFTA]), so import duties are exempt if they follow certain procedures. In the case of jeans, or blue denim pants made of cotton, 16.6 percent of the product value is required as duty when the sourcer imports them from most countries in the world (U.S. International Trade Commission [USITC], 2011). However, under CAFTA, if the sourcer imports them from member countries the 16.6 percent import duty is exempted (see Figure 4.9). This could be a significant saving for the sourcer, and a good reason for sourcing contracts for jeans with countries in Central America.

Second, sourcing these jeans from countries in Central America also helps the sourcer save transportation cost, compared with sourcing them from Bangladesh or Pakistan. This factor compensates for the higher labor costs that Central American countries might have. Thus, it is critical to evaluate production cost beyond labor cost, as there are many other costs to include in calculating the final product acquisition cost.

Quality

The quality of fabrics, trims, and manufacturing skills is an important way to differentiate the company from competitors (see Figure 4.10). This differentiation will then contribute to the company's long-term competitive advantage. One thing to keep in mind is that not all sourcers need the highest-quality fabrics, trims, or manufacturing skills. Each company has unique target consumer groups that buy at a certain price point. Mass-market discount retailers want products

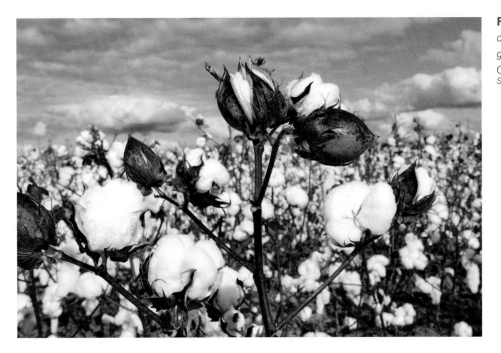

FIGURE 4.9 *In the case of cotton jeans, 16.6 percent of the product value is required by the U.S. government as import duty when imported from CAFTA member countries.*
Source: © sframe/Fotolia.

FIGURE 4.10 *Providing quality fabrics, trims, and manufacturing skills is an important way to differentiate the company from competitors.*
Source: amst/Shutterstock.

at low price with decent quality, while high-end department stores would need to have products at high price with unique fabrics and trims. Depending on the target consumers' wants and needs, the sourcer must consider different levels of quality. Some fabric suppliers and manufacturing plants are set up to satisfy high-end consumers, while others are established to meet mass-market consumers' demands. Thus, finding the right suppliers that will provide the right quality, not necessarily the highest quality, is an important mission for the sourcer.

Lead time

Even if the cost and quality needs are met, lead time and compliance issues are other critical factors when evaluating suppliers. Lead time is the total amount of time required to receive goods from the suppliers from the moment contracts are issued. Lead time includes raw material–production and delivery time, apparel-manufacturing time, shipping period from the suppliers' countries to the sourcer's location, and any other time necessary to take care of import–export procedures. Many people in the industry say clothing is now a perishable item, similar to food. Consumers' tastes change so fast that if products fail to be delivered in the market at the right time, many apparel products become obsolete and almost useless. Thus, when selecting suppliers, the sourcer must consider how quickly suppliers can finish production and deliver the goods to the marketplace. If the products are highly fashionable with a short selling season, lead time becomes even more important than overall cost.

Social and environmental compliance issues

Human rights used to be the main compliance issue that the sourcer had to consider when selecting suppliers in foreign countries. In particular, child labor has been an ongoing topic in the global apparel-manufacturing industry. Nike has been accused of using child labor in four countries since the late 1990s, and today there are multiple websites and communities that communicate child labor practices performed by major textile and apparel companies around the world (Boggan, 2001). Since then, most sourcers have become aware that they cannot make contracts with suppliers that practice unfair labor activities, including prison labor, forced labor, and late or no compensation. Most major retailers now ask their suppliers to submit their compliance certificates after the suppliers' factories are properly inspected by the retailer's own agents or third-party organizations. Thus, the sourcer must find suppliers that comply with fair labor practices and are certified by third-party organizations.

In addition to labor practices, recently, with an increasing demand for sustainable business practices and sustainable products, retailers are now asking for more than just proof of the suppliers' fair labor and environmentally responsible business practices (see Figure 4.11). Walmart announced in 2009 that it would require all suppliers to declare their Sustainable Product Index to communicate suppliers' efforts to be sustainable in both social and environmental arenas (Walmart, 2011). According to Walmart, these efforts must be transparent and easily communicated to consumers. Trends for sustainability and transparency are expected to continue, meaning that sourcers now have to identify suppliers who can meet all of these requirements and demands.

The place

The sourcers must consider place factors when selecting the right suppliers as well. The place factor includes not only physical infrastructure of the suppliers' facilities, but also the overall business climate of the country in which the suppliers operate. Physical infrastructure of the

FIGURE 4.11 *Retailers are now asking for more than just proof of the suppliers' environmentally responsible business practices.*
Source: © hroephoto/Fotolia.

suppliers' facilities ranges from telecommunication systems and stability of electricity and water supply to access to machinery maintenance and parts in the event of machinery malfunctioning. Not all factories have such well-established infrastructure, particularly in low-wage developing countries.

In addition, some countries have a high level of bureaucracy to conduct businesses, especially for foreign businesses. Lack of government support for import and export also could be a problem for the sourcer, particularly if raw materials must be transported from other countries before they are assembled in the supplier's country. The sourcer cannot afford a month to make raw materials and legally enter them into the supplier's country and another month just to export the finished goods legally out of the supplier's country. Both bureaucratic procedures and lack of government infrastructure would delay exporting, transportation modes, and payment. The sourcer must consider all of these aspects before making sourcing contracts with suppliers.

Consistency

All of the factors discussed previously are important when making decisions for each sourcing objective. However, there is no more important factor than the consistency of the supplier's optimal cost, quality, lead time, compliances, and infrastructure. The sourcer might be swayed initially by a supplier's low cost or fast lead time. However, a sourcing contract between the sourcer and the supplier is a future promise of product delivery, and therefore the sourcer must be convinced that the supplier will be able to deliver products on the promised date. Thus, checking the supplier's past records and reputation with regard to consistency in its price, quality, lead time, labor and environmental practices, and overall infrastructure is vital before making any sourcing contract decisions.

summary

For any companies to make decisions on whether to make products on their own or source them from outside the organization, they must go through complex evaluation processes to assess the outcomes of different sourcing options. Some companies have an objective to minimize cost, maximize profit, strengthen core capabilities, and reduce potential risks. Depending on the company's overall objectives, it might choose direct sourcing, CMT contracting, full-package sourcing, and/or joint venture sourcing. Direct sourcing is doing everything on your own with your own fabrics and materials in your own manufacturing facilities. CMT contracting is to source cut, make, and trim processes outside the organization, while full-package sourcing lets external companies perform the entire product development, manufacturing, and logistics functions. Finally, joint venture sourcing refers to forming partnerships with companies in foreign countries. Each option has unique advantages and disadvantages with respect to control, flexibility, and risks. The sourcer must understand all of these aspects before making any decisions on sourcing options (see Figure 4.12).

FIGURE 4.12 *The sourcer and the supplier must clearly understand different options of global sourcing before signing the contracts.*
Source: © FotolEdhar/Fo tolia.

Once a sourcing option is chosen, the sourcer must evaluate several key factors for each supplier before making any sourcing contracts. These factors are the overall cost, quality, lead time, compliance issues, and infrastructure that each supplier could offer. Labor cost is part of the overall cost, and so a holistic approach to overall cost calculation is recommended. Finding the supplier who can deliver the right level of quality products could be more important than the supplier who might offer the highest-quality product, depending on the sourcer's target consumer market. Lead time is critical when the product line has fast-changing demand characteristics. Working with suppliers that comply with all regulations, rules, and requirements in a transparent manner is ever more important than before due to advances in information technology. Finally, the supplier's infrastructure and skill in communicating with the sourcer, as well as the business climate of the supplier's country, are critical for successful sourcing. Thus, the sourcer must consider all of these key aspects before selecting suppliers.

key terms

Cut Make Trim (CMT) contracting refers to sourcing the part or the entire production from another company for only cutting, making, and trimming processes.

Direct sourcing refers to sourcing the part or the entire production from a company's own manufacturing facilities located in foreign countries.

Full-package sourcing usually refers to sourcing the entire products from the suppliers, often including design, fabrics, raw materials, sewing, and quality inspection.

Joint venture sourcing refers to sourcing products from companies with which the sourcer has a business partnership agreement.

Opportunity cost is the value of something that must be given up to acquire or achieve something else.

Production cost refers to the cost of making or manufacturing products, including raw materials, cutting, making, trimming, and finishing.

Service cost refers to non-production-related expenses associated with transportation, legal counsel, travel, telecommunication, human resource management, accounting services, information technology, quality testing/inspection services, and many other needs.

learning activities

1. Conduct market research in global sourcing. Go to major retail stores and identify an apparel product category, such as women's athletic wear. Then check countries of origin for the products available in that category. Report:
 a. The percentage of the products that have been globally sourced
 b. The names of the countries where the products were produced
 c. The estimated percentage each country controls for that product category
 d. Conclusions regarding the extent of global sourcing in this product category

2. Conduct business research in global sourcing. Use online research tools and report examples of the following sourcing options currently performed by major retailers:
 a. Direct sourcing
 b. CMT contracting
 c. Full-package sourcing
 d. Joint venture sourcing

3. Why did the retailers discussed in question 2 use such different sourcing options?

4. Research various international shipping companies such as Maersk Line, APL, and Hanjin shipping. Then find out the transit time between the following shipping schedules:
 a. Shanghai, China, to Long Beach or Los Angeles, California
 b. Puerto Quetzal, Guatemala, to Long Beach or Los Angeles, California
 c. Ho Chi Minh City, Vietnam, to Newark, New Jersey
 d. Kolkata, India, to Charleston, South Carolina

5. How did the different transit times reported in question 4 affect the overall lead time for the sourcer?

6. Using the online version of *The World Factbook,* published by the U.S. Central Intelligence Agency, discuss various infrastructure and business climates in India, Turkey, Malaysia, and El Salvador.

references

American Apparel Manufacturers Association. (1997). *Dynamics of sourcing.* Author: Arlington, VA.

Boggan, S. (2001, October 20). *Nike admits to mistakes over child labor.* Retrieved September 15, 2011, from *The Independent:* http://www1.american.edu/ted/nike.htm

Consumer Product Safety Commission. (2011). *Section 101. Children's products containing lead: Lead paint rule.* Retrieved September 11, 2011, from Consumer Product Safety Improvement Act: http://www.cpsc.gov/about/cpsia/sect101.html

Hill, G., & Hill, K. (2005). *Joint venture.* Retrieved September 11, 2011, from *The Free Dictionary*: http://legal-dictionary.thefreedictionary.com/Joint+Venture

Investopedia. (2011). *Opportunity cost.* Retrieved September 11, 2011, from http://www.investopedia.com/terms/o/opportunitycost.asp#axzz1YayT5DVz

Seshadri, S. (2005). *Sourcing strategy: Principles, policy, and designs.* New York, NY: Springer.

U.S. International Trade Commission. (2011). *HTS online reference tool.* Retrieved September 11, 2011, from http://hts.usitc.gov

Walmart. (2011). *Sustainability index.* Retrieved June 3, 2011, from http://walmartstores.com/Sustainability/9292.aspx

GLOBAL SOURCING STEP 1: NEW PRODUCT DEVELOPMENT

LEARNING OBJECTIVES

Once a business decides to expand its supply chain through global sourcing, the company's employees in various positions will then be engaged in specific tasks toward this goal. Some tasks need to be completed in sequential order, while others could happen simultaneously with other business processes. An overview of the processes involved in global sourcing is presented in this chapter; the next six chapters delve into specifics of each step. Upon completion of this chapter, students will be able to:

- Articulate the seven core steps of global sourcing.
- Understand the role of sourcing personnel in demand and supply management.
- Comprehend the role of sourcing personnel during the product development line reviews.
- Understand how textile and apparel products are classified by the U.S. International Trade Commission.
- Appreciate why product classification knowledge is important during the new product development stage.

5

Seven core steps of global sourcing

Sourcing personnel have a variety of responsibilities throughout the global supply chain. As discussed in Chapter 1, the objective of sourcing is centered on acquisition and delivery of parts or finished products and, therefore, sourcing personnel are mainly responsible for business activities related to finding and attaining the parts or products, and delivering such products to the right places at the right times. In addition to these core sourcing activities, sourcing personnel, as members of the supply chain management team, are closely involved in demand and supply management, business process coordination, and business model development. Overall, seven core steps of global sourcing are found in today's businesses. They are (1) new product development; (2) macro environmental analysis for supplier selection; (3) micro-level analysis for supplier selection; (4) purchase order and methods of payment; (5) preproduction, production, and quality assurance; (6) logistics and importing processes; and (7) sourcing performance evaluation, including final costing. Figure 5.1 shows the seven core steps of global sourcing. These steps create a cycle of sourcing project, in which the results of the previous sourcing project are used to create a new sourcing project. This chapter discusses the very first step of global sourcing—new product development.

Step 1: New product development
Global sourcing and new product development

Sourcing personnel get involved in the very initial stage of new product development as part of the company's demand and supply management efforts. Often, sourcers and product developers

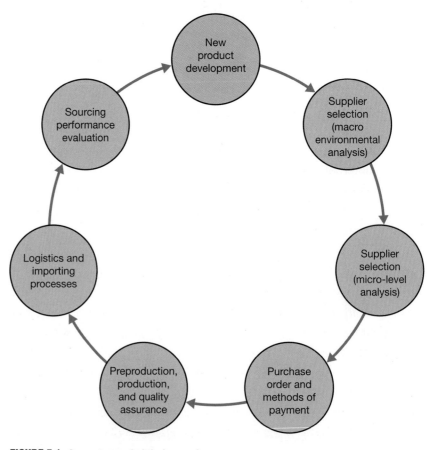

FIGURE 5.1 Core steps of global sourcing

together or separately attend various trade shows, such as the Magic Show in New York or in Las Vegas in the United States. Sourcers learn about new materials, new vendors, and new technologies through these trade shows and deliver such new knowledge to their company. During the product development stage, multiple responsible parties, such as sales, merchandisers, designers, retail analysts, and financial analysts, get together and review the past retail sales history, current sales performance, future trends, and so on to anticipate future demand. This future demand anticipation helps product developers formulate the best set of new product lines and assortment plans for maximum sales and profits in the next season. The main responsibility of sourcing personnel during this stage is to share cost and quality performance for the goods sold in the past seasons. The history of garment cost performance helps product developers identify the products with low cost and high sales, as well as the products with high cost and low sales. This information will directly help product developers' decisions on selecting new product lines for the next season.

Let's assume that Amazing Jeans is planning to develop a new product line for the 2015 holiday season. Typically, the first meeting for the new product development project would happen approximately 12 to 18 months before the actual selling period. This interdepartmental meeting for new product development would review what sold well and what did not, based on the past years' holiday season sales. To optimize the 2014 sales, the interdepartmental team may consider having new size assortments, new fabric contents, and/or new fabrication. For example, let's say the current size ratio of Amazing Jeans's signature knit top is 1-2-2-1 for the sizes of small, medium, large, and extra-large (or, S-M-L-XL = 1-2-2-1). The sales history of the past two seasons shows that larger-sized garments of this particular style had over 90 percent sell-through while smaller-sized garments of this style had less than 75 percent sell-through. This resulted in unnecessary deep discounts for smaller-sized garments and, therefore, fewer profits. Therefore, product developers and sales teams suggest a new size assortment of S-M-L-XL = 1-1-2-2. This assortment suggests fewer units of the size S garment while more units of the size XL be produced. Although this change makes sense for the optimal potential sales, sourcing personnel must consider added cost to produce more units of size XL at the expense of fewer units of size S. Larger-sized garments require more raw materials and labor to complete, resulting in higher costs. Experienced sourcing personnel would be able to anticipate the changes in costs based on changes in size assortments and communicate the consequences with other teams before making any final decisions on size assortments.

Similarly, let's assume that the interdepartmental team considers changing fiber content of Amazing Jeans's signature knit top from a blend of cotton and polyester to 100 percent cotton to increase the moisture absorbency of the finished garments. During this discussion, sourcing personnel must evaluate the costs of cotton and polyester fibers and yarns, and make everyone aware that the change in fiber content would result in changes in total cost of production. In today's market environment, an increase in cotton usage results in higher production cost than fabrics made of a blend of polyester and cotton. The average cotton price quadrupled from 2002 to 2011 and the experts believe this trend will not change in the next few years (National Cotton Council of America, 2011). This type of information is critical for the financial bottom lines of business performance, and sourcing personnel's involvement in this stage is very important for overall financial success (see Figure 5.2).

Another example of sourcing personnel's involvement in product development can be found in the fabric development stage. Let's assume that a designer of Amazing Jeans is interested in using an exotic, high-quality fabric that he or she found at a recent fabric show. However, this

FIGURE 5.2 *Sourcing personnel must evaluate the variable costs of fabrics and their relation to total cost of production.*
Source: James Tye © Dorling Kindersley.

fabric is too expensive for its target market and the company must find alternatives. Sourcing personnel would get involved in this stage to see if any of the existing suppliers could deliver similar or alternative fabric options for the designer. Or, sourcing personnel may find viable alternatives for new fabrics during their travels to factories and mills in foreign countries. When traveling to foreign factories, sourcing personnel are the eyes and ears of product developers. At the same time, they are also an important messenger for foreign factories and suppliers to the product developers in the sourcer's home country.

These are just a few examples why sourcing personnel's input is important and how sourcing personnel could contribute to the initial demand and supply management stage. The earlier this communication is established among sales teams, product developers, merchandisers, sourcing personnel, and other key positions, the more efficient and effective the whole supply chain management would be. As seen in these examples, close communication across the company is very important.

Global sourcing and line reviews

Once new product development plans are determined, including product lines and assortment plans, product developers will make sample garments with proposed fabrics and trims. This process ensures that new product lines that are proposed in a two-dimensional sketch format are attractive and functional in a three-dimensional garment format (see Figure 5.3). Most key stakeholders of the company will get together, review the proposed samples of each product line, and discuss whether these product lines will be successful as planned. Some industry members call this process "line review." During the line review, typically product developers and merchandisers will present these samples to key stakeholders of the company. During this

FIGURE 5.3 *New product lines are proposed first as two-dimensional sketches.*
Source: Slaven/Shutterstock.

evaluation process, sales personnel are focused on whether these products will generate more sales than last year. Sales team members will also evaluate the proposed new products and proposed retail prices.

On the other hand, during the line review sourcing personnel are evaluating whether proposed products are functional, producible, and affordable. The functionality criterion ensures whether a proposed garment would actually serve as a wearable garment. Sourcing personnel check if a proposed garment has a sufficient number of buttons, zippers of an adequate length, or proper opening–closure mechanisms to be wearable. Sourcing personnel also consider if a proposed garment is actually producible in manufacturing facilities. Details of trims are typically important. For example, heat-transfer (or hot fix) rhinestone details require certain glues and heat pressures to be attached on fabrics with smooth surfaces (see Figure 5.4). If a highly brushed or pile fabric is proposed for a garment, then heat-transfer rhinestones will not be applicable. The strength of glue would not be strong enough to keep heat-transfer rhinestones attached on the fabric during the normal use. In that case, rhinestone details with rivets may need to be considered.

Finally, another concern that sourcing personnel may have during the line review stage is whether or not a proposed product can be produced within the budget. Typically, sourcing personnel have cost information from the previous years. Any new trims, manufacturing techniques, fabrications, and size or color assortments would affect the final cost. Therefore, sourcing personnel must let everyone know if a potential increase or decrease in costs is expected. Ideally, the company wants to produce products that could create higher sales at lower price with higher quality than the past. Updated fabrications and trims might increase the chance of future sales. However, if the cost is too high, then new product lines must be revisited to make the best decisions for the overall financial needs of the company.

FIGURE 5.4 *There are many different ways to apply rhinestones on textile and apparel products.*
Source: Tom McNemar/Shutterstock; Bocman 1973/Shutterstock.

Global sourcing and product classifications

While product developers finalize style details, sourcing personnel may need to check the proposed products against product classifications recognized by the sourcer's country. In the United States, the U.S. International Trade Commission (USITC) publishes the *Harmonized Tariff Schedule of the United States (HTSUS)* with product classification numbers, article descriptions, tariff rates, and special tariff programs (USITC, 2012a). The actual classification of goods and interpretation of *HTSUS* are performed by the U.S. Customs and Border Protection

FIGURE 5.5 *Any business that brings goods to the United States must pay duties on foreign goods based on product classification and the interpretation of the U.S. Customs and Border Protection.* Source: © Pierre-Yves Babelon/Fotolia.

(USCBP). That is, when any businesses or entities bring goods from foreign countries to the United States, the importers must pay for duties on foreign goods based on the product classification and interpretation of USCBP (see Figure 5.5). These import records are also used to track the movement of products in each classification category.

An understanding of the right classification of the proposed products is very important for sourcing personnel for a few reasons. First, by understanding the rules of product classification and interpretation of such classifications, sourcing personnel should be able to provide the best options for new product development. Product details and fiber contents directly affect how the proposed products would be interpreted and classified by USCBP. Second, this, in turn, would help sourcing personnel correctly estimate the duty amounts when finished goods are imported. Therefore, accurate costing is possible. Third, a thorough understanding of the harmonized tariff codes (HTCs) also helps sourcing personnel take advantage of various trade agreements with special duty rates. Chapter 6 discusses specific free trade and trade preference programs. The next section focuses on how the knowledge of product classification directly affects new product development.

HARMONIZED TARIFF SCHEDULE OF THE UNITED STATES

The ***Harmonized Tariff Schedule of the United States (HTSUS)*** is organized by sections and chapters. Currently, there are 22 sections and 99 chapters. Sections 11 and 12 address textile-based goods. In particular, Section 11, Chapters 61 and 62 deal with apparel products. Chapter 61 includes knitted apparel, while Chapter 62 contains nonknitted or woven apparel. Table 5.1 shows Sections 11 and 12 of *HTSUS* published in 2012.

Each product category is represented by a 10-digit number for statistical purposes. The heading of each product category consists of the first 4-digit numbers. There are two subheadings each with a 2-digit number, followed by an additional 2-digit number for the statistical suffix. Let's assume that sourcing personnel have just reviewed the new product lines of boy's denim pants proposed by the merchandising and product development teams. While the details of the newly

TABLE 5.1

By chapter, *Harmonized Tariff Schedule of the United States*

Section XI: Textile and Textile Articles

Chapter	Section Notes
Chapter 50	Silk
Chapter 51	Wool, fine or coarse animal hair; horsehair yarn and woven fabric
Chapter 52	Cotton
Chapter 53	Other vegetable textile fibers; paper yarn and woven fabric of paper yarn
Chapter 54	Man-made filaments
Chapter 55	Man-made staple fibers
Chapter 56	Wadding, felt and nonwovens; special yarns, wine, cordage, ropes and cables and articles thereof
Chapter 57	Carpets and other textile floor coverings
Chapter 58	Special woven fabrics; tufted textile fabrics; lace, tapestries; trimmings' embroidery
Chapter 59	Impregnated, coated, covered, or laminated textile fabrics; textile articles of a kind suitable for industrial use
Chapter 60	Knitted or crocheted fabrics
Chapter 61	Articles of apparel and clothing accessories, knitted or crocheted
Chapter 62	Articles of apparel and clothing accessories, not knitted or crocheted
Chapter 63	Other made up textile articles; sets; worn clothing and worn textile articles; rags

Section XII: Footwear, Headgear, Umbrellas, Sun Umbrellas, Walking Sticks, Seatsticks, Whips, Riding-Crops and Parts Thereof; Prepared Feathers and Articles Made Therewith; Artificial Flowers; Articles of Human Hair

Chapter	Section Notes
Chapter 64	Footwear, gaiters, and the like; parts of such articles
Chapter 65	Headgear and parts thereof
Chapter 66	Umbrellas, sun umbrellas, walking sticks, seatsticks, whips, riding-crops, and parts thereof
Chapter 67	Prepared feathers and down and articles made of feathers or of down; artificial flowers; articles of human hair

Source: U.S. International Trade Commission (2012a).

proposed products are being discussed, sourcing personnel may want to check product descriptions against *HTSUS* and find out appropriate rates of duties.

To do so, first, because denim pants are woven apparel, Chapter 62 is a proper place for Amazing Jeans's sourcing personnel to look. Within the chapter, *HTSUS* is organized based on product descriptions and the gender of the products' intended wearers, represented by the first 4-digit heading numbers. For example, men's overcoats belong to heading 6201, while women's overcoats are classified in 6202. In addition, babies' garments are separated from boys' or girls', and the proper heading for babies is 6209. *HTSUS* defines "babies' garments and clothing accessories" as "articles for young children of a body height not exceeding 86 centimeters" (USITC, 2012b, p. 61.2). The height of 86 centimeters is approximately 2.82 feet or 33.86 inches. Typically, babies' apparel products are available in sizes 0 to 24 months in the United States. Any children's wear larger than size 2T (2-year-old toddler) is classified as "Girls" or "Boys" in *HTSUS*. In the case of clothing in size 2T and 24 months, the distinction between "boys" and "babies" products could be an important factor for children's wear sourcing personnel, since the garment in size 2T is classified as "boys" while that in size 24 months is classified as "babies." This distinction could directly impact duty rates, as explained next.

TABLE 5.2

Headings and article descriptions of chapter 62 of *HTSUS* (2012)

Heading	Article Description
6201	Men's or boys' overcoats, carcoats, capes, cloaks, anoraks (including ski-jackets), windbreakers and similar articles (including padded, sleeveless jackets), other than those of heading 6203
6202	Women's or girls' overcoats, carcoats, capes, cloaks, anoraks (including ski-jackets), windbreakers, and similar articles (including padded, sleeveless jackets), other than those of heading 6204
6203	Men's or boys' suits, ensembles, suit-type jackets, blazers, trousers, bib and brace overalls, breeches, and shorts (other than swimwear)
6204	Women's or girls' suits, ensembles, suit-type jackets, blazers, dresses, skirts, divided skirts, trousers, bib and brace overalls, breeches, and shorts (other than swimwear)
6205	Men's or boys' shirts
6206	Women's or girls' blouses, shirts, and shirt-blouses
6207	Men's or boys' singlets and other undershirts, underpants, briefs, nightshirts, pajamas, bathrobes, dressing gowns, and similar articles
6208	Women's or girls' singlets and other undershirts, slips, petticoats, briefs, panties, nightdresses, pajamas, negligees, bathrobes, dressing gowns, and similar articles
6209	Babies' garments and clothing accessories
6210	Garments, made up of fabrics of heading 5602, 5603, 5903, 5906, or 5907
6211	Track suits, ski-suits, and swimwear; other garments
6212	Brassieres, girdles, corsets, braces, suspenders, garters, and similar articles and parts thereof, whether or not knitted or crocheted
6213	Handkerchiefs
6214	Shawls, scarves, mufflers, mantillas, veils, and the like
6215	Ties, bow ties, and cravats
6216	Gloves, mittens, and mitts
6217	Other made up clothing accessories; parts of garments or of clothing accessories, other than those of heading 6212

Source: U.S. International Trade Commission (2012b).

Table 5.2 shows the current product descriptions classified by the heading numbers. By surveying the heading numbers and article descriptions, sourcing personnel of different product categories should be able to find out the correct heading for their products. In the case of Amazing Jeans's boys' denim pants, 6203 is the correct heading recognized by *HTSUS*.

Once the main heading number is identified, sourcing personnel then need to find the appropriate subheadings, classified by specific garment style and fiber contents. In the case of Amazing Jeans's denim pants, the denim fabrics could be made of 100 percent cotton or with a blend of cotton and synthetic fibers, such as polyester or nylon. With a recent price hike of cotton fibers, many cotton fibers have been substituted by synthetic fibers, such as polyester. *HTSUS* has separate subheadings of 42 for cotton trousers and 43 for trousers made of synthetic fibers. That is, if the majority, or over 50 percent, of the fabrics are made of cotton, the trousers belong to a subheading of 42 and the majority of the fabrics are made of synthetic fibers, the trousers are classified to be a subheading of 43. Once the first set of the 2-digit subheading is decided, sourcing personnel could read the rest of the article descriptions to find the complete 10-digit heading and subheading numbers and the rates of duty. In the case of Amazing Jeans's boys' denim pants, the complete 10-digit *HTSUS* number for cotton trousers is 6203.42.40.36 and that of trousers made with synthetic fibers is 6203.43.40.20.

The 3-digit numbers in parentheses after the article description—347 for boys' cotton blue denim trousers and 647 for boys' synthetic fibers trousers—represents the quota category to which each product type belongs. In the past, the United States had limited the quantity of textile and apparel products that can be imported from other countries. Import quotas were used to benefit textile and apparel producers in the United States by limiting the total amount of foreign goods entering into the U.S. market annually. The quantity of foreign goods was tracked by the 3-digit quota category number. Therefore, knowing the 3-digit quota category number for each product classification was very important in the past. As of January 1, 2005, however, textile and apparel quotas have been eliminated among the member countries of **World Trade Organization (WTO).** That is, most of the textile and apparel products are now imported into the United States without any quantity restrictions as long as the suppliers' countries are WTO members. However, these 3-digit quota category numbers are still used to track product movements among WTO members as well as to track textile and apparel products imported from non-WTO member countries. Figure 5.6 shows the appropriate page of *HTSUS* (2012a) for Amazing Jeans's boys' denim pants made of both cotton and synthetic fibers.

RATES OF DUTY IN NEW PRODUCT DEVELOPMENT

By identifying the correct heading and subheading numbers of the proposed products, sourcing personnel could estimate proper rates of duty. When doing so, sourcing personnel may want to consider two critical aspects of the proposed products to reduce the overall cost of sourcing. First, sourcing personnel must compare different duty rates assigned for different fiber contents of the proposed products. In the case of Amazing Jeans's boys' denim pants, if they are made of cotton (6203.42.40.36), they are subject to a tariff of 16.6 percent of the value of the imported goods in either dozens (number of pieces) or kilograms (weight), whichever is higher, from countries classified as "general" (see Figure 5.6). If they are made with a majority of synthetic fibers (6203.43.40.20), they require 27.9 percent of the value of imported goods as duty. The difference of 11.3 percent in the duty could make a huge difference in the overall sourcing cost. Sourcing personnel must communicate this potential cost difference to the merchandising, sales, and product development teams so that the interdepartmental team, as a whole, can make the most optimal decisions whether the proposed products should be made of fabrics with a majority of cotton or synthetic fibers.

Second, sourcing personnel must have full knowledge of different duty rates from different countries, depending on trade preference programs between the sourcer's and the supplier's countries (see Figure 5.6). In the case of Amazing Jeans's boys' cotton denim pants (6203.42.40.36), if those goods are imported from countries classified as "general," the duty rate is 16.6 percent. On the other hand, if they are from countries in the "special" column with free trade agreements or trade preference programs with the United States, the goods would have duty-free access to the U.S. market. In this example, boys' cotton denim pants from Bahrain (BH), Canada (CA), Chile (CL), Israel (IL), Jordan (JO), Morocco (MA), Mexico (MX), Oman (OM), Dominican Republic and other countries in Central America (P), Peru (PE), and Singapore (SG) are subject to zero duty. Boy's cotton denim trousers from Australia (AU) are subject to a reduced duty rate of 8 percent. These zero or reduced duty rates are imposed to encourage importing this type of goods from these specific countries. Column 2 of the rates of duty indicates that boys' cotton denim trousers from certain other countries are subject to 90 percent of the value of the imported goods. This high duty rate is imposed to discourage trades between the countries and the United States. Currently, there are two countries listed in column 2—Cuba and North Korea.

Heading/ Subheading	Stat. Suf- fix	Article Description	Unit of Quantity	Rates of Duty		
				1		2
				General	Special	
6203 (con.)		Men's or boys' suits, ensembles, suit-type jackets, blazers, trousers, bib and brace overalls, breeches, and shorts (other than swimwear) (con.):				
		Trousers, bib and brace overalls, breeches, and shorts (con.):				
6203.42		Of cotton:				
6203.42.10	00	Containing 15 percent or more by weight of down and waterfowl plumage and of which down comprises 35 percent or more by weight; containing 10 percent or more by weight of down	doz. kg	Free		60%
6203.42.20		Other: Bib and brace overalls		10.3%	Free (BH,CA, CL,IL,JO,MA,MX, OM,P,PE,SG) 8% (AU)	90%
	05	Insulated, for cold weather protection (359)	doz. kg			
	10	Other: Men's (359)	doz. kg			
	25	Boys', sizes 2-7: Imported as parts of playsuits (237)	doz. kg			
	50	Other (237)	doz. kg			
	90	Other (359)	doz. kg			
6203.42.40		Other		16.6%	Free (BH,CA, CL,IL,JO,MA,MX, OM,P,PE,SG) 8% (AU)	90%
	03	Containing compact yarns described in statistical reporting numbers 5205.42.0021, 5205.43.0021 5205.44.0021, 5205.46.0021, or 5205.47.0021 (347)	doz. kg			
	06	Other: Men's trousers and breeches: Corduroy (347)	doz. kg			
	11	Blue denim (347)	doz. kg			
	16	Other (347)	doz. kg			
	21	Boys' trousers and breeches: Corduroy: Imported as parts of playsuits (237)	doz. kg			
	26	Other (347)	doz. kg			

FIGURE 5.6 Possible headings and subheadings for denim trousers classified by the Harmonized Tariff Schedule of the United States (2012)
source: United States International Trade Commission. (2012b).

Heading/ Subheading	Stat. Suf- fix	Article Description	Unit of Quantity	Rates of Duty		
				1		2
				General	Special	
6203 (con.)		Men's or boys' suits, ensembles, suit-type jackets, blazers, trousers, bib and brace overalls, breeches, and shorts (other than swimwear) (con.):				
		Trousers, bib and brace overalls, breeches, and shorts (con.):				
6203.42 (con.)		Of cotton (con.):				
6203.42.40 (con.)		Other (con.):				
		Other (con.):				
		Boys' trousers and breeches (con.):				
		Blue denim:				
	31	Imported as parts of playsuits (237)	doz. kg			
	36	Other (347)	doz. kg			
		Other:				
	41	Imported as parts of playsuits (237)	doz. kg			
	46	Other (347)	doz. kg			
	51	Men's Shorts (347)	doz. kg			
		Boys Shorts':				
	56	Imported as parts of playsuits (237)	doz. kg			
	61	Other (347)	doz. kg			

FIGURE 5.6 (*Continued*)

90 chapter 5

Harmonized Tariff Schedule of the United States (2012)
Annotated for Statistical Reporting Purposes

Heading/ Subheading	Stat. Suf- fix	Article Description	Unit of Quantity	Rates of Duty		
				1		2
				General	Special	
6203 (con.)		Men's or boys' suits, ensembles, suit-type jackets, blazers, trousers, bib and brace overalls, breeches, and shorts (other than swimwear) (con.):				
		Trousers, bib and brace overalls, breeches, and shorts (con.):				
6203.43		Of synthetic fibers:				
6203.43.10	00	Containing 15 percent or more by weight of down and waterfowl plumage and of which down comprises 35 percent or more by weight; containing 10 percent or more by weight of down .	doz. kg	Free		60%
		Other:				
		Bib and brace overalls:				
6203.43.15	00	Water resistant (659)	doz. kg	7.1%	Free (BH,CA, CL,IL,JO,MA,MX, OM,P,PE,SG) 6.3% (AU)	65%
6203.43.20		Other	14.9%	Free (BH,CA, CL,IL,JO,MA,MX, OM,P,PE,SG) 8% (AU)	76%
	05	Insulated, for cold weather protection (659)	doz. kg			
		Other:				
	10	Men's (659)	doz. kg			
		Boys', sizes 2-7:				
	25	Imported as parts of playsuits (237)	doz. kg			
	50	Other (237)	doz. kg			
	90	Other (659)	doz. kg			

FIGURE 5.6 (*Continued*)

global sourcing step 1: new product development **91**

Heading/ Subheading	Stat. Suf- fix	Article Description	Unit of Quantity	Rates of Duty		
				1		2
				General	Special	
6203 (con.)		Men's or boys' suits, ensembles, suit-type jackets, blazers, trousers, bib and brace overalls, breeches, and shorts (other than swimwear) (con.):				
		Trousers, bib and brace overalls, breeches, and shorts (con.):				
6203.43 (con.)		Of synthetic fibers (con.):				
		Other:				
6203.43.25	00	Certified hand-loomed and folklore products (647) .	doz. kg	12.2%	Free (BH,CA, CL,IL,JO,MA,MX, OM,P,PE,SG) 8% (AU)	76%
		Other:				
6203.43.30		Containing 36 percent or more by weight of wool or fine animal hair		49.6¢/kg + 19.7%	Free (BH,CA, CL,IL,JO,MA,MX, OM,P,PE,SG) 8% (AU)	52.9¢/kg + 58.5%
		Trousers and breeches:				
	10	Men's (447)	doz. kg			
	20	Boys' (447)	doz. kg			
	30	Shorts (447)	doz. kg			
		Other:				
6203.43.35		Water resistant trousers or breeches (647)		7.1%	Free (BH,CA, CL,IL,JO,MA,MX, OM,P,PE,SG) 6.3% (AU)	65%
	10	Ski/snowboard pants (647) . .	doz. kg			
	90	Other (647)	doz. kg			
6203.43.40		Other .		27.9%	Free (BH,CA, CL,IL,JO,MA,MX, OM,P,PE,SG) 8% (AU)	90%
		Trousers and breeches:				
	10	Men's (647) 	doz. kg			
		Boys':				
	15	Imported as parts of playsuits (237)	doz. kg			
	20	Other (647) 	doz. kg			
		Shorts:				
	30	Men's (647) 	doz. kg			
		Boys':				
	35	Imported as parts of playsuits (237)	doz. kg			
	40	Other (647) 	doz. kg			

FIGURE 5.6 *(Continued)*

92 chapter 5

FIGURE 5.7 *Understanding classifications and trade terms across the globe can help minimize cost.*
Source: TRINACRIA PHOTO/Shutterstock.

In the case of boys' denim pants in size 2T (6203.42.40.36) and babies' denim pants in size 24 months (6209.20.30.00), assuming both products are made of cotton, boys' pants are subject to 16.6 percent rate of duty while babies trousers are subject to 14.9 percent (see Figure 5.6). Despite the denim pants in size 2T and 24 months that may have similar garment size and constructions, the duty rates are different, affecting the overall financial sourcing performance.

In any case, by understanding trade relationships between the United States and other countries, sourcing personnel could narrow down the set of potential suppliers for the proposed products (see Figure 5.7). While doing so, sourcing personnel must consider different production capabilities of different countries and let product developers understand potential limitations of garment production. For example, sourcing personnel may want to produce the proposed products in the Dominican Republic to take advantage of free duty. Yet, let's assume that the suppliers in the Dominican Republic do not have the equipment to apply rhinestones with rivets on denim fabrics. Instead, Dominican Republic suppliers have embroidery equipment and the quality of embroideries is highly recommended. Sourcing personnel may want to discuss this with product developers to see if the proposed products could be made with embroidery details, rather than rhinestone applications. The changes in this type of detail could result in significant savings in the overall costs and potentially higher profits. The interdepartment team of new product development could make the final decisions on garment details for optimal sales and optimal costs.

If there are any questions on product classifications, particularly if the proposed product style is new, sourcing personnel may get consultations from a trade lawyer or representatives of USITC (see Figure 5.8). USITC representatives would review the styling of the proposed products and approve it with a proper product classification. This approval document then can be submitted to the U.S. Customs when the finished goods arrive at a U.S. port for duty assessment and statistical tracking. This preapproval from USITC representatives during the product development stage would ensure the sourcer's product development team is proposing properly classified goods and allows the sourcing team to correctly estimate duties.

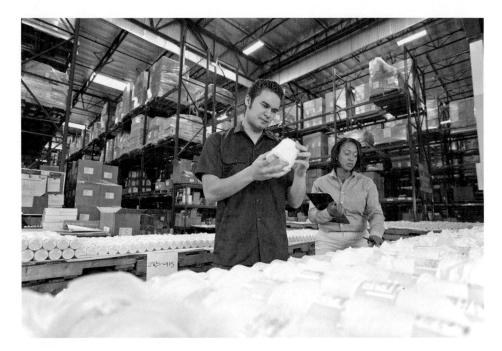

FIGURE 5.8 *If there are any questions about product classifications, sourcing personnel may consult with a trade lawyer.*
Source: Monkey Business Images/Shutterstock.

summary

Any given project in global sourcing involves seven core steps: (1) new product development; (2) macro analysis for supplier selection; (3) micro analysis for supplier selection; (4) purchase order and payment methods negotiation; (5) preproduction, production, and quality assurance; (6) logistics and importing; and (7) sourcing performance evaluation, including final costing. During the new product development stage, sourcing personnel need to share cost and quality performance of the goods sold in the past seasons. This helps the new product development team create successful new product lines and optimal assortment plans that could maximize sales and profits and minimize unsold goods (see Figure 5.9).

During the line review of new product development, sourcing personnel focus on the proposed products whether they are functional, producible, and affordable. At the same time, they identify the correct article description, the 10-digit product classification number, and duty rates for each of the proposed products. This process during the product development stage helps the product development team make the most optimal fibers and design choices. It also helps the sourcing team gain the most accurate duty assessments and optimal supplier selections. Often, sourcing personnel seek preapproval on any products with new styles or details that may affect product classifications to avoid any surprises when the finished goods enter the sourcer's country.

FIGURE 5.9 *Strong product development management results in successful new product lines that maximize profits while minimizing unsold goods.*
Source: © Kzenon/Fotolia.

key terms

Harmonized Tariff Schedule of the United States (HTSUS) is the primary resource for determining tariff classifications for goods imported into the United States.

U.S. Customs and Border Protection (USCBP) is one of the Department of Homeland Security's largest and most complex components. Its primary missions are to keep terrorists and their weapons out of the United States, to secure the border, and to facilitate lawful international trade and travel.

World Trade Organization (WTO) is an international organization whose purpose is to facilitate open international trades for economic development and growth of all participating member countries by reducing trade obstacles and ensuring a level playing field.

learning activities

1. Find any professionals whose primary responsibility is to develop new product lines in the textile and apparel industry. Ask what their job responsibilities are and if any of their job responsibilities are related to global sourcing.

2. Find out the (a) 10-digit heading and subheading numbers, (b) quota category number, and (c) rates of duty from "general" countries for the following apparel products:
 a. Size 4T Girls' Cotton Denim Woven Jacket
 b. Women's Ski Woven Pants Separates Made of Nylon with Water Resistance
 c. Men's Polyester Knitted Bathrobes
 d. Women's Woven Scarves Made of Silk
 e. Men's Woven Suits Made of 70% Polyester and 30% Wool
 f. Size 18 Month Girls' Cotton Dresses

3. Conduct market research for the products listed in question 2. Pick one product item for each product classification and document the suggested retail price (for example, a girl's cotton denim jacket, $40). Assuming the cost of each product that foreign suppliers require to produce is 25 percent of the suggested retail price (for example, $10. 25% of $40), calculate appropriate duties based on the duty rates you found from question 2 (9.7% of $10 = $.970). Repeat these processes for the rest of the items:

Article Description	Retail Price	Supplier Cost	Duty (%)	Duty ($)
Girls' Cotton Denim Jacket	$40	$10	9.7%	$0.970
Women's Ski Nylon Pants				
Men's Cotton Knitted Bathrobes				
Women's Silk Scarf				
Men's Suit (70% Polyester/30% Wool)				
18 Month Girls' Cotton Dress				

references

National Cotton Council of America. (2011). *Monthly prices*. Retrieved December 15, 2011, from http://www.cotton.org/econ/prices/monthly.cfm

U.S. International Trade Commission. (2012a). *By chapter, harmonized tariff schedule of the United States*. Retrieved January 17, 2012, from http://www.usitc.gov/tata/hts/bychapter/index.htm

U.S. International Trade Commission. (2012b). *Chapter 62 articles of apparel and clothing accessories, not knitted or crocheted.* Retrieved January 20, 2012, from Harmonized Tariff Schedule of the United States (2012): http://www.usitc.gov/publications/docs/tata/hts/bychapter/1200c62.pdf

GLOBAL SOURCING STEP 2: MACRO ENVIRONMENTAL ANALYSIS FOR SUPPLIER SELECTION

LEARNING OBJECTIVES

Once types and classifications are decided for new products, sourcing personnel canvas the world to find the best supplier for a given sourcing project. To do so, first, sourcing personnel may evaluate macro environmental factors that different countries and regions may offer as the second step of a global sourcing process. This chapter reviews analyses of a supplier country's political, economic, social, and technological environments (PEST analysis), as well as trade agreements and preference programs. Upon completion of this chapter, students will be able to:

- Understand the importance of PEST analysis when evaluating suppliers' countries for global sourcing.
- Articulate various political, economic, social, and technological factors that may directly and indirectly influence global sourcing.
- Comprehend the type of trade barriers, such as tariffs and quotas, and their effects on the welfare of consumers, domestic suppliers, and governments.
- Explain the current stature of textile and apparel trades that the United States has with other countries.
- Comprehend the uniqueness of trade agreements and preference programs.
- Search using the right sources to gain the most up-to-date information on textile and apparel trades.
- Understand the importance of knowledge of trade agreements in global sourcing.

6

Step 2: Macro environmental analysis for supplier selection

While new products are being developed, sourcing personnel take all the information on new products and start to engage in the selection of the best supplier that could produce and deliver the products for the company. In particular, if sourcing personnel are looking into new countries as sourcing destinations, macro environmental analysis must be performed to see if entering a new country would be feasible for any given sourcing project. This chapter discusses the second stage of the seven core steps of global sourcing—macro environmental analysis in supplier selection (see Figure 6.1).

Macro environmental factors
PEST analysis

When sourcing personnel review supplier options for their new products, they consider several macro environmental situations for each supplier's country, including political, economic, social, and technological (PEST) environments. Business literature calls it a **PEST analysis**. Experienced sourcing personnel already know the overall PEST environments of each of their supplier's countries so a new PEST analysis is not always necessary. However, if sourcing personnel initiate new sourcing projects in new countries, they may have to conduct a thorough PEST analysis of a new country.

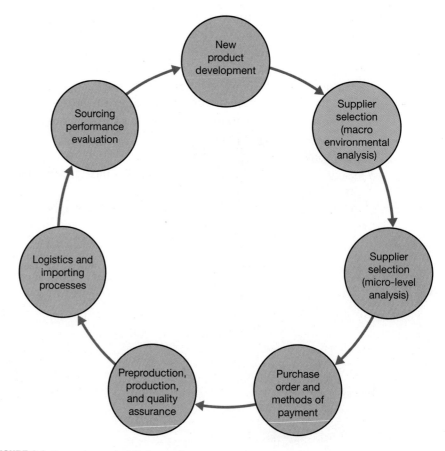

FIGURE 6.1 Core steps of global sourcing

Examples of political environments that could affect global sourcing are tax policies, trade agreements, import–export regulations, or political stability in the supplier's country. Sourcing personnel must consider the types of free trade agreements or trade preference programs that the supplier's country has with the sourcer's country. Even without such trade agreements, if the supplier's country offers favorable conditions for the sourcers, such as less tax and fewer bureaucratic procedures on exports, it would be considered a favorable option for the sourcers. In addition, a stable government structure and strong relationships with the sourcer's country are always a plus for sourcing personnel.

Economic factors of the supplier's country affecting the sourcer may include currency exchange rates and inflation rates. If the supplier country's currency is highly fluctuating and its economy has a severe inflation rate, it would be extremely difficult to estimate the true cost of finished goods that are usually available three to six months after supplier selection is made. That is, during the sourcing project, the value of the goods may change, depending on currency fluctuation rates. This is a very uncertain situation for both suppliers and sourcers, making it difficult to maintain stable business relationships.

Social factors in the supplier's country that the sourcer must consider when selecting suppliers are work ethics, culture, and the quality of the labor force in the textile and apparel industry (see Figure 6.2). For example, if people in the supplier's country are willing to work and learn and are skillful enough to produce the sourcer's products, the overall cost of producing such products would be lower than otherwise. Often, reputation of the sourcer's country among the people in the supplier's country is important to create a favorable cooperative culture. This favorable culture could eventually help increase production efficiency and improve sourcing performance.

Finally, technological factors that the sourcer may need to consider when selecting foreign suppliers are ease of communication; infrastructure related to air, ocean, and ground transportation; the degree of automation in the textile and apparel industry; and so on. In global sourcing, proper and timely communication is a key for success as changes are frequent and numerous.

FIGURE 6.2 *The sourcer must consider work ethics, culture, and the quality of the labor force in the supplier's textile and apparel industry.*
Source: Tim Draper © Rough Guides

In particular, if the proposed products require much communication between the supplier and the sourcer, due to a fast-fashion and complete design nature, the degree of easy and reliable communication is critical for supplier selection. Therefore, whether or not the supplier's country has a stable, reliable communication infrastructure—such as power, telecommunications, and mail or courier services—is very important.

In addition, the access to air, ocean, and ground transportation directly affects overall delivery time. Sourcing personnel must consider how difficult or easy it is for finished goods to be transported to the nearest port once production is completed. Some countries in tropical areas experience annual typhoons or hurricanes in summer; shipping goods out of such countries during that time could be a challenge. In addition to possible natural disasters, the degree of technological advancement in textile and apparel production in the supplier's country could affect overall product quality, production efficiency, and costs. If the potential supplier country does not have advanced supporting industries, such as equipment or machine repair service, it would take much longer to get back on production when such equipment failure occurs. Therefore, sourcing personnel must have a good understanding of each supplier country's technological capabilities.

This type of PEST analysis is not something sourcing personnel must engage in every day. However, when needed, sourcing personnel may look for new suppliers from new countries. If sourcing personnel are not sure about a new country and want to know more about macro environments there, they could attend various trade workshops or conferences (see Figure 6.3). A government agency, such as the Central Intelligence Agency (CIA) in the case of the United States, publishes *The World Factbook* for PEST environments for almost all countries in the world at a macro level (Central Intelligence Agency, 2012). Although there is no definite answer as to which country is the best for textile and apparel sourcing, an overview of each country's PEST environments through this resource would be a good way to start a global sourcing project.

FIGURE 6.3 *Sourcing personnel wanting to know more about macro environments can attend trade workshops or conferences, such as this one in Moscow.*
Source: © Pavel Losevsky/Fotolia

Enforcement of intellectual property rights

In addition to PEST, sourcers must consider if they could share their unique designs and brands and be protected for their intellectual property rights in the suppliers' countries. **Intellectual property rights** are the rights given to persons over the creations of their minds. These rights give a creator or an inventor an exclusive right over the use of his or her creation for a certain period of time (World Trade Organization [WTO], 2012b). There are four major intellectual property rights that sourcers may need to consider: (a) trademarks, (b) copyrights, (c) patents, and (d) trade secrets (Cohen, 2008). **Trademarks** include name, logo, color, and three-dimensional images that could represent the sourcer's company or brand. Similar logos or colors that would likely create confusion among consumers are considered a trademark infringement (Figure 6.4 shows an example of trademark violation of Coca-Cola). **Copyrights** protect drawing, designs, websites, or marketing materials that the sourcer may have. Similar designs and drawings that would jeopardize the sourcer's potential sales violate copyrights. **Patents** cover specific processes and products that the sourcer may uniquely possess. And finally, **trade secrets** could be any confidential or classified information that the sourcer may share only with the supplier.

Most apparel sourcers share their designs, patterns, artworks, and brand logos and names with suppliers so the suppliers could produce the goods for sourcers. However, during these collaborations some suppliers may violate the sourcer's intellectual property rights and use sourcers' trademarks, copyrights, patents, and trade secrets for their own profit and market gains. Some of these "fake" or unauthorized goods are even shipped back to the sourcer's country and disrupt the consumer market.

The U.S. Customs and Border Protection (USCBP) and the U.S. Immigration and Customs Enforcement (USICE) monitor counterfeit and pirated goods coming into the United States. In 2011, the total retail value of the products seized by both organizations was $1.1 billion (U.S. Customs and Border Protection [USCBP], 2013). Among those, apparel, footwear, and perfumes and colognes were the top seized commodities, each representing 11.4 percent (or $126.3 million), 8.7 percent (or $97 million), 4.6 percent (or $51 million), representatively. Sixty-two percent of infringed products were made and shipped from China, followed by Hong Kong (18 percent), and India (3 percent).

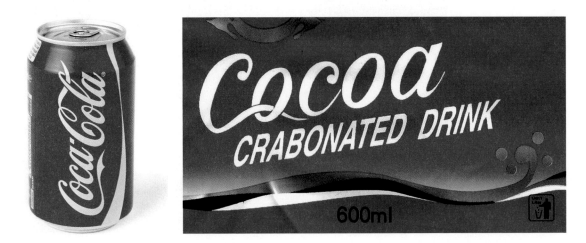

FIGURE 6.4 *Cases of trademark violations are easily found in the global marketplace.*
Source: © Ian Dagnall/Alamy

Intellectual property rights are strictly adhered to in the United States and these infringed goods are seized by the U.S. government agencies. However, some of these goods still can be sold in other countries, including the supplier's. For example, in 2008 62 percent of infringed goods produced in China stayed in China for Chinese consumption. This percentage was reduced from 71 percent in 2007. However, more of these goods were exported to the world, from 29 percent in 2007 to 38 percent in 2008 (USCBP, 2013). The regulations and enforcement of intellectual property rights differ in each country, making it extremely difficult to enforce them in the global marketplace. For example, in China, trademarks must be filed within the China Trademark Office to be protected. Both design and invention patents can be protected. However, design patents require no substantive examinations to get new patents. Therefore, it is much easier to copy others' designs (Cohen, 2008). In the case of India, although there is legal protection of trademarks, copyrights, and patents, there are no statutory protections for trade secrets (Keating, 2009). All of these statistics suggest that sourcers must carefully review the trend of the manufacturing and sales of the counterfeited and pirated goods in the supplier's country, as well as the country's laws on intellectual property rights. This would help sourcers protect their own brand, design, and market knowledge in global sourcing.

Trade barriers and trade agreements

Among all the factors described in PEST analysis, trade agreements and programs between the sourcer's and the supplier's countries could be one of the most important factors for any sourcing personnel's decision making. The trade agreements and programs directly affect the sourcer's overall costs because these preferential agreements are established to promote trade and reduce trade barriers between the countries. Retailers and importers favor trade liberalism with little or no trade barriers (see Figure 6.5). Without any barriers retailers, importers can import foreign products at low costs. On the other hand, domestic manufacturers and producers want

FIGURE 6.5 *Retailers and importers favor trade liberalism with little or no trade barriers.*
Source: Pressmaster/Shutterstock

trade protectionism with more restrictions on imports. The textile and apparel industry has been a core focus in trade negotiations since the Industrial Revolution. To conduct successful global sourcing, it is critical for sourcing personnel to understand fundamentals of trade barriers and trade agreements as one of the political environmental factors at the macro level.

Trade barriers

There are two major tools used by many governments today to discourage importing and encourage domestic manufacturing: tariffs and quotas. **Tariffs** are duties (or taxes) imposed on goods being imported from foreign countries (USCBP, 2006). **Quotas** are established to set a physical limit on the quantity of a good that can be imported into a country in a given period of time (USCBP, 2006). Both of these tools result in higher costs of the imported goods and, therefore, help domestic producers compete against low-priced imported goods.

As we learned through the law of supply and demand in international trade theory discussed in Chapter 2, these trade barriers raise the overall product cost, either through tariffs or quotas. This increased price would then reduce the overall demand for such products, while domestic producers may still protect some of their market shares (Nicholson, 2005). Figure 6.6 shows the effect of tariffs and quotas on domestic producers' and consumers' welfare shifts through the perspective of the law of supply and demand (Nicholson, 2005). P_t represents the price with tariffs and P_w denotes the price of the goods from the world. The higher price due to tariffs, P_t, helps promote domestic manufacturers to produce more products from Q_2 to Q_4 as they no longer compete at the P_w level. However, consumers' demand for goods at P_t discourages consumption and, therefore, the overall demand for that product would decrease from Q_1 to Q_3.

This shift in domestic manufacturing and consumption results in overall reduction in gains from trade from areas E_0E_1A to E_0E_2B. Out of this reduction of gain, area E_2E_1AB, the area E_2DCB represents the government's tariff revenues and the areas BCA and E_2E_1D will be lost within the economy. These areas are called deadweight loss in economic literature, representing the welfare that has not been transferred to consumers or domestic manufacturers (Nicholson, 2005). This theory suggests that, through trade barriers, the total consumer welfare is reduced

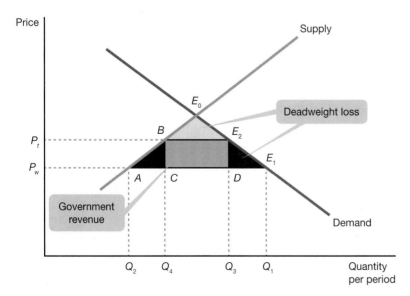

FIGURE 6.6 International trade and changes in welfare
Source: Nicholson (2005, p. 327).

TABLE 6.1

Examples of tariffs and the total cost to the sourcer

Tariff Type	Product Description and HTS Number	Cost to the Sourcer (before Tariffs)	Rates of Duty (Tariff)	Total Cost to the Sourcer (after Tariffs)
Ad valorem	Women's cotton knitted top (6106.10.00.10)	$20.00 per unit	19.7%	20*.197 = $23.94
Combination	Men's wool knitted overcoats (6101.90.05.00)	$60.00 per unit & 0.3 kg/unit	61.7 cents/kg + 16%	.617*.3 + 60*.16 = $69.79

by area $P_tE_2E_1P_w$ at the expense of domestic suppliers' gain (area P_tBAP_w) and the government's revenue. This model is applied for quotas and other types of trade protection that increase the overall price of foreign goods.

TARIFFS

There are three different types of tariffs—ad valorem, specific, and combination (USCBP, 2006). Ad valorem tariffs are assessed based on the percentage of the value of the products that are being imported. Specific tariffs are set based on a predetermined monetary amount per unit (for example, $5 for every jacket, regardless of the value of the jacket). Finally, combination tariffs are assessed based on both ad valorem and specific tariffs. In the United States, the *Harmonized Tariff Schedule of the United States (HTSUS)* shows proper types and rates of tariffs per classified product. For apparel products in Chapters 61 and 62 of *HTSUS*, the ad valorem type is the most common. Occasionally, the combination tariff type would be used. Table 6.1 shows examples of apparel products with ad valorem and combination tariffs, and also illustrates the cost to the sourcer before and after tariffs.

In the case of women's cotton knitted top (6106.10.00.10), *HTSUS* indicates that the rate of duty from countries in the general category is 19.7 percent of the unit value. This type of tariff is ad valorem as it assesses the duty rates based on the product value. If the cost of this women's cotton knitted top to the sourcer is $20.00 per garment, the duty would be $3.94 ($20.00 × 19.7%) and, therefore, the total cost after duty to the sourcer would be $23.94. On the other hand, *HTSUS* shows that men's wool knitted overcoats are subject to a combination tariff type; the rate of duty is 61.7 cents per kilogram + 16% for the goods imported from countries in the general category. Assuming the cost of men's wool knitted overcoats to the sourcer before tariffs is $60.00 per garment, the total duty for this garment would be $9.79. This is the sum of 18.5 cents (0.3 of 61.7 cents) and $9.60 (16% of $60.00). Therefore, the total cost to the sourcer after tariffs would be $69.79. Once again, due to tariffs, the overall costs of these garments increase and consumers pay higher retail prices for them. Meanwhile, the government gains revenues from tariffs, and domestic apparel manufacturers may maintain domestic market shares to some degree.

QUOTAS

In the United States, there are two types of quotas, which provide a quantity control on imports—absolute quotas and tariff-rate quotas (U.S. Department of Homeland Security [USDHS], 2010). When country A sets an absolute quota against country B on product C during the period, country B could ship only a certain amount of quantity of product C during that period. Typically, quotas are set annually, starting from January 1. If country B produced too many

products within that year and quotas ran out, the suppliers in country B may have to wait until the next January 1 when new quotas are available. When quotas run out on product C and it is no longer allowed to move from country B to country A, it is said that product C from country B has been "embargoed" (USCBP, 2006). Embargo is a partial or complete prohibition of trade with a particular country.

Tariff-rate quotas (TRQs) allow a specific quantity of merchandise to be entered into country A from country B at a reduced duty rate during a specific period (USDHS, 2010). Quantities beyond the specific quantity specified in the quota restriction can enter country A; however, they will be subject to higher rates of duty. In the case of textile and apparel products, the amount of products entered with TRQ is being monitored through tariff preference levels (TPLs). Therefore, TPL utilization rates are important for any sourcing personnel to monitor because any goods exceeding the specified quantity will be subject to higher duty rates.

As of January 1, 2005, quotas on textiles and apparel products were eliminated among the member countries of the World Trade Organization (WTO; Office of Textiles and Apparel [OTEXA], 2009). WTO is a forum for governments to negotiate trade agreements and settle any trade disputes, including intellectual property. Under the principle of trade liberalization, textile and apparel quotas among the WTO members have been eliminated via a 10-year plan since 1995. The 10-year plan ended on December 31, 2004, and since then there are no quota restrictions on textile and apparel products as long as these goods are traded among WTO member countries. Table 6.2 shows the current member and observing countries of WTO as of 2013.

TABLE 6.2
Members and observers of the world trade organization (as of 2013)

Members	Observers
Albania; Angola; Antigua and Barbuda; Argentina; Armenia; Australia; Austria; Kingdom of Bahrain; Bangladesh; Barbados; Belgium; Belize; Benin; Plurinational State of Bolivia; Botswana; Brazil; Brunei Darussalam; Bulgaria; Burkina Faso; Burundi; Cambodia; Cameroon; Canada; Cape Verde; Central African Republic; Chad; Chile; China; Colombia; Congo; Costa Rica; Côte d'Ivoire; Croatia; Cuba; Cyprus; Czech Republic; Democratic Republic of the Congo; Denmark; Djibouti; Dominica; Dominican Republic; Ecuador; Egypt; El Salvador; Estonia; European Union (formerly European Communities); Fiji; Finland; Former Yugoslav Republic of Macedonia (FYROM); France; Gabon; The Gambia; Georgia; Germany; Ghana; Greece; Grenada; Guatemala; Guinea; Guinea-Bissau; Guyana; Haiti; Honduras; Hong Kong, China; Hungary; Iceland; India; Indonesia; Ireland; Israel; Italy; Jamaica; Japan; Jordan; Kenya; Republic of Korea; Kuwait; Kyrgyz Republic; Lao People's Democratic Republic; Latvia; Lesotho; Liechtenstein; Lithuania; Luxembourg; Macao, China; Madagascar; Malawi; Malaysia; Maldives; Mali; Malta; Mauritania; Mauritius; Mexico; Moldova; Mongolia; Montenegro; Morocco; Mozambique; Myanmar; Namibia; Nepal; Netherlands—for the Kingdom in Europe and for the Netherlands Antilles; New Zealand; Nicaragua; Niger; Nigeria; Norway; Oman; Pakistan; Panama; Papua New Guinea; Paraguay; Peru; Philippines; Poland; Portugal; Qatar; Romania; Russian Federation; Rwanda; Saint Kitts and Nevis; Saint Lucia; Saint Vincent & the Grenadines; Kingdom of Saudi Arabia; Senegal; Sierra Leone; Singapore; Slovak Republic; Slovenia; Solomon Islands; South Africa; Spain; Sri Lanka; Suriname; Swaziland; Sweden; Switzerland; Chinese Taipei; Tajikistan; Tanzania; Thailand; Togo; Tonga; Trinidad and Tobago; Tunisia; Turkey; Uganda; Ukraine; United Arab Emirates; United Kingdom; United States of America; Uruguay; Vanuatu; Bolivarian Republic of Venezuela; Viet Nam; Zambia; Zimbabwe	Afghanistan Algeria Andorra Azerbaijan Bahamas Belarus Bhutan Bosnia and Herzegovina Comoros Equatorial Guinea Ethiopia Holy See (Vatican) Iran Iraq Kazakhstan Lebanese Republic Republic of Liberia Libya Samoa Sao Tomé and Principe Serbia Seychelles Sudan Syrian Arab Republic Uzbekistan Yemen

Although this zero-quota policy helped make global trades easier, some countries, including the United States, were concerned about the dominance of cheap products from China in global textile and apparel trades. To help ease this type of sudden market disruption, the United States put in place a safeguard plan to control the quantity of textile and apparel products imported from China under the U.S.–China Textile Agreement (OTEXA, 2012). This agreement was effective from January 1, 2006, to December 31, 2008. As of March 2, 2013, textile and apparel quotas have been completely eliminated among the 159 WTO member countries (WTO, 2013). Currently, 25 additional countries are in the "observer" status and in the process of becoming full members of WTO (WTO, 2013).

Trade agreements

Due to the elimination of quotas, most of today's sourcing personnel in WTO member countries do not pay attention to absolute quotas anymore. However, tariffs, trade preference programs, TPLs, and TRQs are still important as they directly impact the overall cost to the sourcer. In the United States, the Office of Textiles and Apparel (OTEXA) monitors textile and apparel trade policies and practices, both imports and exports, to ensure compliance with WTO and international trade agreement commitments. The Office of the United States Trade Representative (USTR) also publishes the details of trade agreements (Executive Office of the President, 2012). It is sourcing personnel's responsibility to be up-to-date on all trade agreements and negotiations. The next section discusses free trade agreements and trade preference programs.

FREE TRADE AGREEMENTS

Free trade agreements (FTAs) could be one of the most important and beneficial sources of information for any sourcing personnel to consider when selecting suppliers. FTAs are negotiated to promote trade among member countries by eliminating or reducing tariff rates and easing government trade rules. Under FTAs, qualified goods would gain "duty-free" access to other FTA member countries, resulting in lower prices for the goods.

There are five common provisions in FTAs related to textile and apparel trades. First, FTAs are established to ensure reciprocal market access (OTEXA, 2009). That is, conditions and rules in FTAs are designed to ensure that all member countries would have opportunities to export and import goods in equivalent quantities. The United States is more likely to be an importer of textile and apparel products from FTA member countries, while it would be an exporter of goods such as automobiles and those related to intellectual property to FTA member countries (Executive Office of the President, 2012). That is, by allowing imports of textile and apparel products from another country, the United States would gain easier access to export U.S. automobiles, movies, books, technology, and so on (see Figure 6.7). Therefore, both sides obtain economic gains from free trade agreements.

Second, most FTAs have the **yarn-forward rule of origin** as a common provision for most textile and apparel products to be duty-free (OTEXA, 2012). In general, textile and apparel products are required to be produced in FTA member countries starting from yarn production and including all operations "forward," such as fabric production and apparel assembly, to receive duty-free treatment. This rule ensures that manufacturing activities of yarn, fabric, and apparel would stay within the FTA member countries, promoting further economic activities within FTA regions.

Third, most FTAs also have a safeguard mechanism that allows tariff snapback if textile and apparel imports cause serious damage to domestic markets, such as sudden drops in prices

FIGURE 6.7 *By allowing imports of textile and apparel products from other countries, the United States can gain easier access to export automobiles, movies, books, and other products to foreign countries.*
Source: © Unclesam/Fotolia

through dumping products at below-the-market price (OTEXA, 2009). This type of dumping activity would disrupt the domestic market as unfairly priced goods may hurt products produced in normal, fair market conditions. Therefore, FTAs have certain mechanisms to adjust tariff rates if such dumping activities occur.

Fourth, FTAs have policies on illegal **transshipment**. Transshipment can be illegal if the goods enter the ultimate destination country with a false country of origin. For example, country A is the country of origin where product X was made. However, country A does not have an FTA with country C, the ultimate destination. To take advantage of duty-free treatment of an FTA, product X was transported to country B, the country with an FTA with country C, and was relabeled to show the country of origin to be country B before shipping to country C. This is an illegal transshipment with false country-of-origin labels intended to take advantage of duty-free access. Most FTAs have policies and rules against such illegal activities.

Finally, most FTAs have rules on "short supply" of textile and apparel products (OTEXA, 2009). If any fibers, yarns, or fabrics are not commercially available, or in short supply in the FTA region, raw materials in short supply can be sourced outside the region and the finished goods are still qualified for duty-free treatment (see Figure 6.8). This is a direct violation of the yarn-forward rule of origin. However, it is necessary to have this short supply rule in case the FTA region cannot produce all necessary raw materials. OTEXA publishes the list of raw materials in short supply.

Despite these common provisions in FTAs, most importantly, sourcing personnel must be aware that each FTA has specific and different qualifying conditions, rules, and procedures for products to be truly qualified for duty-free treatment. Exceptions are extensive and one cannot assume how an FTA would work based on other FTAs rules. Therefore, if sourcing personnel want to take advantage of duty-free access, they must carefully review the conditions and rules of each FTA before making sourcing decisions. OTEXA staff members, trade lawyers, and various trade associations hold training sessions for textile and apparel businesses.

As of December 31, 2011, the United States has FTAs with 17 countries and all of those FTAs are currently being fully implemented. In October 2011, U.S. president Obama signed

FIGURE 6.8 *Free trade agreements' short supply rules allow raw materials, such as yarns or fabrics, in short supply to be sourced outside the region while the finished goods still qualify for duty-free treatment.*
Source: Jamie Marshall/Pearson Education

three additional FTAs with South Korea, Colombia, and Panama. Among the 17 countries, 9 countries have separate bilateral agreements with the United States. Bilateral agreements involve only 2 countries, with 1 being the United States in this case. The remaining 8 countries belong to two multilateral agreements, the North American Free Trade Agreement (NAFTA) and the Dominican Republic-Central America-United States Free Trade Agreement (CAFTA-DR). Table 6.3 illustrates countries with which the United States currently has free trade agreements.

TABLE 6.3

Current U.S. free trade agreements

Free Trade Agreement	Partner Countries (Effective Date)
Bilateral	Australia (January 1, 2005) Bahrain (August 1, 2006) Chile (January 1, 2004) Israel (September, 1985) Jordan (December 17, 2001) Morocco (January 1, 2006) Oman (January 1, 2009) Peru (February 1, 2009) Singapore (January 1, 2004) Colombia (October 21, 2011) South Korea (October 21, 2011) Panama (October 21, 2011)
Multilateral	
North American Free Trade Agreement (NAFTA)	Canada (January 1, 1994) Mexico (January 1, 1994)
Dominican Republic-Central America-United States Free Trade Agreement (CAFTA-DR)	El Salvador (March 1, 2006) Honduras (April 1, 2006) Nicaragua (April 1, 2006) Guatemala (July 1, 2006) Dominican Republic (March 1, 2007) Costa Rica (January 1, 2009)

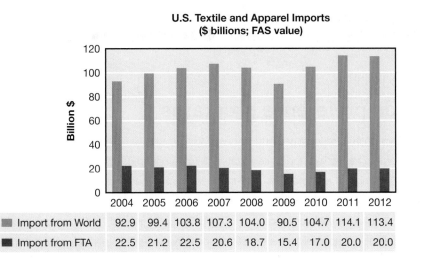

FIGURE 6.9 U.S. textiles and apparel imports
Source: Office of Textiles and Apparel (2013a).

Figures 6.9 and 6.10 show the trends of U.S. textile and apparel imports and exports since 2004. In 2012, the United States imported textile and apparel products worth up to $113.4 billion from the world and 17.6 percent of those, or $20 billion, were imported from FTA partner countries. During the same year, the United States exported textile and apparel products worth up to $22.6 billion, and 66.8 percent, or $15.1 billion, of exports were made to FTA partner countries.

Although there have been slight upward and downward trends in both imports and exports of textile and apparel products in recent years due to economic recession, the contributions of FTAs in textile and apparel trades have been fairly consistent. Through various FTAs, the United States has been able to export textile and apparel products to and import from FTA partner countries in a fairly consistent manner.

Considering the yarn-forward rule of origin and the decline of apparel manufacturing activities within the United States, it is expected that most U.S. exports are in the form of textiles, such as yarns and fabrics, while most imports from FTA partners are apparel products with

FIGURE 6.10 U.S. textiles and apparel exports
Source: Office of Textiles and Apparel (2013a).

duty-free treatment. Experienced sourcing personnel closely monitor macro-level trade statistics to evaluate their supplier mix from various regions and countries to take advantage of duty-free access.

Trade preference programs

In addition to free trade agreements, other programs are available to help reduce trade barriers and promote trades with the United States. A trade preference program (TPP) is legislated by the U.S. Congress and provides duty-free treatment to certain apparel products from designated beneficiary countries that meet the program's rules. TPPs are different from FTAs in that TPPs do not have reciprocal access (OTEXA, 2012). In general, TPPs are designed to allow duty-free entry of apparel from a beneficiary country into the United States if the apparel is cut and assembled in a beneficiary country using U.S. fabrics made of U.S. yarns (OTEXA, 2012). Currently, the United States offers four TPPs:

- The African Growth and Opportunity Act (AGOA).
- The Andean Trade Promotion and Drug Eradication Act (ATPDEA).
- The Caribbean Basin Trade Partnership Act (CBTPA).
- The Haitian Hemispheric Opportunity through Partnership Encouragement Act (HOPE Act).

AGOA

Since October 1, 2000, the African Growth and Opportunity Act (AGOA) has provided duty-free and quota-free treatment for eligible apparel articles made in qualifying sub-Saharan African countries which will continue through 2015 (OTEXA, 2012). In 2006, U.S. president George W. Bush signed the Africa Investment Incentive Act that amended the textile and apparel portions of the AGOA. This 2006 act is now referred to as AGOA IV. Currently, 38 countries in the sub-Saharan African region are eligible for AGOA. Specific eligibilities and qualifying articles must be reviewed carefully before making supplier selections to take advantage of AGOA.

ATPDEA

The Andean Trade Promotion and Drug Eradication Act (ATPDEA) is the latest trade preference program the United States has with Bolivia, Colombia, and Ecuador (see Figure 6.11). ATPDEA is an expanded version of the Andean Trade Preference Act enacted in 1991 with the four countries in the Andean region—Bolivia, Colombia, Ecuador, and Peru. Peru is no longer part of the ATPDEA as of December 31, 2010, since signing the U.S.-Peru Free Trade Agreement (OTEXA, 2012). Under ATPDEA, approximately 5,600 eligible products from Bolivia, Colombia, and Ecuador could enter the U.S. market duty-free. Once again, for those who want to take advantage of the duty-free treatment under ATPDEA, sourcing personnel must pay attention to specific eligibilities per product category.

CBTPA

The Caribbean Basin Trade Partnership Act (CBTPA) is part of the Caribbean Basin Initiative (CBI), an effort to facilitate the economic development and trade diversification of the Caribbean Basin economies, launched in the early 1980s. Since 2000, the United States has promoted economic activities between it and countries in the Caribbean Basin region through CBTPA. CBTPA is expected to expire by September 30, 2020. There are currently 18 countries that receive duty-free

FIGURE 6.11 *The Andean Trade Promotion and Drug Eradication Act (ATPDEA) is the latest trade preference program that the United States has with Bolivia, Colombia, and Ecuador.*
Source: © Julien Eichinger/Fotolia

benefits from CBTPA, including Aruba, Bahamas, Jamaica, Haiti, and Trinidad and Tobago. Sourcing personnel must pay special attention to the list of eligible countries as well as qualifying products and conditions before making supplier selections. Similarly, the Dominican Republic has a "2 for 1" EIA program with the United States. Table 6.4 illustrates member countries of AGOA and CBTPA.

HOPE, HOPE II, HELP

Although Haiti is part of the CBTPA, in 2006 the U.S. government established additional trade preference programs for textile and apparel goods manufactured in Haiti. Additional trade preference programs are the Haitian Hemispheric Opportunity through Partnership Encouragement Act of 2006 (HOPE), the Food Conservation and Energy Act of 2008 (HOPE II), and the Haiti Economic Lift Program of 2010 (HELP). Through these programs, textile and apparel goods manufactured in Haiti receive duty-free treatment when entering into the U.S. market with increased tariff preference levels (TPLs). That is, more products from Haiti could enter the U.S. market with less restriction and zero duty.

TABLE 6.4
Member countries of AGOA and CBTPA

AGOA	CBTPA
Angola, Benin, Botswana, Burkina Faso, Burundi, Cameroon, Cape Verde, Chad, Comoros, Republic of Congo, Democratic Republic of Congo, Djibouti, Ethiopia, Gabon, The Gambia, Ghana, Guinea-Bissau, Kenya, Lesotho, Liberia, Malawi, Mali, Mauritania, Mauritius, Mozambique, Namibia, Nigeria, Rwanda, Sao Tome and Principe, Senegal, Seychelles, Sierra Leone, South Africa, Swaziland, Tanzania, Togo, Uganda, and Zambia	Antigua and Barbuda, Aruba, Bahamas, Barbados, Belize, British Virgin Islands, Dominica, Grenada, Guyana, Haiti, Jamaica, Montserrat, Netherlands Antilles, Panama, St. Kitts and Nevis, St. Lucia, St. Vincent and the Grenadines, Trinidad and Tobago

An example of less restriction would be the Haiti Earned Import Allowance (EIA) program. Haiti "3 for 1" EIA has been effective since October 1, 2008, through HOPE II. Currently, HELP specifies Haiti is allowed a "2 for 1" EIA as of May 2010. That is, under the EIA, for every 2 (or 3) square meter equivalents (SMEs) of qualifying U.S.-made fabric shipped to Haiti for apparel manufacturing, the sourcer may import 1 SME of Haitian-made apparel duty-free using third-party yarn and fabric. EIA relaxes the yarn-forward rule of origin in that Haitian apparel manufacturers could use a certain percentage of non-U.S. yarns and fabrics and still receive duty-free treatment when exporting goods to the United States. This relaxed origin rule helps Haitian manufacturers be competitive with a variety of yarn and fabrics choices beyond U.S. yarn or fabric products.

UTILIZATION RATES OF TPPs

Figure 6.12 illustrates the utilization rates of U.S. trade preference programs specific to textile and apparel products. During the early 2000s, AGOA had some success as 37.6 percent of the allowed quantity of textile and apparel products manufactured in eligible countries entered the U.S. market duty-free. However, this rate has declined since, reaching only 10.1 percent of utilization. This suggests that despite trade preference programs the U.S. government established with these countries, textile and apparel trade has not been as active as AGOA had projected. Similar trends are found in all trade preferences, including ATPDEA and CBTPA. Only the utilization rate of HOPE seems to have increased since 2008.

Perhaps the role of China since the textile and apparel quota elimination in 2005 has played a role in the overall decrease in utilization rates of AGOA, ATPDEA, and CBTPA. Many importers who used to source their products from countries with trade preference programs may have shifted their sourcing destinations to China and other countries that are no longer limited in textile and apparel exports due to quota eliminations. It is also possible that many sourcers selected Haiti to be the manufacturing country to help its economy since the devastating earthquake in 2010.

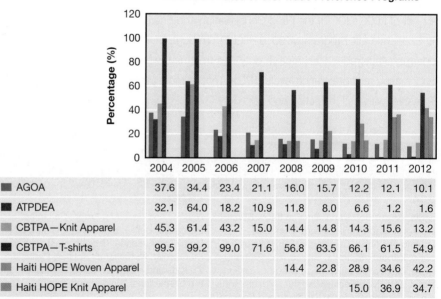

Utilization Rates of U.S. Trade Preference Programs

	2004	2005	2006	2007	2008	2009	2010	2011	2012
AGOA	37.6	34.4	23.4	21.1	16.0	15.7	12.2	12.1	10.1
ATPDEA	32.1	64.0	18.2	10.9	11.8	8.0	6.6	1.2	1.6
CBTPA—Knit Apparel	45.3	61.4	43.2	15.0	14.4	14.8	14.3	15.6	13.2
CBTPA—T-shirts	99.5	99.2	99.0	71.6	56.8	63.5	66.1	61.5	54.9
Haiti HOPE Woven Apparel					14.4	22.8	28.9	34.6	42.2
Haiti HOPE Knit Apparel							15.0	36.9	34.7

FIGURE 6.12 **Textiles and apparel utilization rates of U.S. trade preference programs**
Source: Office of Textiles and Apparel (2013b).

Although we may not know the true reasons, it is very important for sourcing personnel to monitor the trends of trade decreases and/or increases from certain counties and regions. No sourcing personnel want to go to a new country and start new business activities while other companies are leaving due to lack of business incentives and poor competitive advantages.

Free trade agreements and trade preference programs, as discussed in this section, are among the most important factors that sourcing personnel consider and follow on a regular basis. Certainly, what is discussed in this chapter is not the entire list of trade incentives that the United States may have for other countries. For example, the Dominican Republic has an additional "2 for 1 Earned Import Allowance" program as Haiti has. TRQs, such as cotton tariff-rate quota programs and wool tariff-rate programs are also available on a small scale. Each agreement or program may affect the sourcer's bottom lines; therefore, timely and updated information on political and economic discussion between the sourcer's and potential suppliers' countries could be a competitive advantage for sourcing personnel. In fact, many sourcing personnel subscribe to trade newsletters for utilization rates of each TPP and other quota- and trade-related data. They may attend conferences, meetings, and webinars organized by trade associations and government agencies to learn more about current and new trade agreements and TPPs. All of this discussion and consideration takes place at the macro environmental level.

summary

Macro environmental analysis, including PEST analysis, is not something that sourcing personnel conduct every day. Typically, this type of analysis is done when sourcing personnel want to expand their supplier mix to new countries. Before establishing any new business contacts, it is important for sourcing personnel to understand the political, economic, social, and technological environments of the new country so they feel confident about entering into this new business relationship.

Among PEST environments, free trade agreements and trade preference programs that the sourcer's country may have with the supplier's country are important for any sourcing personnel to consider; the details of such agreements and programs could affect the financial bottom line of a global sourcing project. For example, through NAFTA, the United States has duty-free trade agreements with Mexico and Canada. Through CAFTA-DR, the United States has duty-free trade agreements with El Salvador, Guatemala, Costa Rica, and others.

To take advantage of duty savings through free trade agreements, sourcing personnel must know about the yarn-forward rule of origin (that yarn production and any operations forward must be done in member countries). Currently the United States has free trade agreements with 17 countries, and an additional 3 countries

are pending for implementation. Specific details of conditions and country-of-origin rules differ for each agreement and program, and it is sourcing personnel's responsibility to get up-to-date with the latest and most accurate information.

The United States also has four different trade preference programs, including AGOA, ATPDEA, CBTPA, and HOPE. These programs were established to encourage U.S. businesses to import certain products from these member countries. Textile and apparel products are among the core products that are being encouraged (see Figure 6.13).

On the other hand, tariffs and quotas exist to discourage trades. These types of trade barriers ultimately raise the overall price of the imported products, decrease consumer surplus, increase domestic supplier's welfare, and raise a government's revenue. In the United States, the Office of Textiles and Apparel (OTEXA) under the U.S. Department of Commerce oversees textile and apparel trades. OTEXA offers up-to-date trade data, details on free trade agreements, rules on trade preference programs, and so on. For accurate and timely information, many sourcing personnel closely monitor trade data and news published by OTEXA.

Based on PEST analysis and a close review of trade agreements and preference programs, sourcing personnel may narrow

down options to a few ideal countries for a given sourcing objective. These decisions would depend on the product type, which might be eligible for duty-free or quota-free treatment; fiber content, which might be affecting overall duty rates; and raw material sources, which might be impacting Earned Import Allowance programs. It is a complex process, yet experienced sourcing personnel know which countries might be ideal for certain type of products based on past history.

FIGURE 6.13 *Trade preference programs encourage U.S. businesses to import core products such as textiles and apparel, like this Tibetan shop.*
Source: Jamie Marshall/Pearson Education

key terms

Copyrights protect drawing, designs, websites, or marketing materials that the sourcer may have.

Free trade agreements (FTAs) are established to promote trade among member countries by eliminating or reducing tariff rates and by easing government trade rules.

Intellectual property rights are the rights given to persons over the creations of their minds. They give the creator an exclusive right over the use of his or her creation for a certain period of time, including trademarks, copyrights, patents, and trade secrets.

Patents cover specific processes and products that the sourcer may uniquely possess.

PEST analysis refers to macro environmental analysis of a country or an organization. It includes political, economic, social, and technological factors that a country or an organization may pose to an analyzer.

Quotas set a physical limit on the quantity of a good that can be imported into a country in a given period of time. They are one of the trade barriers. There are two types of quotas, including absolute and tariff-rate.

Tariffs refer to duties (or taxes) imposed on goods being imported from foreign countries. They are one of the trade barriers. There are three different types of tariffs, including ad valorem, specific, and combination.

Trademarks include name, logo, color, and three-dimensional images that could represent the sourcer's company or brand.

Trade secrets could be any confidential or classified information that the sourcer may share only with the supplier.

Transshipment refers to an illegal trade activity in which the finished goods enter the ultimate destination country with a false country of origin. Usually, transshipment occurs to take advantage of duty-free treatment often specified in free trade agreements.

Yarn-forward rule of origin of textile and apparel products promotes free trade agreement member countries to engage in yarn production and forward activities, such as fabric and apparel manufacturing, to take advantage of trade benefits, such as duty-free treatment.

learning activities

1. For each of the following countries, discuss the pros and cons for sourcing personnel in finding the best supplier to produce high-end men's wool suits. First conduct PEST analyses through *The World Factbook* (published by the CIA):
 a. Vietnam
 b. Nicaragua
 c. Ghana
 d. Russia
 e. Turkey
 f. China

2. After reviewing free trade agreements, trade preference programs, and *HTSUS*, find possible trade barriers (both tariffs and quotas) that each of the countries listed in question 1 may have for high-end men's wool suits.

3. Go to the Trade Data page at the OTEXA website (Trade Data: US Textiles and Apparel Imports by Category) and find out what are the top three leading exporting countries of:
 a. Cotton apparel products in value to the United States
 b. Man-made fiber apparel products in value to the United States
 c. Wool products in value to the United States

4. Find out the latest status on U.S.–South Korea, U.S.–Colombia, and U.S.–Panama free trade agreements. You may use OTEXA website.

5. Why is an understanding of the latest trade agreements important for sourcing personnel?

6. Search for various trade magazines and newspapers. Come up with recent developments in trade negotiations that may affect U.S. apparel sourcing managers' decision making.

references

Cohen, M. (2008). IP protection for textile, apparel, footwear and travel goods. United States Patetn and Trademark Offices, Department of Commerce. Retrieved October 22, 2013, from http://otexa.ita.doc.gov/pdfs/china_ip_webinar_on_textiles_062508-1.pdf

Central Intelligency Agency. (2012). *The World Factbook.* Retrieved January 25, 2012, from https://www.cia.gov/library/publications/the-world-factbook

Executive Office of the President. (2012). *Trade agreements.* Retrieved January 26, 2012, from http://www.ustr.gov/trade-agreements

Keating, D. (2009). India/South Asia: IT protection for textile, apparel, footwear and travel goods industries. Retrived October 22, 2013, from http://web.ita.doc.gov/tacgi/eamain.nsf/6e1600e39721316c852570ab0056f719/475c76712aaecfc185257527006f967a?OpenDocument

Nicholson, W. (2005). *Microeconomic theory: Basic principles and extensions.* Mason, OH: South-Western, Thompson.

Office of Textiles and Apparel. (2009, February 5). *U.S. textile and apparel trade programs in a post-quota world.* Retrieved from http://otexa.ita.doc.gov/Presentations/Post_Quota_World_Webinar.pdf

Office of Textiles and Apparel. (2012, January 26). *China textiles safeguard.* Retrieved from http://web.ita.doc.gov/tacgi/eamain.nsf/d511529a12d016de852573930057380b/5895f5d4f2548742852573940056c015?OpenDocument

Office of Textiles and Apparel. (2013a). *Trade data: U.S. Imports and exports of textiles and apparel.* Retrieved May 28, 2013, from http://otexa.ita.doc.gov/tbrimp_fta.htm

Office of Textiles and Apparel. (2013b). *Trade preference programs.* Retrieved May 28, 2013, from http://otexa.ita.doc.gov/agoa-cbtpa/agoa-cbtpa_2012.htm

U.S. Customs and Border Protection. (2006). *Importing into the United States: A guide for commercial importers.* Retrieved January 25, 2012, from http://www.cbp.gov/linkhandler/cgov/newsroom/publications/trade/iius.ctt/iius.pdf

U.S. Customs and Border Protection. (2013). *2011 Seizure statistics.* Retrieved October 22, 2013, from http://www.iprcenter.gov/reports/ipr-center-reports/2011-seizure-statistics/view

U.S. Department of Homeland Security. (2010, July 20). *Types of quotas.* Retrieved from Quota Frequently Asked Questions: http://www.cbp.gov/xp/cgov/trade/trade_programs/textiles_and_quotas/quota_frq/types_quotas.xml

Walmart. (2012). *Sustainability Index.* Retrieved January 31, 2012, from http://walmartstores.com/sustainability/9292.aspx

World Trade Organization. (2012a). *Understanding the WTO: The organization members and observers.* Retrieved December 2, 2013, from http://www.wto.org/english/thewto_e/whatis_e/tif_e/org6_e.htm

World Trade Organization. (2012b). *What are intellectual property rights?* Retrieved August 22, 2012, from https://www.wto.org/english/tratop_e/trips_e/intel1_e.htm

GLOBAL SOURCING STEP 3: MICRO-LEVEL ANALYSIS FOR SUPPLIER SELECTION

LEARNING OBJECTIVES

Once analyses of potential sourcing destinations at the macro level are conducted, sourcers then look at potential suppliers at a micro level. Each supplier has different advantages and disadvantages, and sourcers need to take all factors into consideration before making any sourcing decisions. This chapter discusses specific factors that sourcers must consider to find manufacturers who would produce in the right condition, the right product, in the right quality, in the right time, at the right price (5R principles). Upon completion of this chapter, students will be able to:

- Understand the specific factors that sourcers must consider to select the best possible supplier for a specific sourcing project.
- Articulate the "right" conditions, products, quality, time, and price (5R principles) in global sourcing.
- Analyze the consequences of sourcing decisions on the triple bottom lines of sustainability.
- Analyze the production and transit lead time, and the impacts of such lead time on the overall delivery performance.
- Understand different cost terms, including *FAS, FOB, CIF, LDP,* and *DDP* and be able to apply such terms to the sourcer's overall economic performance.
- Analyze the overall cost structures of global sourcing, including direct and indirect costs.

7

(Opposite page) *Source:* Dasha Petrenko/Shutterstock

Step 3: Micro-level analysis for supplier selection

Through PEST (political, economic, social, and technological environments) analysis, a sourcer narrows the choices of countries for a specific sourcing project. At this step, a sourcer now looks into specific factories within these countries, and compares each factory's advantages and disadvantages as a potential supplier. This section discusses the third stage of the seven core steps of global sourcing—micro-level analysis for supplier selection (see Figure 7.1).

Analyses of suppliers at a micro level

Let's assume sourcing personnel of Amazing Jeans reviewed macro environmental factors, free trade agreements, and trade preference programs, and narrowed the sourcing destinations for boys' cotton denim pants (6203.42.40.36) to three options:

1) El Salvador, a member country of CAFTA-DR. It has both quota-free and duty-free access to the U.S. market.

2) China, a WTO member. It has quota-free access to the U.S. market, yet is subject to 16.6 percent duty for boys' cotton denim pants.

3) Vietnam, also a WTO member. It has quota-free access to the U.S. market with 16.6 percent duty for boys' cotton denim pants, yet it has the lowest wage among the three countries.

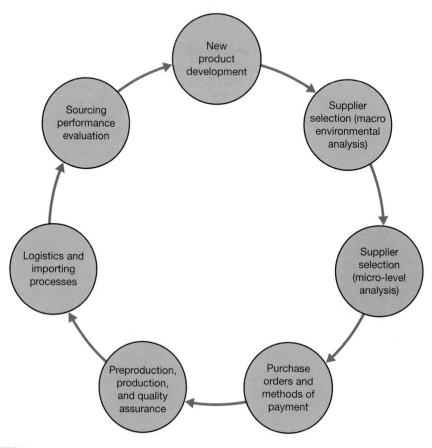

FIGURE 7.1 Core steps of global sourcing

This information is useful for initial cost estimation. However, the information is not the only factor on which to base sourcing decisions. Once macro environments have been assessed and a list of potential countries produced, sourcers then collect a few potential suppliers from each country or region. According to Ha-Brookshire and Dyer (2009), the majority of apparel import intermediaries (AIIs), one of the main sourcing entities in the United States, work with fewer than four suppliers per foreign country. The authors suggested this could be the result of strategic choices made by AIIs to avoid unnecessary competition among suppliers within a country with limited resources. In this example, Amazing Jeans's sourcing personnel may now have six to eight potential suppliers across El Salvador, China, and Vietnam.

Sourcers then focus on analyzing strengths and weaknesses of each supplier to find the optimal choice. The core mission of this analysis is to find an answer to the question—Who would produce *the right products, in the right condition, in the right quality, at the right time, at the right price (5Rs)* for this specific sourcing program? Some suppliers would be too expensive for a given project, whereas others may be too slow. Sourcers go through multiple surveys, negotiations, and assessments before making the final decision. But first and foremost, sourcing personnel must ensure that all of the potential suppliers meet and exceed the minimum level of social and environmental compliances and operate their businesses with the right conditions.

Right conditions

SOCIAL AND ENVIRONMENTAL COMPLIANCES

The first criterion when assessing a supplier as a potential contractual partner is the supplier's business conditions, such as social and environmental compliance enforcement policies and past records of such compliance practices (see Figure 7.2). If the sourcer is an intermediary who sources and delivers finished products to a retailer or a brand owner, he or she is responsible for meeting the policies and regulations of that retailer or brand owner. Therefore, it is critical for

FIGURE 7.2 *When assessing a supplier, the sourcer must consider the supplier's social and environmental compliance enforcement policies, both past and present.*
Source: © Jörg Hackemann/Fotolia

sourcing personnel to fully understand different policies and requirements, commonly referred to as codes of conduct or vendor responsibilities, for different retailers and brand owners.

For example, if Amazing Jeans is producing boys' denim pants under a licensing agreement with the Walt Disney Company (or Disney) to be sold at Walmart, sourcing personnel of Amazing Jeans need to find a supplier who can meet the codes of conduct for manufacturers required by both Disney and Walmart (or, sourcers must force foreign suppliers to improve their business conditions to meet such codes and policies). Disney has its own code of conduct required by suppliers, including policies on child labor, involuntary labor, coercion or harassment, nondiscrimination, compensation, and protection of the environment. Through its code of conduct, Disney requires all of its suppliers to follow certain rules and requirements to maintain the integrity of the Disney brand and comply with the company's corporate responsibility (The Walt Disney Company, 2012).

Similarly, Walmart has its own vendor compliance rules and code of conduct and enforces them with all of its suppliers. The Walmart's Sustainability Index is another requirement that all suppliers, including foreign manufacturers, must answer to before delivering goods to Walmart. The Sustainability Index, a worldwide sustainable product index, was launched in 2009, and all of the company's 1,500 suppliers across the globe must follow and report their efforts toward achieving sustainability. Table 7.1 shows examples of supply assessment criteria enforced by

TABLE 7.1

Examples of supplier assessment criteria enforced by major U.S. retailers

Criterion	Criteria
Child labor	• Ban of child labor. A child is a person younger than 16, or if higher, the local legal minimum age for employment (each company may have different age standards).
Involuntary labor	• Ban of forced or involuntary labor, such as people who are in prison, bonded, or indentured.
Discrimination	• Ban of discrimination in employment on the basis of gender, race, religion, age, disability, sexual orientation, pregnancy, marital status, nationality, political opinion, social or ethnic origin, or any other status protect by country law.
Coercion and harassment	• Suppliers must treat employees with dignity and respect, without physical, sexual, psychological or verbal harassment or abuse.
Association	• Suppliers must respect the rights of employees to associate, organize, and bargain collectively in a lawful manner.
Health and safety	• Suppliers must provide employees with a safe and healthy workplace in compliance with all applicable laws and regulations.
Compensation and timely payment	• Suppliers must comply with all applicable wage and hour laws and regulations, including minimum wages, overtime, maximum hours, and so on, and make payment on time.
Protection of the environment	• Suppliers must comply with all applicable environmental laws and regulations.
Other laws	• Suppliers must comply with all applicable laws and regulations, including those relevant to manufacturing, pricing, sale, and distribution of merchandise.
Subcontracting	• Suppliers must receive a written consent from the company before using any subcontractors.
Monitoring and compliance	• Suppliers must allow the company and its designated agents to monitor and inspect suppliers' activities to confirm all compliance issues stated in the code of conduct.
Environmental impact	• Suppliers must try to protect human health and natural environments by reducing factories' greenhouse gas emissions, reducing overall wastes, and engaging sustainable purchasing strategies.

Note: This list is not all inclusive or exhaustive. Each company may have different mixes of different criteria. There is no universal code of conduct.

Source: Adopted from Walmart (2012). Sustainability Index. Retrieved January 31, 2012, from http://walmartstores.com/sustainability /9292.aspx

major U.S. retailers. Each company may have different mixes of the questions and place different weights on each item, depending on its mission. Each company may also have its own inspectors who travel all over the world and monitor suppliers' business conditions. More often than not, these inspectors may show up at suppliers' facilities unannounced. The important point is that sourcers must award suppliers who comply with policies and regulations as well as enforce policies with those who do not.

In some cases, to gain an objective assessment of foreign suppliers' business practices in labor and environmental protection, sourcing personnel may hire third-party inspection companies such as Intertek and Bureau Veritas (see Figure 7.3). These are independent inspection and audit companies for most consumer goods in the global marketplace. If sourcing personnel face any new supplier with whom they have never had any business experiences before, conducting third-party inspections may be extremely valuable before starting any negotiations. Even after initial inspection, ongoing auditing is important so that sourcing personnel know that the foreign suppliers continue practicing acceptable business practices. After all, these monitoring periods and inspections must be conducted because it is the right thing to do for all of us to be sustainable, not just to avoid potential penalties or bad publicity.

Now, let's go back to our example of Amazing Jeans. Its sourcing team now has a boys' cotton denim jean program to be sourced for Walmart and these products are produced under the licensing agreement with Disney. The sourcer has a list of potential suppliers across El Salvador, China, and Vietnam, all of whom meet both Walmart's and Disney's compliances. Sourcers now can evaluate other specific factors that each supplier may offer to achieve the sourcing objective under the 5R principles.

CUSTOMS-TRADE PARTNERSHIP AGAINST TERRORISM

In addition to social and environmental responsibilities, the sourcer also must ensure that each supplier in a foreign country agrees to work with the U.S. government to join the antiterror partnership

FIGURE 7.3 *Intertek is one of the independent consumer product inspection or audit companies.*
Source: Courtesy of Intertek (2013).

FIGURE 7.4 *The sourcer also must make sure that each supplier in a foreign country agrees to work with the U.S. government in antiterrorism partnerships.*
Source: © Yevgenia Gorbulsky/Alamy

(U.S. Customs and Border Protection [USCBP], 2012; see Figure 7.4). **Customs-Trade Partnership Against Terrorism (C-TPAT)** is a voluntary supply chain safeguard program led by USCBP. C-TPAT began in November 2001, two months after the September 11 attacks in New York City, to improve the safety and security of private companies' supply chains against terrorism. As of June 2011, more than 10,000 private companies all over the world—including U.S. importers, truck carriers, rail and ocean carriers, Customs brokers, marine port authorities, and ocean transportation intermediaries—have been certified by USCBP (USCBP, 2012). These businesses signed an agreement to work with USCBP to protect the supply chain, identify security gaps, and implement specific security measures and best practices. They also agreed to provide USCBP with a security profile that they implement to help protect the supply chain. If any potential suppliers are already certified and approved for C-TPAT, sourcers receive benefits when importing the finished goods to the United States because C-TPAT members are considered low risk to the United States and, therefore, their shipments are less likely to be examined when the goods arrive at a U.S. port. This can be another important factor that sourcers must consider when evaluating whether or not the supplier operates his or her business under the right conditions.

Right products

Typically, each garment factory is organized to produce single or a few particular product categories, such as knit products or woven products, so it can achieve the highest efficiency. Woven apparel factories normally require more advanced and sophisticated sewing machines and setups, and higher precision on garment constructions than factories producing knitted apparel. Similarly, factories established to produce small-article products, such as underwear or innerwear, are set up differently from factories for large-article products such as men's suits and outerwear. Therefore, sourcing personnel must clearly understand the product category to be sourced and create a pool of suppliers who can produce the right products for the sourcers. In the case of

Amazing Jeans's boys' denim pants, sourcing personnel must evaluate each potential supplier and find a factory specializing in woven, denim pant manufacturing with the proper equipment for any specific trim details, which are often used in denim pants.

Right quality

The term *quality* means different things to different consumers and companies (see Figure 7.5). When consumers enter a Walmart store, they have a certain expectation of product quality, while those in an expensive department store expect a different level of quality. The goal of sourcing personnel is to deliver products of the right quality—the quality expected by the target consumers of the products. In the case of Amazing Jeans's boys' denim pants, sourcing personnel must consider cotton yarn options as they represent different quality levels. Typically, yarns made of Egyptian cotton, or other long-staple cotton, are expensive and, therefore, usually used for high-end products. Combed cotton yarns (made of short-staple cotton put through an extra combing process before spinning to remove additional impurities) are less expensive than long-staple cotton, yet more expensive than carded cotton. Because of the extra combing process, combed yarns are softer, stronger, and costlier than carded cotton yarns that are made without the combing process. Therefore, carded cotton yarns generally are used for mass-market products while combed cotton yarns are used for midtier market products. For Amazing Jeans's boys' denim pants for Walmart, carded yarns would be the expected quality choice for the

FIGURE 7.5 *The term quality means different things to different consumers and companies.*
Source: urfin/Shutterstock

mass-market consumers whom Walmart targets. This statement is made based on an assumption that there are no other factors, such as large volume, to be considered.

Right time

Today, production lead time and delivery schedules are more important than ever due to fast-fashion trends and fickle consumers' tastes. Even if a supplier could deliver the right products in the right quality at the right price, if it cannot produce the goods at the time when sourcers need them, it makes no sense for sourcers to select that particular supplier. Production lead time can be affected by the supplier's production efficiency, capacity, and obligations to other buyers. Some factories are known for fast production, yet they may suffer from poor quality that requires long, additional rework. Others may promise more than what they can do within a certain period of time and repeatedly ask for delivery extensions. Experienced sourcers check with other buyers and suppliers to evaluate factories' records of production and delivery performance.

Delivery time may be affected by shipping distance, the availability and frequency of logistics options, or natural environmental conditions that may delay international shipping. Therefore, when selecting a supplier, sourcers must include the supplier's proposed estimated time of departure (ETD) from its factory (Ex-Factory) and shipping companies' estimated time of arrival (ETA) at a U.S. port. This information is critical to accurately assess the total duration of delivery time. Table 7.2 shows an example of different delivery durations, depending on the location of the supplier and logistics options. In this case, even if a supplier from El Salvador proposes a later ETD Ex-Factory date by 7 days, the goods will be arriving in a port in Los Angeles, California, 9 to 15 days earlier than the shipment that a supplier in China would make. Meanwhile, the transit time between Ho Chi Minh, Vietnam, and Los Angeles, California, is approximately 22 to 25 days. Therefore, even if a supplier in Vietnam ships two weeks earlier than a supplier in El Salvador, the ETD of Los Angeles, California, from Vietnam is almost a week later than that from El Salvador. Experienced sourcing personnel know transit times from most major ports in the world and ocean shipment schedules. Or, at least they would have access to a logistic specialist who may have this information readily available. Sourcers could also check with international shipping companies to find detailed and up-to-date information. Overall, both production lead time and ocean transit time are important factors to consider.

Right price

For similar reasons that a sourcer must pay attention to quality, sourcing personnel may want to select the supplier who can produce the goods at the right price—not necessarily at the lowest price. During the initial costing stage in particular, sourcing personnel must consider both the

TABLE 7.2
Example of ocean shipping duration estimation

	From Shanghai, China	From San Salvador, El Salvador	From Ho Chi Minh, Vietnam
Proposed ETD X-Factory Ocean transit time	April 15 14–17 days	April 22, 2014 5–7 days	April 8, 2014 22–25 days
Proposed ETA in Los Angeles, California, USA	May 2–May 5	April 27–April 29	April 30–May 3

Source: Sea-Rates.com (2012).

direct costs of garment production and transportation and the indirect costs of sampling, communication, travel, or rework. In addition to initial costs, the history of the supplier's changes in costs must be considered. Some suppliers may play a "bait-and-switch" game during negotiations: They may offer one price and increase the price during the production when sourcers may not have other options. Although changes in cost from the initial to the final are very common as changes in design and details could still happen during production, if suppliers increase the cost for no particular reason and withhold shipments for additional payment, this could be a big problem for sourcers. Thus, it would be a good idea to check each supplier's reputation based on past history prior to selecting the supplier.

DIRECT COST

During the initial costing stage, the sourcer must take both direct and indirect costs into consideration. There are five major components of direct costs that most apparel sourcers need to consider—fabric, labor, trims or embellishments, transportation, and duties. Typically, fabric cost is the most significant portion of the total cost. This is particularly true for high technology and functional clothing such as athletic and outdoor wear. Labor cost for cutting, making, and trimming (CMT) garments varies, depending on the country, as different countries have different minimum wage requirements. Although variations exist among different countries, the cost for trims and embellishments, including packing, are fairly similar between countries. Transportation costs and duties have been discussed previously, and sourcers must add up costs of all these components and evaluate the direct costs quoted by various suppliers.

When comparing direct costs from several different suppliers from different countries, sourcers must understand that each supplier may have different terms for costs. Different terms mean different responsibilities, so it is vital that sourcers understand the differences before finalizing the total cost. The terms of cost are:

- Ex Point of Origin
- Free Along Side (FAS)
- Free on Board (FOB)
- Cost, Insurance and Freight (CIF)
- Cost and Freight (C&F or CNF)
- Landed Duty Paid (LDP)
- Delivered Duty Paid (DDP) (American Apparel Manufacturers Association [AAMA], 1998; Walker Customs Broker LLC, 2012).

Figure 7.6 shows the examples of common international trade terms of sales.

Ex point of origin. **Ex Point of Origin** means that the seller (the supplier in the context of global sourcing) prepares the goods at the point of origin (mostly the facility in which the goods were made and packed) and assumes all the costs and risks until the buyer (the sourcer in the context of global sourcing) picks up the goods from that facility. For example, $3.00 Ex Point of Origin per garment means that, when calculating the total cost, the sourcer is responsible for all costs and risks beyond the point of origin, such as transportation from the supplier's point of origin to a port of the supplier's country, ocean freights, marine insurance policies, duties, and transportation from the sourcer's country's port to the sourcer's warehouse.

Free along side. **Free Along Side (FAS)** points out that the supplier delivers the goods alongside the vessel so the goods can be within the reach of the loading tackle. Therefore, the

DDP	LDP	CIF	FOB	Cost Elements Paid by the Buyer
				Cost of production, including product packaging, export packing, certifications (i.e., U/L, FCC), quota charges, etc.
				Delivery of goods from factory to export port (i.e., "FOB port").
				Government export licenses, permits, fees, inspections.
				Product inspection and testing prior to shipment.
			FOB	In-country agent fees and commissions.
				Consolidation of goods at FOB port with other shipments.
				International freight forwarder fees.
				Main carriage (air or ocean) from FOB port to destination port, including rail transportation in destination country.
		CIF		Cargo insurance covering the goods shipped.
				Entry at destination port: customs, duties, fees, and taxes.
				Customs brokerage fees.
	LDP			Storage (demurrage) fees at port of destination.
				Break bulk (splitting shipment for different U.S. destinations).
DDP				Delivery to customer.

FOB	"Free on Board"	Customer purchases goods at the foreign port; is responsible for international freight, cargo insurance, customs entry and duties, and delivery to customer's distribution center.
CIF	"Cost, Insurance and International Freight"	Customer purchases goods at U.S. port; is responsible for customs entry and duties and delivery to customer's distribution center.
LDP	"Landed, Duty Paid at Distribution"	Customer purchases goods at U.S. port, entered and cleared through customs; is responsible for delivery to customer's distribution center.
DDP	"Delivered Duty Paid"	Customer purchases goods upon arrival at customer's distribution center; price paid includes all import and delivery costs.

FIGURE 7.6 Common international trade terms of sale
Source: Walker Customs Broker LLC. (2012). Common international trade terms of sales. Retrieved October 31, 2012, from http://www.walkerchb.com/WCB%20COMMON%20TERMS%20OF%20SALE.pdf

supplier is responsible for all associated costs and risks until the goods reach the loading area of the ocean freight vessel. Thus, comparing a $3.00 Ex Point of Origin with $3.00 FAS, the sourcer must realize that the $3.00 FAS is a cheaper option for the sourcer because the supplier is responsible for all the costs and risks up to the loading area. However, the sourcer must arrange the services of loading the containers onto the vessel, ocean freights and insurances, and duty payments once the goods have arrived at the point of destination. *FAS* is a term that the Office of Textiles and Apparel uses to collect and track trade data.

Free on board. **Free on Board (FOB)** is a term used to indicate that the supplier is responsible for all the costs and risks until the goods are placed in or on the vessel at the loading point. Once again, compared to $3.00 FAS per garment, the $3.00 FOB is a slightly better option for the sourcer as that $3.00 would cover all costs and risks until the goods are placed on the vessel. However, the sourcer still needs to take account for the cost of ocean freights, ocean insurances, and duty payments once the goods have arrived at the point of destination.

Cost, insurance, and freight. **Cost, Insurance, and Freight (CIF)** covers all costs and risks of apparel manufacturing, ocean insurance policies, and freights until the goods reach the point of destination that the sourcer designated. For example, if the supplier offers the cost of "$3.00 CIF Long Beach, California, U.S.A.," this term means that the supplier assumes all costs and risks until the goods reach the port in Long Beach, California, and the cost of such activities is $3.00 per garment. Therefore, if there were any damages to the goods during the ocean shipment (for example, mildew from moisture) and the goods were no longer in proper shape, the seller files for insurance claims and gets compensated for damaged goods (see Figure 7.7). Once again, compared to $3.00 FOB, $3.00 CIF is a cheaper option for the sourcer. However, the sourcer is still responsible for duty payments once the goods have arrived at the point of destination.

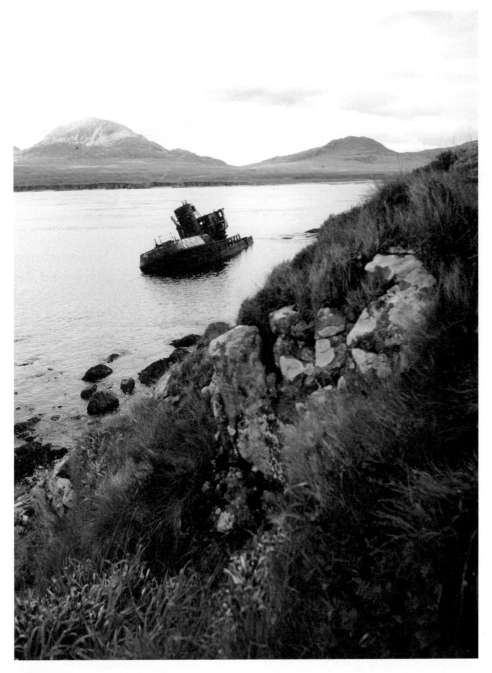

FIGURE 7.7 *With CIF, any damages to the goods during the ocean shipment can be compensated if the seller files insurance claims.*
Source: Ian O'Leary/Dorling Kindersley/Pearson Education

Cost and freight. **Cost and Freight (C&F or CNF)** is similar to CIF, yet C&F does not include the cost of ocean insurance policies. Some sourcers want to be in charge of insurance policies instead of relying on the supplier. One of the advantages of having your own insurance coverage is the sense of security that the goods are insured properly and no one forgot to insure them. Another advantage could be the ability to control insurance costs as the premium would be based on the sourcer's own loss history, not those of a freight company or the supplier who may have had higher loss history, resulting in higher insurance costs. Again, $3.00 C&F is a cheaper option than $3.00 FOB as this $3.00 includes ocean freights. However, it is a more expensive option than $3.00 CIF for the sourcer because the sourcer still has to purchase ocean insurance policies, assuming the point of origin and the destination are same.

Landed duty paid. **Landed Duty Paid (LDP)** covers all costs and risks associated with shipping up to the point at which the goods are delivered to the point of destination and cleared for the sourcer's country's Customs with the payment of appropriate duties. For example, if the term is "$3.00 LDP to Long Beach, California," this means that the supplier is responsible for apparel manufacturing, ocean shipments and insurances, and duties imposed by the sourcer's government. Therefore, $3.00 LDP is a cheaper option than $3.00 CIF for the sourcer because the $3.00 covers the duties. However, typically, the supplier asks for more money for any LDP transactions because the supplier assumes a greater amount of risks and costs.

LDP is a preferred option if the sourcer does not have expertise in international logistics or Customs clearance. LDP could be also a good idea when the sourcer does not have enough resources to track and be in charge of many ocean shipments. However, it is also important for sourcers to be sure that the suppliers have the capabilities of coordinating ocean shipments, insurance policies, and Customs clearance. In addition, the sourcer also needs to check if the supplier has sufficient financial resources to be able to pay duty once the goods arrive at a port of the sourcer's country. The goods will not be released by Customs without duty payment, and such a situation could cause a significant delay and penalties.

Delivered duty paid. **Delivered Duty Paid (DDP)** includes one additional step of transportation to LDP. That additional step is the transportation cost from the port of the sourcer's country, such as Long Beach, California, to the sourcer's final destination, such as his or her distribution center. Therefore, if the supplier offers $3.00 DDP per garment, this means that $3.00 includes all costs and risks until the goods are delivered to the sourcer's distribution center. Therefore, compared to $3.00 CIF or LDP, $3.00 DDP is a better deal for the sourcer as the sourcer needs little or no involvement in transporting the goods from the supplier's point of origin to the sourcer's distribution center. Similar to LDP, DDP would be a great option if the sourcer has neither expertise nor resources to arrange international shipments. However, both DDP and LDP could leave the sourcer in the dark because the supplier is in charge of all the activities. The lack of control during the shipment may not be a good idea for many sourcers.

Overall, FOB, CIF, and LDP are the most common terms used in global sourcing. The selection of cost term is negotiated between the sourcer and the supplier. FAS is often used for trade data collection and analyses as it accounts for only the true cost of product manufacturing. It is extremely important for sourcers to understand each term so they can make the best decision on any sourcing project.

Examples of initial costing. Let's discuss the differences between these cost terms using the example of Amazing Jeans's boys' cotton denim jeans quoted by suppliers in El Salvador, China, and Vietnam. Table 7.3 illustrates direct cost factors for the jeans. Costs could vary depending on the total quality, lead time, availability of raw materials, weight of

FIGURE 7.8 *The average five-pocket jeans' SAM ranges between 12 and 17.*
Source: pixs4u/Shutterstock

finished garments, size of the ocean shipment container, and many other factors. However, for easy comparisons, this example is made based on a few assumptions as follows:

- The cost of fabric, $1.50 per pair, is the same for all suppliers as the fabrics will be produced and shipped from one designated fabric supplier.
- The cost of trim or embellishments per garment, $0.50, is also same. Although there are some differences, the degree of variances in costs among the countries is very small.
- The total quantity meets the minimum quantity of production required by a supplier.
- The skills of the operators among the potential suppliers are similar with the Standard Allowed Minute (SAM) of 15 (the average five-pocket jeans's SAM ranges between 12 and 17). This means it takes 15 minutes, or 0.25 hour, to completely assemble one pair of jeans. Figure 7.8 shows the average five-pocket jeans's SAM, ranging between 12 and 17.
- The average labor cost of sewing operators in each country is approximately 20 percent higher than the country's minimum wage (not all apparel operators work at minimum wages). The current minimum wage of El Salvador is $2.00 per hour (Minimum-wage.org, 2009), therefore $2.40 per hour is used. The minimum wage of Vietnam is reported to be $1.00 per hour, therefore $1.20 is used for calculation (Minimum-wage.org, 2009). China has no minimum wage set for the entire nation. Instead, different parts of China have different standards of living. However, as of 2008, the average wage of an apparel worker in the coastal region was more than 38 percent higher than those in Vietnam (Au, 2009). Therefore, $1.66 was used in this calculation.
- All transportation is through ocean shipments. Ocean rates vary, depending on whether containers are full or not, how heavy the merchandise is, how far the merchandise needs to travel, and how early sourcers could reserve the cargo. Therefore, it is extremely difficult to estimate the correct rates. However, assuming everything else is equal except the travel distance from El Salvador, Vietnam, and China, we could reasonably estimate freights and ocean shipment insurances at $0.20, $0.40, and $0.50 per pair of jeans (that is, the ocean freight from China to Long Beach is double of that from El Salvador and three-fourths of that from Vietnam).

TABLE 7.3
Direct cost factors per garment for boys' cotton denim jeans program

Factor	El Salvador	China	Vietnam
1. Fabric	$1.50	$1.50	$1.50
2. Trim or embellishments	$0.50	$0.50	$0.50
3. Labor for CMT and packing	$0.60 ($2.40 × 0.25/hr)	$0.42 ($1.66 × 0.25/hr)	$0.30 ($1.20 × 0.25/hr)
FOB	$2.60	$2.42	$2.30
Freights and insurance	$0.20	$0.40	$0.50
CIF	$2.80	$2.82	$2.80
Duty	$0.00 (Duty-free due to CAFTA-DR)	$0.40 (16.6% of FOB)	$0.38 (16.6% of FOB)
LDP	$2.80	$3.22	$3.18
Domestic transportation	$0.20	$0.20	$0.20
DDP	$3.00	$3.42	$3.38

- The cost of domestic transportation is the same because all shipments from El Salvador, Vietnam, and China arrive at the same port in the United States. Therefore, the distance from that port to Amazing Jeans's distribution center is being considered.

As Table 7.3 shows, when comparing costs in the FOB term, Vietnam could be the best option for the sourcer because labor costs influence the overall direct cost structure. This is especially true if the sourcer designates particular fabrics from particular fabric producers and all suppliers must use same fabrics. This direct cost structure could change if the supplier has vertical operations where all fabrics and trims are made within the supplier's organization. At least, we can see the impact of low wage on FOB in Table 7.3. If sourcers do not have the knowledge of other direct costs beyond FOB, they may select Vietnam as the sourcing destination due to the lowest FOB cost. However, by the time ocean freights and insurances are added, costs in the CIF term are almost the same across El Salvador, China, and Vietnam. Finally, when the duty is added, El Salvador has the lowest cost. Table 7.3 shows how important it is for any supplier countries to have duty-free access to U.S. markets. Between China and Vietnam, both of whom are not duty-exempt countries, Vietnam has an advantage over China due to lower labor cost. In this light, one might agree that global sourcing businesses seek the lowest wages in the world.

However, this example also shows that not all global sourcing businesses selected the country with the lowest wage as trade agreements and preference programs significantly affect the total direct cost. In this case, although the FOB cost from El Salvador is 13.0 percent higher than that from Vietnam ($0.30 over $2.30), the LDP cost from El Salvador is 13.6 percent lower than that from Vietnam ($0.38 over $2.80). Therefore, experienced sourcers would choose El Salvador, the country with the highest wage among the three, for this sourcing project as it offers the lowest total direct cost.

INDIRECT COST

In addition to direct costs, there are other hidden indirect costs that sourcers must keep in mind throughout global sourcing (see Figure 7.9). Examples of indirect costs are the cost of making and shipping samples, the cost of reworking products if production failed during inspections, the cost of monitoring preproduction and production processes, the cost of communicating through e-mails or phone calls, the cost of expediting the shipments due to production delays, or even the cost of financing suppliers during the global sourcing project. In addition, sourcers could taint their

FIGURE 7.9 *In addition to direct costs, there are other hidden indirect costs that sourcers must keep in mind throughout global sourcing.*
Source: adirekjob/Shutterstock

companies' reputation due to irresponsible business practices conducted by a supplier. When the supplier's poor labor management or environmentally irresponsible business activities are publically known, the sourcer's reputation and businesses could also be affected. This is one of the indirect costs that no sourcer could afford, and another reason why triple bottom lines must be met simultaneously for long-term success and sustainability for humans and businesses.

This type of indirect cost almost always incurs during sourcing projects. Therefore, the prior history of a supplier's production and delivery is important to check to avoid any indirect costs. Even if the past records of a supplier are exceptionally good, sourcers still need to expect indirect costs. For example, natural disasters, such as earthquakes and hurricanes, could affect a supplier's production capacity, requiring reproduction or new production. Political unrest in the supplier's country may cause difficulties in preproduction and production monitoring. Air shipments due to late production could impact the sourcer's economic bottom line significantly as well as the environmental bottom line. Therefore, it is an industry norm to build in 5 to 10 percent additional cost to SAM or FOB to prepare for unexpected indirect costs.

Overall, the right price means the most optimal price for the sourcer after accounting for all direct and indirect costs. Sourcers should not focus on only one factor of direct costs. Rather, they must see the big-picture costing structure when evaluating suppliers' prices.

Summary

When comparing multiple offers from various suppliers across the world, sourcing personnel must consider many different factors before making sourcing decisions. The ultimate goal of sourcers' evaluations at this stage is to find the best possible option to produce the right products, in the right conditions, in the right quality, in the right time, at the right price. Different sourcing projects may force sourcers to weight the factors differently. For example, for a project that needs the shortest lead time due to fast-changing demand characteristics, sourcers may make lead time and travel time the most important factor. For a project that needs the highest efficiency

in apparel production due to extremely low retail price of the garments, sourcers may put the heaviest weight on price. In any case, all of these five factors (5Rs) must be considered and sourcers must make the best possible decision for a given sourcing project.

Right conditions examine the supplier's commitment and policies to improve society as well as the environment, two of the three triple bottom lines of sustainability (see Figure 7.10). Most of today's retailers take social and environmental compliances and policies very seriously. It is a sourcer's responsibilities to ensure that goods are made responsibly and help improve retailers' commitment to sustainability. In addition, a supplier's commitment to help improve the security of the global supply chain through C-TPAT certification is an important factor for sourcers to consider.

By right products we mean that sourcer must find a supplier who can produce the right products for a specific sourcing project. Each supplier has different capabilities and just because a supplier is large and has extensive experience does not mean that the supplier could deliver what the sourcer needs. Sourcers also must pay

attention to the quality of products each supplier produces. Highest quality may not be the necessary requirement if a sourcer is seeking a supplier who can produce goods for middle or mass markets in the United States. Highest quality may also mean different things, depending on the country in which each supplier operates. Therefore, a clear understanding of the degree of quality that each supplier can offer is extremely important for any sourcing decision.

Speed to market is even more important in today's marketplace than in the past. Lead time to produce and transport the finished goods can often be more important than other factors to harvest the highest economic gains if the goods are highly fashionable. Therefore, to properly calculate the total lead time, sourcers must make sourcing decisions based on the demand characteristics of the products, a supplier's past history of lead time, a supplier's commitment to other buyers, and ocean shipment transit time.

Finally, calculating the right price is another important factor that sourcers must keep in mind. *FOB, CIF,* and *LDP* are the most common terms for costs in global sourcing. Sourcers must be savvy enough to ask the suppliers about their cost terms. Depending on the term, sourcers take different risks and, therefore, it is critical for them to fully understand the advantages and disadvantages of each cost term and be able to make the best possible sourcing decisions. Costs could also be direct and indirect. Sourcers must anticipate various factors affecting direct and indirect costs throughout the sourcing project.

Overall, successful sourcing decisions must be made after careful consideration of all 5Rs. Successful sourcing will ensure that textile and apparel industries are sustainable in the future.

FIGURE 7.10 *Nairobi, Kenya. Right conditions examine the supplier's commitment and policies to improve society as well as the environment.*
Source: Natalia Pushchina/Shutterstock

key terms

Cost and Freight (C&F or CNF) is similar to Cost, Insurance, and Freight (CIF), but does not include the cost of ocean insurance policies.

Cost, Insurance and Freight (CIF) covers all costs and risks of apparel manufacturing, ocean insurance policies, and freights until the goods reach the point of destination that the sourcer designated.

Customs-Trade Partnership Against Terrorism (C-TPAT) is a voluntary supply chain safeguard program led by U.S. Customs and Border Protection.

Delivered Duty Paid (DDP) includes the transportation cost from the port of the sourcer's country to the sourcer's facility to LDP.

Ex Point of Origin indicates that the seller (the supplier in the context of global sourcing) prepares the goods at the point of origin (mostly the facility in which the goods were made and packed) and assumes all the costs and risks until the buyer (the sourcer in the context of global sourcing) picks up the goods from that facility.

Free Along Side (FAS) indicates that the supplier is responsible for delivering the goods alongside the vessel so the goods can be within the reach of the loading tackle.

Free on Board (FOB) indicates that the supplier is responsible for all the costs and risks until the goods are placed in or on the vessel at the loading point.

Landed Duty Paid (LDP) covers all costs and risks associated with shipping up to the point at which the goods are delivered to the point of destination and cleared for the sourcer's country's Customs with the payment of appropriate duties.

learning activities

1. Discuss why "right conditions" of each supplier are important for sourcing managers' decisions, regardless of individual cost.

2. Select three major (or publicly trading) retailers or apparel brands at different price levels. Find out the codes of conduct, supplier assessments, or any other compliance requirements for each. Then compare and contrast the compliance requirements for all three retailers or brands and discuss why such differences exist.

3. Search for various apparel manufacturing companies on the Internet. Read the descriptions of what they can do, and determine what type of apparel products would be ideal for each company. Discuss similarities and dissimilarities among the companies in terms of the type of manufacturing equipment.

4. Go to the Sea-Rates.com website and find out the transit time and ocean rates for a full container load for the following routes:
 a. Cape Town, South Africa, to Charleston, South Carolina
 b. Taipei, Taiwan, to Long Beach, California
 c. Karachi, Pakistan, to Newark, New Jersey
 d. Istanbul, Turkey, to Newark, New Jersey
 e. Mumbai, India, to Long Beach, California

5. Through Internet research, find out the major ports in the following countries:
 a. United States
 b. Guatemala
 c. India
 d. China
 e. Singapore

6. Discuss the advantages and disadvantages, from the sourcer's perspective, of each of the following direct costs:
 a. $4.00 FOB Shanghai, China
 b. $5.15 CIF Newark, New Jersey
 c. $5.00 LDP Seattle, Washington
 d. $6.00 C&F Long Beach, California

7. Show examples of how indirect costs could affect the overall triple bottom lines— economic, social, and environmental goals—of a sourcer's company.

8. Show examples of how higher direct costs could help the sourcer's company's overall triple bottom lines—that is, how a sourcer's company pays more yet achieves higher financial, social, and environmental performance.

references

American Apparel Manufacturers Association. (1998). *Sourcing without surprises: Report of the Technical Advisory Committee, American Apparel Manufacturers Association.* Alexandria, VA: Author.

Au, K.-F. (2009, January). *The manufacturing apparel industry in China.* Retrieved May 22, 2012, from Around the World: China: http://www.udel.edu/fiber/issue3/world/ApparelIndustry.html

Ha-Brookshire, J., & Dyer, B. (2009). Framing a descriptive profile of a transformed apparel industry: Apparel import intermediaries in the United States. *Journal of Fashion Marketing and Management, 13*(2), 161–178.

Minimum-wage.org. (2009). *World minimum wage rates 2012.* Retrieved May 22, 2012, from http://www.minimum-wage.org/minwage/international

Sea-Rates.com. (2012). *Sea rates.* Retrieved May 10, 2012, from http://www.searates.com/reference/portdistance/?country1=149&fcity1=27598&country2=200&fcity2=15873&speed=14

U.S. Customs and Border Protection. (2012, March 14). *What is C-TPAT?* Retrieved June 1, 2012, from http://www.cbp.gov/xp/cgov/trade/cargo_security/ctpat/ctpat_program_information/what_is_ctpat

Walker Customs Broker LLC. (2012). *Common international trade terms of sales.* Retrieved October 31, 2012, from http://www.walkerchb.com/WCB%20COMMON%20TERMS%20OF%20SALE.pdf

The Walt Disney Company. (2012). *Code of conduct for manufacturers.* Retrieved January 30, 2012, from http://corporate.disney.go.com/citizenship/codeofconduct.html

GLOBAL SOURCING STEP 4: PURCHASE ORDER AND METHODS OF PAYMENT

LEARNING OBJECTIVES

The sourcer finally issues a purchase order when initial costing has been agreed on and the details of production and products have been settled. While issuing a purchase order, the sourcer also negotiates how to make payment to the supplier once the supplier fulfills his or her contract. Upon completion of this chapter, students will be able to:

- Understand the role and the importance of a purchase order between the sourcer and the supplier and the necessary items and details that a good purchase order may include.
- Evaluate the types of information necessary to complete a purchase order in global sourcing.
- Appreciate how important it is for sourcers to know the full apparel production process from fabric and raw materials to complete apparel production and sourcing in the global marketplace.
- Analyze different levels of risk and cost associated with various methods of payment, including consignment sales, open account, document collection, letters of credit, and cash in advance.
- Appreciate various terms involved in document collections and letters of credits.
- Create the optimal payment method for any given sourcing project.

8

(Opposite page) *Source:* Russell Shively/Shutterstock

Step 4: Purchase order and methods of payment

Once initial costs are estimated and the supplier is selected, sourcers then create a purchase order, a legal sales contract. A purchase order stipulates what has been agreed between the supplier and the sourcer, including product details, quantity, price, delivery date and method, packing instruction, quality assurance policies, and so on. Methods of payment are also negotiated at this stage. Some methods of payment require a purchase order as a required document to arrange payments to the foreign supplier. Therefore, a good purchase order illustrates every detail a supplier may need to know to produce and deliver the goods in the way the sourcer wants. The purchase order also shows how the payment would be made by the sourcer once the supplier fulfills its contracts. Considering the multiple translations and interpretations made by supplier personnel in a foreign country, clear communication is critical for any purchase order to be effective. This section discusses the fourth stage of the seven core steps of global sourcing:purchase order issuance and payment method negotiation (see Figure 8.1).

Purchase order issuance

Once a supplier is selected with acceptable initial costs, the next step for sourcing personnel to take is to issue a purchase order and to negotiate a method of payment. A purchase order serves as a legal contract between the buyer (i.e., the sourcer) and the seller (i.e., the supplier). A purchase order stipulates what the buyer has purchased and what the seller has agreed to

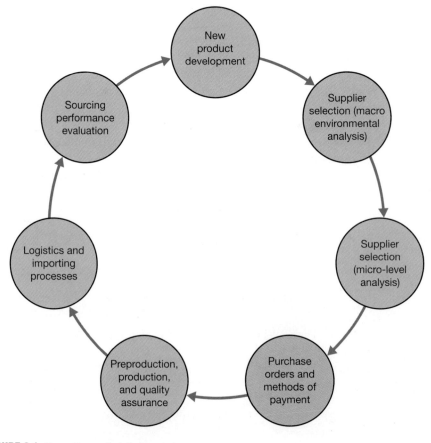

FIGURE 8.1 Core steps of global sourcing

provide at a particular price as well as the delivery terms. Both parties must agree on all the details listed on the purchase order and sign it in order for the purchase order to be legally effective. A payment method also needs to be discussed and negotiated, as each method of payment offers its own risks and costs to both sourcers and suppliers.

Although the format and detail requirements of a purchase order may vary depending on the company that issues a purchase order, a typical purchase order will include the following information: (a) product identification; (b) product descriptions; (c) quantity per unit and total quantity per contract; (d) price per unit, total contractual amount, and the terms of the price; (e) delivery date and method; and (f) other terms and conditions if necessary. The method of payment must also be stated on the purchase order.

Product identification number

When multiple products and styles are involved, it is easy to communicate each of the unique products by a number. Each company will generate a unique identification number for each product or style. This number is useful when communicating between the sourcer and the supplier and helps eliminate miscommunication. This number is also useful for production and sales tracking.

The product identification number could be linked with a Universal Product Code (UPC), or a bar code, so that retailers can track how many units of each product are sold at the point-of-sale (POS). The most common form of UPC in the U.S. retail marketplace is UPC-A consisting of a scannable strip of black bars and white spaces and 12-numerical digits (GS1 US, 2012). Recently, a two-dimensional code, or Quick Response (QR) code, was developed to track and store a greater amount of information than a unidimensional code (Furht, 2011). The QR code was invented in 1994 by Denso Wave Incorporated, a subsidiary of Toyota, to track vehicles during the manufacturing process. A QR code consists of black modules arranged in a square pattern on a white background. Both UPC and QR codes, along with product descriptions, can be used to communicate a specific style on a purchase order. Figure 8.2 illustrates examples of UPC, and Figure 8.3 shows an example of QR code.

EAN13

EAN8

UPC-A

FIGURE 8.2 *There are many different types of UPCs.*
Source: GS1 US. (2012). EAN/UPC. Retrieved January 5, 2012, from Standards: http://www.gs1us.org/standards/barcodes/ean_upc

4557 A 890T 8125SS 7

CODE39

4557 A 890T 8125SS 7

CODE93

/T/U/U/W A /X/Y/PT /X/Q/R/USS /W

CODE39EXT

4557

CODE128

4557 A 890T 8125SS 7

RM4SCC

FIGURE 8.3 *QR codes are two-dimensional, with a greater amount of information storage.*
Source: Morrison, A. (2011, March). Technology tools for the classroom: QR codes. Retrieved from Pearson school systems: http://www.pearsonschoolsystems.com/blog/?p=280

Product descriptions

A complete list of product details is necessary for successful global sourcing. In particular, the details on a purchase order must have been negotiated between the supplier and the sourcer, and it should reflect the costing sheet and any amendments since the initial cost. The less information a purchase order has or the vaguer that information is, the more likely a supplier will need to guess what the missing detail is and, therefore, the more likely it is that wrong products can be produced. Detailed information on a purchase order may include but is not limited to:

- Acceptable fabrics, including fiber content, fabric construction, and fishing techniques.
- Acceptable trims or embellishments, if any, including fiber content, trim construction, and finishing details.
- Trim or embellishment placement.
- Technical design sketches with size specifications.
- Production techniques.
- Label or tag requirements and placement.

In the case of Amazing Jeans's boys' cotton denim jeans, a purchase order must include fabric details such as the fiber content, yarn quality, yarn size, type of knit, fabric weight, finishing technique, and so on. For example, the information on the quality of yarns and the size of the yarns is critical for the thickness, softness or stiffness, and cost of the finished fabrics. The desired type of woven denim, such as twill or plain, and washing techniques are also necessary, as both affect the appearance of the finished fabrics. In addition, the weight of the denim fabric per a standardized size (such as square yard or square meter) indicates the thickness, density, or bulkiness of the finished fabrics. Amazing Jeans's purchase order may also require an enzyme wash during the finishing procedure for added softness. After considering all of these details, the sourcer must stipulate acceptable fabric details on a purchase order. The following is an example of a proper description of acceptable fabrics that could be used in global sourcing contracts:

> **Fabric description:** 100% cotton, Carded yarn in size No. 5, 12 oz. twill denim, enzyme washed.

This is just an example of the type of information that would be necessary for the supplier to prepare the right fabrics for boys' cotton denim pants. Different specific information would be necessary for other type of fabrics. These details are important for the sourcer to clearly communicate to the supplier what is desired for the new products. The supplier will know exactly what is required to be produced under the purchase order.

In addition to fabric and trim details, a purchase order would include technical design sketches showing production details, size specifications, and grading rules. These are critical for the supplier to understand how the garment would be constructed at the factory and how each garment would be graded to different sizes. Similar details are necessary for trims, artworks, labels, and manufacturing techniques. If buttons are required on the product, a purchase order must specify what the button will look like in terms of size and shape (see Figure 8.4). The raw materials of the button must be communicated (for example, plastic or metal), and the total number of required buttons in one garment, including the placement of each button, needs to be specified. Similarly, a purchase order includes the required labels and tags, such as a care label, a brand label, and a size tag, and clearly illustrates what each label will look like and where and how each label will be attached.

FIGURE 8.4 *Even communicating what type of button a certain item of apparel needs is not as easy as it sounds.*
Source: Andy Crawford/Dorling Kindersley/Pearson Education

Once again, without these details the supplier would be more likely to assume what the missing details would be, and sourcing personnel would be more likely to find surprises during or after production. Therefore, a more detailed and complete purchase order will prevent any surprises at the end of the sourcing assignment. In today's businesses, most of these product details are being communicated digitally through computer software.

Contract Quantity

A purchase order also includes the total quantity that the sourcer wants the supplier to produce (see Figure 8.5). The total quantity is a sum of the quantities per style, per size, per color, and per other assortment requirements. Let's assume the total contract of Amazing Jeans's boys' cotton denim pants program shows 120,000 pieces and this contract has two different styles: 75% of regular-length pants and 25% of capri-length pants. Each style requires three different color (or shade) choices with an even quantity breakdown and a size ratio of 7/8-10/12-14-16 (or S-M-L-XL) = 1-2-2-1 (this ratio is typically provided by retail analysts and retail buyers). Then, the purchase order must show the breakdown of the total quantity per style, per color, and per size. That is, the purchase order shows 30,000 pieces per color, resulting in a total of 90,000 pieces of regular-length pants. It should also show 10,000 pieces per color for a total of 30,000

FIGURE 8.5 *A purchase order also includes the total quantity that the sourcer wants the supplier to produce.*
Source: Britta Jaschinski/Dorling Kindersley/Pearson Education

pieces of capri-length pants. Finally, 30,000 pieces of each color, regular-length pants will then be divided into four different sizes of 7/8-10/12-14-16 with the ratio of 1-2-2-1. The same division applies to 10,000 pieces of short-sleeve shirts. Table 8.1 shows an example of quantity breakdown for a 120,000-piece order.

Price per unit, total contractual amount, and terms of the price

A proper purchase order includes the price agreed on between the sourcer and the supplier. Some negotiations will be done per unit and others per contract. The most common price unit is piece, set, or dozen. The garment weight, represented by pounds or kilograms, could also be used as a unit of the price. Regardless of the negotiation unit, the sourcer and the supplier must be clear as to what these prices represent and include, including a correct cost term such as FOB, CIF, or LDP. Table 8.1 shows price per piece in FOB and the total price of the entire 120,000-piece order. In this example, a pair of boys' cotton denim pants in regular length is $0.25 more expensive than those in capri length. This contract shows that the purchase order of 120,000 pieces of Amazing Jeans boys' cotton denim pants is contracted at US$352,500 for FOB.

Delivery date and method

In addition to quantity and price, a purchase order includes a delivery date and method. The most common way to transport goods in global sourcing is by ocean shipment. Air shipments are faster, but the cost is much higher than ocean shipments. In either case, a purchase order should indicate an acceptable shipping mode as well as a delivery date, as in ETD Ex-Factory. This information clearly communicates the ETD Ex-Factory date that both parties agree on so that the sourcer would be able to find out when the shipment will arrive in the United States, depending on the shipping mode. Sourcing personnel then communicate this information to

TABLE 8.1

Example of quantity breakdowns and prices

Style Number	Quantity (Pieces)	Color	Quantity (Pieces)	Size	Quantity (Pieces)	Unit Price (FOB)	Total Price (FOB)
12345	90,000	Light	30,000	7/8	5,000	$ 3.00	$ 15,000.00
Regular length				10/12	10,000	$ 3.00	$ 30,000.00
				14	10,000	$ 3.00	$ 30,000.00
				16	5,000	$ 3.00	$ 15,000.00
		Medium	30,000	7/8	5,000	$ 3.00	$ 15,000.00
				10/12	10,000	$ 3.00	$ 30,000.00
				14	10,000	$ 3.00	$ 30,000.00
				16	5,000	$ 3.00	$ 15,000.00
		Dark	30,000	7/8	5,000	$ 3.00	$ 15,000.00
				10/12	10,000	$ 3.00	$ 30,000.00
				14	10,000	$ 3.00	$ 30,000.00
				16	5,000	$ 3.00	$ 15,000.00
12345	30,000	Light	10,000	7/8	1,667	$ 2.75	$ 4,583.33
Capri length				10/12	3,333	$ 2.75	$ 9,166.67
				14	3,333	$ 2.75	$ 9,166.67
				16	1,667	$ 2.75	$ 4,583.33
		Medium	10,000	7/8	1,667	$ 2.75	$ 4,583.33
				10/12	3,333	$ 2.75	$ 9,166.67
				14	3,333	$ 2.75	$ 9,166.67
				16	1,667	$ 2.75	$ 4,583.33
		Dark	10,000	7/8	1,667	$ 2.75	$ 4,583.33
				10/12	3,333	$ 2.75	$ 9,166.67
				14	3,333	$ 2.75	$ 9,166.67
				16	1,667	$ 2.75	$ 4,583.33
Total	120,000						$ 352,500.00

other teams, such as distribution centers, imports, and finance, so these teams can be prepared to receive, store, and pay for the shipment in a timely manner. Chapter 10 discusses various shipping modes and advantages and disadvantages of each shipping mode in detail.

Other terms and conditions

Other terms and conditions can also be useful for a purchase order, if both the supplier and sourcer agree with each other. Examples of other conditions are quality assurance policies, order cancellation policies, or contingency plans in case any of the contractual conditions are not met. Full details on quality assurance policies are discussed in Chapter 9. More and more sourcers are now heavily involved in quality assurance policies from preproduction to production and shipping stages. Some sourcers fully disclose their specific quality assurance policies through their operating procedures or purchase orders.

Sometimes, though not often, a purchase order could be canceled due to declining consumer demands or changes in consumer tastes. Hopefully, the decision on cancellation is made prior to producing any bulk fabrics or trims so the supplier has not actually produced finished goods yet. However, if the cancellation occurs in the middle of fabric or garment production, both parties would need some type of contingency plan to find a way to reduce

financial damage and distribute goods through other channels. In other cases, a purchase order can be canceled if either of the parties fails to fulfill certain requirements and obligations to each other. A functioning purchase order should include these contingency plans in case there is a failure of commitment and execution of the purchase order. These plans should include examples of contractual failures and the consequences of such failures, such as order cancellation or charge backs. The following statements are examples of the cancellation policies and contingency plans that the sourcer may want to include in a purchase order:

> The sourcer reserves the right to cancel all or any portion of the purchase order, or charge back the supplier for any associated financial loss, if any or all of the following criteria are not met at the time goods are ready to depart the country of origin:
>
> - Complete and satisfactory laboratory test reports for each style within this purchase order under the general performance standard for textiles and apparel items (see Figure 8.6).

FIGURE 8.6 *The sourcer may reserve the right to a satisfactory laboratory test report or he or she may charge back the supplier.*
Source: anyaivanova/Shutterstock

- An inspection report issued by an authorized sourcer's representative.
- An approval letter on any overage or shortage in quantity from an authorized sourcer's representative.

Payment method negotiation

While a purchase order is being issued, the sourcer also must negotiate how to make payments to the supplier. Similar to cost terms, different methods of payment impose different risks and expenses to both suppliers and sourcers. Therefore, it is important for sourcers to understand clearly the risks and benefits associated with different payment methods in global sourcing. In addition, a purchase order must specify the method of payment and any required conditions of such payment. In general, there are five major ways to make payments to suppliers or sellers in trades: (a) consignment sales, (b) open account, (c) documentary collection, (d) letter of credit, and (e) cash in advance (Seyoum, 2000).

Consignment sales

Under the **consignment sales contract**, the sourcer does not pay until the supplier's goods are sold to a third party. That is, the supplier provides the merchandise to the sourcer on a deferred payment basis with little or no collateral. While the sourcer is seeking a potential buyer for this merchandise, the title (a document showing the ownership) of the goods belongs to the supplier, and the title would be transferred to the sourcer only once the goods are sold to a third party and the payment is made to the supplier.

For the sourcer, consignment payment is one of the least risky methods of payment. The sourcer spends the least amount of capital to receive the merchandise and sells it in a timely fashion (see Figure 8.7). When the goods are not sold, the sourcer can return them to the supplier

FIGURE 8.7 *In consignment agreements, the supplier who sends the merchandise will not get paid until a representative in another country sells the goods to a third party.*
Source: © adisa/Fotolia

with little or no cost. On the other hand, for the supplier, consignment sales are highly risky because the sourcer may not make sincere efforts to sell the goods or may not make payments even if the goods are sold. Consignment sales require a great degree of trust on the part of the supplier that the sourcer will be active in making sales and will pay once the merchandise is sold.

However, in certain cases consignment sales are still effective for the supplier. For example, if the supplier wants to test new products in the market or test a market in a new country (Seyoum, 2000), consignment sales could be an attractive option for the supplier because the sourcer might be more willing to receive the supplier's merchandise and try to sell to other buyers. Consignment sales could also be effective if the supplier's own sales representative or dealer acts as a sourcer in a different country. That is, the supplier that sends the merchandise will not get paid until its own sales representative in another country sells the goods to a third party. Other than these examples, consignment sales are hardly used in global sourcing.

Open account

Open account is similar to consignment sales, except that the term of payment usually ranges from 30 to 120 days regardless of whether the sourcer sold the goods to a third party (Seyoum, 2000). This type of open account, with 30 to 120 days of term of payment, is intended to provide sufficient time for the sourcer to ship the goods to another buyer or sell them to ultimate consumers to raise cash for the payment to the supplier.

Once again, open account is rarely used in global sourcing unless the supplier and the sourcer have a trusting relationship or share ownership. Without shared trust or ownership, open account could be extremely risky for the supplier, while the sourcer has a very limited amount of risks. Similarly, open account is extremely costly and risky for the supplier, as the supplier is responsible for all costs related to producing and shipping the merchandise to the sourcer without any payment. Similar to consignment sales, open account is often used when the supplier is interested in testing new markets or gaining access to new markets through the help of the sourcer in a different country (Seyoum, 2000).

Documentary collection (documentary draft)

Documentary collection, also called documentary draft, is one of the most common methods of payment in global sourcing (Seyoum, 2000; see Figure 8.8). Documents in global sourcing, including the title to the goods, are important because they are critical for the goods to go through Customs once reaching the sourcer's country. Without the necessary documents, the goods cannot be identified for proper ownership or enter the sourcer's country legally. Therefore, as much as it is important to produce the goods in the right condition, in the right quality, in the right time, and at the right price, acquiring all the necessary documents from the supplier is also critical for successful global sourcing, particularly for FOB and CIF contracts. FOB and CIF contracts require the sourcer to be responsible for Customs clearance; Customs reviews the merchandise and assesses necessary duties based on the documents submitted by the sourcer.

In documentary collection, two banks—the supplier's (remitting bank) and the sourcer's (collecting bank)—are involved to facilitate the payment. Document against payment (D/P) and document against acceptance (D/A) are the two most common types of document collection (Seyoum, 2000). In a typical document against payment transaction, the following procedures take place:

FIGURE 8.8 *Documentary collection (or documentary draft) is one of the most common methods of payments in global sourcing.*

1) A purchase order is issued between the supplier and the sourcer. The supplier makes the shipment of the merchandise and prepares the necessary documents as the purchase order stipulates.

2) The supplier submits the documents to its bank with the instruction letter indicating a D/P condition. The remitting bank forwards these details to the collecting bank.

3) Upon receipt of these details, the collecting bank contacts the sourcer and presents the documents and the instruction letter.

4) The sourcer makes the payment to its bank in exchange for the documents.

5) The collecting bank pays to the remitting bank, and the remitting bank makes payments to the supplier (Seyoum, 2000).

D/A is similar to D/P, but in the case of D/A the supplier allows the sourcer a certain period of time before making payments (Seyoum, 2000). Usually D/A has either a time draft or a date draft condition. A time draft indicates the payment is due within a certain time (usually 30 days) after the sourcer accepts the documents. A date draft shows the payment is due on a certain date. In either case, if these terms are agreed on between the sourcer and the supplier, the sourcer's bank releases the documents to the sourcer. The sourcer is then able to clear Customs with those documents and legally sell the merchandise in the sourcer's country. Once the payments are made by the sourcer as specified as in D/A, then the sourcer's bank submits the payment to the supplier's bank and, in return, to the supplier. In this light, D/A is a riskier option than D/P for the supplier and a more favorable option for the sourcer (Seyoum, 2000).

In the document collection transactions, banks are simply agents to collect payments. Banks assume no responsibility for losses that may arise from delay of shipment, damage during shipments, or loss of documents (Seyoum, 2000). Banks do not check whether documents submitted by the supplier are correct or authentic. Verifying the content of the documents and checking the authenticity of signatures and statements are the responsibilities of both sourcers

FIGURE 8.9 *Unlike document collections, the sourcer's bank assumes liability for payment to the supplier on behalf of the sourcer in letter of credit (L/C) transactions.*
Source: © Vladislav Kochelaevs/Fotolia

and suppliers in document collection. However, banks in document collections help reduce transaction costs and increase transaction speed for both suppliers and sourcers.

Letter of credit

Letter of credit (L/C) is another common method of payment in global sourcing. Just as in document collections, two banks are involved in L/C transactions. Unlike document collections in which banks act only as agents between the supplier and the sourcer, however, the sourcer's bank assumes liability for payment of the purchase price to the supplier on behalf of the sourcer in L/C transactions (Seyoum, 2000; see Figure 8.9). An L/C is a document stipulating this transactional relationship.

L/C transactions are possible when a bank makes credit available to its client, the sourcer in the global sourcing context, in consideration of collateral securities. The types of securities vary depending on the sourcer's creditworthiness and the relationship it has with the bank. When the sourcer's credit is not excellent and the bank has little history with the sourcer, the bank may ask the sourcer to provide funds prior to issuing any new L/Cs. Even if the sourcer's credit is favorable and the bank is willing to loan the money to the sourcer, the bank still may ask for a pledge of the documents of title to the goods in case the sourcer cannot repay the bank. Some banks also open L/Cs based on a certain percentage of a total L/C value as a form of commission.

At any rate, L/C transactions are possible if the following four distinct bilateral contracts are present: (1) a sales contract or a purchase order between the sourcer and the supplier, (2) a credit and repayment contract between the sourcer and the issuing bank, (3) a letter of credit between the issuing bank and the supplier as beneficiary, and (4) a payment contract between the advising bank and the supplier (Seyoum, 2000).

Based on these four bilateral contracts, a typical L/C transaction takes the following procedures:

a) A purchase order is issued and agreed on between the supplier and the sourcer.

b) The sourcer applies for an L/C from its bank (issuing bank) with all the details and conditions stipulated in the purchase order.

c) The sourcer's bank issues an L/C to the supplier's bank (advising bank) with the supplier as beneficiary.

d) The advising bank notifies the supplier that an L/C has been issued on its behalf and is available upon presentation of the necessary documents.

e) The supplier reviews the L/C and agrees with all the terms and conditions. He or she arranges shipments and prepares the necessary documents as listed in the L/C. If the supplier does not agree with certain conditions, or if certain information is incorrect, amendments to the L/C can be made. Most amendments require agreement by both sides.

f) After shipments are made, the supplier submits all necessary documents to the advising bank for payment. If a certain payment contract between the supplier's bank and the supplier is already made, depending on the condition of the contract, the supplier may get paid upon presentation of the documents.

g) The advising bank sends the documents and payment instructions to the issuing bank.

h) The issuing bank reviews the documents and other conditions, and if all is good and in compliance, the issuing bank makes payment to the advising bank.

i) The issuing bank gives documents to the sourcer and presents the term draft for acceptance. With a sight draft, the sourcer makes payment to the issuing bank upon presentation of the documents (L/C at sight). With a time draft, the sourcer makes payment to the issuing bank on or before the draft maturity date. For example, L/C net 30 days means that the sourcer must pay its bank within 30 days of the receipt of the documents.

j) The sourcer arranges for Customs clearance with the documents and takes receipt of the merchandise (Seyoum, 2000).

There are a few important advantages in using L/Cs for payment. Because of the banks' guarantees to payments, both supplier and sourcer would be less vulnerable to contract violations by each party (Seyoum, 2000). Through a payment contract between the supplier and its bank, the supplier is guaranteed to receive the payment as long as he or she ships the goods and presents the necessary documents. Through the credit available by its bank, the sourcer does not need to make prepayment to the supplier until the goods are shipped and the documents are in the supplier's or its bank's possession. Therefore, the competing needs of both supplier and sourcer are met through L/Cs (see Figure 8.10).

Despite these advantages, L/Cs also offer disadvantages to sourcers and suppliers. First, to get credit from the bank, the sourcer must maintain a good credit rating. Without a good credit rating, the sourcer may have to come up with cash or other collateral securities before opening any new L/Cs. In addition, L/Cs require complex communications and coordination among the supplier, the sourcer, and each of their banks. The slightest discrepancy and miscommunication could result in delay of payments, interruption in document presentation, and even nonpayment. Discrepancies occur when there are differences between the documents presented after the shipment and the original letter of credit. There are three types of discrepancies: accidental, minor, and major (Seyoum, 2000).

FIGURE 8.10 *The competing needs of both supplier and sourcer are met through L/C agreements.*
Source: Monkey Business Images/Shutterstock/Pearson Education

Accidental discrepancies include typographical errors, omission of the L/C number, arithmetic errors, a lack of signature, and so on. These discrepancies can easily be corrected by the supplier, and the supplier's bank could easily communicate with the supplier to correct them before submitting the documents to the sourcer's bank.

Minor discrepancies include failure to legalize the documents, lack of required documents, or different languages used between the documents and the L/C. Most of these discrepancies can be resolved through e-mails and resubmissions. That is, the sourcer may notify the supplier to legalize the documents and resubmit them, or submit a missing document, or change the language on the documents and resubmit them. This type of solution does not require L/C amendments that can be time-consuming. The sourcer could provide a written waiver of these discrepancies to its bank.

Major discrepancies are fundamentally incorrect and affect the nature of the L/C transaction (see Figure 8.11). For example, presentation of documents after the expiry date of the L/C, the shipment of the goods after the expiry date of delivery or the L/C, or the shipment of incorrect products without the sourcer's approval might occur. These discrepancies cannot be resolved with simple corrections of documents. These are violations of the contract without the sourcer's approval. These discrepancies may result in nonpayment, as the supplier made shipments under unacceptable conditions. However, if the sourcer wants to accept the late shipments or the products that have been shipped already, the sourcer could amend the L/C, authorizing the acceptance of such shipments.

The principles and guidelines for L/C transactions in internal trades are available in the Uniform Commercial Code (UCC) and the Uniform Customs and Practice for Documentary Credits (UCP) (Seyoum, 2000). If UCC or UCP provisions are not sufficient to resolve any disputes, courts apply general principles of law to reach a resolution (Seyoum, 2000).

There are several types of letters of credit. Some of the most popular types are irrevocable, confirmed, transferable, back-to-back, revolving, and negotiable (Seyoum, 2000):

- Irrevocable L/Cs cannot be amended or canceled without the agreement of all parties involved.

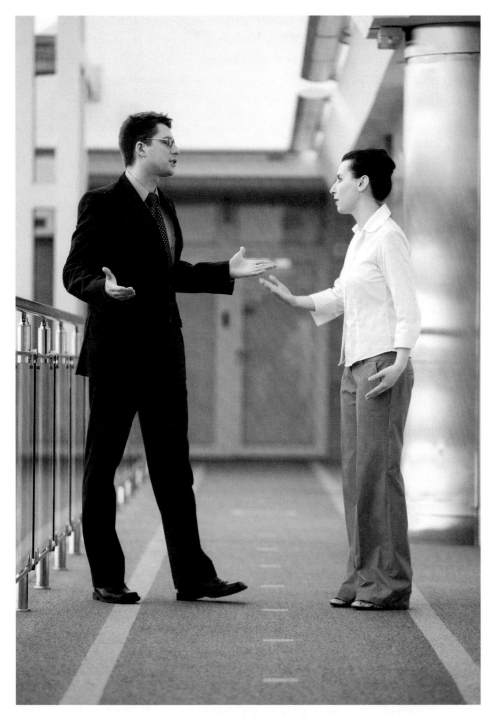

FIGURE 8.11 *Major discrepancies are fundamentally incorrect and affect the nature of the L/C transaction.*

- Confirmed L/Cs are letters in which the advising bank confirms its obligation to pay the supplier so long as the supplier follows the approved terms and conditions.
- Transferable L/Cs allow the supplier (or the beneficiary) to transfer the credit to another beneficiary (only one secondary beneficiary).
- Back-to-back L/Cs allow the supplier (or the beneficiary) to open secondary L/Cs to other beneficiaries. These are useful for the supplier that needs to purchase fabrics and other raw materials before apparel production, as the supplier could open secondary L/Cs for its fabric and raw material suppliers.

- Revolving L/Cs help the sourcer cover multiple shipments over a long period of time. Instead of arranging a new L/C for each shipment, the sourcer could establish a revolving L/C so that the supplier could continue to make shipments until it fulfills the entire contract.
- Negotiable L/Cs allow the supplier to negotiate payments at any bank, not just the advising bank.

Overall, a letter of credit can be an excellent and safe option for sourcers in global sourcing. However, the procedures can be complex, and multiple parties are involved to make transactions. Sourcers must fully understand the nature of L/C transactions and be able to make decisions on what type of L/Cs would be allowable for each different supplier. Once again, each option may impose different risks and costs to the sourcer, and it is the sourcer's responsibility to choose the optimal method of payment for his or her sourcing projects.

Cash in advance

Finally, **cash in advance** requires the sourcer to pay before a shipment is made (see Figure 8.12). Therefore, the supplier assumes no risk of delay in payment or nonpayment. When the sourcer has a poor credit rating, or when the sourcer has little or no prior history or relationship with the supplier, cash in advance is often required by the supplier. If the sourcer is brand new to the market and wants to make samples at the supplier's facilities, the supplier may ask for cash in advance for sample-making services. Cash in advance could also be used when the financial and political situation of the sourcer's country is unstable. In that case, the supplier may require the sourcer to pay in advance prior to shipments. Cash in advance is the riskiest and most expensive option for the sourcer.

FIGURE 8.12 *Cash in advance requires the sourcer to pay before shipment is made.*
Source: schankz/Shutterstock

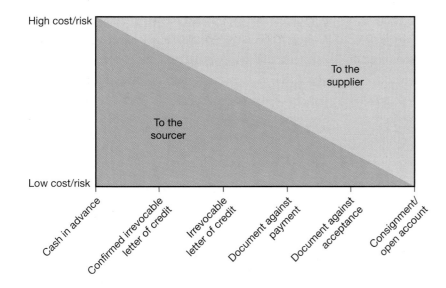

FIGURE 8.13 Methods of payment in global sourcing

Evaluation of payment terms

As discussed previously, each payment term poses different risks and costs to the sourcer and the supplier. Figure 8.13 illustrates risk and cost trade-offs among different methods of payments in global sourcing. To the sourcer, open account and consignment sales are the least costly methods of payment, followed by document against acceptance and document against payment. Cash in advance is the riskiest and most expensive option for the sourcer. The irrevocable letter of credit is fairly costly for the sourcer as the sourcer must have a good credit rating or good relationship with the bank. However, it also protects the sourcer, allowing him or her to receive documents from the supplier within the agreed-on terms and conditions. Once again, it is extremely important to understand the cost and benefits of each payment term, and the sourcer must discuss the method of payment during the initial negotiation. The method of payment agreed on by both parties must be written on the purchase order. This purchase order will then be used for the sourcer to open a new letter of credit (if that is what has been agreed on) through its bank.

summary

Once a supplier is selected for its economic, social, and environmental performance, the sourcer, as a buyer, would then issue a purchase order. A purchase order is a legal sales contract agreed on and signed by both supplier and sourcer. A good purchase order should be easy to read and understand and will state what needs to be completed for the supplier to fulfill the order for payment. A typical purchase order includes the following information: (a) product identification; (b) product descriptions; (c) quantity per unit and total quantity per contract; (d) price per unit, total contractual amount, and terms of the price; (e) delivery date and method; and (f) other terms and conditions if necessary.

A payment method should also be specified on a purchase order. There are various types of payment methods of which sourcers must be aware. Letters of credit and document collections are some of the most common payment methods in global sourcing. Both payment methods involve two banks, the supplier's and the sourcer's. Documents, including the title to the goods, are sent and received through banks in exchange for payments. In global sourcing, both suppliers and sourcers face risks, such as nonpayment for the supplier and lack of documents for the sourcer, and letters of credit and document collections help protect against some of those risks for both parties. Open accounts, consignment sales, and cash in advance could be options for payment. Each of these options poses different risks and costs to both suppliers and sourcers. Sourcers must carefully consider different options for payment method and select the most optimal choice for sourcing projects.

key terms

Cash in advance refers to a sales agreement that the sourcer pay before shipment is made by the supplier. The supplier assumes no risk of delay in payment or nonpayment.

Consignment sales contract refers to a sales agreement in which the sourcer does not pay until the supplier's goods are sold to a third party. That is, the supplier provides the merchandise to the sourcer on a deferred payment basis with little or no collateral.

Documentary collection (documentary draft) refers to a sales agreement between the sourcer and the supplier that the payment would be made by the sourcer's bank (remitting bank) to the supplier's bank (collecting bank) once necessary documents are prepared and submitted by the supplier. The sourcer assumes liability for payment.

Letter of credit (L/C) refers to a sales agreement between the sourcer and the supplier that the sourcer's bank assumes liability for payment to the supplier on behalf of the sourcer. A certain amount of credits are issued by the sourcer's bank to the sourcer so the sourcer's bank could guarantee the payment to the supplier within the credit amount.

Open account refers to a sales agreement that is similar to consignment sales, except that the term of payment usually ranges from 30 to 120 days, regardless of whether the sourcer sold the goods to a third party.

learning activities

1. Discuss the role and the importance of a purchase order in global sourcing.

2. Select one of your favorite articles of clothing from your closet. Come up with the best way to describe the required fabric and raw materials for a purchase order, as if you were a sourcing manager for that garment.

3. Search for "purchase order" online. Find out what type of information purchase orders usually communicate. Discuss how each element could be relevant or not to global sourcing projects.

4. Compare how letters of credit and document collections in the business setting can be compared with credit card and debit card transactions in the personal setting.

5. Discuss what types of risks and costs could be involved in international transactions. Explain why it would be a safer and less risky option to get banks involved in global sourcing.

6. Show real examples where open account and cash in advance could be useful in global sourcing.

7. Contact various industry members you might know. Ask what the common or preferred payment method is for their international businesses.

references

Furht, B. (2011). *Handbook of augumented reality.* Boca Raton, FL: Springer.

GS1 US. (2012). *EAN/UPC*. Retrieved January 5, 2012, from Standards: http://www.gs1us.org/standards/barcodes/ean_upc

Seyoum, B. (2000). Chapter 11. Methods of payment. In B. Seyoum, *Export-import theory, practices, and procedures* (pp. 193–221). Binghamton, NY: Haworth Press.

GLOBAL SOURCING STEP 5: PREPRODUCTION, PRODUCTION, AND QUALITY ASSURANCE

LEARNING OBJECTIVES

A purchase order is issued and the supplier fully understands what needs to be produced by when and how. The preproduction stage begins as the purchase order is being issued. Upon approval of all materials and components, the supplier starts production and the sourcer monitors that production while ensuring acceptable quality. Upon completion of this chapter, students will be able to:

- Understand the objectives of the various processes that take place during the preproduction and production stages.
- Comprehend the laws and regulations that sourcers must follow, and why complying with these laws is important for global sourcing.
- Appreciate the role of the U.S. Consumer Product Safety Commission, U.S. Federal Trade Commission, and U.S. Customs and Border Protection in global sourcing.
- Create and analyze how Time & Action calendars can be used in global sourcing.
- Understand and evaluate how final audits are done.
- Comprehend how strict and disciplined monitoring throughout preproduction and production could help both sourcers and suppliers.

9

Step 5: Preproduction, production, and quality assurance

Upon completion of the purchase order, the supplier starts preparing raw materials and production techniques for main production. If the letter of credit is an agreed-on method of payment, the sourcer opens a letter of credit to the supplier. The supplier then can use that guarantee of payment by the issuing bank to finance raw material purchases or production, labor costs, and other expenses. Most sourcers in today's marketplace are heavily involved in preproduction stages with extensive approval processes. Upon approval, the supplier starts production and prepares the finished goods for shipment. The sourcer arranges quality assurance and inspection procedures prior to any shipments. This section discusses the fifth stage of the seven core steps of global sourcing—preproduction, production, and quality assurance (see Figure 9.1).

Preproduction, production, and quality monitoring

Preproduction approval

Once a purchase order is issued and signed by both sourcer and supplier, the sourcing or production team starts to engage in preproduction approval processes. The supplier produces or obtains all necessary components and raw materials for garment production, following the purchase order.

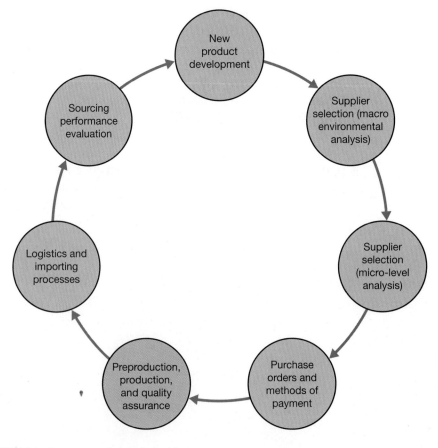

FIGURE 9.1 Core steps of global sourcing

The sourcer's team approves all of these components, from colors to size, construction, and qualities, determining whether or not they are acceptable for actual production. The objective of preproduction approvals is to prepare all the necessary and correct components for garment production in a timely manner. Apparel sewing factories are striving for high efficiency for profits and sustainability; any delay or stoppage during the production could potentially yield significant financial loss and unnecessary energy consumption. Therefore, no matter how small they are, if there are any missing items or delayed approvals, the entire garment production will be delayed.

During the preproduction approval stage, many samples are exchanged between the sourcer and the supplier, including **color lab dips** (small swatches of different shades of colors that are dyed in a laboratory setting); **pattern strike-offs** (small pieces of printed fabrics or materials prepared in a laboratory or sample-making setting); fabric swatches representing the bulk production (samples representing true fabric construction, weight, hand, and other properties); and samples of necessary buttons, shanks, other notions, and so on. Figures 9.2a through 9.2g show various examples of approval samples. Upon approval, the suppliers are instructed to produce all of these components.

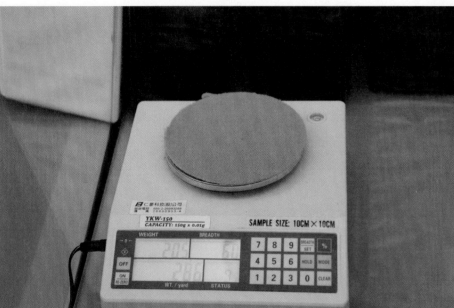

FIGURE 9.2a *A piece of fabric showing 205 grams per square yard is placed on a fabric scale.*

FIGURE 9.2b *An operator applies pressure to cut sample fabrics to a standardized size.*

FIGURE 9.2c *A sourcer makes comments on fit and construction techniques in Excel for a foreign manufacturer.*

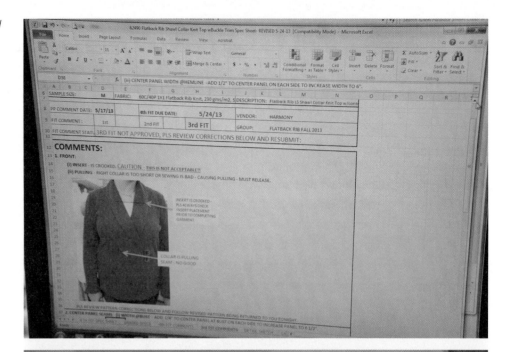

FIGURE 9.2d *A foreign supplier sends a print strike-off sample to a sourcer to get an approval before printing the bulk fabric.*

FIGURE 9.2e *A sourcer evaluates color lab dip choices sent from a foreign supplier in a light box against color standards.*

FIGURE 9.2f *A foreign supplier sends fabric color lab dip samples to a sourcer for an approval before bulk fabric dyeing.*

FIGURE 9.2g *It is critical to save fit and production samples in an organized way for future references.*

Approval of all these components and raw material production leads to the supplier's production of **preproduction samples (PPSs)**. PPSs are the samples made with all approved components by the supplier's sample department. PPSs also represent the supplier's cutting, grading, and sewing techniques. For both supplier and sourcer, a PPS is the first time to see what the actual production looks like in the supplier's production facility, using the supplier's equipment and production skills. Small changes are still possible during the PPS approval stage, such as changing the placement of notions or garment pattern alterations. However, at this stage it is almost impossible to change the color or construction of the main fabric as the bulk fabric already would have been produced. Close communication is extremely important during the preproduction stage because each approval from the sourcer's team leads to production of the approved materials. Once they are produced, it is extremely difficult to change without additional cost, energy consumption, and time.

Once all components are produced and PPSs are approved, the entire garment production takes place. Throughout the production, sourcers may want to require necessary testing and inspections to monitor acceptable production processes and qualities. Usually, inspecting the goods in the first 5 to 10 percent of the production is extremely important to prevent any problems for the rest of the production run. Experienced sourcers arrange a systematic procedure to inspect production schedules and qualities throughout the production stage.

Finally, upon completion of production, the supplier proceeds to packing. Many of today's retailers require suppliers and sourcers to provide products packed ready to be sold in their retail stores. This type of packing is called **floor-ready packing**. By getting the goods packed floor-ready by suppliers overseas, retailers and sourcers save a significant amount of labor and time that they would have spent packing in their own countries, which typically have higher labor costs. Therefore, by knowing exactly how the goods will be sold in a retail store and asking the foreign supplier to pack them in that way, retailers and sourcers strive to gain higher efficiency and financial gains. The final goods with floor-ready packing are then ready for final audits. Sourcers should conduct final audits before shipment to ensure that the supplier fulfilled the purchase order correctly and in a satisfactory manner.

Label preparation and approvals

During the preproduction stage (or even before), the sourcer also needs to provide correct label information to the supplier. Each country has different rules and regulations on how to label textile and apparel products to help protect consumers (see Figure 9.3). Currently, in the United States most textile products and apparel must display four key pieces of information at the point of sales: (a) fiber content, (b) country of origin, (c) identity of the manufacturer or another responsible party, and (d) care instruction (U.S. Federal Trade Commission [U.S. FTC], 2005). There are a few exemptions to these rules. Some products—such as upholstery stuffing materials, linings, backing, bandages, shoes, headwear, and textiles used in handbags and luggage—are not covered by the current FTC label rules. Full detailed information is available from the FTC's website (U.S. FTC, 2005).

Sourcers first must know what information needs to be displayed for each product. Second, with close consultation with designers, product developers, or store management teams, sourcers must decide where such information should be displayed. The location of this information or labels should be carefully selected to comply with the rules, without jeopardizing the esthetics of the finished goods and comfort of the wearers. The FTC (2005) requires that labels or care information be permanently attached to the products and be legible throughout their useful life. They must be attached or available so that consumers can easily find them at the point of sale. In addition, some retailers require particular label placements for esthetic or handling issues.

FIBER CONTENT

Since the Textile Fiber Products Identification Act (first approved September 2, 1958), the FTC advises that most textile products and wearing apparel must declare fiber content in generic fiber names, with percentages by weight of each fiber, in a descending order of predominance (U.S. FTC, 2005). The FTC has 3 percent tolerance of fiber content for multifiber fabrics. That is, if a fabric is made of 60 percent cotton and 40 percent polyester, cotton could range from 57 to 63 percent while polyester from 37 to 43 percent. However, the 3 percent tolerance does not

FIGURE 9.3 *Every country has different rules and regulations on how to label textile and apparel products to help protect consumers.*
Source: © gunnar3000/Fotolia

FIGURE 9.4 *Sourcers must carefully examine the FTC's rules and advise the best way to communicate fiber content to the supplier.*
Source: © Gleam/Fotolia

apply for one-fiber products. If the label says it is 100 percent cotton, it must be 100 percent cotton, not 97 percent cotton and 3 percent other fibers.

Any fibers making up less than 5 percent of the total weight can be listed as "other fibers" under the 5 percent rule. However, this rule does not apply to wool or recycled wool fibers. A significant number of consumers are known to be allergic to wool and, therefore, even if it is used in only a small amount, according to the Wool Products Labeling Act of 1939 all wool must be declared at the point of sale. Fur has a special set of rules according to the Fur Products Labeling Act (approved August 8, 1951), and in accordance with the Dog and Cat Protection Act of 2000, importing, exporting, manufacturing, selling, trading, advertising, and distributing any products made with dog or cat fur, often shoes and boots, are prohibited in the United States.

In addition to these rules, the FTC publishes extensive instructions on how to display fiber content for textile products (U.S. FTC, 2005). Therefore, sourcers must carefully examine FTC rules and advise the best way to communicate fiber content to the supplier (see Figure 9.4).

COUNTRY OF ORIGIN

Country of origin (COO) labels were not required by law for any products imported into the United States before 1890 (Morello, 1984). At that point, although not required, some companies included COO markings to show prestige and increase marketability. Products without COO labeling were understood to be either domestic or nonprestige imported products intended for the U.S. market. However, after the First World War, the U.S. government required any products imported from Germany to carry the words "Made in Germany" to punish German industries (Morello, 1984). A formal implementation of COO rules took place with U.S. Congress's enactment of the Tariff Act of 1930, which required all U.S. imported products to include COO information (U.S. Customs and Border Protection [USCBP], 2006).

Currently, the FTC and USCBC require all textile and apparel products to have a "one-country" origin; however, the country of origin depends on when during the production process the fibers, fabric, or apparel are purchased. For natural fibers, the country in which fibers are grown is considered a country of origin. For synthetic fibers, the country in which fiber extrusion was conducted is the place of origin. The location of knitting and weaving processes are important in determining country of origin for fabrics. For apparel, the country where significant apparel assembly processes such as sewing or manufacturing operations took place is considered the country of origin. Some researchers argue that the one-country-origin policy misleads consumers about the true contributions of different countries involved in hybrid or multinational products (products are made with components from two or more countries) (Bilkey & Nes, 1982). That is because the textile and apparel industry is so fragmented in the global marketplace, and multiple countries are involved to produce one garment. To address this problem, researchers have suggested declaring **country of manufacturing (COM)**, **country of parts (COP)**, **country of design (COD)**, and/or **country of brand (COB)** would help clarify true contributions of different countries for products (Bilkey & Nes, 1982; Ha-Brookshire, 2012). The automobile industry has already started declaring COP and COD. However, to date, the FTC and USCBC enforce a one-country COO for textile and apparel products.

The FTC (2005) also has specific rules on the products made in the United States. If those products are made in the United States with imported fabrics, the country of origin must say "Made in U.S.A. of imported fabric" or "Assembled in U.S.A. of imported components" without much detail of the origin of the fabric or components. The only exception to this rule is "flat" products such as sheets, towels, comforters, and so on. The fabrics of these products are very significant and sewing is relatively insignificant. Therefore, flat products are required to include the country of parts—in this case, where the fabrics are made (for example, "Made in U.S.A. of fabric made in China"). If goods are made in Sri Lanka but finished domestically, then the label must say "Made in Sri Lanka, Finished in U.S.A." Examples of finishing work could be attaching labels, ironing, and packing.

All of the rules explained previously are for products in traditional retail settings. When these products are advertised in catalogs or mail-order materials or on the Internet, the description must include either (a) "Made in U.S.A." if the products are made in the United States with all U.S. components and parts (see Figure 9.5); (b) "Imported" if the products are sourced from overseas; or (c) "Made in U.S.A. and [or] imported" (U.S. FTC, 2005) "Made in U.S.A. and imported" indicates the products are manufactured in the United States with imported materials. This label also suggests part of the manufacturing was done in the United States and part in a foreign country. Finally, "Made in U.S.A. or imported" reflects some of the components being manufactured in the United States and others in a foreign country. Neither of these rules requires businesses to declare which specific components are made in which specific country, leaving consumers with confusion. Perhaps COO rules for advertisements in catalogs or mail-order materials or on the Internet may need to be changed. Regardless, sourcers must completely understand and comply with the current rules and regulations related to country of origin so the goods can legally enter the country.

IDENTITY OF MANUFACTURER OR RESPONSIBLE PARTY

Once again, the FTC (2005) requires that all textile and apparel products identify either the company name *or* the **registered identification number (RN)** of the manufacturer, importer, or other company responsible for the products. Although an RN is not required to do business in the United States, any businesses that manufacture, import, market, distribute, or handle textile

FIGURE 9.5 *Producers may use a "Made in U.S.A." tag only if the product is made in the United States with all or virtually all U.S. components and parts.*
Source: Brooke Becker/Shutterstock

and apparel products in the United States can register through FTC and receive an RN. Businesses can then use these RNs to specify the responsible party for the goods. Consumers could use RNs to find contact information of any textile and apparel products about which they may have complaints or questions. RNs and company information are available from the FTC's Registered Identification Number Database website (U.S. FTC, 2012).

CARE LABELING RULE

Finally, the FTC's Care Labeling Rule requires textile and apparel businesses to attach "reasonable" care instructions to garments prior to sale (U.S. FTC, 2001) including manufacturers and importers of textile and wearing apparel products; manufacturers and importers of piece goods, or fabrics, sold to consumers; and any person or organization that directs or controls the manufacturing or importing of apparel or piece goods. All textile and apparel products—except for shoes, gloves, hats, handkerchiefs, belts, neckties, disposal items, and some piece goods sold for making apparel at home—are subject to the Care Labeling Rule. Small samples for institutional buyers and garments that are custom-made with materials provided by consumers are also exempt from the Care Labeling Rule. The full list of products that are exempted from the Care Labeling Rule is included in the FTC publication *Clothes Captioning: Complying with the Care Labeling Rule* (U.S. FTC, 2001).

For products requiring normal care, care instructions must include five basic elements: (a) washing, (b) bleaching, (c) drying, (d) ironing, and (e) other warnings (U.S. FTC, 2001). Figure 9.6 shows the examples of standard wash care symbols for clothing and other textile products. Washing instructions include washing method (by hand or by machine). If machine is allowed, water temperature (hot, warm, or cold) and recommended cycle (normal or gentle) are also required. Bleaching instructions should specify whether or not bleaching agents could be used and, if so, the type of bleach (nonchlorine or chlorine) must be listed. Drying instructions suggest if the products can be machine or line dried. In the case of machine drying, suggested temperature

FIGURE 9.6 Examples of standard wash care symbols found on clothing and other textile products
Source: Peter Bull/Dorling Kindersley/Pearson Education

(hot, warm, or cold) and recommended cycle (high, medium, or low) should be stated. When tumble drying is not recommended, the instruction must illustrate how to dry the garment after wash. Ironing instructions are also necessary, including surfaces (iron on the reverse or iron except appliques) that can be ironed and the iron temperature (hot, warm, or cool). Finally, other warnings, such as wash with like colors or wash before first wear, can be included to avoid any damage to the products that may occur during washing and drying. Either wording or symbols are allowed. Violations of the Care Labeling Rule are subject to up to $16,000 per offense per item, as enforced by the FTC.

Care Label

- Material: To be printed on the cotton woven label measuring 1 inch wide by 2.5 inches long.
- Placement: Center back, under the waist seam; must be sewn in.
- Content (in the following order):

<div style="border:1px solid">

Size M

100% Cotton
Exclusive of decoration

Made in El Salvador

Machine wash cold
With like colors
In normal cycle
Only nonchlorine bleach if necessary
Tumble dry medium
Cool iron if needed on the reserve side

RN 12345

</div>

LABEL PREPARATION AND APPROVAL

In addition to the FTC's requirements, the sourcer's company may also use labels to indicate the size of the garment, fit, or other information. It is the sourcer's responsibility to gather all of the necessary label information and placements of such labels and share them with the supplier. The sourcer must be an expert in labeling rules and requirements and provide correct information

to the supplier to avoid any problems. In the case of Amazing Jeans's boys' cotton denim pants, the sourcer could suggest the following information to the supplier to meet the FTC's requirements.

Production monitoring through a time & action calendar

Ideally, all of these processes would happen in a timely manner without any surprises or delays. Sourcing personnel should know the status of every purchase order and be responsible for on-time delivery of each sourcing project. However, when dealing with multiple purchase orders and multiple styles per purchase order, it is not easy to be up-to-date with the status of all sourcing projects. To help this process, sourcing personnel may create a **Time & Action (T&A) calendar**, or a preproduction and production monitoring plan. A T&A calendar may look different, depending on the company; however, its core purpose is to provide a target date for each approval and production process to meet the delivery on time. Therefore, to create a functioning and reasonable T&A calendar, sourcing personnel must know what needs to be approved and what processes must be monitored for on-time production and delivery. In addition, once this calendar is issued for each purchase order, all people involved must be aware of the deadlines for each step, and sourcing personnel must ensure that everyone else, including the supplier, follows this calendar.

Table 9.1 shows an example of a T&A calendar with several major approval requirements for a 120,000-unit purchase order of Amazing Jeans boys' cotton denim pants. This calendar shows the target approval date for each requirement, with an expected lead time for each process. In addition, the column for actual dates allows sourcing personnel to track each step to anticipate any potential shipment delays. The lead time for each process could vary, depending on each supplier's capacity and capabilities. Some sourcing personnel may want to expand this calendar to include other requirements, such as garment performance testing approval, shipment sample approval, and so on. Depending on the desired degree of control that sourcing personnel may want to have over the supplier and the past performance history of the supplier, the list of activities in this calendar could be expanded or shortened. This calendar could also be linked to product lifecycle management (PLM) software to track the entire process of including new product development, preproduction and production, shipment, and sales of finished goods.

TABLE 9.1

Example of a time & action calendar

Step	Activities	Lead Time	Target Date	Actual Date
1	Purchase order	7	6/30/2015	
2	Lap dips approval	14	7/7/2015	
3	Bulk fabrics approval	30	7/21/2015	
4	Trim approval	30	8/20/2015	
5	PPS approval	14	9/19/2015	
6	Production	45	10/3/2015	
7	Packing/Inspection	14	11/17/2015	
8	X-Factory	N/A	12/1/2015	

Using a T&A calendar, sourcing personnel may want to stay engaged in monitoring preproduction and production stages once a purchase order has been issued. Throughout this monitoring process, the key is to understand the time requirements for each process and anticipate future delays or changes. At any point, if a delay is expected, sourcing personnel must evaluate the consequences of such delays and communicate them with other interdepartmental teams such as sales staff, merchandisers, or marketers. For example, based on the T&A calendar in Table 9.1, the marketing team may assume it would be able to get samples from initial production in early October 2015 to take photos for special magazine or television commercials. If any of the previous processes have been delayed and production is not started until late October 2015, this could be a potential problem for the marketing team. Early communication about such delays would help the marketing team solve these problems.

Another example could involve the distribution center (DC) management team. According to the T&A calendar shown in Table 9.1, the Ex-Factory date is December 1, 2015. This information is used by the DC team to plan the labor and physical space to handle 120,000 units of denim pants upon arrival. If there were any changes in shipment dates and the Ex-Factory date changed to two weeks earlier or two weeks later, the DC team must adjust its labor and space plans appropriately.

These examples show how interdepartmental communications affect other departmental teams' functions and performances; sourcing personnel have the key information that other teams need to complete their responsibilities. In today's marketplace, this type of information is available through PLM or other software, and most people within the company have access to such information so they can make informed decisions for their unique roles. It is sourcing personnel's responsibility to keep updated, monitor the progress, and inform others of any critical changes.

Quality assurance

Throughout the preproduction and production monitoring stage, the sourcer also puts several quality assurance strategies in place. There are two major quality assurance strategies that sourcers must consider: product quality regulations and final inspection of the finished goods.

Apparel quality regulations

Each country has different regulations for products to be safely produced, marketed, and sold to consumers. It is the sourcer's responsibility to safely produce the goods and make the finished goods available to consumers in the sourcer's country. In the U.S. apparel marketplace, sourcers must consider five types of quality regulations before producing and importing goods for U.S. consumers: (1) flammability laws and standards, (2) regulations for toys and children's articles with small parts, (3) Consumer Product Safety Improvement Act requirements, (4) restricted substances regulations, and (5) voluntary guide for drawstrings on children's apparel recommendations (see Figure 9.7). Children's apparel is under a great deal of scrutiny by law. It is critical for sourcers of children's wear to fully understand the responsibilities and requirements to produce and distribute safe products.

FLAMMABILITY

In the United States, the U.S. Consumer Product Safety Commission (CPSC) administers flammability-related laws and standards. Clothing has the potential to catch fire and consumers

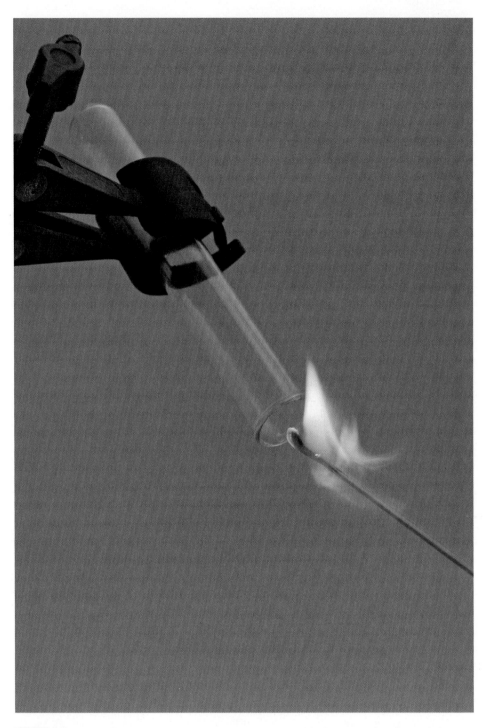

FIGURE 9.7 *In the U.S. apparel marketplace, sourcers must consider five types of quality regulations, including flammability.*
Source: Pearson Education Ltd. Trevor Clifford

may get injured from such fire. CPSC warns about this and other hazard issues through its quarterly journal, *Consumer Product Safety Review*. In a 2008 issue, the journal reported the death of a 61-year-old male whose flannel pajamas caught fire while cooking on a hot plate in his home (U.S. Consumer Product Safety Commission [U.S. CPSC], 2008). He was burned on 65 percent of his body and the cause of death was thermal injuries.

To help reduce these types of injuries and deaths, CPSC requires all textiles and apparel intended for the use of wearing to meet certain flammability regulations. Since the **Flammable**

Fabrics Act of 1953, several laws and regulations have been in effect. Flammable Fabrics Act regulations are found in subchapters 1602 through 1633 of the Code of Federal Regulations (CFR) of the United States (National Archives and Records Administration, 2012a).

Part 1610 specifies standards and testing procedures for the flammability of all adult and children's clothing textiles (National Archives and Records Administration, 2012a). There are three classifications for flammability of textiles. First is Class 1, or normal flammability; this is acceptable for most clothing products. For plain surface textile fabric, if it is tested following the procedures described by CFR 1610.60, the time of flame spread is 3.5 seconds or more for Class 1. For raised surface textile fabrics, such as terry cloth or flannel, it is considered normal flammability if the time of flame spread is more than 7 seconds. In addition, the intensity of the flame should be very low so as not to ignite or fuse the base fabrics. Therefore, it is expected that consumers have sufficient time to put out a flame or react to fire caught on clothing.

Class 2, or intermediate flammability, fabrics may ignite or show fusing of the base fabrics, and have a flame spread time of 4 to 7 seconds. Class 2 is applicable only for raised surface textile fabrics, not for plain surface textile fabrics. Class 2 may be used for some types of clothing as well. Class 3 exhibits rapid and intense burning and is dangerously flammable. Therefore, Class 3 is prohibited from being used for clothing. The time of flame spread of plain surface textile fabrics in Class 3 is less than 3.5 seconds, and that of raised surface textile fabrics is less than 4 seconds. Therefore, consumers would have less time to react to the fire, making it extremely dangerous. There are some exceptions to CFR 1610. Hats, gloves, footwear, interlining fabrics, and fabrics that are inherently flame retardant, such as acrylic, modacrylic, and wool, are exempted from CFR 1610 (National Archives and Records Administration, 2012a).

Two additional CFR parts are in effect for children's sleepwear since 1996. Part 1615 provides the standard for the flammability of sizes 0 to 6X, and Part 1616 is for sizes 7 through 14 (National Archives and Records Administration, 2012a). Both Parts 1615 and 1616 are applied to children's pajamas, nightgowns, robes, or similar related items intended for sleeping. Under these codes, fabrics are tested under specific conditions recommended by CPSC and the char length is compared. To be used for children's sleepwear, the average char length of five specimens should be less than 4 inches (17.8 centimeters) and no individual specimen can have a char length of 10 inches or more (25.4 centimeters).

Diapers, underwear, infant garments (size 9 months or smaller), and tight-fitting garments (as specified by CFR 1615.1[o]) are exempted from Parts 1615 and 1616 (National Archives and Records Administration, 2012a). However, all of these products still have to meet Part 1610. The logic behind these exemptions is that diapers, underwear, and infant garments are not supposed to be exposed to open flame. In addition, usually tight-fitting garments are less likely to catch fire than loose-fitting ones, particularly ones with ruffles and frills. CPSC provides the maximum dimensions for chest, waist, seat, upper arm, thigh, wrist, and ankle to be classified as tight-fitting garments (National Archives and Records Administration, 2012a). While exempted from CFR 1615 and 1616, CPSC recommends these garments include a label, such as "For child's safety, garment should fit snugly. This garment is not flame resistant. Loose-fitting garments are more likely to catch fire" (CFR 1615. 10 [i]) to inform consumers (see Figure 9.8).

In general, different fibers have different flammability characteristics (Stone & Kadolph, 2003). Cotton and linen are natural cellulosic fibers and, therefore, they burn with a hot and vigorous flame and do not melt away from the flame. Many synthetic fibers, such as nylon, polyester, olefin, and spandex, burn slowly and may melt away from small flames without igniting (Stone & Kadolph, 2003). While the flame-retardant fibers still burn yet very slowly, some synthetic fibers, such as aramid, novoloid, and vinyon, do not burn (Stone & Kadolph, 2003). In

FOR CHILD'S SAFETY, GARMENT SHOULD FIT SNUGLY. THIS GARMENT IS NOT FLAME RESISTANT. LOOSE-FITTING GARMENT IS MORE LIKELY TO CATCH FIRE.

FIGURE 9.8 Recommended text for hangtag for tight-fitting children's sleepwear

addition to these basic characteristics of fibers, sourcers must be sure to meet flammability laws and regulations for each fiber type and product category. Standards for children's sleepwear are extremely strict and the consequences of violations could be extremely dangerous to consumers and negative for sourcers' reputation in the marketplace.

REGULATIONS OF TOYS AND CHILDREN'S ARTICLES WITH SMALL PARTS

In the United States, CFR Part 1501 provides rules on small parts used in children's wear (under three years of age). CFR Part 1501 was established to prevent children from choking, aspiration, and ingestion of small parts, such as decorative or functional trims and findings on the garment. This rule states that no parts should be small enough to fit entirely into the test cylinder 1.25 inches (3.17 centimeters) in diameter under their own weight. In addition, if any components or pieces (excluding paper, fabric, yarn, fuzz, elastic, and string) of small parts become detached from the article as a result of the "use and abuse" testing (CFR 1500.51 and 1500.52) and fit into the test cylinder, the article is also considered a failure. Full information on the test procedure and interpretation of this rule is available from Title 16, Part 1501 of the CFR National Archives and Records Administration (2012b). All testing laboratories must follow these guidelines.

CONSUMER PRODUCT SAFETY IMPROVEMENT ACT OF 2008

More recently, CPSC organized a variety of new regulations and testing requirements for children's products (under 12 years of age) and some nonchildren's products under the **Consumer Product Safety Improvement Act (CPSIA)**. According to CPSC, the act "fundamentally changed how product safety is regulated in the United States" (U.S. CPSC, 2012b). Under CPSIA, all manufacturers, importers, distributors, or retailers of consumer goods in the United States must ensure that almost all children's products (see Figure 9.9):

a) Comply with the new children's product safety rules.

b) Are tested for compliance by a CPSC-accepted laboratory.

c) Have a written Children's Product Certificate (issued by the manufacturer or importer) that provides evidence of the product's compliance.

In addition, CPSIA required creating and maintaining a publicly available and searchable database (available at the SaferProducts.gov website) so consumers could report and search injuries and the risk of injuries related to the use of specific consumer products.

Two of the major new requirements or changes in requirements related to textiles and apparel enforced by CPSIA, in addition to flammability and small parts regulations, are related to the content of lead and the ban on phthalates. The acceptable content of lead in children's products is now reduced from 600 parts per million (ppm) to 100 ppm. All children's products must be mandatorily tested following predetermined procedures (or ASTM F963). ASTM International, formerly known as the American Society for Testing and Materials, is an organization that develops and provides international testing standards for consumer products (U.S. CPSC, 2012a). Lead can be found in metal buttons, metal zippers, jewelry, or small metal jewelry on garments. Phthalates are chemical plasticizers often used in the production of plastics or certain inks; they are often used to make plastics softer or more pliable. For apparel, phthalates can be found in inks used for screen printing or in plastic findings (U.S. CPSC, 2012b). Through CPSIA, all phthalates are completely banned from children's products in the U.S. marketplace, and sourcers must ensure their foreign suppliers do not produce or use small parts and inks that may contain phthalates.

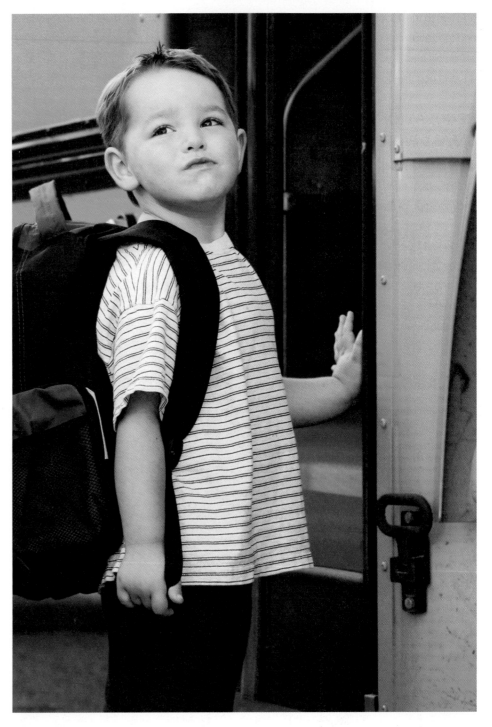

FIGURE 9.9 *Under the CPSC, apparel manufacturers must comply with new children's product safety rules.*
Source: Rob Hainer/Shutterstock

In addition, sourcers are responsible for testing both lead and phthalate contents through third-party inspection laboratories and obtaining Children's Product Certificates (U.S. CPSC, 2012b). According to CPSIA, sourcers also need to provide "tracking labels (or distinguishing permanent marks)" for the products, including (a) the name of the manufacturer or private labeler, (b) the location and date of production of the product, and (c) detailed information on the manufacturing process, such as a batch or run number. Violations of rules provided by CPSIA are subject to penalties of $5,000 to $100,000 per violation.

OTHER RESTRICTED SUBSTANCES

In addition to lead and phthalates, some other substances are also restricted for apparel products. The American Apparel and Footwear Association (AAFA) publishes a *Restricted Substances List* twice a year to educate apparel and footwear manufacturers, importers, and distributors (AAFA, 2012). The list is compiled after reviewing the requirements of various government agencies and organizations warning against harmful substances. Everyone throughout the textile and apparel supply chain must be aware of these restricted substances and make an effort to comply with U.S. laws and regulations. Examples of restricted substances are azo dyes, formaldehyde, polyvinylchloride (PVC), nickel, asbestos, and so on. Sourcers must get final products tested for the existence of the restricted sustances.

VOLUNTARY GUIDE FOR DRAWSTRINGS ON CHILDREN'S OUTERWEAR

Drawstrings on children's clothing can be hazardous when they are not property produced. In a recent study on recalls by CPSC, the authors found that 51 (or 21.4 percent) out of 238 product recalls in the product category of infants' and children's (12 years of age or younger) textile-based products between September 30, 2008, and September 20, 2010, were related to hooded sweatshirts with drawstrings (Norum & Ha-Brookshire, 2012). The value of drawstring-related recalls was up to $11.3 million, and these drawstring products resulted in 68 occurrences of strangulations, and even a death. Poorly designed and manufactured children's wear with drawstrings could cause accidents and injuries. Figure 9.10 illustrates potential hazards from improper drawstrings on children's outerwear (U.S. CPSC, 1999). Drawstrings on the neck area could strangulate the wearer, while those on the waist could also cause entanglement.

To avoid these problems, CPSC recommends that all children's upper outerwear intended for sales in the United States comply with the voluntary consensus safety standard published by

FIGURE 9.10 Examples of hazards from drawstrings
Source: U.S. Consumer Product Safety Commission (1999, September). Guidelines for drawstrings on children's upper outerwear. Retrieved June 1, 2012.

ASTM International. To avoid strangulation or entanglement from drawstrings, ASTM recommends that:

a) There shall be no drawstrings in the hood and neck are of children's upper outerwear sizes 2T to 12;

b) Drawstrings at the waist and bottom of children's upper outerwear sizes 2T to 16 shall:
 i. not exceed 3 inches (or 7.5 centimeters) in length outside the drawstring channel when the garment is expanded to its fullest width;
 ii. have no toggles, knots, or other attachments at the free ends; and
 iii. be bartacked, if the drawstring is one continuous string. (ASTM International, 2012)

Therefore, sourcers of children's outerwear must ensure that the products are appropriately designed and produced, following ASTM International's guidelines.

Final goods inspection

In addition to complying with laws and regulations during preproduction and production, sourcers also put regular inspection schedules in place, including (a) visual inspection of fabric, (b) fabric and garment performance testing, and (c) final audits. Depending on how the purchase order has been constructed, the responsible party for the inspection may differ. For example, if the contract is based on a full-package term, then it is the supplier's responsibility to conduct fabric inspection, performance testing, and final audits. However, the sourcer may require acceptable testing results and copies of all the inspection or testing reports prior to shipment. This request could be listed on the letter of credit. That is, without acceptable test results, the goods cannot be shipped and the payment will not be made. If the contract is based on a CMT term, it is the sourcer's responsibility to inspect the fabrics before the fabrics are cut, made, and trimmed at the supplier's facility, while the suppliers are responsible for part of garment performance testing and final audits. Regardless, the goal of final goods inspection is to ensure that garments are made properly with acceptable quality and prepared as the sourcer indicated.

VISUAL INSPECTION OF FABRIC

Fabric is one of the most important raw materials for garments. Once fabrics are produced, sourcers ensure that fabric producers conduct an acceptable level of fabric inspection. The two most common fabric inspection methods are the 4-point system and the 10-point system (Intertek Labtest, 2005). Both methods require visual checking of fabric quality. Defects are scored with penalty points according to the size and significance. Table 9.2 shows the size of

TABLE 9.2
4-point and 10-point systems of visual fabric inspection

	Size of Defects (Inches)	Assigned Points
4-point system	3 inches or less	1
	Over 3 inches but not over 6 inches	2
	Over 6 inches but not over 9 inches	3
	Over 9 inches, or full width	4
10-point system	1 inches or less	1
	Over 1 inches but not over 5 inches	3
	Over 5 inches but not over 10 inches, or half width	5
	Over 10 inches or full width	10

Source: Intertek Labtest (2005).

defects and assignment points for both methods. The 4-point system is used for both woven and knitted fabrics, while the 10-point system is used specifically for woven fabrics. Under the 10-point system, if the total penalty points do not exceed the yardage of a piece, then the piece is graded as "first quality" (Intertek Labtest, 2005). If the total penalty points are greater than the yardage of the piece, it is graded as "second quality" (Intertek Labtest, 2005). Both methods establish a numerical designation per inspection, and these numbers are used to assess the quality of the fabric. The acceptance of the fabric is dependent on the requirements mutually agreed on by seller and buyer (Intertek Labtest, 2005).

FABRIC AND GARMENT PERFORMANCE TESTING

Performance of fabrics and garments also needs to be tested and tracked. There is no one set of standards for performance that would satisfy all different markets. In addition, different countries have different standards for acceptable quality of fabrics and garments. Therefore, if sourcers produce the products for multiple countries and multiple retailers that may have different performance standards, sourcers must ensure the finished goods meet all different levels of standards and recommendations.

For all markets, the most recommended procedure is to conduct a visual inspection of bulk fabrics. If the fabric is visually acceptable, then it is appropriate to test the performance of that fabric either internally (if the facility has all testing equipment and capabilities) or externally. If it passes, the bulk fabric then can be used for garment production. If the testing results are not acceptable, the fabric supplier has to correct the problems by refinishing or producing the fabric again. Some issues, such as dimensional stability and colorfastness, can be corrected by refinishing techniques. Other problems could be more severe and may require reproduction.

Once the bulk fabric is approved and used for garment production, it is recommended that sourcers arrange apparel performance tests. The earlier these tests are conducted, the earlier sourcers may find problems in production. In the case of Walmart, garments from the first 10 percent of production are randomly selected and submitted for garment performance tests. If any issues occur, the production is adjusted and corrected before completing the entire production. This section discusses a set of general guidelines recommended for apparel products produced for the major markets in the United States. Since these are recommended levels, each company may require different standards, depending on the markets it serves. These guidelines are organized to include mandatory performance tests as well as supplementary performance tests. They also test for both fabric and garment performance (see Table 9.3).

In the United States, there are four major categories of mandatory testing for apparel: (a) fiber labeling, (b) care labeling, (c) flammability, and (d) hazardous chemicals. The laboratory tests for fiber content are listed on the garment label. Following the FTC's rules, no tolerance is allowed if the fabric has single-fiber content. If there are multiple fibers, the "3% tolerance" rule is applied. For care labeling tests, the laboratory follows the care instruction listed on the garment label and evaluates the results of normal washing and wear. Dimensional stability, colorfastness, garment appearance, and retention rating are measured. Acceptable levels in the U.S. major markets are listed in Table 9.3. For colorfastness and retention rating, the laboratory takes appropriate testing procedures (available from ASTM International) and determines if the loss of color is satisfactory for the intended end use. The number 5 implies almost no color loss, while 1 suggests severe color loss. In the United States, 4 or 3 are the acceptable levels for most colorfastness tests. Flammability tests are mandatory as well as tests for existence of hazardous chemicals.

TABLE 9.3
General testing guidelines for U.S. major market apparel

Mandatory Tests	Test Items		Requirements
Fiber labeling[1]	Single-fiber content		No tolerance
	Multiple-fiber content		+/- 3%
Care labeling	Dimensional stability (shrinkage)[2]		
	a. Washing	Woven	-3.5%/+3.0%
		Knit	+/- 5.0%
	b. Dry cleaning	Woven	+/- 2.5%
		Knit	+/-3.0%
	Colorfastness		
	a. Washing	Color change	4
		Color staining	3
	b. Dry cleaning	Color change	4
		Color staining	4
	c. Chlorine bleach	Color change	4
	d. Nonchlorine bleach	Color change	4
	e. Actual laundering[3]	Color change	3–4
		Color staining	4
	Garment appearance		
	a. Retention after washing or dry cleaning		No undesirable effect
	Retention rating[4]		3.5
Flammability	Flammability test		
	a. Children's sleepwear		CFR Part 1615/1616[5]
	b. Wearing apparel		CFR Part 1610
Hazardous chemicals	Children's wear		
	a. Lead for children's wear		100 ppm
	b. Phthalates for children's wear		None
	All apparel		
	a. Restricted substances		Within the tolerance for each
Supplementary Tests			
Colorfastness	Rubbing/Crocking	Dry	4
		Wet	3
	Light	10-hr exposure/ Light standard 3	Lining/underwear: 4
		20-hr exposure/ Light standard 4	Outerwear: 4
		40-hr exposure/ Light standard 5	Swimwear: 4
	Perspiration	Color change	4
		Color staining	3
	Water	Color change	4
		Color staining	3
	Chlorine water[6]	Color change	4
	Seawater[6]	Color change	4
		Color staining	3

Beyond mandatory testing, sourcers also ensure the garments are satisfactory for their end use purpose. There are three major categories for supplementary performance tests: (a) colorfastness, (b) strength, and (c) performance (Intertek Labtest, 2005). First, if the products have special functions, such as swimwear, outdoor wear, and rainwear, they must be tested to ensure the garments perform those special functions as they claim. Colorfastness tests of rubbing, light, perspiration, water, chlorinated water, and seawater evaluate the loss of color during intended usage. Perspiration colorfastness is important for athletic wear. Colorfastness

TABLE 9.3 (Continued)

Strength	Tensile strength (1-inch grab test)		
	a. Blouse		25 lb
	b. Shirt/dress/skirt/pajamas/lining		30 lb
	c. Jacket/coat/vest		37 lb
	d. Pocketing		50 lb
	e. Dungarees/overall/trousers/shorts/jeans		50 lb
	Tearing strength		
	a. Blouse		1.5 lb
	b. Pajamas/lining		1.8 lb
	c. Shirt/dress/skirt/jacket/coat/vest		2.0 lb
	d. Pocketing		2.5 lb
	e. Dungarees/overall/trouser/shorts/jeans		2.5 lb
	Seam properties		
	a. Blouse/shirt/dress/skirt	Slippage	15 lb
		Strength	22 lb
	b. Pajamas/lining	Slippage	18 lb
		Strength	25 lb
	c. Jacket/coat/vest	Slippage	22 lb
		Strength	30 lb
	d. Pocketing	Slippage	22 lb
		Strength	30 lb
	e. Dungarees/overall/trousers /shorts/jeans	Slippage	25 lb
		Strength	37 lb
	Bursting strength		
	a. Fabric		40 lb/sq in
	b. Seam		35 lb/sq in
Performance	Pilling resistance (random tumbler test)		3–4
	Water repellency		
	a. Spray test		90
	b. Rain test		Max. 1.0 g water absorption

Note: [1]The requirement may vary with different fabric structure and fiber content.
[2] (+) sign means extension, (-) sign means shrinkage.
[3] Contrast color fabric only.
[4] Wash and wear test is applied on the durable press garment.
[5] Must meet Code of Federal Regulation Part 1615 and 1616.
[6] For swimwear and beachwear.

Source: Adapted from Intertek Labtest (2005).

of chlorinated water and seawater must be evaluated for swimwear and beachwear. Light colorfastness is also important if the products are intended to be used outdoors or at the beach. Different end uses require additional colorfastness tests, in addition to mandatory colorfastness tests (see Figure 9.11).

In the strength test category, tensile strength, tearing strength, seam properties, and bursting strength are evaluated (Intertek Labtest, 2005). Different products have different standards to ensure garments are constructed sufficiently to be used for their intended end uses. Finally, pilling resistance is tested and, if the product claims to be rainwear, water repellency is also evaluated. All of the test procedures, scoring schema, and interpretation of the results are guided by ASTM International. There are many different laboratories providing testing services. USCPSC publishes the list of CPSC-accepted testing laboratories through its website (U.S. CPSC, 2012a).

OTHER PERFORMANCE TESTING

In addition to mandatory and supplementary performance testing, there are other specific performance tests available. Particularly with the recent popularity of eco-friendly or sustainable

FIGURE 9.11 *Different end uses require additional colorfastness tests besides the mandatory colorfastness tests.*
Source: Cyril Hou/Shutterstock

products, many testing laboratories provide the degree of eco-friendliness or sustainability of the textile and apparel products. Once again, there is no one set of standards that communicates how eco-friendly or sustainable the products are. Because of this, multiple companies come up with their own indices and ratings. For example, the U.S. Outdoor Industry Association and the European Outdoor Group have launched the Eco Index initiative that specifically focuses on the environmental impact of products throughout a product's life cycle stages (Outdoor Industry Association, 2011). Testing or inspection service companies, such as Intertek and Bureau Veritas, offer their own sustainability certification services. Similarly, NSF International and the Public Health and Safety Company have various certification programs in product assessment, process verification, and standard development categories (NSF International, 2011).

Regardless of the specific choice of index, one of the most important things for any sourcer to keep in mind is that if there is a claim that a specific product has specific functions or social or environmental impact, the sourcer must be able to provide the evidence so that the claim will not be false. Any product claims, such as eco-friendliness, greenness, and sustainability, must be substantiated by tangible evidence and such evidence must be transparent. Without such transparency, the claim could be misleading and even fraudulent.

FINAL AUDITS

Once all tests are complete and production is complete, final audits are conducted to ensure that all products have been produced according to the purchase order. A final audit not only includes overall garment construction, but also inspects the total quantity, assortment, and packing. American National Standards Institute (ANSI) and American Society for Quality (ASQ) provide a random sampling inspection method, Z1.4 (Intertek Labtest, 2005). This standard also exists as ISO 2859, NF06-022, BS 6001, and DIN 40080, internationally.

Single sampling plans for normal inspection level II

Lot or Batch Size	Sample Size	Acceptable Quality Levels (Normal Inspection)										
		0.10	0.15	0.25	0.40	0.65	1.0	1.5	2.5	4.0	6.5	10
151–280	32	0	0	0	0	0	0	1	2	3	5	7
281–500	50	0	0	0	0	0	1	2	3	5	7	10
501–1,200	80	0	0	0	0	1	2	3	5	7	10	14
1,201–3,200	125	0	0	0	1	2	3	5	7	10	14	21
3,201–10,000	200	0	0	1	2	3	5	7	10	14	21	21
10,001–35,000	315	0	1	2	3	5	7	10	14	21	21	21
35,00–150,000	500	1	2	3	5	7	10	14	21	21	21	21
151,001–500,000	800	2	3	5	7	10	14	21	21	21	21	21

Source: Intertek Labtest (2005).

ANSI Z1.4 is the most widely used and accepted sampling method based on the mathematical theory of probability (Intertek Labtest, 2005). It provides:

- The number of samples to be inspected in a given lot or shipment size.
- A specific criteria for acceptance or rejection of a shipment or lot based on the number of defects found.
- A fair assessment of product quality to both buyers and sellers.

Table 9.4 illustrates single sampling plans for normal inspection level II. Lot or batch size refers to the total number of finished goods to be inspected. Sample size indicates the appropriate sample size to be randomly selected from the total lot or batch for individual inspection. The numbers in the acceptable quality levels (AQLs) indicate the maximum number of defects that are allowed for the lot to be considered satisfactory.

For example, let's assume the supplier has 30,000 units ready for a final audit. The sourcer may select the allowed quality to be AQL 2.5 and 4.0 for major and minor defects respectively. Under this request from the sourcer and ANSI Z1.4, the inspectors would randomly select 315 units and individually inspect them. AQL 2.5 allows up to 14 units (4.4 percent out of 315 units) to show major defects and AQL 4.0 allows up to 21 units (6.7 percent out of 315 units) to show minor defects from this inspected sample size of 315. If the sample size is equal to or exceeds the lot or batch size, 100 percent inspection is recommended. The inspector, supplier, and sourcer have a common understanding about what are considered major and minor defects (see Figure 9.12). The inspector would report the results to both supplier and sourcer.

If the lot has passed, the supplier is ready to ship the 30,000 unit lot. If it has failed, the supplier may have to rework to correct problems. Some defects, such as incorrect packing or heavy writing, are easily corrected. Others, such as incorrect measurement and sizes, may require complete reproduction. The severity of defects is discussed between supplier and sourcer as they conclude what to do with the rejected lot. In some cases, if the lot has failed because of uncorrectable defects, the lot could be classified as "second quality" and sold to discount retailers or other markets. This decision must be made in collaboration with the sourcer, particularly if the products are produced under a licensing agreement. Licensors do not want their licensed products to be sold in the secondary market without their approvals and knowledge.

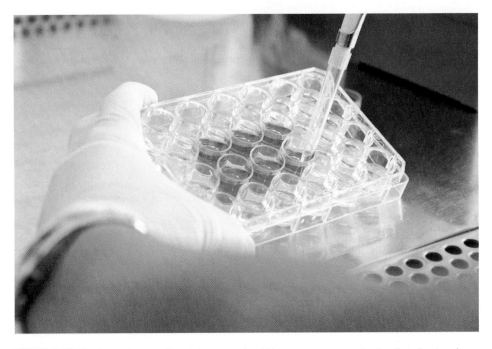

FIGURE 9.12 *The inspector, supplier, and sourcer should have a common understanding about major and minor defects.*
Source: © corepics/Fotolia

Application of quality assurance policies

Now that we have reviewed the quality assurance procedures that sourcers must follow and consider, let's go back to Amazing Jeans's boys' cotton denim pants to come up with strategies for quality assurance during production and final audits. As discussed in Chapter 8, the total quantity of the purchase order for this specific sourcing program is 120,000 units and the products are for boys in the age range of 7 to 16, in sizes 7/8-10/12-14-16. Then, what type of quality assurance programs would the sourcer have in place? First, the sourcer would arrange fabric visual inspection. Because the denim is a woven fabric, the 10-point system is recommended for this. The sourcer would provide a maximum numeric score that he or she would accept as first quality. Second, for fabric and garment performance tests, the sourcer may require fabric and garment performance tests be conducted using samples randomly selected from the first 10 percent of production, as well as from the remaining 90 percent of production. The two sets of testing would ensure the consistency of garment production. The sourcer would also create a list of tests and acceptable levels for each test. Table 9.5 shows the required and recommended fabric and garment performance tests for Amazing Jeans's boys' cotton denim pants.

Table 9.5 suggests that, because the fiber content is 100 percent cotton, no tolerance is allowed for fiber labeling. Since denim is a woven fabric, 3 percent extension or 3.5 percent shrinkage are allowed for dimensional stability. Colorfastness from washing and nonchlorine bleach must be passed because the care label specified "Nonchlorine bleach only if necessary" as previously discussed. Retention after washing must show no undesirable effect. Flammability of the garment must be passed following CFR Part 1610. Because some of this order is intended for children who are younger than 12 years of age, the content of lead and phthalates must be tested to comply with CPSIA.

TABLE 9.5

Fabric and garment performance tests for Amazing Jeans's boys' cotton denim pants program (120,000 units, in sizes 7–16)

Mandatory Tests	Test Items		Requirements
Fiber labeling	Single-fiber content: 100% cotton		No tolerance
Care labeling	Dimensional stability (shrinkage)		
	Washing	Woven	-3.5%/+3.0%
	Colorfastness		
	Washing	Color change	4
		Color staining	3
	Nonchlorine bleach	Color change	4
	Garment appearance		
	Retention after washing		No undesirable effect
Flammability	Flammability test		
	Wearing apparel		CFR Part 1610
Hazardous chemicals	Children's wear		
	Lead for children's wear (up to size 12)		100 ppm
	Phthalates for children's wear (up to size 12)		None
	All apparel		
	Restricted substances		Within the tolerance for each
Supplementary Tests			
Colorfastness	Rubbing/Crocking	Dry	4
		Wet	3
	Light	20-hr exposure/Light standard 4	Outerwear: 4
	Water	Color change	4
		Color staining	3
Strength	Tensile strength (1-inch grab test)		
	Pocketing		50 lb
	Dungarees/overall/trousers/shorts/jeans		50 lb
	Tearing strength		
	Pocketing		2.5 lb
	Dungarees/overall/trouser/shorts/jeans		2.5 lb
	Seam properties		
	Pocketing	Slippage	22 lb
		Strength	30 lb
	Dungarees/overall/trousers	Slippage	25 lb
	/shorts/jeans	Strength	37 lb
	Bursting strength		
	Fabric		40 lb/sq in
	Seam		35 lb/sq in

In addition, several supplementary tests are recommended. Colorfastness from rubbing and crocking are recommended as part of the pants could be rubbed against any other objects during the wear. Light colorfastness of 20-hour exposure against light standard 4 is recommended for the pants' outdoor wear. Water colorfastness would be important for color loss during laundering. In terms of strength tests, tensile strength, tearing strength, seam properties, and bursting strength tests are recommended to ensure the durability of the products.

After performance testing and complete production of 120,000 units, final audits must be arranged. For normal inspection, the sourcer may require AQL 2.5 for major and 4.0 for minor defects for acceptable quality. If the 120,000 units are available as a shipment lot, following

ANSI Z1.4, the inspector would select 500 units as samples and inspect them individually. If both major and minor defects are fewer than 21, respectively, the entire 120,000 units can be shipped as the lot is deemed acceptable.

The sourcer must share all quality assurance strategies with the supplier from the very beginning of the project, and both supplier and sourcer must be aware of all sampling, testing, and inspection costs and build them into their costs. These processes also take time and timely coordination between sourcer's and supplier's teams. Therefore, putting proper quality assurance plans in place, communicating the requirements with the supplier, monitoring tests, and interpreting test results are all important tasks that sourcers must complete. Often, sourcers add these test or inspection schedules into the Time & Action calendar so everyone involved knows the status and the importance of getting acceptable test results in a timely fashion.

summary

As soon as a purchase order is issued and signed by both supplier and sourcer, preproduction approvals must be conducted. Suppliers submit various approval samples, including fabrics and necessary trims and notions. Garment construction samples are also submitted and the sourcer's team needs to see all the components and approve them for production. One of the key pieces of information that the sourcer must provide during the preproduction stage is all necessary information related to labels so the supplier can prepare such labels correctly. The FTC requires (a) fiber content, (b) country of origin, (c) identity of the manufacturer or another responsible party, and (d) care instructions

FIGURE 9.13 *The FTC requires that country of origin be specified on the tag of every textile product.*
Source: © jim/Fotolia

for all textile and apparel products (see Figure 9.13). Different products require different label information and, therefore, the sourcer must gather proper information and share it with the supplier.

Once all components are ready for apparel production, the supplier prepares preproduction samples for final approval by the sourcer. Upon approval of PPSs, the supplier starts garment production. During production, the sourcer may monitor the progress, following a Time & Action calendar, and communicate the status of production and delivery with other key personnel within the company. The sourcer also orders various tests and inspections to ensure product quality and safety, including (a) visual inspection of fabric, (b) fabric and garment performance tests, and (c) final audits (see Figure 9.14).

Sourcers may use internal testing laboratories. However, some of the tests require third-party test results. Depending on the product category and product safety regulations, sourcers may coordinate several tests with external test laboratories throughout the production. The Consumer Product Safety Improvement Act of 2008 is one of the latest regulations related to on textile and apparel products. Sourcers must be fully aware of this law and ensure that all products are tested and pass. For most apparel for adults, products need to be tested for flammability, restricted substances, fiber labeling, care labeling, colorfastness, and other supplementary tests. In addition, some children's apparel may require testing for small parts and drawstrings.

Finally, when production is complete, final audits must be done to ensure the goods are produced and packed in the right manner. Final audits can be done by internal or external inspectors. Regardless, random sampling inspection methods, such as ANSI Z1.4, are recommended for final audits. When final audits fail and problems are beyond correction, the results must be discussed between sourcers and suppliers as to whether or not sourcers can accept the entire lot as first or second quality. However, if sourcers carefully monitor the entire preproduction and production processes, it is rare to see final audits fail. Sourcers and suppliers must work together to make shipments happen, so that the sourcers receive the products that they want in the right time and the suppliers get paid for such services.

FIGURE 9.14 *Sourcers may coordinate several tests with external test laboratories throughout production.*
Source: © nikesidoroff/Fotolia

terms

key terms

Color lab dips refer to small swatches of different shades of colors that are dyed in a laboratory setting.

Consumer Product Safety Improvement Act (CPSIA) provides new regulations and testing requirements for children's products and other products.

Country of brand (COB) indicates the country in which the brand of the product was originally created and, typically, the headquarters of where the brand is located.

Country of design (COD) indicates the country in which the product was conceptualized and designed.

Country of manufacturing (COM) refers to the country in which asembly or manufacturing of the finished product took place.

Country of parts (COP) indicates the country in which parts or components of a product were produced.

Flammable Fabrics Act regulates the manufacturing of highly flammable textile and apparel products.

Floor-ready packing refers to the finishing technique in which final products are packed and arranged to be ready for retail operation in foreign factories, without extra handling and preparation at the sourcer's country.

Pattern strike-offs refer to small pieces of printed fabrics or materials prepared in a laboratory or sample-making setting.

Preproduction samples (PPSs) are the garments made with all approved components by the supplier's sample department. PPSs also represent the supplier's cutting, grading, and sewing techniques.

Registered identification number (RN) of the manufacturer is a number issued by the U.S. Federal Trade Commission to a textile-and-apparel-related business operating in the United States. RN is allowed in place of the name of the business or responsible party on the label or tag.

Time & Action (T&A) calendar refers to a preproduction and production monitoring plan often used by textile and apparel businesses. It shows a plan of future activities and helps track the completed tasks.

learning activities

1. Select one of your favorite garments from your closet. Inspect the care label. Compare the content with *Threading Your Way through the Labeling Requirements under the Textile and Wool Acts* at the FTC's website. See if your label is correct and includes all necessary information. If not, suggest the correct label information.

2. Read the *Laboratory Test Manual for 16 CFR 1610: Standard for the Flammability of Clothing Textiles* (October 2008) available at the Consumer Product Safety Commission website. Then discuss the following:
 a. Why is the specimen rack set at a 45-degree angle?
 b. What is a plain surface textile fabric?
 c. What is a raised surface textile fabric?
 d. Why are there different requirements for a plain and a raised surface textile fabric?
 e. What types of fabrics are exempted from flammability testing?

3. Find information on the Consumer Product Safety Improvement Act of 2008 at the CPSC website, and the *Threading Your Way through the Labeling Requirements under the Textile and Wool Acts* at the FTC's website. Assuming you are a sourcing manager of the following products, come up with (a) all the necessary tests and inspections, and (b) proper care labels to comply with CPSIA:
 a. Infant bibs, 100 percent cotton with a small screen printing
 b. Girls' onesie pajama for size 3, 50 percent polyester and 50 percent cotton with a three-dimensional small stuffed animal
 c. Outdoor jacket for boys in size 10, 100 percent polyester, with water-resistance function
 d. Men's dress suits, 60 percent polyester and 40 percent wool
 e. Women's dress, 100 percent silk

4. Assume you have a shipment batch of 30,000 units ready for final audits. Explain the following according to ANSI Z1.4:
 a. If you are a sourcer for a high-end department store, what would be the AQL levels for major and minor defects you require? For those levels, what are the maximum allowed major and minor defects?
 b. If you are a sourcer for a low-end discount retailer, what would be the AQL levels for major and minor defects you require? For those levels, what are the maximum allowed major and minor defects?
 c. In either case, what is the sample size?

5. Assuming you are a sourcing manager for Ralph Lauren's classic Polo shirts and these products are sold at major retailers in the United States, come up with your own preproduction, production, and quality assurance policies.

references

American Apparel and Footwear Association. (2012, March 21). *Resticted substances list—English*. Retrieved June 5, 2012, from https://www.wewear.org/industry-resources/restricted-substances-list/english

ASTM International. (2012). *ASTM F1816-97 (2009) Standard safety specification for drawstrings on children's upper outerwear*. Retrieved June 1, 2012, from http://enterprise.astm.org/filtrexx40.cgi?+REDLINE_PAGES/F1816.htm

Bilkey, W., & Nes, E. (1982). Country of origin effects on product evaluation. *Journal of International Business Studies, 1*, 89–99.

Ha-Brookshire, J. (2012). Country of parts, country of manufacturing, and country of origin: Consumer purchase preferences and the impact of perceived prices. *Clothing and Textiles Research Journal, 30*(1), 19–34.

Intertek Labtest. (2005). *Apparel and soft home furnishing textile products: Buyers' guide* (3rd ed.). Springfield, NJ: Intertek Testing Services.

Morello, G. (1984). The "made-in" issue: A comparative research on the image. *European Research, 12*, 5–21.

National Archives and Records Administration. (2012a, June 1). *Electronic code of federal regulations*. Retrieved June 5, 2012, from http://ecfr.gpoaccess.gov/cgi/t/text/text-idx?sid=f663a1a1668cc7aa41c5e5dba17fecc4&c=ecfr&tpl=/ecfrbrowse/Title16/16cfrv2_02.tpl

National Archives and Records Administration. (2012b, June 4). *Part 1501*. Retrieved from Title 16: Commercial Practices: http://ecfr.gpoaccess.gov/cgi/t/text/text-idx?c=ecfr&sid=91c1c52ef39e75df4cb2b91bffccff11&rgn=div5&view=text&node=16:2.0.1.3.72&idno=16

Norum, P., & Ha-Brookshire, J. (2012). Analysis of children's textile and apparel product safety issues using recall data from the U.S. Consumer Product Safety Commission. *International Journal of Fashion Design, Technology and Education, 1*, 25–31.

NSF International. (2011). *Certification programs*. Retrieved June 10, 2011, from http://www.nsf.org/business/certification_programs

Outdoor Industry Association. (2011). *The eco index*. Retrieved June 10, 2011, from http://www.outdoorindustry.org/resources.working.php?action=detail&research_id=53

Stone, J., & Kadolph, S. (2003, July). *Facts about fabric flammability*. Retrieved June 1, 2012, from http://www.extension.iastate.edu/Publications/NCR174.pdf

U.S. Consumer Product Safety Commission. (1999, September). *Guidelines for drawstrings on children's upper outerwear*. Retrieved June 1, 2012, from http://www.snowsports.org/LinkClick.aspx?fileticket=GOiw0tLp0C4%3D&tabid=525

U.S. Consumer Product Safety Commission. (2008). Consumer Product Safety Review. *Consumer Product Safety Review, 12*(1), 1–12.

U.S. Consumer Product Safety Commission. (2012a). *List of CPSC-accepted testing laboratories*. Retrieved June 5, 2012, from http://www.cpsc.gov/cgi-bin/labsearch

U.S. Consumer Product Safety Commission. (2012b, April 2). *The Consumer Product Safety Improvement Act of 2008*. Retrieved June 5, 2012, from http://www.cpsc.gov/about/cpsia/cpsia.html

U.S. Customs and Border Protection. (2006). *Importing into the United States: A guide for commercial importers*. Retrieved January 25, 2012, from http://www.cbp.gov/linkhandler/cgov/newsroom/publications/trade/iius.ctt/iius.pdf

U.S. Federal Trade Commission. (2001, November). *Clothes captioning: Complying with the Care Labeling Rule*. Retrieved June 1, 2012, from http://business.ftc.gov/documents/bus50-clothes-captioning-complying-care-labeling-rule

U.S. Federal Trade Commission. (2005, May). *Threading your way through the labeling requirements under the Textile and Wool Acts*. Retrieved May 31, 2012, from http://business.ftc.gov/documents/bus21-threading-your-way-through-labeling-requirements-under-textile-and-wool-acts

U.S. Federal Trade Commission. (2012). *Registered identification number database*. Retrieved June 1, 2012, from http://www.ftc.gov/bcp/rn/index.shtml

GLOBAL SOURCING STEP 6: LOGISTICS AND IMPORTING PROCESSES

LEARNING OBJECTIVES

Throughout the global sourcing project, sourcers make numerous logistics decisions to move raw materials to production sites, and to move finished goods to each individual store. The most major logistics decisions involve moving finished goods from the supplier's country to the sourcer's. Freight forwarders help sourcers make the right decisions. Once the goods arrive at a sourcer's port, the goods are officially filed for entry with the sourcer country's Customs. Customs review the documents and authorize the release of the goods. Customs brokers can help sourcers throughout the process. Upon completion of this chapter, students will be able to:

- Understand the definition of logistics and its four core functions including labeling, packing, traffic management, and storage/inventory management.
- Comprehend and analyze the difference between material management and physical distribution in logistics.
- Analyze the differences between the systems approach, total cost approach, and opportunity cost approach in logistics decisions.
- Understand the benefits and costs of different transportation modes and the role of freight forwarders in global sourcing.
- Appreciate and evaluate how Time & Action calendars can be used in global sourcing.
- Understand the purpose of Customs clearance when foreign goods arrive at a port in the sourcer's country.
- Comprehend the import process required by the U.S. Customs and Border Protection and the role of Customs brokers in this process.

10

(Opposite page) *Source:* © ctrif/Fotolia

Step 6: Logistics and importing processes

Once production is complete and goods are shipped, sourcing personnel work with the import and/or logistics department to legally import foreign goods into the sourcer's country. Logistics has been of increasing importance in recent years as sustainability efforts have increased. Shipping's impact on climate change, air quality, noise, and waste has been criticized and "greener" (or environmentally friendly) logistics options have been suggested by many logistics companies. In addition, each country requires different sets of documents and enforces different rules and regulations when importing goods from foreign countries. Sourcers must be able to work closely with logistics and import specialists and make the best choices for the environment, society, and business profits. This chapter discusses the sixth stage of the seven core steps of global sourcing—logistics and importing processes (see Figure 10.1).

Logistics

Although the terms *logistics, transportation,* and *distribution* are often used interchangeably, *logistics* implies broader aspects of business functions than simple transportation or distribution functions. **Logistics** refers to the systematic management of all activities required to move and distribute products throughout the supply chain, including flow and storage of raw materials and finished products from point of origin to point of consumption (Seyoum, 2000). That is, both flow and storage are important functions that are part of logistics. In addition, logistics includes the

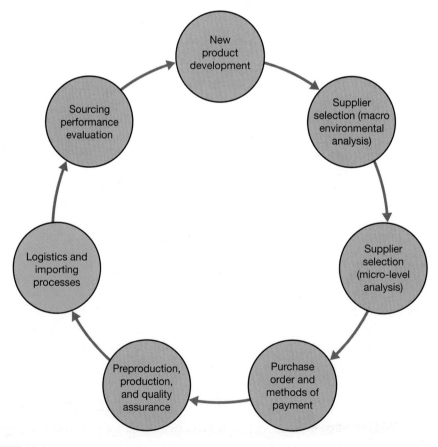

FIGURE 10.1 Core steps of global sourcing

movement and storage of both raw materials and finished goods, called materials management and physical distribution, respectively (Seyoum, 2000).

Materials management and physical distribution

Materials management primarily deals with the timely movement or flow of materials from the sources of supply to the point of manufacture, assembly, or distribution (inbound materials) (Seyoum, 2000). Therefore, materials management includes the acquisition, transportation, inventory management, and storage of raw materials for main production, as well as such activities for finished products from the point of manufacture to the firm's distribution center.

For example, in the case of boys' cotton denim pants, at Amazing Jeans all activities related to acquiring, transporting, storing, and managing inventory of raw materials, such as fabrics, zippers, buttons, sewing threads, and labels, prior to jean manufacturing are part of materials management. At this stage, the goal of materials management is to manage all of these activities in a timely and sustainable fashion so the optimal level of jean manufacturing could occur. Materials management also includes the acquisition, transportation, storage, and inventory management of the finished goods, boys' cotton denim pants, to the Amazing Jeans distribution center from the point of pant manufacturing. At this stage, the goal of materials management could be to move the finished products cost-effectively, sustainably, and legally.

Physical distribution relates to the movement or flow of materials from the firm's point of manufacturing origin and/or distribution center to the point of sales (or outbound materials) (Seyoum, 2000). Therefore, transporting the finished goods from the firm's distribution center to individual stores in which the products will be available to consumers, and managing for optimal inventory and sales levels are all part of the functions of physical distribution (see Figure 10.2). For example, in the case of Amazing Jeans boys' cotton denim pants for Walmart, the sourcer will be engaged in physical distribution from the sourcer's distribution center to Walmart's distribution center (namely outbound). At the same time, Walmart will have a team managing the products coming from their suppliers' distribution centers to Walmart's distribution centers (namely inbound). Therefore, both sourcer and buyer must work together to coordinate product movement; these coordinated activities are part of logistics functions. Sometimes, the sourcer's physical distribution team may transport the finished goods directly to Walmart stores. Through physical distribution, each store would be able to have a sufficient level of product inventory.

Approaches to logistics decisions

Both materials management and physical distribution are highly interdependent for the overall success of logistics. After all, without proper materials management, physical distribution would not happen. The success of logistics requires the unique combination of packing, handling, storage, and transportation so the products will be available to consumers at the right cost, in the right time, in the right place, in the right condition, with the least damage made to the environment and society throughout the logistics functions. Three approaches have been proposed for successful logistics: (a) the systems approach, (b) the total cost approach, and (c) the opportunity cost approach (Seyoum, 2000).

FIGURE 10.2 *Physical distribution refers to the flow of materials from the point of manufacturing origin and/or distribution center to the point of sale.*
Source: andrew metto/Shutterstock

SYSTEMS APPROACH

The systems approach is based on the argument that logistics decisions must be made while considering both inbound and outbound material activities. Therefore, through effective logistics, the whole business system must be benefited, not just individual units (Seyoum, 2000). For example, although all activities related to inbound materials may have been coordinated perfectly, if the physical distribution was done inefficiently and ineffectively, producing, storing, and transporting the finished goods from foreign suppliers' facilities to the sourcer's distribution center would not yield the most optimal sales. This could be particularly true for fast-fashion products that are extremely sensitive to market trends.

The systems approach could also be useful to assess the environmental impact of the entire logistics function. That is, the systems approach could offer a new framework that, through effective logistics, would benefit the earth as a whole, not just individual firms or units. Therefore, even if certain logistics decisions may benefit one company, if the environment is damaged through logistics functions, such decisions may need to be reconsidered to help improve the environment as well as provide for the long-term survival of the company. Sourcers face these types of questions and dilemmas every day. When production is late and there is not sufficient time to transport the finished goods from a foreign supplier's facility to the sourcer's country, air shipments are often discussed to avoid missing particular sales periods. Although air shipments may save time in transportation, unnecessary air shipments contribute to further air pollution and excessive energy consumption.

After all, environmentally and economically responsible logistics must consider both environmental impact, such as pollution and emission, and economic impact, such as cost, speed, and on-time deliveries (Emmett & Sood, 2010). Careful consideration of both negative and positive consequences from different logistics functions are necessary not only to help the sourcer's business but also to improve and protect the environment in which we live.

TOTAL COST APPROACH

The total cost approach to logistics takes the total cost as the ultimate decision factor. Therefore, sourcers who make logistics decisions based on the total cost approach may review the cost of individual logistics functions throughout the supply chain and decide which option they will choose. One thing to keep in mind here is that the total cost may not necessarily be the monetary cost. Many decisions related to logistics have some consequences in terms of energy consumption, pollution, and climate change (see Figure 10.3). These consequences would take a significant amount of resources and money to reverse or protect them. Therefore, sourcers must consider both direct and indirect short- and long-term costs when calculating the total cost.

OPPORTUNITY COST APPROACH

Finally, the opportunity cost approach considers values that would be missed by undertaking another logistics decision. For example, in the case of Amazing Jeans's boys denim pants sourced through a supplier in Vietnam, the decision to source zippers from another country, such as Japan, instead of acquiring them from Vietnam where pant manufacturing occurs would require the sourcer to consider opportunity costs, including transportation cost from Japan to Vietnam, inventory shortage or overage, and additional tracking/monitoring efforts. However, the advantage of sourcing zippers from Japan—higher quality—may outweigh drawbacks. Sourcers must consider both costs and benefits of each decision related to logistics.

FIGURE 10.3 *The total cost approach takes into account energy consumption, pollution, and climate change.*
Source: © mario beauregard/Fotolia

Logistics functions

There are four major functions of logistics: (1) labeling, (2) packing/packaging, (3) traffic management, and (4) inventory and storage (Seyoum, 2000). We will discuss them briefly in the following sections.

LABELING

While labeling in Chapter 9 deals with labeling requirements for individual products, labeling requirements in logistics are typically enforced to ensure proper handling, such as "Do Not Roll" and "Keep Upright," or to identify shipments, such as "Live Animals." Sourcers are required to comply with domestic labeling laws. Therefore, sourcers must work closely with suppliers to ensure all cartons and containers are marked clearly and correctly. In the United States, the following information is required to be labeled on all containers and cartons that are being imported into the United States:

- Shipper's mark (or purchase order number).
- Country of origin.
- Weight in both pounds and kilograms.
- The number of packages.
- Handling instructions.
- Final destination.
- Port of entry.
- Whether the package contains hazardous materials.

These markings should appear on three faces of the container (not on the bottom).

PACKING AND PACKAGING

Proper packing is another important logistics function. Although the terms packing and packaging are used interchangeably, packaging is typically used for marketing and sales purposes, while packing is important for transportation and handling in transit. Without proper packaging, it would be difficult for consumers to obtain all necessary information about the products and the retailers may have to spend a lot more resources in handling and displaying the products in store. Without proper packing, however, the merchandise may also break, get wet, or even lost or stolen during shipments. Therefore, merchandise should be packaged in an effective way for marketing and merchandising, but it must also be packed in strong containers, adequately sealed and filled, with evenly distributed weight. Pallet packing can ease handling and some retailers require their goods to be packed in specific pallet sizes (see Figure 10.4). Insufficient or

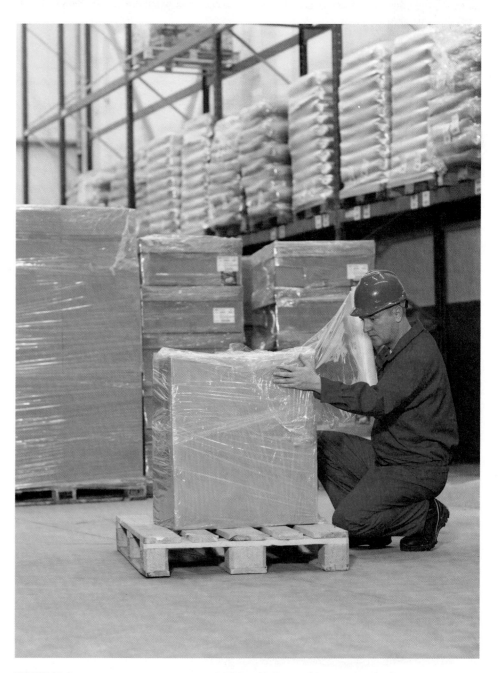

FIGURE 10.4 *Pallet packing also includes a moisture barrier to ensure product quality during the shipment.*
Source: Marcin Balcerzak/Shutterstock

improper packing may result in delays in the delivery of goods, rejection of the goods, or even claims against damage that might have occurred during transit. For this purpose, packing is more concerned with logistics, while packaging is more concerned with marketing. However, packing and packaging must be designed and executed side by side because one function affects the other.

In addition, as consumers' interests in sustainability increase, many businesses are interested in "green" (or environmentally friendly) packaging and packing. There are four main goals of green packing: reduce, reuse, recycle, and reform (Emmett & Sood, 2010). The first is to reduce the unnecessary packaging materials while keeping them sufficient to communicate product details to consumers. The second goal is to be able to reuse packaging or packing materials for other purposes and extend the life of the packing materials. The third goal is to use recyclable materials for packing and packaging and, finally, reforming packaging stresses on reviewing the core reasons for packaging and how the same function may be fulfilled without any environmental impact. This review would help reform the way businesses package and pack fundamentally.

Figure 10.5 shows the hierarchical functions of packaging and packing. At its core, packaging and packing should be able to:

- Protect products during transit.
- Protect products during storage.
- Communicate critical product information.
- Make products easy to handle throughout logistics cycles.
- Draw attention to products for consumer purchase.
- Convince consumers to purchase products (adapted from Emmett & Sood, 2010).

Sourcers help execute the vision of green packaging and packing by weighing both functional necessities of packaging/packing and their environmental impact. Sourcers must also consider the economic impact and find a balance between the two.

TRAFFIC MANAGEMENT

Traffic management refers to the control and management of transportation services, including selection of transportation mode and carrier, consolidation of small cargo, documentation,

1. Protect textile and apparel products during transit
2. Protect products during storage
3. Communicate critical, required product information

4. Make product easy to handle throughout logistics cycles
5. Draw attention to products for consumer purchase

6. Convince consumers to purchase products

FIGURE 10.5 Hierarchy of packaging/packing functions
Source: Adapted from Emmett & Sood (2010, p. 140).

and the filing of loss and damage claims. The selection of transportation mode and carrier is dependent on the delivery speed that sourcers want and the cost. Some small shipments are consolidated with other companies' small shipments. This may require changing airports or ports of departure. If the purchase order has been issued with terms of FOB or FAS, all of the decisions on traffic management must be made through sourcers with the help of traffic managers. If the purchase order has the terms of CIF, CNF, LDP, or DDP, the supplier is responsible for managing traffic.

Among the logistics functions, the traffic management function could be the most important for green (environmentally friendly) logistics. In global sourcing, green traffic management could be achieved by:

a) Selecting an appropriate transportation mode or a combination of modes that would be cost-effective and timely as well as environmentally responsible.

b) Maximizing the carrying capacity per transportation in roundtrips.

c) Reducing the number of movements and optimizing the routes.

d) Using efficient transportation companies that are committed to reducing energy consumption and emission levels (Emmett & Sood, 2010).

Within these principles, sourcers carefully examine the benefits and costs of each transportation decision with traffic managers and freight forwarders to optimize economic profits, while reducing environmental impact.

INVENTORY AND STORAGE

Inventory and storage is the fourth function of logistics discussed in this chapter. Transportation is not the only cost factor in logistics. The cost associated with holding inventories is also substantial throughout logistics. Appropriate inventory management ensures that goods are constantly flowing in and out of the sourcer's warehouses, reducing the overall costs of merchandise carrying and transportation. These product movements generate sales and profits. If the goods have to be stored for a while, the sourcer must consider where to store such inventory. In general, labor and rent associated with inventory management and storage is cheaper in the supplier's country than the sourcer's country. However, storing the goods in the supplier's country may not provide high levels of security from theft or protection from damages.

From the green logistics perspective, environmentally friendly warehousing is as important as green traffic management. Much energy and many resources are spent at warehouses. By careful planning, storage and inventory management can be effective and save cost and energy (see Figure 10.6). Green warehousing focuses on reducing the environmental impact of warehousing by:

• Constructing green (or energy-efficient) warehouses.

• Using renewable and efficient-energy sources.

• Optimizing storage space through just-in-time production and delivery.

• Optimizing movement and handling of goods.

• Reducing frozen inventory (Emmett & Sood, 2010).

Some apparel companies and retailers have their own warehouses, while others use warehousing services from other companies. Sourcers could work closely with managers of distribution centers and warehouses to implement green housing guidelines to achieve financial gains while minimizing the environmental impact of storage and inventory management.

FIGURE 10.6 *By careful planning, storage and inventory management can be effective and save cost and energy.*
Source: © Kadmy/Fotolia

Transportation modes

In terms of traffic management, sourcers have three different transportation modes: by air, water (ocean and inland), and land (rail and truck) (Seyoum, 2000). Experienced logistics managers carefully consider various transportation modes in both the suppliers' countries as well as the sourcer's country to achieve the most optimal transportation choices. In foreign countries, there may be different regulations and government policies for transportation modes. Some governments have more control over their countries' transportation systems while others have privatized them. Therefore, logistics decisions must include foreign countries' regulations and laws related to transportation and knowledge of the bureaucracy involved to import raw materials and export finished goods to other countries.

In global sourcing, ocean shipments are the most common transportation mode, although air shipments for fast delivery could also be possible (see Figure 10.7). Once finished goods enter the sourcer's country, inland water, rail, or truck could be selected for domestic transportation. Each mode offers different cost, speed, and environmental impacts. Ocean shipments from long-distance points of product origin would be cost-effective, yet delivery speed is not as fast as air shipments. Inland rail shipments may also be more cost-effective, yet slower and less flexible in terms of schedules, than inland truck shipments. Per unit, air shipments may cause the highest degree of pollution to the environment. However, if the sourcer loses the sales opportunity due to late delivery, the entire product may get canceled or become obsolete. Then, all the energy and materials used to produce the finished products may be wasted. Therefore, careful consideration between overall cost, delivery speed, and impact on the environment must be made before making logistics decisions. Well-mixed transportation modes are recommended to achieve both financial profits as well as environmental responsibility.

FIGURE 10.7 *Ocean shipments are the most common transportation mode in global sourcing.*
Source: © EvrenKalinbacak/Fotolia

AIR TRANSPORTATION

Traditionally, air transportation has been the least utilized mode of transportation for cargo, accounting for less than 1 percent of total international freight movement (Seyoum, 2000). However, as consumers' demands and tastes change faster than ever, more and more businesses consider air transportation. Technological innovations also help aircraft handle more and heavier cargo than before. The popularity of integrated transportation service companies, such as DHL, UPS, and FedEx, also has helped increase air transportation for cargo. Integrated transportation service companies provide door-to-door service to most international destinations and are extremely useful, reliable, and convenient for small-size shipments. Air cargo rates are typically determined by the distance to the point of destination and weight and size of the shipment. Sourcers may be able to negotiate special commodity rates with carriers for frequent shipments.

OCEAN FREIGHT

Ocean transportation is the least expensive and the most popular transportation mode in international trades. It is ideal for moving bulk freight of finished goods or raw materials. Almost all ocean shipments are made by containers, resulting in less handling at ports. Typically, suppliers would load the cargo at their warehouses or points of manufacturing into a metal container, usually 20 to 40 feet (or 6.1 to 12.2 meters) long, 8 feet (or 2.4 meters) high, and 8 feet (or 2.4 meters) wide. The container is then delivered to a port and loaded onto a containership for ocean transportation. This reduces tremendous handling time once the goods arrive at ports. Although some products cannot be containerized, such as automobiles and live animals, most apparel will be containerized for ocean transportation.

There are two important terms that sourcers must remember in ocean transportation: *full-container-load cargo (FCL)* and *less-than-container cargo (LCL)*. FCL is loaded and unloaded under the risk and account of one shipper or consignee (the person to whom the shipment is to be delivered, typically the sourcer). In general, the products in FCL are homogeneous and destined for one consignee. LCL is usually delivered at the supplier's port and

FIGURE 10.8 *Land transportation such as trucks and trains are ideal for moving the products between neighboring countries.*
Source: Kim Seidl/Fotolia

gets consolidated with other shippers' merchandise. Once the freight has arrived at the sourcer's port, if there are multiple consignees for the consolidated merchandise, all of the consignees must clear their products through the Customs for the container to be released for pick up. In many cases, ocean carriers also provide lower rates for FCL than LCL, as FCL requires less handling. Therefore, FCL is an easier and more efficient way to prepare ocean shipments.

LAND TRANSPORTATION

Land transportation, such as trucks and trains, are ideal for moving the products between neighboring countries (see Figure 10.8). In the United States, land transportation is used for transportation from and to Canada and Mexico. Often, goods from countries from Central America are also transported through land. Compared to rail, trucking is more flexible and faster. Rail transportation can handle large quantities and provide storage services during transit. In the United States, much physical distribution, from the retailers' distribution centers to each store, is made by land.

Freight forwarders

Regardless of transportation mode, sourcers work closely with freight forwarders for logistics. A **freight forwarder** is the party that facilitates the movement of cargo from the supplier's country to the sourcer's country on behalf of shippers and processes the documentation for Customs clearance (Seyoum, 2000). More specifically, a freight forwarder:

- Advises the shipper on the most economical choice of transportation and the best way to pack and ship the cargo to minimize cost and prevent damage.
- Reserves air, ocean, or land transportation and arranges for pickup, transportation, and delivery of the goods from the point of origin to the final destination.

- Ensures that the goods are properly packed and labeled and all necessary documents are prepared for Customs clearance at the port of destination.
- Ensures that all requirements are met to help the supplier get paid and the sourcer receive necessary documents when a letter of credit is used.
- Tracks and traces cargo in transit.
- Often helps shippers negotiate better cargo rates.

If the purchase order is issued on the terms of FOB, sourcers work closely with freight forwarders to arrange all of the international transportation activities. If it is based on CFI, CNF, LDP, or DDP, the supplier is responsible for working with freight forwarders to arrange transportation and deliver the goods to the agreed point of destination.

Importing procedures

Once final goods arrive at the sourcer's port, they need to go through certain processes to enter the sourcer's country legally (see Figure 10.9). In the United States, Customs and Border Protection (USCBP) is responsible for entry of foreign goods. According to USCBP, "the importer of record," such as the owner, purchaser, or licensed Customs broker designated by the owner, purchaser, or consignee, must file entry documents for goods with the port director at the goods' port of entry (U.S. Customs and Border Protection [USCBP], 2006). Customs brokers are private individuals, partnerships, or corporations that are licensed, regulated, and empowered by USCBP to assist importers and exporters in meeting federal import–export requirements (USCBP, 2012a). Customs brokers charge a fee to submit necessary information and appropriate payments to USCBP on behalf of their clients. Once again, depending on the terms of the purchase order, either sourcers (in the case of FOB, CIF, or CNF) or suppliers (in the case of LDP or DDP) are responsible for arranging entry of goods.

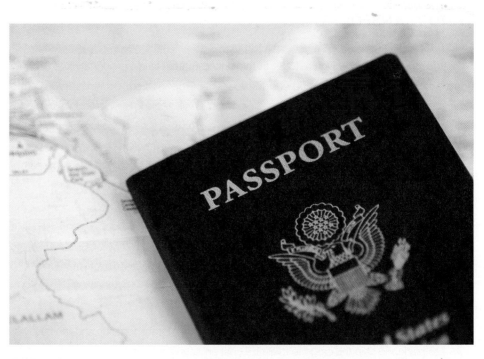

FIGURE 10.9 *Once final goods arrive at a port they need to go through certain processes to legally enter the sourcer's country.*
Source: © ckellyphoto/Fotolia

The merchandise entry process requires two steps: (1) filing the documents necessary to determine whether merchandise may be released from CBP, and (2) filing the documents that contain information for duty assessment and statistical purposes (USCBP, 2006). Delivery of the merchandise must be authorized by USCBP and estimated duties must be paid for any imported goods to legally enter the United States.

Entry documents

Within 15 calendar days of a shipment's arrival at a U.S. port of entry, the following minimum entry documents must be filed for most textile and apparel ocean shipments, although additional documents may also be required:

- Entry Manifest (CBP Form 7533).
- Evidence of right to make entry (document showing the identity of the importer of record).
- Bill of lading.
- Commercial invoice issued by the supplier based on the information from the purchase order.
- Packing lists.
- Country of origin certificates.
- Other documents to determine merchandise admissibility.

Figure 10.10 shows the form of Inward Cargo Manifest for Vessel Under Five Tons, Ferry, Train, Car, Vehicle, Etc. (CBP Form 7533). In addition, CBP Form 7523 (Entry and Manifest of Merchandise Free of Duty, Carrier's Certificate and Release) or CBP Form 3461 (Application and Special Permit for Immediate Delivery) can be filed, depending on the type of merchandise and delivery needs. CBP Form 7509 is for air cargo. Freight forwarders know which forms need to be filed. More information is available from the USCBP website (USCBP, 2012b).

The **bill of lading (B/L)** shows the receipt of the merchandise for its transportation to the destination specified in the bill and, therefore, is issued by the transportation carrier (Johnson, 1997). Depending on the terms of the purchase order and payment arrangements, the B/L that was issued by the carrier will be sent to an appropriate bank, if a letter of credit is issued, or to the sourcer directly, on open account purchases. For an air shipment, an air waybill is issued. Figure 10.11 shows a sample ocean bill of lading, and Figure 10.12 shows an example of an international air waybill. All of these documents can be submitted electronically via the Automated Broker Interface (ABI) program of the Automated Commercial System (ACS).

A commercial invoice, packing lists, country of origin certificates, and other necessary documents are issued by the supplier, and all of these are required to be filed with USCBP. Figure 10.13 shows examples of a commercial invoice, packing lists, country of origin certificates, and multiple country declaration. (All the numbers and information, including company names and addresses, are incorrect. However, they show what these documents look like and what type of information is required to complete these forms.) In this particular example the supplier is located in Guatemala, which is part of the Central America Free Trade Agreement (CAFTA) with the United States. This supplier uses raw materials and components from four different countries, such as Guatemala, United States, El Salvador, and Korea. Both country of origin certificates and multiple country declarations show which components came from which companies and countries. These details are important for the goods to be qualified for duty-free access to the U.S. market under CAFTA.

DEPARTMENT OF HOMELAND SECURITY
US. Customs and Border Protection

Approved OMB No. 1651-001
Exp. 03-31-2012

INWARD CARGO MANIFEST FOR VESSEL UNDER FIVE TONS, FERRY, TRAIN, CAR, VEHICLE, ETC.

(INSTRUCTIONS ON REVERSE)

CBP Manifest/In Bond Number

Page No.

1. Name or Number and Description of Importing Conveyance	2. Name orf Master or Person in Charge	
3. Name and Address of Owner	4. Foreign Port of Lading	5. U.S. Port of Destination
6. Port of Arrival	6. Date of Arrival	

Column No. 1	Column No. 2	Column No. 3	Column No. 4	Column No. 5
Bill of Lading or Marks & Numbers or Address of Consignee on Packages	Car Number and Initials	Number and Gross Weight (in kilos or pounds) of Packages and Description of Goods	Name of Consignee	For Use By CBP only

CARRIER'S CERTIFICATE

To the Port Director of CBP, Port of Arrival:

The undersigned carrier hereby certifies that _____ of _____

is the owner or consignee of such articles within the purview of section 484, Tariff Act of 1930.

I certify that this manifest is correct and true to the best of my knowledge.

Date _____ Master or Person in charge _____

(Signature)

Previous Editions are Obselete

CBP Form 7533 (06/09)

FIGURE 10.10 Entry manifest for inward cargo manifest for vessel under five tons, ferry, train, car, vehicle, etc.
Source: U.S. Customs and Border Protection

Entry process

Following presentation of the entry documents, the shipment may be examined. In particular, textiles and textile products are considered trade-sensitive and subject to a higher percentage of examinations than other commodities (USCBP, 2006). USCBP examines the goods and documents to determine the following information:

- The value of the goods for Customs purposes and their dutiable status.
- Whether the goods are marked with their country of origin, or special marking or labeling have been done properly if required.

DRAFT BL

BOOKING NO:

SHIPPER: FAX:	EXPORT REFERENCES:
CONSIGNEE: (Complete Address and Fax #)	FORWARDING AGENT: **BROKER CODE:**
NOTIFY: (Complete Address and Fax #)	ALSO NOTIFY: (Complete Address and Fax #)
VESSEL AND VOYAGE NO:	PLACE OF RECEIPT:
	PORT OF LOADING:
PORT OF DISCHARGE:	PLACE OF DELIVERY:

Marks & Numbers	Number of Packages	Description of Goods	Gross Weight	Measurement
		Container No./Seal No.		

Number of OBLs/Non-Negotiables **BL with Rates/Without Rates**	**BL Date:**	**Freight Charges:** Prepaid or Collect **Arbitrary Charges:** Prepaid or Collect
Select One: Shipped on Board Received for Shipment: On Board Container:	**Special Instructions:**	

FIGURE 10.11 Example of an ocean bill of lading
Source: OceanAiR Logistics, http://www.cargaaerea.com/documentation_oceanbill.pd

- Whether the shipment contains prohibited articles, including illegal narcotics.
- Whether the goods are in excess of the invoiced quantities or a shortage exists (USCBP, 2006).

These details are important to protect domestic markets as well as to estimate the correct amount of duties. A correct quantity, or a matching quantity between the invoice and the actual cargo, is important as most duties are assessed based on the quantity of the merchandise. For products whose duties are assessed based on net weight, USCBP will subtract the weight of the box, cask, bag, or other articles that contain the merchandise from the weight of the product so the customer does not pay for the non-merchandise components within the container. That allowance is called *tare*.

Despite the importance of examination, for budget issues the majority of the shipments are released without examination if no legal or regulatory violations are found. The importer of record then deposits duties and is able to pick up the merchandise from the port.

Shipper's Name and Address	Shipper's Account Number	Not Negotiable **Air Waybill** issued by
		Copies 1, 2, and 3 of this Air Waybill are originals and have the same validity.

| Consignee's Name and Address | Consignee's Account Number | It is agreed that the goods declared herein are accepted in apparent good order and condition (except as noted) for carriage SUBJECT TO THE CONDITIONS OF CONTRACT ON THE REVERSE HEREOF. ALL GOODS MAY BE CARRIED BY ANY OTHER MEANS INCLUDING ROAD OR ANY OTHER CARRIER UNLESS SPECIFIC CONTRARY INSTRUCTIONS ARE GIVEN HEREON BY THE SHIPPER, AND SHIPPER AGREES THAT THE SHIPMENT MAY BE CARRIED VIA INTERMEDIATE STIPPING PLACES WHICH THE CARRIER DEEMS APPROPRIATE. THE SHIPPER'S ATTENTION IS DRAWN TO THE NOTICE CONCERNING CARRIER'S LIMITATION OF LIABILITY. Shipper may increase such limitation of liability by declaring a higher value for carriage and paying a supplemental charge if required. |

Issuing Carrier's Agent Name and City	Accounting Information

Agent's IATA Code	Account No.	

Airport of Departure (Addr. of First Carrier) and Requested Routing	Reference Number	Optional Shipping Information

To	By First Carrier	Routing and Destination	to	by	to	by	Currency	CHGS	WT/WL PPD COLL	Other PPD COLL	Declared Value for Carriage	Declared Value for Customs

Airport of Destination	Requested Flight/Date	Amount of Insurance	INSURANCE–If carrier offers insurance and such insurance is requested in accordance with the conditions thereof, indicate amount to be insured in figures in box marked "Amount of Insurance".

Handling Information

HOLD FOR PICKUP

SCI

No. of Pieces RCP	Gross Weight	kg lb	Rate Class / Commodity Item No.	Chargeable Weight	Rate / Charge	Total	Nature and Quantity of Goods (incl. Dimensions or Volume)

Prepaid	Weight Charge	Collect	Other Charges
	Valuation Charge		
	Tax		
	Total Other Charges Due Agent		I hereby certify that the particulars on the face hereof are correct and that insofar as any part of the consignment contains dangerous goods. I hereby certify that the contents of this consignment are fully and accurately described above by proper condition for carriage by air according to applicable national governmental regulations.
	Total Other Charges Due Carrier		
Total Prepaid	Total Collect		Signature of Shipper or his Agent
Currency Conversion Rates	CC Charges in Dest. Currency		
For Carrier's Use only at Destination	Charges at Destination	Total Collect Charges	Executed on (date) at (place) Signature of Issuing Carrier or it's Agent XXX-

FIGURE 10.12 Example of an international air waybill
Source: UPS Inc., http://www.ups.com/aircargo/using/services/supplies/airwaybill.html

If an importer wishes to postpone release of the goods, the importer of record could file for a U.S. Customs warehouse (or bonded warehouse) entry (USCBP, 2006). Sometimes, the importer of record may not have a full set of documents from the supplier and needs additional time to get those documents. At other times, packing or container marks may have been done incorrectly and, after the examination, USCBP asks the importer of record to correct those mistakes before release of the goods. Then, the importer of record must keep the merchandise in a U.S. Customs warehouse while correcting those mistakes. Goods may be kept in the bonded warehouse for up to five years. However, the cost of storing in a U.S. Customs warehouse facility is extremely high. So, unless it is totally necessary, warehouse entry is not advisable.

COMMERCIAL INVOICE

Shipper/Export	No. & Date of Invoice	
C. S. A. TRADING, S. A.	CSA07-TPS055	30-May-07
	No. & Date of L/C	
For Account & Risk of Messers	L/C Issuing Bank	
	Term of Sale	
Notify party	Remarks	
		"FREIGHT PRE-PAID"
	BILL OF LADING NO. MTGBLGB1092007	

Port of Loading	Final Destination
PUERTO QUETZAL	CALIFORNIA
Carrier	**Sailing on or about**
APL LINE	30-May-07

Marks and numbers of PKG	Description of Goods			Quantity		U-price	Amount
WAREHOUSE	**CONTAINER NO. APHU453838-8**						
	LADIES 100% COTTON BERMUDA W/2X1 RIB WAISTBAND, SCREEN AND APPLIQUE						
	STYLE#	COLOR					
	MR22453	Swimmers Blue		13,800	PCS	$0.10	$1,380.00
	TOTAL	1150	CTNS	13,800	PCS		$1,380.00
	GRAND TOTAL	1,150	CTNS	13,800	PCS		$1,380.00

CONTRY OF ORIGIN; MADE IN GUATEMALA

MR22453

-FABRIC COMPOSITION
1) CM 20/1S RING SPUN

-FIBER CONTENT
1) 100% COTTON

TOTAL NET WEIGHT	2,645.00	KGS
TOTAL GROSS WEIGHT	4,945.00	KGS
TOTAL MEASURMENT	38.03	CBM

C. S. A. TRADING, S. A.

AUTHORIZED SIGNATURE

FIGURE 10.13 Examples of a draft commercial invoice, draft packing lists, draft country of origin certificates, and draft multiple country declaration

PACKING LIST

Shipper/Export	No. & Date of Invoice	
C. S. A. TRADING, S.A.	CSA07-TPS055	30-May-07

No. & Date of L/C

For Account & Risk of Messers	L/C Issuing Bank

Term of Sale

Notify party	Remarks
	"FREIGHT PRE-PAID"

BILL OF LADING NO. MTGBLGB1092007

Port of Loading	Final Destination
PUERTO QUETZAL	CALIFORNIA
Carrier	**Sailing on or about**
APL LINE	30-May-07

Marks and numbers of PKG	Description of Goods	Quantity	U-price	Amount
WAREHOUSE	**CONTAINER NO. APHU453838-8**			
	LADIES 100% COTTON BERMUDA W/2X1 RIB WAISTBAND, SCREEN AND APPLIQUE			
	STYLE# COLOR			
	MR22453 Swimmers Blue 13,800 PCS			
	TOTAL 1150 CTNS 13,800 PCS			
	GRAND TOTAL 1,150 CTNS 13,800 PCS			

CONTRY OF ORIGIN; MADE IN GUATEMALA

MR22453

- FABRIC COMPOSITION
1) CM 20/1S RING SPUN

- FIBER CONTENT
1) 100% COTTON

TOTAL NET WEIGHT	2,645.00	KGS
TOTAL GROSS WEIGHT	4,945.00	KGS
TOTAL MEASURMENT	38.03	CBM

C. S. A. TRADING, S.A.

AUTHORIZED SIGNATURE

FIGURE 10.13 *(Continued)*

CSA TRADING, S.A.

PACKING LIST # CSA07-TPS055

Commodity : LADIES' 100% COTTON FRENCH TERRY BOTTOMS
Destination : BELL, CA 90201
Style No: MR22453
Cont/ Seal : APHU453838-8 Seal: 07973
ETD/ETA dates 5/30 - 6/8

STYLE No.	CTN No.	To.	CTNS	CARTON DIMM. (Inch) L	W	H	G.W (KG)	N.W (KG)	M3
MR22453	1	1150	1150	23	19.5	4.5	4,945	2,645.0	38.03
TOTAL			1150				4,945	2,645.0	38.03

*** DETAILS :** MANUFACTURER: HANDSOME GUATEMALA, S.A.

COLOUR	CTNS	Ctn No FROM	TO	XS	S	M	L	XL	XXL	Total PCS
SWIMMERS BLUE	100	1	100	12						1200
	250	101	350		12					3000
	350	351	700			12				4200
	250	701	950				12			3000
	150	951	1100					12		1800
	50	1101	1150						12	600
	1150									13800

COLOR AND SIZE BREAKDOWN

COLOR AND SIZE			XS	S	M	L	XL	XXL	TOTAL
SWIMMERS BLUE			1200	3000	4200	3000	1800	600	13800
TOTAL:			1,200	3,000	4,200	3,000	1,800	600	13,800

FIGURE 10.13 *(Continued)*

If the goods are not filed for entry within 15 calendar days after arrival, they may be moved to a general-order warehouse at the importer's risk and expense. If the entry has not been filed for over six months since the arrival, the goods may be sold at public auction or destroyed by USCBP (USCBP, 2006).

Throughout the entry process, sourcers must understand that different trade agreements and preference programs require different documents and evidences to gain duty-free access. By working closely with freight forwarders, Customs brokers, and suppliers, sourcers are able to smoothly complete the entry process once the goods arrive at a sourcer's port (see Figure 10.14).

Special duties

In addition to regular duties, USCBP may require additional duties, such as antidumping and countervailing. Both antidumping and countervailing duties are assessed on imported goods that are intended for sale in the United States at abnormally low prices (USCBP, 2006). These

CERTIFICATE OF ORIGIN
U.S.-DOMINICAN REPUBLIC-CENTRAL AMERICA FREE TRADE AGREEMENT

1. Exporter Name and Address: CSA TRADING,S.A.	2. Importer Name and Address:
	$0.00 $0.00 $0.00

3. Producer Name and Address:	5. Preferential Group:
4. TAX ID#: 2400597-5	

6. Description: **LADIES 100% COTTON BERMUDA W/2X1 RIB WAISTBAND, SCREEN AND**	7. HTSUS-Tariff classification number:

8. Document Period:

☐ Single shipment.

☒ Multiple shipment.

Commercial Invoice No.: **CSA07-TPS055**

Blanket Period: From: January 2007 To: December 2007

MAS AIR	05/05/2007	Each description below is only a summary
A	Cotton, synthetic or artificial knit fabrics **(boxes 9, 10)**	
B	Elastomeric yarn knitted fabrics **(boxes 10)**	
C	Cotton, synthetic or artificial woven fabrics **(boxes 9, 10)**	
D	Wool and silk woven fabrics **(box 10)**	
E	Cotton, synthtetic or artificial knit or woven apparel **(boxes 10, 11, 12) if apply (boxes 9,13, 14)**	
F	Woven and Non-Cotton Vegetable Fiber knit or woven apparel **(boxes 11, 12) if apply (boxes 13, 14)**	
G	Single transformation	
H	Most Favored Nation Program **(boxes 11, 12 US only) if apply (boxes 13, 14)**	
I	Short supply **(boxes 9, 10, 11, 12, 15) if apply (boxes 13, 14)**	
J	Traditional folklore handicraft goods **(box 16)**	
K	Other made up textile articles **Chapter 63(boxes 9, 10, 11, 12,14,15) Chapter 94 (boxes 9,10,11,15)**	
L	Luggage and hand bags	

9. US/DR-CAFTA Fiber producer name/address: N/A	10. US/DR-CAFTA Yarn producer name/address: **NATIONAL TEXTILES LLC**
11. US/DR CAFTA Fabric producer name/address: **VIVA MUNDO TEXTILE, S.A.**	12. US/DR CAFTA Thread producer name/address: **COATS NORTH AMERICA**
13. US/DR CAFTA Visible Linings producer name/address: N/A	14. US/DR CAFTA Elastic producer name/address: **GRUPO FABRIL C & T, S.A.**
15. Name of the fiber, yarn or fabric of the short supply list: N/A	16. Name of the folklore article: N/A
17. Company: C. S. A. TRADING, S.A.	18. Telephone/facsimile:
19. Name (Print or Type):	20. Title: LEGAL REPRESENTATIVE AND GENERAL MANAGER
21. Authorized Signature:	22. Date: 30/May/07

I certify that:

The information on this document is true and accurate and I assume the responsibility for proving such representations. I understand that I am liable for any false statements or material omissions made on or in connection with this document;

I agree to maintain, and present upon request, documentation necessary to support this certification, and to inform, in writing all persons to whom the certificate was given of any changes that

The goods originated in the territory of one or more of the Parties, and comply with the origin requirements specified for those goods in the United States-Dominican Republic--Central America Free Trade Agreement, there has been no further production or any other operation outside the territories of the parties,

other than unloading, reloading, or any other operation necessary to preserve it in good condition or to transport the good to the United States; and

Republic-Central America Free Trade Agreement, there has been no further production or any other operation outside the territories of the parties,

This certification consists of ___07___ pages including all attachments.

FIGURE 10.13 *(Continued)*

MULTIPLE COUNTRY DECLARATION

I, _____ declare that the articles described and covered by the invoice or entry to which this declaration relates were exported from the country identified below on the dates listed and were subjected to assembly, manufacturing, or processing operations in and/or incorporate materials originating in the foreign territory or country or countries or the U.S. or an insular posession of the U.S. identified below. I declare that the information set forth in this declaration is correct and true to the best of my information, knowledge, and belief.

CSA07-TPS046

A GUATEMALA
B USA
C EL SALVADOR
D KOREA

MARKS OR NUMBERS OF IDENTIFICATION	DESCRIPTION OF ARTICLE AND QUANTITY IN DOZ.	DESCRIPTION OF MANUFACTURING AND/OR PROCESSING OPERATION	COUNTRY OF EXPORT	DATE AND COUNTRY OF MANUFACTURING AND / OR PROCESSING		
				DESCRIPTION OF MATERIAL	COUNTRY OF PRODUCTION	DATE OF EXPORTATION
STYLE# MR22453	LADIES 100% COTTON BERMUDA W/2X1 RIB WAISTBAND, SCREEN AND APPLIQUE 13,800 PCS. (1,150 DZ)	YARN	B	100% Cotton 20/1	B	19-Jan-07
		KNITTING	A	TRIMS	A	
		DYEING	A	MAIN LABEL	D	
		CUT/SEW/PACK	A/B	CARE/CONTENT LABEL	D	
		TRIMING	A	DPCI LABEL	A	
		PRESSING	A	THREAD	B	
		FINISHING	A	HANGTAG	N/A	
		PACKING	A	POLY BAG	A	
		INSPECTION		TAG PIN	A	
				CARTON	A	
				HANGER & SIZER	A	
				ELASTIC	A	

Date: 30-May-07

NAME:

SIGNATURE :

TITLE: PRESIDENT

COMPANY:

ADDRESS:

COUNTRY OR COUNTRIES WHEN USED IN THIS DECLARATION INCLUDES TERRITORIES AND U.S. INSULAR POSESSIONS. THE COUNTRY WILL BE IDENTIFIED IN THE ABOVE DECLARATION THE ALPHABETICAL DESIGNATION APPEARING NEXT TO THE NAMED COUNTRY.

FIGURE 10.13 *(Continued)*

FIGURE 10.14 *By working closely with everyone involved, sourcers are able to complete the entry process smoothly.*
Source: Deklofenak/Shutterstock

low prices are deemed to be the result of unfair foreign trade practices, giving some imports an unearned advantage over competing U.S. goods.

Dumping refers to a business practice of trying to sell products at lower prices in the United States than those same products would bring in the supplier's home market. Dumping also includes trying to sell products in the United States at a price lower than the cost to manufacture those items. Dumping is possible if suppliers want to gain new markets by offering lower-than-manufacturing-cost prices. Therefore, by adding antidumping duties, the overall import cost would increase, resulting in higher retail prices. Low prices of imported goods are also possible through government subsidies to reduce manufacturers' costs in producing, manufacturing, or exporting particular products. In that case, countervailing duties are assessed to low-priced products that have benefited from foreign governments' subsidies. In the United States, the Department of Commerce, the International Trade Commission, and USCBP administer and enforce antidumping and countervailing duty laws.

Special notes for textile and apparel importers

Finally, Section 333 of the Uruguay Round Implementation Act (URIA; 19 U.S.C. 1592a) requires the secretary of the treasury to publish a list of foreign producers, manufactures, suppliers, sellers, exporters, or other foreign persons found to have violated this act by using false, fraudulent, or counterfeit documentation, labeling, or prohibited transshipment of textile and apparel products (USCBP, 2006; see Figure 10.15). Because of various free trade agreements and trade preference programs, fraudulent documents such as country of origin certificates or multiple country declaration have been common. That is, a large number of exporters have created and submitted fraudulent country of origin certificates and claims to take advantage of duty-free access to the United States. Section 333 of the Uruguay Round Implementation Act tries to prevent such fraudulent business practices.

Transshipment is another illegal business activity. Let's say the goods are in fact made in one country, such as China, but shipped to another country that has a free trade agreement with the United States, such as El Salvador, before entering the United States. While in El Salvador,

FIGURE 10.15 *Any foreign persons found to have violated the URIA by using false documentation of textile products are placed on a federal black list.*
Source: Jim Parkin/Shutterstock

the goods are relabeled to show El Salvador as a country of origin. Then the entry documents are filed as CAFTA-eligible goods to take advantage of duty-free. This process is considered illegal transshipment. Once again, this type of business activity is prohibited by the Uruguay Act and, if any exporters and importers violated this act, their information will be published through the Department of the Treasury.

In addition, the Uruguay Act also ensures that textile and apparel sourcers, importers, and retailers exercise "reasonable care" in carrying out import procedures with accurate documentation and packing and labeling regarding the product's origin (USCBP, 2006). USCBP suggests that to meet the reasonable care standard, textile and apparel sourcers and importers should consider asking the following questions when dealing with new suppliers or suppliers who are on the list of the secretary of treasury:

1) Has the importer had a prior relationship with the named party?
2) Has the importer had any seizures or detentions of textile or apparel products that were directly or indirectly produced, supplied, or transported by the named party?
3) Has the importer visited the company's premises to ascertain that the company actually has the capacity to produce the merchandise?
4) Where a claim of an origin-conferring process is made in accordance with 19 CFR 102.21, has the importer ascertained that the named party actually performed that process?
5) Is the named party really operating from the country that he or she claims on the documentation, packaging or labeling?
6) Does the country have a dubious or questionable history regarding this commodity?
7) Have you questioned your supplier about the product's origin?
8) If the importation is accompanied by a visa, permit, or license, has the importer verified with the supplier or manufacturer that the document is of valid, legitimate origin? Has the importer examined that document for any irregularities that would call its authenticity into question? (USCBP, 2006, p. 32)

After all, it is the sourcer's responsibility to import goods legally without any violations against international treaties. Reasonable and due processes are recommended throughout the import process.

summary

Throughout global sourcing, various functions of logistics take place to move raw materials to the production sites and to move finished goods to the sourcer's distribution centers. Both materials management (or inbound materials) and physical distribution (or outbound materials) are part of logistics. Logistics decisions could be made by the systems approach, the total cost approach, or the opportunity cost approach. The systems approach is particularly useful for sourcers who want to make decisions for their business activities to be sustainable. The systems approach necessitates that logistics decisions be made to improve the business or the world as a whole, not just individual business units.

Four major functions of logistics are labeling, packing/packaging, traffic management, and storage and inventory (see Figure 10.16). Labeling is an important function of logistics mandated by governments to properly label the container and packaging to communicate product identity and country of origin. Packing protects products in transit and is critical for communicating product details through display. Green packing initiatives focus on reducing and reusing packaging materials, and using recyclable materials. Traffic management controls and manages transportation services. Green transportation emphasizes selecting the right mix of transportation modes, optimizing transportation capacity utilization, and supporting energy-efficient fleet management. Finally, storage and inventory management are important parts of logistics because well-managed inventory has a constant flow of movement, delivering timely products efficiently. Green warehousing efforts are as critical as green transportation, and there are many ways to store and manage inventory efficiently while reducing the environmental impact.

There are three transportation modes, air, ocean, and land. Each mode has its own advantages and disadvantages. Air transportation is fast, yet consumes a great deal of energy. Ocean transportation is the most efficient and least costly option for commodity transportation between countries, but it is not as flexible as other modes. Trucks and rails are important land transportation modes, yet they are not suitable for long-distance international travel. Experienced sourcers must carefully consider different options to achieve financial gains, while minimizing impact on the environment.

Finally, through the logistics functions, finished goods arrive at the sourcer's port. By law, all imported goods must be filed for entry with Customs and part of those goods may be inspected. In the United States, entry of goods requires submitting various documents, including entry manifest, commercial invoice, packing lists, country of origin certificate, and other necessary documents to verify the products' identity and dutiable status. Customs examines the documents and authorizes release, if there are no violations. Sourcers (if FOB, CIF, or CNF) or suppliers (if LDP or DDP), depending on the terms of cost, pay duties to Customs and arrange pickup at the port. In special cases, antidumping duties and countervailing duties may be assessed if the goods are thought to have an abnormally low price. Textile and apparel products are highly trade-sensitive and have a higher chance of getting inspected by the U.S. Customs and Border Protection. Sourcers must carefully follow suggestions recommended by USCBP and execute due process throughout global sourcing.

FIGURE 10.16 *Labeling is a major function of logistics in the textile and apparel industry.*
Source: © Art Directors & TRIP/Alamy

key terms

Bill of lading (B/L) is a document showing the receipt of the merchandise for its transportation to the destination specified in the bill. It is typically issued by the transportation carrier.

Dumping refers to a business practice of trying to sell products at lower prices in the United States than those same products would bring in the supplier's home market.

Freight forwarder is the party that facilitates the movement of cargo from the supplier's country to the sourcer's country on behalf of shippers and processes the documentation for Customs clearance.

Logistics refers to the systematic management of all activities required to move and distribute products throughout the supply chain, including flow and storage of raw materials and finished products from point of origin to point of consumption.

Materials management in logistics primarily deals with the timely movement or flow of materials from the sources of supply to the point of manufacture, assembly, or distribution (inbound materials).

Physical distribution in logistics includes the movement or flow of materials from the firm's point of manufacturing origin and/or distribution center to the point of sales (outbound materials).

Traffic management refers to the control and management of transportation services, including selection of transportation mode and carrier, consolidation of small cargo, documentation, and filing of loss and damage claims.

Transshipment is an illegal business activity involved in false declaration of country of origin to take advantage of duty-free or reduced-duty benefits.

learning activities

1. What is logistics? How does logistics differ from transportation, warehousing, global sourcing, and supply chain?

2. Pick up an air waybill from a local FedEx or UPS office. Review it carefully and share what type of information the form requires you to provide and why you think such information is necessary.

3. Which approach do you agree with the most for logistics decisions—the system, total cost, or opportunity cost approach? Explain why.

4. If you happen to be a proponent of the systems approach and your managers do not support your position, what type of convincing reasons and evidence would you show your managers to accept your position?

5. Imagine you are a sourcing manager for Amazing Jeans. For boys' cotton denim pants, come up with specific strategies for your logistics to be green, in terms of:
 a. Labeling
 b. Packing and packaging
 c. Transportation
 d. Warehousing

1. What product categories within textile and apparel provide the greatest amount of packaging as part of their sales? If you are a sourcing manager for such product categories, what specific packaging strategies would you suggest to make your logistics green?

2. Research energy consumption and carbon footprints on ocean, air, and land transportation modes. Discuss advantages and disadvantages of each mode in terms of its environmental impact.

3. Discuss why textile and apparel products are considered trade-sensitive?

4. Examine each document necessary to submit to U.S. Customs and Border Protection to file an entry of the goods. What information is required and why does USCBP need such information?

5. Who is responsible for filing an entry for the following purchase order once the goods have arrived at a sourcer's port under each of the following terms?
 a. CIF
 b. FOB
 c. LDP

references

Emmett, S., & Sood, V. (2010). *Green supply chains: An action manifesto.* Chichester, United Kingdom: Wiley.

Johnson, T. E. (1997). *Export/import procedures and documentation.* New York, NY: American Management Association.

Seyoum, B. (2000). Chapter 6. International logistics and transportation. In B. Seyoum, *Export-import theory, practices, and procedures* (pp. 99–121). Binghamton, NY: Haworth Press.

U.S. Customs and Border Protection. (2006). *Importing into the United States: A guide for commercial importers.* Retrieved January 25, 2012, from http://www.cbp.gov/linkhandler/cgov/newsroom/publications/trade/iius.ctt/iius.pdf

U.S. Customs and Border Protection. (2012a). *Becoming a customs broker.* Retrieved June 5, 2012, from http://www.cbp.gov/xp/cgov/trade/trade_programs/broker/brokers.xml

U.S. Customs and Border Protection. (2012b). *Forms.* Retrieved June 5, 2012, from http://www.cbp.gov/xp/cgov/toolbox/forms

GLOBAL SOURCING STEP 7: SOURCING PERFORMANCE EVALUATION

LEARNING OBJECTIVES

At the end of each sourcing cycle or fiscal year, a sourcer's performance is evaluated. Without evaluations, problems cannot be addressed and improvements for future sourcing would be difficult to make. Three dimensions of sourcing performance evaluations are suggested, following the triple bottom line theory of sustainability. Upon completion of this chapter, students will be able to:

- Understand the goals of global sourcing and how each goal should be evaluated under the framework of the triple bottom lines of sustainability.
- Comprehend the complex relationships among the three dimensions of global sourcing performance—economic, social, and environmental.
- Articulate and evaluate the specific evaluation metrics of the three dimensions of global sourcing performance.
- Analyze the characteristics of outstanding global sourcing companies.
- Evaluate the consequences of failing one of the three dimensions of global sourcing performance.
- Apply sourcing performance evaluation methods and establish a new set of optimal performance evaluation strategies for different global sourcing companies.

11

Step 7: Sourcing performance evaluation

By legally entering finished goods into the sourcer's country and arranging for physical distribution, sourcers' main responsibilities are fulfilled. At the end of each sourcing project, sourcers must evaluate their performance and make suggestions to better future sourcing projects. Finally, the results of sourcing evaluation can directly affect new product development, completing the circle of the whole global sourcing process. Typically, most business activities are examined from the cost and profit perspectives. Other factors, such as quality and timely delivery, affect the company's financial bottom line, cost, and profit. That is, any failure in producing quality products and delivering goods on time may incur penalties or loss of sales. Therefore, sourcing performance evaluation based on cost and profit is quite common in today's business environments. However, given the fact that global sourcing affects so many people and countries in the world, a more holistic approach is recommended to evaluate global sourcing projects, including social and environmental performance. This chapter discusses the seventh and final stage of the seven core steps of global sourcing—sourcing performance evaluation (see Figure 11.1).

Sourcing performance evaluation

Evaluation of past business activities is always important to improve future business activities. Sourcing performance can be evaluated per individual sourcing project or per annual performance

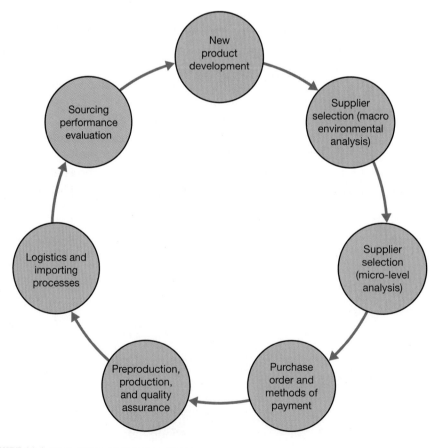

FIGURE 11.1 Core steps of global sourcing

collectively. Project-to-project or year-to-year performance evaluations are recommended to carefully examine which projects were successful and which were not. These evaluations would then be available to help predict future performance.

In general, researchers suggest that outstanding global sourcing, regardless of industry categories, has several common characteristics. After researching several successful global sourcing businesses, Trent and Monczka (2005) reported that, first, companies with outstanding global sourcing performance show executives' commitment to global sourcing. These companies have rigorous and well-defined global sourcing processes, as well as carefully designed organizational structures that are optimal for global sourcing. Next, necessary resources for global sourcing are readily available within the companies, the company's communication systems are well integrated with information technologies, and they have well-defined methodologies for measuring cost savings. Some of these characteristics can be shared with textile and apparel sourcing businesses, yet performance measures of textile and apparel sourcing must go beyond cost savings.

To assess sourcing performance beyond short-term cost savings, we must go back to Chapter 1. In Chapter 1, we discussed the goals of global sourcing as improving businesses' economic performance, advancing social conditions in the world, and protecting the natural environment. Considering that global sourcing of apparel takes place to satisfy humans' clothing needs and wants, and that these satisfaction processes must meet the **triple bottom lines** for humans to be sustainable on Earth, the evaluation of sourcing performance must be done by examining economic, social, and environmental impacts of sourcing projects. Figure 11.2 illustrates the dimensions of global sourcing, incorporating all three bottom lines of sourcing performance.

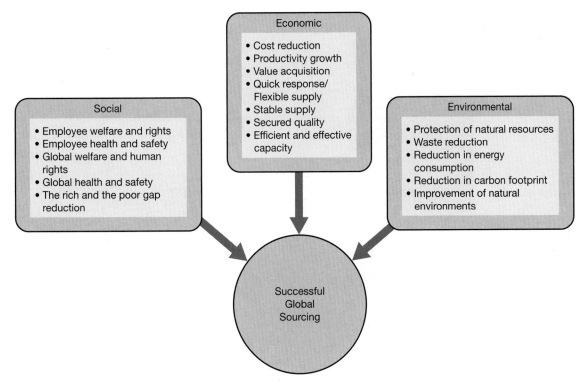

FIGURE 11.2 Dimensions of global sourcing performance evaluation

Metrics of economic performance of global sourcing

At the end of each global sourcing cycle, businesses must be able to gain sufficient financial or economic gains to continue their businesses. Without financial gains, businesses cannot survive or continue to survive. Without business survival, global sourcing would not take place and international trade and employment of foreign workers would not happen. This creates precisely the opposite outcome of our efforts to be sustainable. Therefore, financial performance is absolutely necessary to sustain the global textile and apparel supply chain.

To achieve higher financial gains, as discussed in Chapter 1, most sourcers seek to reduce costs, increase productivity, acquire critical new values, supply products in flexible time frames, ensure consistent supply, guarantee acceptable quality, and efficiently and effectively manage capacity of global manufacturing and sourcing. Some companies may put more weight on cost reduction and productivity growth than flexible supply. Other companies may put emphasis on new value acquisition or long-term vendor–supplier relationships over capacity management. Each company has different obligations to its shareholders. Publicly trading companies are required to meet their shareholders' needs, while private companies may require different achievements to continue their businesses. Therefore, companies evaluate economic sourcing performances differently to measure how successfully such obligations are met.

The bottom line of economic performance evaluation is to measure how much global sourcing has helped improve the company's financial performance. Although it sounds simple, in reality it is extremely difficult to isolate the contribution of global sourcing alone to the company's overall financial performance (see Figure 11.3). In addition, there is no one specific set of criteria recommended for evaluation of global sourcing. Global sourcing is

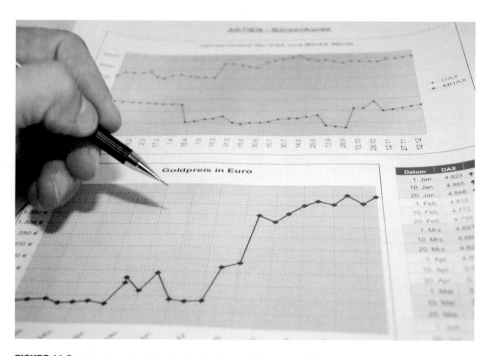

FIGURE 11.3 *It is extremely difficult to isolate the contribution of global sourcing alone to the company's overall financial performance.*
Source: © the_builder/Fotolia

highly interdependent with other business functions, and the outcomes of global sourcing are the results of interdepartmental collaboration. Therefore, instead of isolating the contribution of global sourcing itself, companies usually conduct an overall postproduction or postshipment evaluation for the entire process of product development, global sourcing, sales, and postsales of finished products. If all of these processes were successful, final performance is more likely to be positive.

Despite the difficulties of pinpointing the success of global sourcing, there still are some basic guidelines that industry members use to assess global sourcing performance. For that purpose, both objective and subjective measures are recommended. First, for objective measures, true final costs must be calculated and reported. Final costs may significantly differ from initial costs estimated prior to a purchase order. Throughout the sourcing processes, additional expenses could have incurred, including cost of rework, higher transportation costs due to higher oil prices, or cost of air shipments due to late production. Sourcers must track all of the expenses beyond what the purchase order specified and conclude the final costs. These final costs are then reviewed at both micro and macro level to evaluate the overall financial performance of a sourcing project.

Overall, final costs should include the expenses of various components throughout a sourcing project. In the 2010 survey by Kurt Salmon and *Apparel* magazine across U.S. apparel sourcing executives, the respondents shared that final costs must capture costs of fabric, trim, packaging/labeling, duties/taxes, factory overhead/markup, washing/finishing, inland transportation, insurance, landing charges, and so on (Pincus, Burns, & Tippner, 2010).

Second, subjective measures of financial performance of global sourcing could be evaluated through sourcers' self-evaluation and sourcing teams' peer evaluation of performance. Table 11.1 shows an example of a survey that could be used by sourcing personnel to assess their overall sourcing performance.

In addition to self-evaluation, surveys from other departments with regard to the overall effectiveness and efficiency of the global sourcing team can be helpful. These surveys could measure if the sourcing team works well and seamlessly with related departments, such as product development, sales, distribution, design, import, and accounting teams. These surveys ask

TABLE 11.1
Self-evaluation of economic sourcing performance

Item	Points (on a scale of 1–10)
1. I believe sourcing helped reduce cost tremendously.	
2. I believe sourcing helped grow productivity tremendously.	
3. I believe sourcing helped deliver goods quickly to respond to market needs.	
4. I believe sourcing helped secure delivery reliability.	
5. I believe sourcing helped secure supply reliability.	
6. I believe sourcing helped secure quality reliability.	
7. I believe sourcing managed the company's capacity efficiently and effectively.	
8. I believe overall performance of sourcing was positive.	

Note: This rubric was created by the author based on her years of industry experience in global sourcing, as well as research and teaching experience. These are suggested, not determined, items for self-evaluation.

TABLE 11.2

Peer evaluation of economic sourcing performance

Item	Points (on a scale of 1–10)
1. I believe the sourcing team helped reduce cost tremendously.	
2. I believe the sourcing team helped grow productivity tremendously.	
3. I believe the sourcing team helped deliver goods quickly to respond to market needs.	
4. I believe the sourcing team helped secure delivery reliability.	
5. I believe the sourcing team helped secure supply reliability.	
6. I believe the sourcing team helped secure quality reliability.	
7. I believe the sourcing team managed the company's capacity efficiently and effectively.	
8. I believe the sourcing team effectively communicated with my team.	
9. I believe the sourcing team was willing to work with my team.	
10. I believe the overall performance of the sourcing team was positive.	

Note: This rubric was created by the author based on her years of industry experience in global sourcing, as well as research and teaching experience. These are suggested, not determined, items for self-evaluation.

the same questions used in self-evaluation to measure "perceived" sourcing effectiveness by nonsourcing teams. The surveys could also ask about the overall effectiveness of internal communications and coordination that are critical for overall success. These surveys would complement sourcers' self-evaluation to give firms a better grasp on the overall success of sourcing. Table 11.2 shows an example of a survey that could be used by nonsourcing teams to assess the effectiveness of global sourcing.

Social and environmental performance of global sourcing

The economic success of global sourcing also must be evaluated in terms of the social and environmental impacts that global sourcing projects might have created. The welfare, rights, health, and safety of sourcers' and suppliers' employees are important, and evaluating how sourcing projects have helped improve such important issues is critical for overall sustainability. Even more, through global sourcing, the supplier country's communities and society may have been improved. Perhaps, through global sourcing, more young people might have gained access to employment and education. The communities may now have more educated young people and become more advanced overall.

On the other hand, if global sourcing was done irresponsibly, the welfare, rights, health, and safety of suppliers' employees might have been jeopardized and violated (see Figure 11.4) and the reputation of the sourcers' company may have been damaged. After all, a tarnished reputation decreases the morale and self-pride of a company's employees. As discussed in Chapter 1, global sourcing is critical for advancing economies and living conditions in developing countries and reducing the gap between the rich and the poor across the nations.

The impacts on the natural environment also must be assessed for global sourcing projects, raising many questions. By working with suppliers who have effective water-

FIGURE 11.4 *Global sourcing companies must be responsible for foreign employee welfare, rights, health, and safety.*
Source: © Dinodia Photos/Alamy

treatment processes, did a particular global sourcing project help decrease water pollution in the supplier's country? Did sourcers convince suppliers to obtain new energy-efficient power systems to help reduce overall energy consumption in the supplier's country? Did sourcers carefully select transportation modes to reduce the overall carbon footprint of the products during transit? Did sourcers ask suppliers to use any recyclable materials in production and packing? All of these questions directly affect the impact of global sourcing on natural environments.

Both social and environmental impacts may not be assessable for short-term sourcing projects and it may take awhile to quantify and qualify sourcers' efforts to improve society and the environment. However, similar to the self-evaluation and peer evaluation surveys assessing economic sourcing performance discussed previously, self-evaluations by sourcers and evaluations by suppliers could be developed to assess overall social and environmental sourcing performance (see Tables 11.3 and 11.4). Perhaps these evaluations could be done annually, while economic performance evaluation could be done quarterly or semiannually.

Wise balance between economic, social, and environmental performance

The results of performance evaluation must be carefully evaluated. A wise balance between economic, social, and environmental performance is necessary as one cannot be sustained without the others (see Figure 11.5). Also, it should be noted that not all three performances must be perfectly achieved in equal weights. Perhaps, economic performance should be

TABLE 11.3

Self-evaluation of social and environmental performance of global sourcing

Item	Points (on a scale of 1–10)
Social Performance	
1. I believe sourcing helped improve the welfare of my company's employees.	
2. I believe sourcing helped improve the welfare of the supplier's employees.	
3. I believe sourcing helped improve the welfare of the supplier country's people in general.	
4. I believe sourcing helped improve the rights of my company's employees.	
5. I believe sourcing helped improve the rights of the supplier's employees.	
6. I believe sourcing helped improve the rights of the supplier country's people in general.	
7. I believe sourcing helped improve the health of my company's employees.	
8. I believe sourcing helped improve the health of the supplier's employees.	
9. I believe sourcing helped improve the health of the supplier country's people in general.	
10. I believe sourcing helped improve the safety of my company's employees.	
11. I believe sourcing helped improve the safety of the supplier's employees.	
12. I believe sourcing helped improve the safety of the supplier country's people in general.	
13. I believe overall social performance of sourcing was positive.	
Environmental Performance	
1. I believe sourcing helped reduce the wastes of my company.	
2. I believe sourcing helped reduce the wastes of the supplier.	
3. I believe sourcing helped reduce wastes in general.	
4. I believe sourcing helped reduce the energy consumption of my company.	
5. I believe sourcing helped reduce the energy consumption of the supplier.	
6. I believe sourcing helped reduce energy consumption in general.	
7. I believe sourcing helped reduce the carbon footprints of my company.	
8. I believe sourcing helped reduce the carbon footprints of the supplier.	
9. I believe sourcing helped reduce carbon footprints in general.	
10. I believe sourcing helped protect the natural environments in my country.	
11. I believe sourcing helped protect the natural environments in the supplier country.	
12. I believe sourcing helped protect natural environments in general.	
13. I believe overall environmental performance of sourcing was positive.	

Note: This rubric was created by the author based on her years of industry experience in global sourcing, as well as research and teaching experience. These are suggested, not determined, items for self-evaluation.

weighted a little heavier than the other two. Some companies, such as TOMS shoes, are more concerned with social performance while others, such as Patagonia, are more active in environmental performance. It is each company's vision and choice to decide which performance metrics should be given higher priority than others and to what extent. However, a sole focus on economic performance at the expense of social and environmental damages may not help the companies in the long run.

TABLE 11.4

Supplier's evaluation of social and environmental performance of global sourcing

Item	Points (on a scale of 1–10)
Social Performance	
1. I believe sourcers helped improve the welfare of my company's employees.	
2. I believe sourcers helped improve the welfare of my country's people in general.	
3. I believe sourcers helped improve the rights of my company's employees.	
4. I believe sourcers helped improve the rights of my country's people in general.	
5. I believe sourcers helped improve the health of my company's employees.	
6. I believe sourcers helped improve the health of my country's people in general.	
7. I believe sourcers helped improve the safety of my company's employees.	
8. I believe sourcers helped improve the safety of my country's people in general.	
9. I believe overall social performance of sourcers was positive.	
Environmental Performance	
1. I believe sourcers helped reduce the wastes of my company.	
2. I believe sourcers helped reduce wastes in general.	
3. I believe sourcers helped reduce the energy consumption of my company.	
4. I believe sourcers helped reduce energy consumption in general.	
5. I believe sourcers helped reduce the carbon footprints of my company.	
6. I believe sourcers helped reduce carbon footprints in general.	
7. I believe sourcers helped protect the natural environments in my country.	
8. I believe sourcers helped protect natural environments in general.	
9. I believe overall environmental performance of sourcers was positive.	

Note: This rubric was created by the author based on her years of industry experience in global sourcing, as well as research and teaching experience. These are suggested, not determined, items for self-evaluation.

FIGURE 11.5 *A balance between economic, social, and environmental performance is necessary because one cannot be sustained without the other two.*
Source: Borys Khamitsevych/Shutterstock

summary

Global sourcing of textile and apparel, as one of the critical supply chain activities, must be conducted to satisfy humans' clothing needs and wants in a sustainable fashion. Without sustainability, our clothing production and consumption will not be able to last generations to generations. As a forerunner of globalizing the industry and the world, textile and apparel global sourcing must be evaluated holistically, including its economic, social, and environmental performances.

Economic performance of global sourcing may be measured through (a) cost reduction, (b) productivity growth, (c) value acquisition, (d) quick response and flexible product supply, (e) supply assurance, (f) quality assurance, and (g) capacity management (see Figure 11.6). Social performance could be examined through improvement of the welfare, rights, health, and safety of all people involved in global sourcing as well as all the people in the world. Environmental performance of global sourcing can be assessed through its overall impact on protecting natural resources and the environment and reducing energy consumption, carbon footprint, and waste.

The weight of each of global sourcing's economic, social, and environmental performances could vary, depending on each com-

pany's vision and commitment. However, sourcers must keep in mind that short-term, profit-focused performance evaluation will not guarantee their long-term survival and success. A wise balance between the three performances is recommended for all textile and apparel sourcing projects.

FIGURE 11.6 *Economic performance of global sourcing can be measured through quick response and flexible product supply.*
Source: © endostock/Fotolia

key terms

Triple bottom line sourcing performance evaluation assesses the economic, social, and environmental impacts of a given sourcing project.

learning activities

1. Search for and show examples of textile and apparel companies that are heavily focusing on social improvement for their global sourcing strategies.

2. Search for and show examples of textile and apparel companies that are heavily focusing on environmental improvement for their global sourcing strategies.

3. Search for and show examples of business failures in the textile and apparel manufacturing and retail industries as a result of focusing only on economic performance.

4. Assume you are a sourcing manager or supply chain executive in the following companies. Come up with the optimal sourcing performance evaluation strategies (self, peer, or supplier evaluations? Annually or semiannually?) and metrics (specific questions and the weight of each of the three performance categories) for each company and justify why you made such decisions.
 a. Ralph Lauren
 b. Macy's
 c. Walmart
 d. Hurley
 e. Buckle
 f. Martha Stewart's Home Collections
 g. Donna Karan

references

Pincus, A., Burns, A., & Tippner, K. (2010). *Excellence in global sourcing.* Retrieved October 25, 2013, from http://apparel.edgl.com/reports

Trent, R., & Monczka, R. M. (2005). Achieving excellence in global sourcing. *MIT Sloan Management Review, 47*(1), 24–32.

CURRENT AND FUTURE GLOBAL SOURCING

LEARNING OBJECTIVES

This final chapter discusses major changes that have been made in the realm of global sourcing from the U.S. sourcing executives' perspective. The chapter also shows the current key trends in global sourcing and projects the outlook for future global sourcing. Finally, this book concludes that global sourcing is one of the key drivers of the global economy and, by sourcing responsibly and ethically, it will continue to shape the way we do business. Upon completion of this chapter, students will be able to:

- Understand the major changes that have occurred and are currently occurring in the field of global sourcing.
- Analyze the key trends in global sourcing.
- Articulate and apply the major risks that today's sourcing executives face.
- Analyze the impact of global sourcing on the global economy.
- Be able to project our businesses and lives in the future from the global sourcing perspective.

12

Major changes in global sourcing from 2007 to 2011

The Kurt Salmon Association, one of the top consulting companies for the apparel retail industry, and *Apparel* magazine, one of the leading apparel trade publications, have been publishing key trends in global sourcing since 2007 under the title of *Excellence in Global Sourcing*. The report summarizes the results of annual surveys among apparel sourcing executives in the United States. Three key areas of trends in global sourcing in particular have been assessed and analyzed.

In 2011, the fifth anniversary report revealed major changes that have occurred in global sourcing since 2007. These changes are found in three key areas: (a) the degree of diversification of sourcing regions or partners, (b) the degree of control or involvement throughout the global sourcing process, and (c) the focus on improving information visibility throughout the supply chain (Burns & Weiner, 2011). First, in terms of diversification of sourcing regions or sourcing partners, the report suggests that today's U.S. apparel sourcing executives are under pressure to find new sourcing regions, such as Cambodia, Vietnam, and countries in the Central and South Americas, and to diversify their access to raw materials and labor throughout the world (see Figure 12.1). Diversified sourcing regions or partners help mitigate risks that may arise by being dependent on one region or one partner. The 2007 annual report showed China was the dominating sourcing destination, and 40 percent of the respondents said the top 10 percent of suppliers produced 80 percent of their entire products. This trend has changed significantly since then due to a sharp increase in labor costs in China and unpredictable export policies by the Chinese government (Burns & Weiner, 2011; Pincus, Burns, & Tippner, 2010).

The second major change in global sourcing during the late 2000s was reported to be the significant increase in U.S. sourcers' control and involvement in the suppliers' activities and

FIGURE 12.1 *Today's U.S. apparel sourcing executives are under pressure to find new sourcing regions such as Cambodia and Vietnam.*
Source: SNEHIT/Shutterstock

performance (Burns & Weiner, 2011). The popularity of direct sourcing has surged since 2007. In direct sourcing, suppliers typically own foreign supplier operations or foreign production facilities, and sourcers therefore gain and maintain maximum control throughout the entire manufacturing process in foreign countries. If not using direct sourcing, sourcers preferred establishing offices or other physical presences in foreign countries to create direct relationships with suppliers (Burns & Weiner, 2011). Today, the report shows more and more sourcers are directly involved in the entire supply chain and managing suppliers' capacity and business activities at a much deeper and more intimate level than ever before.

The third major change in global sourcing was found to be that the sourcers' need to share sourcing data and processes was much stronger than in 2007. Back then, data sharing was in its infancy, but today many sourcers use data sharing systems such as product development management (PDM) or product lifecycle management (PLM) software for global sourcing (Burns & Weiner, 2011). These data sharing systems help increase visibility at each step of global sourcing, allow sourcers to collaborate better with suppliers and improve the overall efficiency of sourcers' businesses in general. Consumer demands for sustainability and transparency, as more and more consumers today want to know where products come from and how these products are made, have also affected and continue to affect sourcers' need for data sharing.

Key trends in current global sourcing

Unstable commodity prices

One of the key sourcing trends in today's marketplace is the pressure that sourcers receive to lower costs when commodity and raw materials prices fluctuate widely. The most significant macro environmental trends that today's apparel sourcing executives identify are the prices of cotton and oil (Burns & Weiner, 2011). Figure 12.2 illustrates a steep increase in the price of cotton since 2009, from $0.63 to $1.56 (National Cotton Council of America, 2012). Similarly, the price of oil has quadrupled since 1996 to approximately $90 per barrel in 2012. All of these prices critically affect the overall cost of apparel manufacturing, logistics, and other sourcing-related activities. For the same period, the price of clothing has not increased at such rates, and sourcers have to find countries with extremely low-cost labor to mitigate high commodity prices.

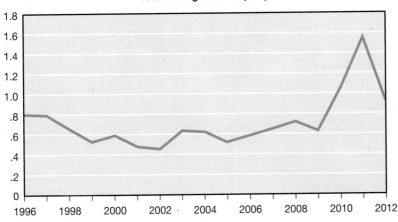

Year Average Cotton ($/lb)

FIGURE 12.2 Price of cotton in the United States
Source: National Cotton Council of America. (2012). Monthly prices. Retrieved June 6, 2012.

Significant risks to global sourcing strategy

The 2011 *Excellence in Global Sourcing* report showed survey results with regard to key risks beyond macro environmental threats that today's apparel sourcers face. First, an increase in labor costs in sourcing countries was reported to be one of the most significant risks for apparel sourcers (Burns & Weiner, 2011; see Figure 12.3). Almost 50 percent of the survey respondents shared concerns about labor costs, an increase from 41 percent in 2010 (Pincus et al., 2010).

For example, Shaun Rein, the author of a book titled *The End of Cheap China: Economic and Cultural Trends That Will Disrupt the World,* discusses rising labor costs in China due to a rising number of people in the middle class and a diminishing pool of low-cost labor within the country (Rein, 2012). Some reports suggest hourly labor costs in the manufacturing sector in China grew by 100 percent from 2002 to 2008, while the corresponding figure in United Sates was only 19 percent (Venture Outsource, 2011). Experts explain that low-cost and abundant labor was possible in China because many rural surplus laborers migrated to urban areas for industrial and manufacturing jobs. This trend has significantly decreased in recent years, and cities in China have experienced labor shortages, resulting in higher wages (Layolka, 2012). The aging population in China is another factor for increases in labor costs. By 2020, China is expected to have more than 200 million people over age 60, a population that would be less likely to contribute to manufacturing (Layolka, 2012). Similar labor concerns are found today in many other countries. In June 2012, over 50,000 garment workers in Dhaka, Bangladesh, staged violent demonstrations to demand wage increases (Lamson-Hall, 2012). Similar strikes occurred in May 2012 led by 5,000 Cambodian garment workers (Danaher, 2012). These are critical concerns that today's sourcers have to face.

Second, the 2011 *Excellence in Global Sourcing* report showed that the economic situation and domestic demands for apparel in the United States are the next most significant risks that sourcers are currently experiencing (Burns & Weiner, 2011). Economic recession and financial crisis in the United States, starting in 2007, have presented a great challenge to the ability to

FIGURE 12.3 *Increase in labor costs in sourcing countries is reported to be one of the most significant risks for apparel sourcers.*
Source: michaeljung/Shutterstock

	2007	2008	2009	2010	2011	2012
Clothing and Footwear	352.7	348.0	334.8	350.7	354.0	370.8

FIGURE 12.4 Clothing and footwear consumption expenditure of U.S. households
Source: Organisation for Economic Co-operation and Development (2013, December 3). Final consumption expenditure of households.

predict future demands of most consumer products. According to the Organization for Economic Co-operation and Development (OECD; 2013), U.S. consumers in 2012 spent approximately 3.4 percent of their household income, or US$370.8 billion, on clothing and footwear. Figure 12.4 illustrates the trends of U.S. household consumption expenditure for clothing and footwear (OECD, 2013). Fluctuating demand and uncertain economic situations make it difficult for sourcers to commit to large quantities far ahead. Therefore, shorter lead times are preferred as late commitment of quantity and production could be possible through more precise demand forecasting.

Third, the survey respondents pointed out that the depreciation of the U.S. dollar compounds the problem of unpredictable and declining consumer demands for clothing. The U.S. Dollar Index, or USDX, measures the value of the U.S. dollar relative to the majority of its most significant trading partners (Investopedia, 2012). USDX directly affects currency exchange rates. Figure 12.5 illustrates U.S. dollar indices from 2007 to 2011 published by the U.S. Federal Reserve. Figure 12.5 shows a gradual decrease in the value of the U.S. dollar against other major currencies. More specifically, it shows that the U.S. dollar has lost the strength of its buying power from $84.04 in March 2009 to $69.85 in May 2011, representing an almost 17 percent decrease in its value (U.S. Federal Reserve, 2012). This means sourcers now need 17 percent more dollars to purchase the same clothing and textile products than they did in 2009.

FIGURE 12.5 U.S. dollar index (2007–2011)
Source: U.S. Federal Reserve. (2012). Nomina major currencies dollar index. Retrieved June 15, 2012.

Other risks, such as supplier capacity and capabilities, potential trade agreements, stability of countries or regions, and product quality or recalls pose threats to sourcing executives (Burns & Weiner, 2011). In particular, almost 40 percent of the survey respondents in 2011 pointed out that they were extremely concerned about both supplier capacity or capabilities and the stability of the countries or regions. It seems that today's U.S. apparel sourcing executives do not have confidence in their existing suppliers' capability and delivery promises. Political instability seems to worsen their confidence in projecting suppliers' future performance.

Key factors for choosing suppliers

The 2011 *Excellence in Global Sourcing* report also shows that today's U.S. apparel sourcing executives seek suppliers in the Americas (including North, Central, and South Americas), South Asia, Cambodia, and Vietnam. In particular, sourcing from countries in the Central America region—such as Guatemala, El Salvador, Honduras, Nicaragua, Panama, Belize, and Costa Rica—offers U.S. sourcing executives reduced lead time, flexible supply, and the ability to quickly respond to product or inventory needs in the U.S. marketplace (Pincus et al., 2010). Difficulties in predicting consumer demands has pushed sourcers to find suppliers in closer proximity. Central America has a unique geographic advantage for the U.S. market. Figure 12.6 shows the Central American region.

Countries in the South Asia region (see Figure 12.7)—such as Bangladesh, India, Nepal, and Pakistan—are also popular sourcing destinations because the region is home to over one-fifth of the world's population, supplying abundant labor for apparel manufacturing (United Nations Statistics Division, 2011). Cambodia and Vietnam belong to the Southeast Asia region, and both are members of the Association of Southeast Asian Nations (ASEAN).

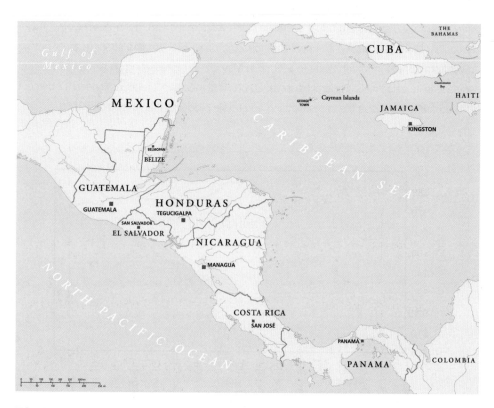

FIGURE 12.6 Central America
Source: Central Intelligence Agency. (2012). Regional Maps. Retrieved June 15, 2012, from The World Factbook.

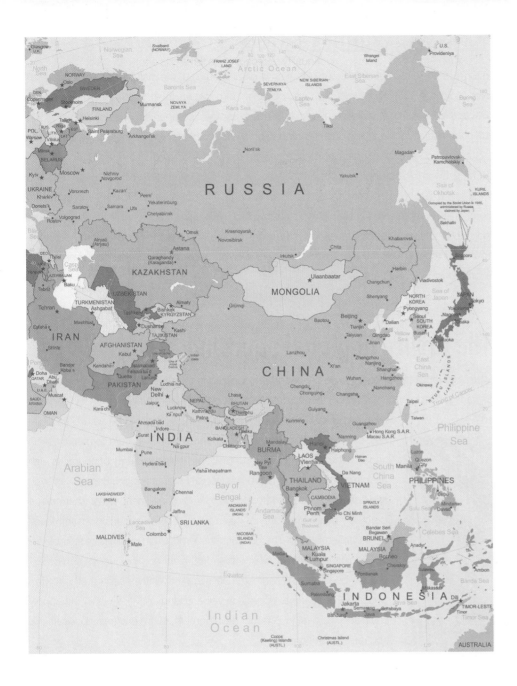

FIGURE 12.7 Asia

Source: Central Intelligence Agency. (2012). Regional Maps. Retrieved June 15, 2012, from The World Factbook.

Their shares in imports for U.S. apparel sourcers have been steadily increasing, and more and more U.S. sourcing executives are interested in learning about these countries as potential sourcing destinations.

In addition, 29 percent of the survey respondents in 2011 reported cost being the most important factor when selecting suppliers, followed by quality (18 percent), lead time (15 percent), and availability of raw materials (11 percent) (Burns & Weiner, 2011). This result supports the argument that cost is not the only factor for global sourcing; sourcers consider many different aspects of the global supply chain before making sourcing decisions. Despite the importance of sustainability and transparency, only 6 percent of the respondents stated that social compliance is an important factor for supplier selection (Burns & Weiner, 2011). This number was substantially decreased from 14 percent in 2010 (Pincus et al., 2010).

Technology utilization

In terms of the status of technology utilization in global sourcing, the majority of sourcing executives indicated Microsoft Excel, Access, or other homegrown tools to be the most popular (Burns & Weiner, 2011). This was particularly true for smaller companies with less than US$100 million annual revenues. Only one-fifth of the survey respondents shared that they use specific systems, such as product development management (PDM) or product lifecycle management (PLM) software, to collaborate both internally and externally. Despite the ability to share data and information between sourcers and suppliers through this software, the majority of sourcing companies do not seem to use these systems. In fact, more than 60 percent of the respondents indicated that they need data sharing systems only "sometimes" or even "never" throughout the sourcing process. This result indicates that there is great room for improvement in terms of data sharing, visibility, and transparency.

The future of global sourcing

More and more of our businesses will become globalized in the future. With the advancement of transportation and information technology, doing business in foreign countries will become

even easier than it is today (see Figure 12.8). It would be natural for businesses to seek other places and countries that offer more favorable conditions for the best market opportunities. There are plenty of countries with people who are willing to work at apparel manufacturing companies even at wages that seem extremely low to U.S. consumers' eyes. Therefore, it is unlikely that the majority of mass production operations will come back to the United States. The bulk of mass production is still more suitable for developing countries in which abundant labor and low wages can be extremely beneficial for sourcers. Developed countries such as the United States will continue to engage in value-added activities within the supply chain such as design, product development, textile engineering, sourcing, and retail operations.

However, not all sourcing must take place long distance. In recent years, many sourcing companies in the United States wanted to "move manufacturing jobs back home." American Apparel is one of the examples of businesses focusing on U.S.-made products. The Central American region has also been a popular choice for U.S. sourcing companies that want to "return to home." Some people call this trend "near-shoring" as opposed to "offshoring" (Stolarski, 2010).

Considering all of these trends, global sourcing is not expected to go away. In fact, global sourcing may become more popular as economies of many other countries rise to the level of the currently developed countries. For example, South Korea and Taiwan used to be popular sourcing destinations by U.S. apparel sourcers. As their economies advanced, economic activities in these countries have shifted from labor-intensive to capital-intensive and knowledge-based. In the apparel sector, these countries are now engaged in global sourcing to satisfy their own domestic apparel demands. Even apparel manufacturing companies in China are

FIGURE 12.8 *In the future, global sourcing will become even easier than it is today.*

Source: Veiamin Kraskov/Shutterstock

relocating their operations to other countries such as Cambodia, Vietnam, and Bangladesh. In the future, finding the right sourcing destinations and the right suppliers may be more challenging, as there will be more sourcing competitors from all over the world.

This highly competitive global sourcing arena may continuously push sourcers for more diversified supplier portfolios throughout the world. China is no longer the country from which sourcers can get anything in any quantity. Sourcers can ill afford to be putting all their eggs in one basket and are better off spreading various textile and apparel manufacturing across the regions and the world. Diversified supplier portfolios neutralize risks and lessen dependency on one supplier or one sourcing country (see Figure 12.9). Therefore, sourcers in the future may have to network with more supply chain members in the whole world, including domestic manufacturers.

FIGURE 12.9 *Diversified supplier portfolios neutralize risks and lessen dependency on one supplier or one sourcing country.*
Source: Ralf Siemieniec/Shutterstock

Finally, the need for transparency throughout the global sourcing process may be more intensified in the near future as more and more consumers demand information on "where the products come from" (Bhaduri & Ha-Brookshire, 2011). Our concerns surrounding our natural and social environments may pressure more businesses to be more transparent, responsible, and ethical in the global marketplace. To the people in developing countries where apparel manufacturing occurs, sourcers are the faces of developed countries, such as the United States. Therefore, sourcers have to keep in mind that what they do matters to their communities and other countries in the world. Ethical courage to do the right thing, even if it is far from home, and consideration of all overt (such as direct manufacturing costs) and hidden (such as pollution) costs will be ever more necessary in the future of global sourcing. For that, the triple bottom line of sustainability provides the core foundation of global sourcing philosophy.

Students in textile and apparel related areas have countless opportunities in global sourcing. Knowledge of global sourcing directly helps trend forecasters, designers, product developers, merchandisers, buyers, retail operators, textile engineers, software developers, and many others in the global supply chain. For those who want to be deeply involved in global sourcing, jobs with titles, such as production assistant, trim assistant, fabric developer, production scheduler, production coordinator, and quality control coordinator could be excellent entry-level employment choices. Sourcers are involved with budgeting, purchasing, social compliance, negotiation, development, inventory management, sampling, planning, and controlling. Any jobs requiring daily or close communication with foreign suppliers would be ideal for future sourcers (see Figure 12.10). Communication skills, willingness to travel, relationship-building and maintenance skills, openness to different cultures and worlds, and the knowledge of global politics, economics, and social and technological trends are important competencies for future sourcers. With such competent sourcers, global sourcing will continue to transform lives and businesses in the world.

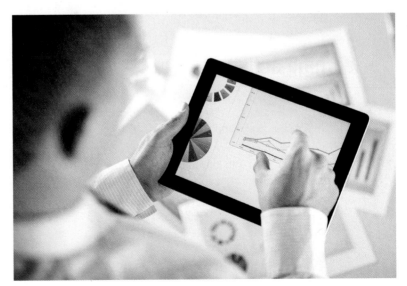

FIGURE 12.10 *Any jobs requiring daily or close communication with foreign suppliers would be ideal for future sourcers.*
Source: © pojoslaw/Fotolia

summary

Major changes have occurred since 2007 in the arena of global sourcing. Instead of putting all their eggs in one basket, more sourcing executives have sought a diversified portfolio of supplier bases. With fluctuating economies and geopolitical instability, sourcing from one country or region or from one supplier poses too many risks to sourcers. In addition, today's sourcers want to be more involved throughout the sourcing process for better control over quality, delivery, and other critical production procedures. Deep involvement also provides a greater degree of visibility and transparency for global sourcing, and more sourcers are seeking such visibility.

One of the key pressures that today's U.S. sourcers face is to maintain low-cost production in an environment in which commodity prices fluctuate greatly. The price of cotton has tripled and the price of oil has quadrupled in the recent past (see Figure 12.11). Despite the hike of commodity prices, the retail price of most apparel products found in the U.S. market has not changed much. Sourcers are constantly looking into lowering costs, increasing productivity, and creating higher-value products than ever before. Rising labor costs in China, Cambodia, and Bangladesh are constant threats. An unpredictable economy, fluctuating consumer demands, and a depreciating U.S. dollar force sourcers to look for different ways to produce the right products, in the right quality, at the right time, and at the right price.

Today, apparel sourcers are everywhere in the world, transforming the way we do business and the way we live. Global sourcing is not going away. Global sourcing is and will be in the forefront of the development of the global economy. By sourcing products responsibly and ethically, sourcers have tremendous opportunities to make positive impacts on the world in both developing and developed countries.

FIGURE 12.11 *The price of oil has quadrupled in the recent past.*
Source: Marquisphoto/Shutterstock

learning activities

1. Explain how domestic demand conditions could pose risks in terms of sourcers' responsibilities.

2. Explain how depreciation of the U.S. dollar affects sourcers' price negotiations with foreign suppliers. Show how depreciation differs from appreciation in the U.S. dollar.

3. Search the articles in the most recent issues of *Sourcing Journal* at the journal's website. What are the most recent news stories related to global sourcing?

4. Discuss how sourcers could make impacts on the world, both positive and negative.

5. Discuss whether or not you think global sourcing will continue in the future.

references

Bhaduri, G., & Ha-Brookshire, J. (2011). Do transparent business practices pay? Exploration of transparency and consumer purchase intention. *Clothing and Textiles Research Journal, 27*(2), 135–149.

Burns, A., & Weiner, M. (2011). *What a difference five years makes: Fifth annual apparel research study and analysis.* Retrieved October 25, 2013, from http://apparel.edgl.com/reports

Central Intelligence Agency. (2012). *Regional maps.* Retrieved June 15, 2012, from *The World Factbook:* https://www.cia.gov/library/publications/the-world-factbook/docs/refmaps.html

Danaher, S. (2012, May 26). *Analysis: Cambodian strikers may cause industry-wide wage increases.* Retrieved June 15, 2012, from http://www.sourcingjournalonline.com/analysis-cambodian-strikers-may-cause-industry-wide-wage-increases

Investopedia. (2012). *U.S. dollar index—USDX.* Retrieved June 5, 2012, from http://www.investopedia.com/terms/u/usdx.asp#axzz1yAZXSAlv

Lamson-Hall, P. (2012, June 15). *Bangladeshi rioters vandalize RMG units, shutter 300—No comment from H&M.* Retrieved June 5, 2012, from *Sourcing Journal:* http://www.sourcingjournalonline.com/labor

Layolka, M. (2012, February 17). *Chinese labor, cheap no more.* Retrieved June 5, 2012, from *The New York Times:* http://www.nytimes.com/2012/02/18/opinion/chinese-labor-cheap-no-more.html

National Cotton Council of America. (2012). *Monthly prices.* Retrieved June 6, 2012, from http://www.cotton.org/econ/prices/monthly.cfm

Organization for Economic Co-operation and Development. (2013, December 3). *Final consumption expenditure of households.* Retrieved from OECD. StatExtracts: http://stats.oecd.org/Index.aspx?DataSetCode=SNA_TABLE5

Pincus, A., Burns, A., & Tippner, K. (2010). *Excellence in global sourcing.* Retrieved October 25, 2013, from http://apparel.edgl.com/reports

Rein, S. (2012). *The end of cheap China: Economic and cultural trends that will disrupt the world.* Hoboken, NJ: Wiley.

Stolarski, D. (2010, August 13). As offshore costs exact their toll, is "nearshoring" a better way? Retrieved June 15 2012, from *Apparel* magazine: http://apparel.edgl.com/news/As-Offshore-Costs-Exact-Their-Toll,-Is–Nearshoring–a-Better-Way-63175

United Nations Statistics Division. (2011, September 20). *Composition of macro geographical (continental) regions, geographical sub-regions, and selected economic and other groupings.* Retrieved June 15, 2012, from http://millenniumindicators.un.org/unsd/methods/m49/m49regin.htm

U.S. Federal Reserve. (2012). *Nomina major currencies dollar index.* Retrieved June 15, 2012, from http://www.federalreserve.gov/releases/h10/Summary/indexn_m.txt

Venture Outsource. (2011, April 17). *2011 report: China manufacturing hourly labor rate, compensation costs impact EMS.* Retrieved June 5, 2012, from http://www.ventureoutsource.com/contract-manufacturing/2011-china-manufacturing-hourly-labor-rate-compensation-costs-ems

index